The Midwest in American Architecture

THE MIDWEST
IN AMERICAN
ARCHITECTURE

EDITED BY

JOHN S. GARNER

UNIVERSITY OF ILLINOIS PRESS

URBANA AND CHICAGO

Library of Congress Cataloging-in-Publication Data

The Midwest in American architecture : essays in honor of Walter L. Creese /
 edited by John S. Garner.
 p. cm.
 ISBN 0-252-01743-9
 1. Chicago school of architecture (Movement) 2. Prairie school
 (Architecture) 3. Architecture, Modern—19th century—Middle West.
 4. Architecture, Modern—20th century—Middle West. 5. Creese, Walter L.
 I. Creese, Walter L. II. Garner, John S., 1945–
 NA722.M53 1991
 720′.977—dc20 90-31986
 CIP

CONTENTS

Walter L. Creese

FOREWORD

 This book is dedicated to Walter Littlefield Creese, who taught architectural history to a generation of students in the School of Architecture of the University of Illinois. Before coming to Illinois in 1958, he taught at the Hite Institute of the University of Louisville and, between 1963 and 1968, served as dean of the School of Architecture and Allied Arts of the University of Oregon before returning to Illinois. He retired in 1987, and when not at home writing he delivers an occasional lecture, interlarded as always with the anecdotes that became his style. It is in the nature of Walter Creese to extend a helping hand to others. Never too busy to share a thought, check a source, or write a letter on one's behalf, he combines the virtues of scholar, teacher, and friend.

Creese's interests have ranged widely to include American and Modern European architecture as well as city planning and environmental history. Because of his adopted midwestern home, he developed an abiding interest in the architecture and landscape architecture of the Chicago and Prairie schools. He encouraged his students to study afresh the works of such well-known architects as Louis Sullivan and Frank Lloyd Wright and to explore the relationships of these men to other architects. An appreciation for the underlying motives and regional influences that distinguished these schools of architecture and the historical sources that reveal them has always concerned him. In the following essays, each written by one of his former students, such appreciation surfaces anew.

Born to a prominent family in Danvers, Massachusetts, in 1919, Walter Creese attended both private and public schools before completing his education at Brown and Harvard. His political inclinations were liberal, and as a young man he was attracted to such New Deal programs as the Tennessee

Valley Authority and Greenbelt New Towns. In completing his most recent book, *TVA's Public Planning: The Vision, the Reality* (1990), he drew upon a lifetime's interest in that large-scale achievement in architecture and planning. Like F. D. R. who initiated those programs, Creese was stricken with poliomyelitis at a time when a cure was unknown and the chances of recovery uncertain. With the help of his family and the will to endure the pain of periodic operations and long convalescences, he managed to overcome the more crippling effects of the disease. The ordeal taught him the value of perseverance and patience, qualities that have earned him the respect of the many students and colleagues he has educated and counseled. Although forced to walk with canes, he never found them an obstacle to the travels his vocation required.

Early in his career, assisted by a Fulbright grant to Great Britain, Creese studied the sources of New Town planning to lay the foundation for his seminal work, *The Search for Environment: The Garden City before and after* (1966). He followed with *The Legacy of Raymond Unwin* (1967) to offer the first in-depth appraisal of the architect who created Howard's first Garden City and advanced the profession of planning in both England and America. While encouraging his students to assess their environment with a critical eye, he set an example himself by traveling America between semesters and during sabbaticals. Driving coast to coast and border to border, and aided in part by Rockefeller and Guggenheim fellowships, he spent his time contemplating both intimate settings and magnificent vistas, culminating in *The Crowning of the American Landscape: Eight Great Spaces* (1985). This work celebrates the splendor of architecture and nature, and their rare although ennobling combination. Creese's descriptions of Riverside and Taliesin evoke the pastoral qualities of two midwestern landscapes and their enhancement through architecture. Beyond them, from Jefferson's Monticello to the Yosemite, he reveals the transcendental nature of environments both cultivated and sublime.

Despite his teaching responsibilities and devotion to research, Creese gave selflessly of his time to put the Society of Architectural Historians (SAH) on a sound footing during its early years. Before serving as president of the SAH, he edited its journal, changing it from a mimeographed bulletin to a prestigious and handsomely printed quarterly publication. His services to the profession were recognized by his election to Honorary Member in the American Institute of Architects, by the Smithsonian Institution for accomplishments in higher education, and by the Department of the Interior for contributions to historic preservation. He is one of the first Americans to be honored by an award from the National Academy for the Advancement of the Handicapped.

Walter Creese and his wife Eleanor make their home on the outskirts of Champaign, Illinois, where they can look out upon the cultivated landscape of the prairie and enjoy its westerly breezes and vermilion sunsets.

PREFACE

 Most historians would question the importance of regionalism in the development of modern architecture. No architect of the late-nineteenth century could help but be influenced by national trends. What cannot be denied is the significance of location in the evolution of a particular school of design such as the Chicago School or the Prairie School.

Since the nineteenth century, the Midwest has been marked by contrast. Its industrial and rural landscapes are sharply defined. As a region, it conveys the image of America's heartland, captured in the poetry of Carl Sandburg and the paintings of Grant Wood. The rich loam of its prairies has yielded an abundance of crops—more corn per acre, for example, than any other region of America—to harvest, mill, and distill. The Survey and Land Ordinance of 1785 and 1787 turned the Midwest into a Cartesian grid of townships six miles square, a classical pattern beautifully illustrated in the color folio plates of the county atlases published throughout the region during the nineteenth century. Such a vast and verdant plain—apportioned in such a rational way—beckoned easterners and European immigrants in search of a fresh start. In architecture as in agriculture, the setting encouraged the use of new technologies to solve problems and to do things on a grander scale and in a more efficient way.

Chicago, the region's largest city by the close of the nineteenth century, followed a different agenda from that of Boston or New York. Its builders were prospectors in search of wealth, investing new money and experimenting with high-risk new industries. They commissioned architects of vision who were willing to eschew convention in favor of novel and expedient forms. The skyscraper that transformed the city's horizon in the 1880s and 1890s was not a regional invention, but rather an innovation. Tall buildings

had been erected elsewhere and earlier, but they did not appear the same as in Chicago, where their massive, simplified forms dominated the landscape. In residential design, the city's industrial barons occasionally rebeled against convention and built prairie houses with low, horizontal planes that would hug the ground and contrast the outcropping of Victorian mansards and Queen Annes. Builders of small banks and commercial buildings with veneers of brick and ornamental terra cotta gambled on such progressive designs to entice new customers. Beyond the original landmarks of a Louis Sullivan skyscraper or a Frank Lloyd Wright house were virtually hundreds of anonymous buildings designed by architects inspired by the new styles and granted the cultural freedom to express them in Chicago and throughout the Midwest.

The School of Architecture of the University of Illinois was also experimental, at least in its founding years. Its graduates answered the challenge of designing buildings in Peoria, Springfield, St. Louis, Indianapolis, and, above all, Chicago. Planted on the prairie south of Chicago but within reach of the city by the Illinois Central Railroad, the University of Illinois announced in 1867 the first architecture program to be situated in the Midwest. Illinois was second only to the Massachusetts Institute of Technology, another land grant institution, in offering a college degree in the field. Like other technical institutes, it was charged with training the offspring of an industrial society. To farm better and to build better were part of its practicum.

The School of Architecture would not receive its first student until 1870, however, when Nathan C. Ricker (1843–1924) enrolled. A Yankee from Maine who moved to Illinois, Ricker was a mature student with an omnivorous appetite for learning; he would complete his studies in record time and then remain at the university the rest of his life to head up the architecture program and design new buildings for an expanding campus. He maintained a studio in the "Old Main," a prominent campus building designed by J. M. Van Osdel, a pioneer Chicago architect who served as a trustee of the university. It may have been Van Osdel who encouraged student Ricker to spend part of 1872 in Chicago. The Great Fire of the preceding year and the ensuing boom in new construction would attract many young draftsmen, including Adler, Burnham, Root, and, later, Sullivan. In 1873, following graduation, Ricker traveled to Europe to visit the Vienna Exposition and to enroll as a special student at the Bauakademie in Berlin.[1]

That Ricker attended the Bauakademie with its regimented instruction in the science of building as opposed to the breezy ateliers of the École des Beaux-Arts is significant. It was, in a sense, the midwestern thing to do. John Milton Gregory, first president of the University of Illinois, had patterned his curriculum to follow the German example in the sciences and liberal arts, with short-term courses in mathematics, history, and drawing, requiring frequent examinations and a thesis for graduation. Ricker's instructor in architecture was Harold M. Hansen, a Scandinavian immigrant who

had attended the Bauakademie as a state scholar. When Ricker replaced Hansen, he instituted shop courses and model building to better understand structural loads and three-dimensional forms. He was assisted by the sculptor Lorado Taft, who conducted a class in clay modeling and architectural ornamentation, and by Charlotte Patchin, who taught freehand drawing.[2]

Their methods were empirical and pragmatic; students learned by doing more than by observing and theorizing. Ricker realized the limits of formal education. "The [student's] ability to make independent designs can only be awakened, the inventiveness only trained, imagination only stimulated, but never injected through education." Ricker would invite Chicago architects and engineers such as Dankmar Adler and William Soohey Smith to give lectures on theater design and foundation design in order to expose his students to the latest practices. Graduates of the new School of Architecture became competent architects, if not always creative designers. Ricker was resigned to believing that "If the power of inventive design is wanting in a pupil, it cannot be implanted by any course of training. . . ." Study could prepare the student for a successful career, but never guarantee one. To him, the best preparation included a technical and cultural understanding of building, which in turn would influence design.[3]

What Ricker found most compelling was a knowledge of the history of architecture, the evolution of style and esthetic theory. The problem he confronted in imparting such knowledge was the scarcity of textbooks for his students to read. Although the university library collected editions of Fergusson, Ruskin, Viollet-le-Duc, and Semper, these early architecture books were more discursive than instructive. But in Rudolf Redtenbacher's *Architektonik* (1883) Ricker found a suitable text and he translated it the following year for his students. Unlike Ruskin or Semper, Redtenbacher was not a polemicist. He gave his readers an unbiased and eclectic approach to the study of architecture in which construction was based on reason, history based on memory, and design based on imagination. Ricker and his students followed the formula: the better one understands the technical and historical lessons of building, the better one designs. It was axiomatic.[4]

Such instruction would also have been anathema to contemporaries of Ricker like Sullivan and Wright. Both had received some formal education (Sullivan at MIT and the École des Beaux-Arts and Wright at Wisconsin), but neither remained at any one school more than a year. They decried the academic approach where one learned by rote exercise. Ricker's earliest students, architects such as Clarence Blackall, Joseph Llewellyn, and Henry Bacon (who designed the Lincoln Memorial in Washington), mastered the lessons of historicism. They epitomized the academic approach. Of Bacon's Lincoln Memorial, Wright opined that it was a government "travesty of great memory."[5] On the other hand, students such as William Drummond, William L. Steele, and Walter Burley Griffin, who graduated between 1890 and 1900, followed in the manner of Sullivan and Wright and made indepen-

dent contributions to the architecture of the Prairie School. Griffin, who also practiced landscape architecture, went on to design Canberra, the capital of Australia (pp. 225–27).

Ricker could only prepare his students for careers based on the convention of existing examples and theories. That some of his students would advance beyond such limitations was highly desirable, if rarely obtainable. Assisted in the teaching of design, Ricker devoted more of his time to teaching history. The first graduate course in the School of Architecture was devoted to history, and for decades, those students pursuing the graduate degree would write a thesis on some aspect of architectural history and theory. They often were required to translate a work from French or German as part of their thesis.

Ricker's first student to specialize in architectural history was Rexford Newcomb (1886–1968). Raised in Independence, Kansas, Newcomb attended the University of Kansas before transferring to the University of Illinois in 1908 to study architecture. He would have been required to take architecture courses 11 and 12, the survey from ancient to modern times, followed by 13 and 14, the sequence in classical architecture, 15 and 16, the two medieval courses, 17 on the Renaissance, and, finally, 18, the modern course (Neoclassicism). Later he would enroll in architecture 106, the graduate course in architectural history introduced by Ricker and taught by each of his successors until the course number was changed in the 1940s. Ricker did not teach all the history courses: beginning in 1890 he was assisted by Charles Gunn, followed by Seth Temple, James M. White, Charles McLane, and Newton Alonzo Wells. Wells, who joined the faculty in 1899, also introduced the first courses in the history of art. In addition to lantern slides for illustrating key monuments, Ricker acquired a large collection of engravings and photos mounted on eleven-by-fourteen-inch cards. For texts, he still referred to Fergusson, Lubke, Durm, Reber, and Gailhabaud, but in 1896 he adopted the first edition of Bannister Fletcher's *A History of Architecture*. The value of Fletcher's "comparative method" was that it provided plans and sections of buildings to accompany exterior views and details. Newcomb would have received his history from Ricker and Wells before graduating in 1911. He would have just missed Fiske Kimball, who arrived from Harvard the following year, although he probably did receive instruction from Frederick Mann. Mann came to Illinois in 1910, after stints at the University of Pennsylvania and Washington University in St. Louis. He and Ricker jointly taught the graduate course before Mann was called to the University of Minnesota to establish a school of architecture there.[6]

Following graduation, Newcomb traveled to California to practice architecture and to offer a course at the University of Southern California. All the while, he worked toward his master of architecture degree at Illinois by researching Spanish missions and publishing in 1916 the first of three books on Spanish colonial architecture. After a brief stint as head of the department of architecture at Texas A&M University, he returned to Illinois to

take over the teaching of architectural history from Ricker in 1918. Prentice Duell and Thomas O'Donnell later would assist with the teaching. Newcomb became a contributing editor to the regional magazine *Western Architect* and developed a special interest in ornamental brick and terra cotta. The architects of the Chicago and Prairie schools, and Sullivan in particular, employed such materials in combination to obtain striking results (pp. 114–15). Newcomb edited the *Tile Monograph Series*, and in journals such as *American Architect*, *The Architect*, and *Western Architect* he called attention to the use of such polychromatic materials by the modernists of his day. He singled out such midwesterners as Irving K. Pond, George G. Elmslie, Dwight Perkins, Robert Spencer, Arthur Heun, George Dean, Hugh Garden, George Maher, Birch W. Long, William Drummond, Max Dunning, and Walter Burley Griffin.[7]

Although Newcomb believed his students should receive broad exposure to the historic architecture of Europe and the Near East, he believed there were lessons to be learned from the study of American architecture as well. His methodology was to examine regional developments as they influenced building type. In the *Architecture of the Old Northwest Territory* (1950), he examined the adaptation of Neoclassical buildings to the frontier settings of Ohio, Kentucky, Indiana, Michigan, and Illinois. What fascinated him were the provincial variations in classical architecture created by challenging new conditions and craft expediences. In an unpublished manuscript, "Midwestern Architecture," Newcomb extolled the achievements of those architects and craftsmen who were able to assimilate the southern and northeastern traditions in building design and construction.[8]

Although Newcomb continued to serve as professor of architecture, in 1931 he was named dean of the newly formed College of Fine and Applied Arts at the University of Illinois. Although his administrative responsibilities kept him busy, he used his position to acquire a faculty of specialists in architectural history. George Mylonas accepted an appointment at Illinois in 1932. Mylonas, who had completed his doctorate at Johns Hopkins, became a noted specialist in ancient Greek architecture and archaeology and directed several excavations in Greece and Asia Minor. Newcomb's other appointment that year was James Grote Van Derpool, who had studied architecture at MIT and the Ecole des Beaux-Arts before turning to graduate study in architectural history at Harvard. Van Derpool taught the courses in Medieval and Renaissance architecture until the arrival of Alan K. Laing in 1940, the school's first specialist in the medieval period. Like Van Derpool, who would depart in 1946 to become Columbia University's Avery Architecture Librarian, Laing was an MIT and Harvard product. His charm, sense of humor, and ability to teach history were complemented by his ability to oversee a diverse faculty of designers, engineers, and historians, who in the postwar period composed the expanding School of Architecture that Laing eventually chaired.

With such well-qualified specialists to teach the undergraduate courses,

Newcomb concentrated on the graduate course. His own research and writing focused on the American experience, and although he felt compelled to expand on the story of early American architecture that had been introduced by scholars like Kimball, Mumford, and Tallmadge, Newcomb became intrigued by the sources of modern architecture, which he endeavored to place in perspective. He was perhaps the first to recognize the skyscraper as a truly American contribution to the history of architecture; moreover, he understood the pioneering advancements in foundation engineering, skeletal framing, and fireproofing that led to its development. Newcomb's interest on the subject would be carried forward by one of his last appointments, Turpin Bannister (p. 252).

Despite the brilliant written retrospectives of Sullivan and Wright, it befell architectural historians to put their work in perspective. Contemporaries such as Ricker saw the opportunity to employ European lessons to a new set of circumstances where existing conditions (not hidebound traditions) would dictate the results. The works of Adler and Sullivan were merely exemplary of such lessons and opportunities. It mattered not that Elmslie was a Scot, Adler a German, Beman and Root, easterners, or that Griffin—like Wright—was a son of the middle border. When they accepted the circumstances and challenges imposed by location, the results were independent and different-appearing. "Thus [in Newcomb's assessment] the Midwest continues to experiment, contributing in pioneer fashion to that continuum which we call American architecture."[9]

NOTES

1. Ricker has been a subject of interest because of his pioneering contributions to architecture education in America. The best concise statement on Ricker's life is found in Alan K. Laing, *Nathan Clifford Ricker, 1843–1924: Pioneer in American Architectural Education* (Urbana: School of Architecture, 1973), pp. 3–29. Ricker was employed in the Chicago office of J. W. Roberts, although he had witnessed the destruction of the Great Fire when called to service as a university cadet to guard against looting. Wayne Michael Charney and John W. Stamper, "Nathan Clifford Ricker and the Beginning of Architectural Education in Illinois," *Illinois Historical Journal* 79 (Winter 1986):257–66.

2. Winton U. Solberg, *The University of Illinois 1867–1894: An Intellectual and Cultural History* (Urbana: University of Illinois Press, 1968), pp. 141–42 passim; Sidney Fiske Kimball, *University of Illinois: The Department of Architecture: Development, Condition, Ideals* (Urbana: Department of Architecture, 1913), pp. 1–12; and Turpin C. Bannister, *The Architect at Mid-Century: Evolution and Achievement* (New York: Reinhold, 1954), pp. 81–98. Hansen, although referred to as a Swede, may well have been Norwegian inasmuch as he first graduated from the National School of Architecture of Norway before attending the Bauakademie in Berlin, see bulletin, *Illinois Industrial University, 1871–1872* (Urbana), p. 41.

3. Turpin C. Bannister, "Nathan Clifford Ricker," *Journal of the American Institute of Architects* 20 (August 1953):77–78.

4. Roula Geraniotis, "The University of Illinois and German Architectural Education," *Journal of Architectural Education* 38 (Summer 1984):15–21.

5. Frederick Gutheim, ed., *Frank Lloyd Wright on Architecture* (New York: Grosset and Dunlap, 1941), p. 216.

6. See Rexford Newcomb papers, 1915–46, Archives, University of Illinois at Urbana-Champaign; course descriptions in *University Bulletin, 1910–1911*.

7. Prentice Duell (d. 1960) and Thomas O'Donnell (1885–1964) not only taught architectural history, but also were early involved in historic preservation, Duell at Williamsburg (1929–31) and O'Donnell with HABS (1933–41); Rexford G. Newcomb, "The Architecture of the Midwest," ca.1940, p. 23, Rexford Newcomb papers, Box 3, Archives, University of Illinois at Urbana-Champaign.

8. Newcomb, "The Architecture of the Midwest."

9. Ibid., p. 24.

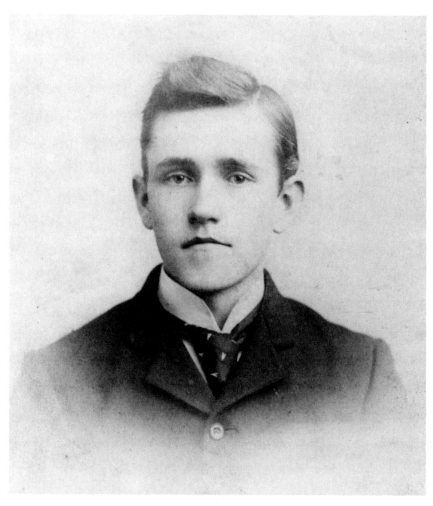

1.1 George Grant Elmslie, ca.1892 (William G. Purcell Papers, Northwest Architectural Archives, University of Minnesota Libraries, Minneapolis)

1

GEORGE GRANT ELMSLIE AND THE GLORY AND BURDEN OF THE SULLIVAN LEGACY

CRAIG ZABEL

On a spring day in 1924, the architect George Grant Elmslie took part in the funeral service for his mentor Louis H. Sullivan. "Well, we buried the greatest architect of our generation today," Elmslie wrote later that day, "in a beautiful spot in Graceland Cemetery, with five others and myself as active pall bearers. Very sad day for me. L.H.S. was a very great man. . . ."[1] Early in his life, Elmslie had known Sullivan better than possibly any other architect. Although they eventually parted ways, Elmslie remained forever loyal to the ideals and dreams of his former master (fig. 1.1).

At the funeral was another past Sullivan apprentice, Frank Lloyd Wright. He had not been involved in the arrangements and recounted, "I attended but stayed outside."[2] Elmslie later noted that "F.L.W[.] was there. I was a pall bearer so was [Kristian] Schneider [Sullivan's modeler of ornament] and some other old timers. F.L.W[.] was not one of us."[3] Yet Wright paid his respects to one of his greatest inspirations on that April day, and it is through his work that one sees the most complete fruition of Sullivan's vision of an organic architecture for democratic America.

Elmslie has been less celebrated by history. In contrast to the bold, impassioned, and prolific career of Wright, Elmslie's contributions to American architecture seem more episodic, subtle, and often of a contributory nature. While Wright was the supreme individualist, Elmslie worked best in association with other architects. Yet, it was Elmslie's apprenticeship with Sullivan for nearly two decades (much longer than Wright's) that legitimized to Elmslie his role as the one best able to explain the true meaning of the Sullivan legacy. Elmslie felt personally obligated to accept this responsibility. At times it would seem like a never-ending burden of trying to set the facts

straight, whereas at other times he could relish the idea of a truthful representation of the glory of Sullivan's ideas and buildings being forged through his guidance.

This active participation in the formation of history was a major concern during Elmslie's final decades. Yet he was not alone. Sullivan's most famous student, Wright, also accepted the calling of interpreting Sullivan's life and work. Wright had a much wider audience than did Elmslie and expressed his ideas through major books, rather than the small articles in professional newsletters that were Elmslie's main outlet for writing. Elmslie often did not agree with Wright's memories and interpretations. He wanted to set the record straight as he saw it, but he seemed to live his life in the shadow of two giants, Sullivan and Wright. How Elmslie helped shape history and how his life and career compare with these two legendary figures in American architecture offers a revealing portrait of the nature of progressive midwestern architecture in the late-nineteenth and early-twentieth centuries.

Characteristic of Elmslie's life is that whereas both Sullivan and Wright acknowledged their personal importance to history by writing major autobiographies, Elmslie wrote an unpublished "Autobiographical Sketch" of a few pages. On one typed draft of his "Sketch," he critiqued his own efforts at self-explanation by writing in longhand at the top of the first page: "This is NOT very interesting to anyone I fear. Ho Hum. VERY DRY and only meant as mere NOTES anyway for some one to enlarge on." He then noted in the upper right corner: "Keep it anyway."[4]

Throughout his life Elmslie was a melancholy figure. Life did not go as he had hoped, and bouts of depression and pessimism often clouded his will to succeed. His career never fully stabilized, and he never enjoyed prosperity. Yet, he had learned so much from Sullivan that the master's legacy was his inspiration. Elmslie's youth had been spent in his native Scotland in and near the northeastern town of Huntly.[5] The traditionally accepted year of his birth, 1871, is contradicted by evidence at the Northwest Architectural Archives at the University of Minnesota. In the mid-1950s, the rector of the Gordon Schools in Huntly (which Elmslie had attended as an adolescent) researched the architect's background and reported that he had been born in 1868. Notes, probably written by Elmslie's former partner William Gray Purcell after Elmslie's death in 1952, exist that state "Elmslie was actually born in 1869," however his sisters wished that 1871 be maintained as the date of public record. In a letter of 1941 to Purcell, Elmslie remarked that he was turning seventy, thereby maintaining even to his closest friend the 1871 birthdate. Beyond the accuracy of establishing historical facts, the discrepancy is probably of no major consequence. However, it does suggest that Elmslie may have toyed with his own age in favor of youth, just as Wright did.[6] Another biographical inconsistency is that the rector from the Gordon Schools refers to Elmslie as "Emslie"[7]; perhaps, as with many immigrant names, the spelling changed in the New World. As Elmslie once reflected, "For 325 years my mother[']s people were in one place. . . . There [are]

old grave stones generation after generation, with changes in spelling as the ages passed. . . ."[8] Elmslie always remained fond of his Scottish homeland. In his later years he often grew nostalgic and wished to revisit it, but never did. He seemed to identify with the ancient Celtic spirit. For example, once upon losing a large commission he invoked an old Scottish ballad: "On an old battlefield. 'Courage my men! I am not dead. I will lie down and bleed a while and then get up and fight again.'"[9]

Elmslie came from a large family and spent his earliest years on a small farm. Like Wright, he had lifelong memories of a bucolic existence closely attuned to the cycles of nature. "As a child, up to fourteen years of age," Elmslie wrote to Wright, "I used to play, also, in a beautiful country, with winding streams and aged forest—rich and fragrant valleys—and old, old, hills covered with white and purple heather."[10] The work was hard yet satisfying, and all was warmed by the closeness of the family. In 1939 he reminisced about the family's house:

> Fireplaces! You ought to have seen our kitchen fireplace in Scotland. Stone slab floored kitchen about 16 × 16 with F.P[.] [fireplace] at one end about 10 feet wide and 4′ deep . . . we burned peat mostly and *what heat* from it. . . . I can remember going with the men to cut the year[']s supply [of peat moss]. . . . It was all stacked to dry, useless until dry. Kitchen was living room too[,] every body in the family was there. There was a Dining Room or Parlour rather that was for the minister when he visited or for others too. A long low house of stone walls, white washed (not the local name) and heather thatched roof, a tiny attic too, long since disappeared I imagine with more comfort but perhaps no more happiness. . . . Sentimental . . . but not to an expatriate who saw it all and lived as a very shy and timid laddie.[11]

Elmslie's world changed dramatically in 1884 when the family joined his father in Chicago. The elder Elmslie had emigrated from Scotland the previous year and was employed by the Armour Meat Company. George Elmslie, like Wright, never received a formal education in architecture. As a teenager in Chicago he attended first a business school and then embarked on an architectural career via the route of apprenticeship. In his early schooling in Scotland he had shown, before the age of twelve, "a special flair for drawing." "It was my parents' desire," Elmslie later recounted, "that I pursue a professional life as engineer and architect—somehow."[12]

In a letter in 1941 to the president of Yankton College in South Dakota (for which Elmslie designed many buildings and built a few), he acknowledged that "I did not have the great benefits usually derived from a college education, myself, which I regret. My training was on the age old system of master and pupil, and my good fortune was, that while my master was a great philosopher and teacher he was as well one of America's great architects— Louis H. Sullivan."[13]

George Grant Elmslie/Zabel

In *Kindergarten Chats*, Sullivan damned a collegiate education in architecture. He felt it would be "better if all architectural schools were at the bottom of the sea. They have no discernible function on land—other than to make mischief." Sullivan was appalled that "young men are taken in by an institution, so-called of learning, a so-called school of architecture, and, in four years are turned out of it mentally dislocated, with vision obscured, hearts atrophied and perverted sensibilities. . . ."[14] What Sullivan offered in his *Chats* was a different form of education, a fictional dialog between an architectural master and a young novice, who asks questions and displays his naiveté, yet slowly learns and develops a true understanding of the Sullivan ideal. Elmslie was such a novice, learning at the master's feet longer than anyone. As he later reflected:

> There is a great deal to be said for the apprenticeship type of training under a master as it was developed in the Middle Ages and later. If work in architecture is to be considered as a LIFE instead of merely something interesting to do the sooner the youth of the land starts the better. The kindergarten is none too soon and sixteen may be even too late if normal birthright plasticity of mind is to be preserved. High school as a rule destroys it and the average college education eats up what is left. Exception as to this may be taken in what is going on under Saarinen at Cranbrook and Wright at Spring Green.[15]

However, before Elmslie gained employment with Sullivan, he was a draftsman for Joseph Lyman Silsbee, a Chicago architect of shingle-style residences. At this point, architecture to Elmslie "seemed a most interesting field but it was years before I felt its fascination and possibilities."[16] It was in Silsbee's office that Elmslie first met fellow apprentice Wright.

Wright departed Silsbee's for the office of Adler and Sullivan, and Elmslie followed about a year later in 1889. According to Wright, it was he who had received Sullivan's "permission to get George Elmslie over from Silsbee's to help me and incidentally make it a little less lonesome for me there."[17] Eventually Wright and Elmslie emerged as the principal draftsmen in the firm and shared a private room next to Sullivan's in the Auditorium Tower office, what is labeled as "Mr. Wright's Room" in Wright's *Genius and the Mobocracy*.[18] Although Wright probably inflated in retrospect his importance to Sullivan at the time, Elmslie later acknowledged his own secondary status to chief draftsman Wright: "I was what Mr. Wright calls his understudy from 1890 till 1893. . . ."[19] It is important to remember that in the early 1890s both Wright and Elmslie were essentially peers: promising young draftsmen working side by side, with Wright the more precocious. Wright's well-known characterization of Elmslie in Sullivan's office has not helped the Scot's reputation: "George was a tall, slim, slow-thinking, rather anaemic but refined Scotch lad who had never been young. Faithful nature. Very quiet and diffident. I

liked him and attached him. I couldn't get along without somebody. No, never."[20]

When Wright's autobiography first appeared in 1932, Elmslie was naturally resentful of this image of a sluggish yet loyal architectural assistant, like a malnourished dog. He felt that the gossipy anecdotes that Wright included of his Sullivan years "were entirely out of place in any serious biography."[21] Wright's description offered only a limited understanding of Elmslie. For Wright, the long-term faithfulness of a quiet man like Elmslie in a self-effacing supporting role held little appeal. On the other hand, what Wright does not bring forth is Elmslie's thoughtful intellect, brilliance in ornamental design, and a kindred romantic spirit in pursuit of an organic architecture.

When Wright was dismissed by Sullivan in 1893 for breaking his contract by designing "bootlegged" houses on the side, Wright's transgression seemed unforgivable to Elmslie. In discussing the episode in a letter to Wright many years later, Elmslie stated: "I was never untrue to Sullivan, not an hour in all the years I was with him."[22] With Wright gone and with Adler's departure in 1895, Sullivan became increasingly dependent on Elmslie. Elmslie tried to deal with clients, sometimes with success, but he was no Dan Burnham. However, in the design of ornament, he displayed a special flair, and Sullivan made the most of it. From the Guaranty Building (1894–95, fig. 1.2) in Buffalo on, Elmslie began to develop his own ornamental motifs in the Sullivan manner.[23] Later in life, when Elmslie felt his contribution in the area of ornament on many of Sullivan's buildings was being ignored, he wrote Purcell: "Damn it all: beginning in 1895 and until 1909 I did 99⅗% of it including outside of the Building in Buffalo, NOT INSIDE, and moved ahead in shaping my own forms all these years. When I left some knowing people wondered what had happened to 'Sullivan[']s ornament."[24] Although Elmslie made many major contributions to such commissions as the National Farmers Bank at Owatonna, Minnesota (1906–8, fig. 1.3), Sullivan was forever the master, and Elmslie was "a good pencil in the Master's hand," to borrow Wright's phrase.[25]

Elmslie, in his later years, would be torn between conflicting beliefs over his true importance during his years with Sullivan. At times he seemed to want to demand recognition for the great deal of work that he had done, whereas at other times he preferred to suppress his own significance in order not to diminish Sullivan's historical importance. When he reprinted his article "Sullivan Ornamentation" in 1946, he wrote Purcell that "I deleted some of it as immaterial[,] the references to my contributions in particular[.] I created more different motifs than he ever dreamed of, but we are talking of 'Sullivan ornament', no body will ever know the facts of my relation to it as one phase of adding perfume to the architectural flower."[26]

Elmslie stayed with Sullivan until 1909. Later in life he would reminisce about the times of camaraderie with other draftsmen (figs. 1.4, 1.5): "These

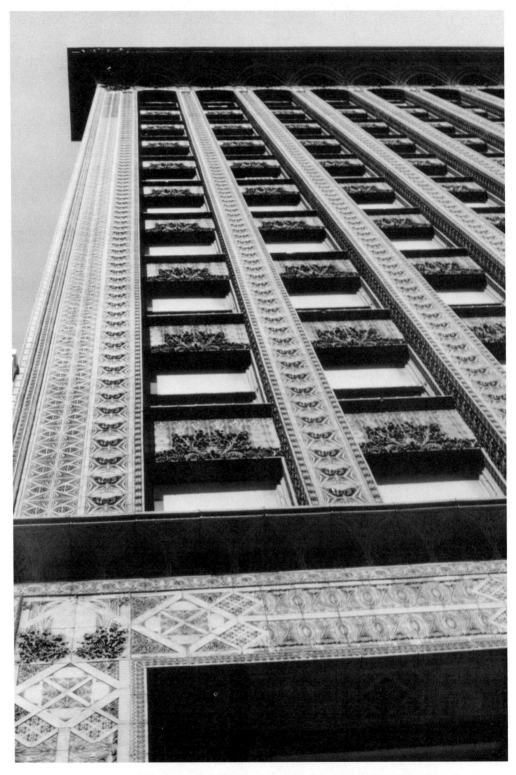

1.2 Adler and Sullivan, Guaranty Building, Buffalo, N.Y., 1894–95.

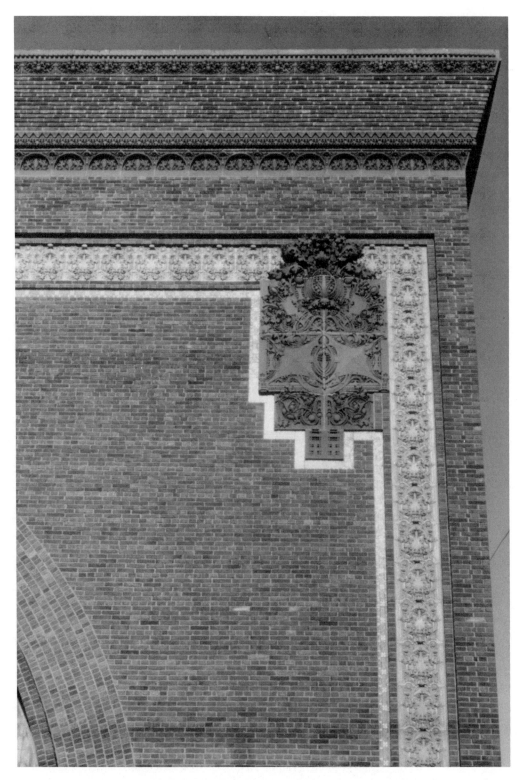

1.3 Louis H. Sullivan, National Farmers Bank, Owatonna, Minn., 1906–8.

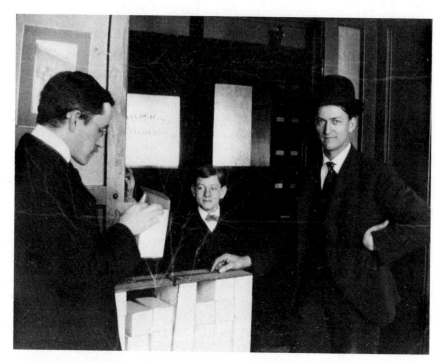

1.4 Elmslie (left) in what appears to be Sullivan's office; note "Louis H. Sullivan, Architect" seen in reverse on glass of door, ca. 1903. (William G. Purcell photograph albums, William G. Purcell Papers, Northwest Architectural Archives, University of Minnesota Libraries, Minneapolis)

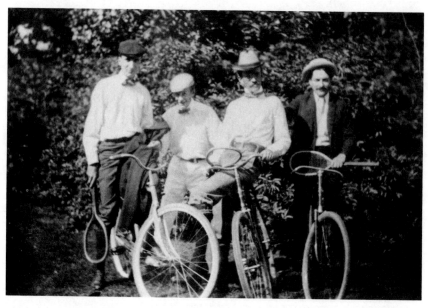

1.5 Left to right: William L. Steele, Charles Hogeboom, George G. Elmslie, and Conrad Kimball, ca.1903. (William G. Purcell Papers, Northwest Architectural Archives, University of Minnesota Libraries, Minneapolis)

were the days of high spirits and enthusiasm[;] we played tennis every Saturday afternoon in Washington Park."[27] However, what was dearest to Elmslie was watching the development of a genius. Along with his role in design, Elmslie would also critique Sullivan's essays at his request—he had become much more than just an assistant. The years when Elmslie was closest to Sullivan were also the years during which Sullivan's often-told personal decline began.[28] He had gone from a builder of skyscrapers in the mid-1890s to an occasional designer of small-town banks by the 1910s. All of this profoundly affected Elmslie and the direction of his career. Had Sullivan's architectural practice remained stable, Elmslie probably would have remained with the master and continued the office after Sullivan's retirement or death: "I was his heir as far as business was concerned. It was so stipulated in his will when I was with him, as well as that I was his chief interest and concern in carrying forward his philosophy as applied to architecture."[29] However, the raw reality of Elmslie's position by 1909 was that there was little or no architectural practice to inherit if he held on.

The situation had been bad for many years. When Elmslie later chastised Wright for his review of Hugh Morrison's book on Sullivan (p. 22), Elmslie recounted the many sacrifices he had made: "I worked for Sullivan for ten years for half pay and acknowledged by him as such. . . . My very great affection for him induced me to stay as long as I did, even when friends for many years had urged me repeatedly to leave. I do not regret what I did but I lost many years, as related to my own welfare, and now think that my contribution to his life was worthy of some regard. . . . During those years I contributed at least fifteen thousand dollars to his budget that I could have earned elsewhere."[30] Elmslie believed that such unparalleled devotion entitled him to be the true heir to the Sullivan legacy.

Elmslie had seen Sullivan at his most brilliant and at his darkest moments: "His wife used to come in and see me in the office, and shed tears not knowing what to do with her Louis, she had to have assistance, every night at times, to help put him in bed. Ho hum . . . Great Man . . . he drank absolutely alone when not at home. I can well imagine the abyssmal [sic] depth of his meditations, alas for his sorrows."[31] Elmslie was forced to make perhaps the most difficult decision of his life: to leave Louis Sullivan. In January 1909 he lyrically described the level of work in Sullivan's office as being "instead of a spring song, the recurring refrain of a dirge." By August, he speculated openly about the need "to leave this office and become associated elsewhere or go, to some other city and shed the 'light' of architectural freshness into dark places (Bah!)."[32]

Elmslie was nearing his forties and was still an architectural apprentice with little income and seemingly little future unless he made a dramatic move. He was not alone in the world; he would live most of his life with several of his sisters. He felt the responsibility of earning a decent income and being an asset to the family. He also began to desire what many pursue when they are in their twenties, a spouse and a career. In 1908, he had grown

fond of a twenty-seven-year-old Chicago woman, Bonnie Marie Hunter. His courtship of her would be tender, slow, and cautious: "I do hesitate to bother her with my presence. I am so much of an antiquity. . . . I did not know a moment's happiness for many years, and the flame burned low, for many clear cut and now quite definite reasons, which would take me a week to tell you."[33]

Many years later, in a letter to Purcell entitled "Comments by a *gloomy Celt*," Elmslie wrote: "Devotion to any man as disciple may lead to the decay of the integrity of one's spirit. Devotion to a beloved woman may lead to the stars and a life of glory, dignity and utter selflessness."[34] Elmslie was first coming to this belief in the fall of 1909 as he worked up the nerve to quit Sullivan's office. What he found especially frustrating was Sullivan's inability to temper his idealism when discussing commissions with potential clients: "Louis can't get off his high horse and he never will. I don't suppose. He doesn't know how to handle people. You could give him all the pieces on the chess board excep[t] 3 pawns and beat him running easy."[35] Elmslie never suggested that Sullivan should compromise artistically, but rather should develop some common sense in the art of wooing clients. For example, in 1909, through Elmslie's efforts, Sullivan had the possibility of doing "some public mausoleum work," an opportunity that was perhaps enhanced by Sullivan's earlier tombs for Graceland Cemetery in Chicago and Bellefontaine Cemetery in St. Louis. However, when Sullivan was shown "copyrighted drawings of the most atrocious architectural pretensions," he quickly dismissed the representative and "abruptly terminated" any possibilities of a commission.[36]

In November 1909, Elmslie reported to Purcell that he was preparing "some sketches of a 500 catacomb building," a project that he seems to have been working on alone: "How I can do it all Heaven only knows. Everything must be on the quiet of present."[37] By late fall 1909, Elmslie began to maneuver behind Sullivan's back to attempt to secure commissions that Sullivan had already lost. He often corresponded with his closest friend, Purcell, who had worked briefly for Sullivan in 1903 and since 1907 had his own practice, Purcell and Feick, in Minneapolis. Elmslie encouraged Purcell to pursue those jobs that Sullivan had let get away. If Elmslie would then join Purcell, they could, in effect, take over the Sullivan practice by default. For loyal and moral George Elmslie, this was not a time when such virtues shined. Despite Elmslie's lifelong condemnation of the circumstances of Wright's departure in 1893 for "bootlegged houses," his own difficult separation in 1909 was not a pure, simple act. In mid-November Elmslie wrote Purcell:

> I didn't tell you that L.H.S. resigned from the Peoples Savings Bank of Cedar Rapids, Iowa. . . . He resigned in an arrogant fit of absurd petulance because of their refusal, until the bids were all in, to make an additional payment on his fees. . . . There is no possible chance of reconciliation, or I wouldn't dream of telling you. What I would like you to do since you, of course, "don't know" any of the facts, is to get after the Job. It is lost here. They are very fond of Owatonna

. . . you can say that you will be assisted by or connected with the poor devil that did so much of the Owatonna.[38]

Although after Elmslie's departure, Sullivan patched things up in Cedar Rapids and the bank was built, one senses the desperate state of affairs in the Sullivan office in late 1909. Elmslie was not maliciously trying to steal commissions from Sullivan, but rather attempting to salvage for himself those Sullivan seemed to have already irredeemably lost.

One part of Elmslie's hidden agenda lay in his wish that Purcell could be licensed to practice architecture in the state of Illinois. Elmslie felt that because Purcell had a firm of his own, he had a better chance to be licensed than did Elmslie, who was only a draftsman. (Elmslie acquired registration and membership in the A.I.A. in 1916 after working as Purcell's partner.) There was an urgency to the letters from Elmslie to Purcell in late November:

I hope you'll consider the license matter quickly as concerns Illinois.

I am considering changing the activity of my friend in Kentucky [the mausoleum?] from L.H.S. to Purcell + Feick of Chicago and Minneapolis, it is important.

There are 3 Bungalos [sic] in Aurora [Illinois] in prospect and 2 houses for friends of personal friends of mine that I am after in the same place[,] a $25,000 apartment a few blocks from here, Babson's garage and servant rooms, and this mausoleum business. A pipe dream possibly but some is bound to come.[39]

Elmslie noted as late as November 21 that "the time is not ripe for me to break with L.H.S." but on December 4, Sullivan briefly recorded in his diary "'George quit Berry stays'."[40] Parker Berry, who had just joined Sullivan's office, would fill Elmslie's former position until 1917. A few days later, Elmslie wrote Purcell: "I am no longer in Mr. Sullivan's employ and the first thing at hand appears in the nature of completing the drawings for the interior of the Bradley house in Madison. . . ." Elmslie was loyally completing yet another Sullivan building even upon leaving the man, yet he also tried to recover from the enormous personal toll that this severing of an apprentice from the master had taken: "It has been a dreadful time and has cost me almost the last ounce of mental and physical endurance. The wrench is terrible, so many years. And now Mr. Sullivan is unfit for any commercial enterprise and appears on his last legs."[41]

The year 1910 was to be the beginning of a new life for Elmslie. He moved to Minneapolis, and Purcell and Feick became Purcell, Feick and Elmslie (fig. 1.6). In 1913, George Feick, an engineer who had little impact on the designs of the firm, left, and the firm was rechristened Purcell and Elmslie. In September 1910, he married his beloved Bonnie (fig. 1.7). Unfortunately, what was to be the happiest period of Elmslie's life was woefully short. After less than two years of marriage Bonnie died following an operation.[42] For a man who had delayed a life of his own for so long and who

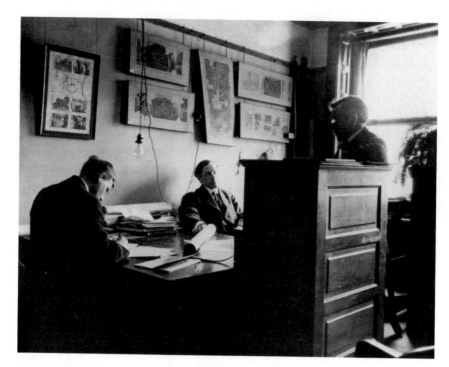

1.6 Feick, Purcell, and Elmslie in their Minneapolis office, ca.1910–12. (William G. Purcell Papers, Northwest Architectural Archives, University of Minnesota Libraries, Minneapolis)

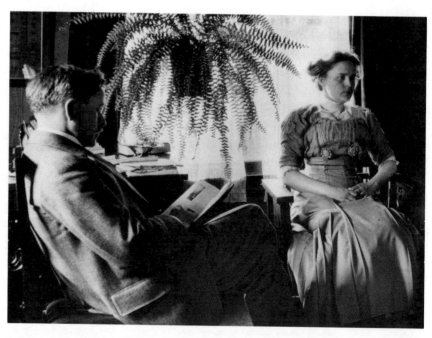

1.7 George and Bonnie Elmslie, ca.1911. (William G. Purcell Papers, Northwest Architectural Archives, University of Minnesota Libraries, Minneapolis)

had briefly attained the stability of marriage and career, the tragedy was an emotional blow from which Elmslie never fully recovered. It would fuel his predilection for depression and until his last days he would ruminate about the long life with Bonnie that fate had denied him. "What is a home without a WIFE and children," Elmslie wrote in 1946, "Lord of Life! how I miss my Sweet, more now than ever. What a life it would have been with ease and peace in our old age!"[43]

Despite Purcell's coaxing to stay in Minneapolis, Elmslie returned to Chicago to live with his sisters: "Minneapolis for me all alone means boarding house as long as I live. . . . Evenings by myself + noon times by myself. . . ."[44] The firm continued with the main office in Minneapolis and Elmslie alone in Chicago. Purcell and Elmslie was one of the most prolific Prairie School firms during the second decade of the 1900s, although financially the business needed to be buttressed by Purcell's family. The full history of the firm and its architecture lies well beyond this discussion, but Purcell and Elmslie considered themselves to be true disciples of Sullivan's ideals while also learning from Wright's architecture, resulting in a unique synthesis distinctive of the firm.[45]

For Elmslie, the firm was both a mission and an opportunity in that he believed that both Sullivan and Wright were fading from the architectural scene in Chicago. The aging Sullivan sporadically built only a few small-town banks, while Wright seemed to be more in the public eye for his turbulent personal life than for his architecture and had retreated to Spring Green, Wisconsin. Elmslie felt Chicago, not Minneapolis, to be "the greatest field for the display of [architecture] . . . in all America. Minneapolis does not compare, beautiful and gracious and prosperous as it is, set side by side with this metropolis, which is the centre of activity for the deliverance of such messages as we believe we have to give."[46] He saw a growing vacuum in Chicago that he wanted Purcell and Elmslie to fill: "I was talking with a public spirited man the other day, who declared that 'here [in Chicago] the progressive movement in architecture was to[o] fought out. . . . At present you are loosing [sic] and loosing badly. The reactionaries are in the saddle completely equipped and you have practically nobody, with Sullivan out and done for, Wright not considered a personal asset to the movement.' "[47]

Purcell and Elmslie did build some buildings in Chicago and its suburbs, for example, the Edison Shop (1912–13, fig. 1.8) on Wabash Avenue and the Service Buildings for Henry Babson (1915–16) in Riverside, but the firm never approached the level of commissions in the Chicago area that Wright had before 1910 and Adler and Sullivan did during the 1880s and 1890s. Opportunities were more prevalent in Minneapolis and small prairie towns like those in which Sullivan was building his banks.

Elmslie's departure from Sullivan did not terminate their relationship, unlike that of Wright and Sullivan, who did not speak for some two decades after 1893. Elmslie still felt responsible for his mentor, at least to some degree, and would visit and check on Sullivan's situation. Purcell and Elmslie

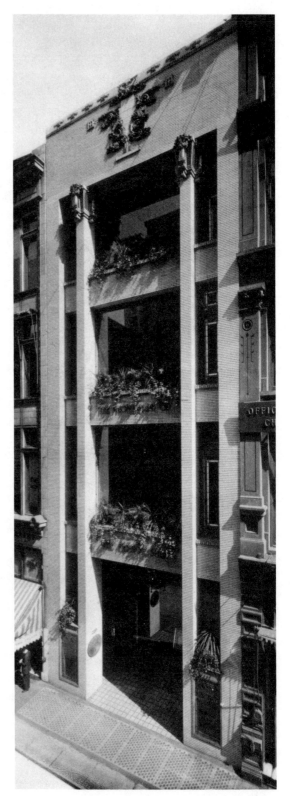

1.8 Purcell, Feick, and Elmslie, Edison Shop, Chicago, 1912–13 (demolished). (William G. Purcell Papers, Northwest Architectural Archives, University of Minnesota Libraries, Minneapolis)

would become greatly concerned when real or imagined trouble developed with one of Sullivan's few commissions; for example, Elmslie tried to save some semblance of Sullivan's original design for the St. Paul's Methodist Episcopal Church in Cedar Rapids, Iowa (1910–14), after Sullivan had angrily backed out. However, the former Sullivan apprentices sometimes competed for the same jobs as their master, as was the case when St. Paul's was originally commissioned. The younger men had mixed feelings; they wanted as much work as possible, but they were pleased for Sullivan when he got a job, and they hoped that he could hold onto it.[48]

Elmslie's personal feelings toward Sullivan were also mixed. "I have never gotten over those L.H.S. years of going all and getting nothing," Elmslie wrote in 1917: "It was too long an experience of master + man." Yet, coupled with this resentment was an enduring idolization of Sullivan's former greatness. It was difficult for Elmslie to observe Sullivan's decline firsthand: "no one feels more fiercely than I do the falling off of the mighty mind, and landing in the depths below. I feel that intensely, more than most because I have known his better side when it was in full control better than anyone else—. . ." Sullivan "seems utterly friendless not from his own statement as he is hanging on hard, but from the general tone of remarks from those he is with a little bit."[49]

Elmslie would remain one of Sullivan's few friends until the very end, but did the relationship ever transcend that of master and apprentice? The question becomes even more difficult when one considers how close Sullivan and Wright grew after their reunion during Sullivan's final decade.[50] It was a building by Wright, not Elmslie, that Sullivan chose to write about in his final articles. In his unrestricted praise for Wright and his Imperial Hotel in Tokyo, Sullivan seemed to pronounce that Wright was the truest offspring of his ideals and would carry the torch better than anyone else into the future.[51] This historical succession of Sullivan to Wright was thus blessed by Sullivan before his death. No such public pronouncements from Sullivan occurred concerning Elmslie's work after 1909. Wright as the prodigal son was reaping honor, while Elmslie's role seemed reduced to that of the ever-loyal yet frustrated son looking on.

Elmslie's own career did not prosper as he had hoped. As World War I came, commissions for Purcell and Elmslie were reduced substantially. There were some successes during these years, however, such as the Woodbury County Courthouse (1915–17, fig. 1.9) in Sioux City, Iowa, which was largely designed by Elmslie in association with William L. Steele, who had won the commission. Nonetheless, Purcell felt the need to leave Minneapolis for Philadelphia, where he worked as advertising manager for Alexander Brothers, a leather belting concern for which Purcell and Elmslie did some work. When Alexander Brothers went bankrupt in 1919, Purcell decided to move to Portland, Oregon, in 1920.[52]

Despite their close friendship, the strain of a faltering business partnership began to take its toll on both Purcell and Elmslie. This was not helped

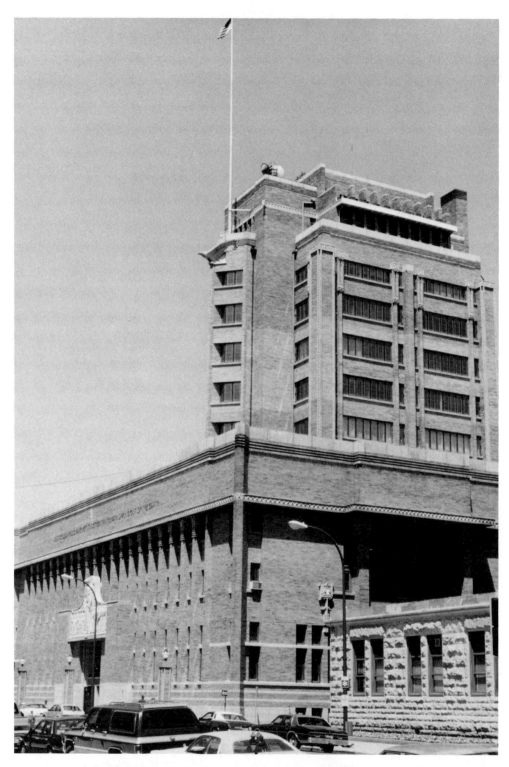

1.9 Purcell and Elmslie (for William L. Steele), Woodbury County Courthouse, Sioux City, Iowa, 1915–17.

by the men's ever-widening physical separation. Elmslie seemed more determined that the partnership survive and reminded Purcell of the boost he had given the firm when he joined in 1910. In 1918 he seemed driven to make the firm a success in order to fulfill a dream of his late wife's: "I have worked hard day by day and many unrecorded nights to the end of making good what she [Bonnie] and I started out to do. . . . to dream a big business. . . . It didn't come true but it must come true . . . WE MUST MAKE IT."[53] Matters did not improve, however, and it was Purcell who asked for the dissolution of the firm in the spring of 1921. The early 1920s was a difficult period for Elmslie, who found himself alone. "I *never think* of those days around /22 [1922] unless they are poked under my eyes, unwittingly—" Elmslie later reflected: "I did not seem to have a friend left in the world."[54] Unfortunately, Elmslie's life had reached a surprisingly similar situation to that of Sullivan's, little money, few friends, and a dark future of an occasional job that allowed for mere survival. Even before his breakup with Purcell, Elmslie tried to promote himself as a bank architect through a series of articles and advertisements in the *Bankers Monthly*, but he built only four more banks and did not receive professional credit for one of them.[55]

When the remodeling of the American National Bank in Aurora, Illinois (1922–23, fig. 1.10) was published in the *Architectural Record*, *Bankers Monthly*, and the local newspaper, Elmslie's name was nowhere to be found.[56] Lawrence A. Fournier and the Bankers Architectural and Engineering Company were listed as architects. Fournier had been a draftsman for Purcell and Elmslie since 1912, and after 1917 worked with Elmslie in Chicago on such projects as American National Bank. However, Elmslie and Fournier had a bitter falling out in 1922; Fournier became frustrated with doing much of the firm's work and getting no credit for it. Elmslie seems to have been predisposed to inactivity, dreaming, writing, and accomplishing very little. "We have no help . . . ," Fournier wrote: "But Damn it I have to push the work and the boss also. That is too much." What especially infuriated Fournier was that Elmslie would not accept the apprentice's input into a design; Elmslie "would let me work my head off but he would never recognize me in any other [relationship] than that of draftsman." Unlike Elmslie when he left Sullivan, Fournier in 1922 resented all that Elmslie stood for: "Once in a while the old 'form and [function]' business is [resurrected] from the dump heap. It is funny to hear it all again. And tragic."[57] The final dispute was over the Capitol Building and Loan Association Building (1922–24) in Topeka, Kansas. Fournier left after arguing over whether he should be listed as associate architect for the Topeka building.[58] In 1923 when he completed the work on the American National Bank, Fournier simply erased any connection Elmslie had with it, an act Elmslie would always resent, although Fournier's predicament in 1922 was not unlike that of Elmslie's in 1909: a maturing apprentice who wanted to take on the full responsibility of being an architect.

Yet Elmslie still attempted to define his relationship with Sullivan, with

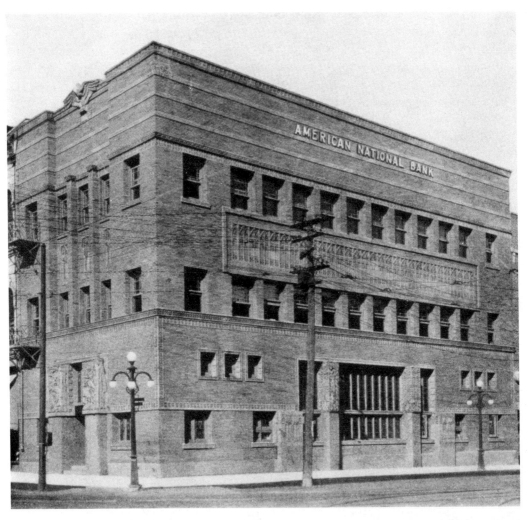

1.10 Lawrence A. Fournier (and George G. Elmslie) and the Bankers Architectural and Engineering Company, American National Bank, remodeling, Aurora, Ill., 1922–23. (William G. Purcell Papers, Northwest Architectural Archives, University of Minnesota Libraries, Minneapolis)

whom he had competed for the Topeka job, as Elmslie later recounted: "They had L.H.S. and myself in mind. They turned him down and took me. He remembered that very ungraciously, as though I had no business to earn a living where he was concerned."[59] The two architects were on the margins of their profession, just trying to hold on. Elmslie later recalled Sullivan's situation: "Sullivan in his later years had a room on the main floor [of The American Terra Cotta and Ceramic Company's office in Chicago] . . . he had a table where he made his prize ornamental drawings, and as he told me he was doing 'piece work' for the first time in his life being paid for each one as completed, [he said this with a] sad and pathetic smile on his masterful

face."[60] The most poignant account of Sullivan's last days, however, was written by Wright in his autobiography and rewritten for his book on Sullivan, *Genius and the Mobocracy*. The circumstances of their final meetings seem to reinforce the image of Wright as the heir apparent to Sullivan's legacy. The master emotionally gave Wright the first copy of *An Autobiography of an Idea*, and, more significantly, a large collection of original drawings. Wright, a quarter century later, would publish a selection of the drawings in *Genius and the Mobocracy*,[61] most were from the heyday of Sullivan's career, the 1880s and 1890s. By his death in 1924 Sullivan had few personal possessions, but it is clear that the carefully preserved drawings were one item that he wanted to hand down to future generations.

After his death, few were concerned with finding out what may have been left of Sullivan's other drawings, records, and letters. What remained of Sullivan's office effects were still at The American Terra Cotta and Ceramic Company's office on Prairie Avenue in Chicago. William Gates, the company's president (pp. 166–68), saved the Sullivan material and had it moved to their factory at Terra Cotta, near Crystal Lake, Illinois. It was Elmslie who finally took an interest in the material. "There would have been none of it left at all if I had not gone to Gates in Crystal Lake to see what, if anything he had of Sullivan's. . . . I was just lucky. All the stuff was on an open porch exposed to wind and rain—Dear old Gates." In another letter, Elmslie amplified the story: "The drawings and archives were, as I said—on a porch but how long no one knows . . . one day one of the company's men called me up and some friend drove me out and there the piled up heap lay."[62]

In September of 1925, Elmslie took a preliminary look at Sullivan's material with Gates and two of Sullivan's former colleagues at the Cliff Dwellers Club, George Nimmons and Max Dunning (both of whom had been very helpful to Sullivan in his last years). Elmslie agreed that he alone should carefully go through the material and eventually distribute the important items to appropriate institutions.[63] He took on the burden of custody of the historically significant collection. How the distribution of the information and items in the archive should be handled would become a preoccupation for the rest of Elmslie's life.

Many people in the Chicago architectural community did see Elmslie as the architect closest to Sullivan. When it was decided to rectify perhaps the most disturbing testimony to Sullivan's bleak end—that his grave in Graceland Cemetery was left unmarked for some five years after his death —Elmslie was the first architect asked to design an appropriate memorial. A committee had been formed from professionals in the field who wanted to raise money and erect a tombstone for Sullivan. *Pencil Points* in May 1928 reported that "the one man who can design this monument better than any other of us is George Elmslie, for many years associated with Sullivan in his life and work. He has consented to make the design."[64] Elmslie did make some drawings, but had a falling out with the committee's chairman,

Thomas Tallmadge. Elmslie then resigned and an uninspired monument by Tallmadge was erected in 1928. "I hope the great man can rest under it," Elmslie quipped.[65] He especially resented Tallmadge, who, in the 1927 edition of his book *The Story of Architecture in America*, had disparagingly entitled the chapter on Sullivan "Louis Sullivan and the Lost Cause."[66]

In the 1930s Elmslie began to emerge in a new role as a fount of information for historians who attempted to put Sullivan into historical perspective. When Lewis Mumford published in *Scribner's Magazine* in April 1931[67] a preliminary version of his section on architecture for his forthcoming book *The Brown Decades*, a pioneering work in the assessment of America's contributions to modern architecture, Elmslie wrote Mumford a long letter in an attempt to correct and better inform the author. Elmslie immediately established his credentials: "For many years I was associated with Louis H. Sullivan and, for many years, did the larger part of his planning and designing. During those years I came to know him as probably no else does know him. A great many pretend to know him now that his greatness is looming larger and larger on the horizon as the days go by; but they fail in real understanding."[68] In this and subsequent letters in 1931, Elmslie went to great lengths to correct facts and to offer better approaches to the interpretation of specific Sullivan buildings. He also felt that Sullivan should be seen more as a "genius" rather than "eccentric," and that emphasizing Sullivan's personal decline only distracted from an understanding of his ideals.[69] Another theme seen in these letters is Elmslie's admiration of Wright as an architect and his dislike of many of his personal traits: "As Sullivan said to me, 'Elmslie, if Wright were only honest he would be half a man.' . . . This is only a side light on Sullivan's personal feeling and has nothing to do with Mr. Wright's preeminence in architecture and Mr. Sullivan's ardent endorsement of it."[70]

Mumford appreciated Elmslie's criticisms, and when *The Brown Decades* appeared later in 1931 one can see that some changes and additions had been made as a result of Elmslie's letters; for example, Elmslie was now "closely identified with most of Sullivan's designs after the partnership with Adler was broken."[71] Yet Elmslie responded with another lengthy letter offering further clarifications and stating his irritation that Sullivan's personal faults were still examined whereas Wright's were not. Nonetheless, Elmslie acknowledged that the book was a better effort than the *Scribner's* article, and "the book as a whole has a great value to me."[72]

In 1932, when Wright published *An Autobiography*, Elmslie was both greatly fascinated and disturbed by Wright's account of his days with Sullivan. After reading the book twice, Elmslie typed a long letter to Wright offering both praise and damnation. He thought the book was beautifully written, "as though it were music—A Song of Life," yet it was not the equal of Sullivan's autobiography. What Elmslie especially resented was the "garrulous miscellany" Wright included in his characterizations, such as his unflattering portrait of Elmslie, and his detailing of Sullivan's decline rather

than dropping "a veil over those last sad days and . . . [keeping] them from the curious public gaze." Moreover, Elmslie wanted to correct statements of Wright's such as after 1909 Sullivan was not "leaning" upon Elmslie for the late banks and Elmslie did not design Sullivan's tombstone.[73]

What underlies this rebuttal from Elmslie is the question of who should interpret the life and work of Louis Sullivan. Wright could certainly contend that he was very close to Sullivan during Sullivan's greatest period of creativity and, at the end, Sullivan's own actions in the early 1920s appeared to anoint Wright as his future spokesman. Nonetheless, Elmslie felt that his years in Sullivan's office had given him more insight than Wright: "The master talked a great deal with me from 1895 to 1909 . . . I think I know the real Sullivan better than you do, or anyone else. I saw him in his intellectual prime. You saw none of him in those years."[74] Although those years were ones during which Sullivan's architectural output decreased, it was the period when Sullivan did a great deal of his most important writing on architecture. Wright did respond to Elmslie's letter with a telephone call and a conciliatory invitation to his home near Spring Green: " 'Come on up dear lad and let us talk about it. The trouble is that we have missed contact for so long.' " Elmslie's answer was "non committal and somewhat sour."[75]

In his letter to Wright Elmslie proposed that he would eventually write his own book on Sullivan: "I hope, in humbleness of spirit, to write a genuine tale some day on the greatest figure in American Architecture."[76] This would not come to pass. However, Elmslie did closely assist Hugh Morrison in writing the landmark monograph *Louis Sullivan: Prophet of Modern Architecture* (1935). The book was dedicated to Elmslie, and in Morrison's foreword he acknowledged Elmslie's instrumental role: "My chief source of information on . . . [Sullivan's work after 1893] and other phases of Sullivan's life has been Mr. George Grant Elmslie, . . . who has carefully preserved not only all available records but an invaluable store of memories. It is not too much to say that without Mr. Elmslie's reverent preservation of material records and his sympathetic understanding and admiration no adequate account of Louis Sullivan could have been written."[77]

During the writing of the book Elmslie seemed very pleased at Morrison's efforts. In the summer of 1934 Elmslie wrote Purcell: "Professor Morrison of Dartmouth has finished his first draft of the life of L.H.S[.] I have annotated it all except for the last 2 chapters . . . Very good, and timely too. . . ."[78] After the publication of the book Purcell and Elmslie approached Morrison with the idea of writing on their own architectural accomplishments. Morrison thought that such a book was an excellent idea, but he did not want to take on such a task because his own interests were turning elsewhere.[79] However, by 1939, when Purcell was trying unsuccessfully to design a house for Morrison at Hanover, New Hampshire, Elmslie had grown more critical of Morrison's book: "I was in contact with his *enthusiasm* for 3 year or more. Some of his writing is very good . . . I gave him suggestions here and there

to be sure and checked over a lot of his M.S. but not all of it and I *wish* I had taken the time and to see to it that he sent it all to me. There are many missteps and many errors of judgment. . . ."[80] Despite these later criticisms, Morrison's book stands as a work based in part on Elmslie's memories, interpretations, and personal archive, and most of it was critiqued by Elmslie before it went to press.

Wright reviewed this first major book on Sullivan in the *Saturday Review of Literature*, generally panning the book and criticizing it for "drawing its information from a single person [Elmslie] (my understudy while 'serving my time' with Adler and Sullivan) and the critic dedicates his criticisms to that personal source." Wright recounted that Sullivan "put into my hands just before he died his own complete collection (hundreds) of the drawings (he had dated them) that represented him to himself at his best," and that Sullivan charged him with the responsibility of " 'writing about my work some day.' "[81]

Elmslie responded with another long letter to Wright, again attempting to spell out his relationship to Sullivan. He agreed that Morrison's book was not perfect, but thought it was a worthy effort. Once more he asserted that he had been closest to Sullivan: "I did more for him than you and all the rest put together, and if you were honest, instead of greedy for a posthumous honor, you would candidly admit it. . . . All of the available Sullivan vital material and miscellanea were turned over to me. . . . Why did not you step in and look into these things yourself in your role of newly assumed spiritual legatee?"[82] The dispute between Elmslie and Wright did not center on a major difference about how Sullivan should be interpreted, but on who should tell the story, what the correct facts were, and how much of Sullivan's personal life should be revealed. At times it seemed petty, a clash of egos, but it was a matter of deep significance to both men. It was as if they were arguing about who was the favorite, almost chosen, son of a revered father. Philosophically, they shared some important common ground. Wright asserted that Sullivan was "essentially a lyric poet-philosopher," and Elmslie concurred that Sullivan "was, essentially a lyric poet," whose greatest legacy would probably be his philosophy.[83]

Elmslie often thought about Wright over the years. He had followed Wright's career from the beginning and grew to dislike the man, but greatly admired the architect. In a rare public statement about Wright, Elmslie did not withhold praise in describing the early Sullivan days: "Wright, even then, bore all the earmarks of what he has become, the outstanding figure of our day. A Brahms in Architecture, if you like." Their early friendship did not end with Wright's dismissal in 1893: "I was loyal to you too. You have forgotten how often I went to Oak Park to do a [bit] of drawing for you."[84] During those years when Wright and Sullivan were not speaking, Elmslie recalled: "The fights I put up for him [Wright], in the days when L.H.S. despised him. . . ." Elmslie never doubted Wright's greatness. When in 1913 Elmslie described a Purcell and Elmslie design of which he was especially proud, he said: "noth-

ing like it in the U.S.A. outside of F.L.W. We humbly bow there for, know all ye wise men, we can't *touch* him, and never will."[85]

Personally, they grew apart. Elmslie, could not stomach Wright's behavior when it seemed to defy conventional morality. The warm reunion of Sullivan and Wright appears to have bred an undercurrent of jealousy in Elmslie. Nonetheless, in the realm of architecture Elmslie was always willing to give Wright his due; in comparing Wright and Sullivan, Elmslie felt: "Both [are] very great men with FLW the greater, by far, in the art of expression and L.H.S. one of the world's great teachers[,] architects AND philosophers, and as the world cares as little as ever for teachers or philosophers F.L.W. has the arena all to himself."[86] Elmslie was often in awe of Wright's architecture: "Some of the work sweeps me off my feet." Even in his critical letters to Wright he offered praise: "I have followed the drama of your work from the beginning, as it has unfolded itself, and have always been allured and fascinated by its greatness."[87] In 1945, after Elmslie's own retirement, he acknowledged "F.L.W. looms larger as a memorable figure as the days pass. . . . The Guggenheim will be another wonder, another eye opener." By 1951 Elmslie could only predict "F.L.W[.] is approaching his zenith of interpretation and creation."[88]

The old grudges were still there. When Wright finally published his promised book on Sullivan, *Genius and the Mobocracy* (1949), little had changed from those passages that Elmslie had questioned in Wright's 1932 autobiography. Elmslie was still presented as "faithful George," "slow of speech and movement, who had never been really 'young.' " The late banks Wright considered "backwash" because Sullivan "had been heavily leaning on George Elmslie." Again, Wright erroneously credits Sullivan's tombstone to Elmslie and condemns "this idea of imitating his [Sullivan's] work as a monument to him." By this point, Elmslie simply wrote Purcell that Wright "likes to pick on me," and rehashed his version of the events.[89]

Wright's late career, especially from 1936 on, was one of major significance and numerous commissions. Elmslie, in contrast, attempted to maintain an active practice during the 1920s and 1930s, but it was one of an occasional built commission and few paychecks. His buildings during this period have drawn less attention than has his earlier work with Sullivan and with Purcell.[90] Nonetheless, many of these works are of a high quality that extend the principles, forms, and ornament of the earlier Chicago and Prairie schools, a physical testimony by Elmslie that the ideas of Louis Sullivan did not expire with Sullivan's death. Some of Elmslie's late buildings seem to be just the last expressions of an earlier age, such as the Keystone (fig. 1.11) and Graham buildings (1922–23 and 1924–26, respectively) in Aurora, Illinois, which rework themes of Sullivan's skyscrapers of the 1890s. Other buildings offer new solutions to older issues; the Old Second National Bank (1924–25) in Aurora transforms the idea of a midwestern bank from Sullivan's ideal of a "jewel box" into a "bank home."[91] Some of the buildings were more experimental; the Healy Chapel (1927–28, fig. 1.12) in Aurora offered a new

1.11 George G. Elmslie, Keystone Building, Aurora, Ill., 1922–23.

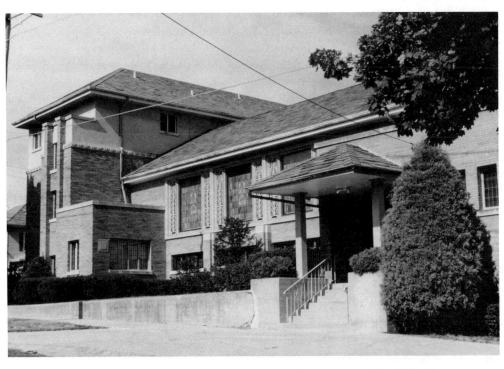

1.12 George G. Elmslie, Healy Chapel, Aurora, Ill., 1927–28.

1.13 George G. Elmslie, First Congregational Church, Western Springs, Ill., 1928–29.

alternative to the traditional funeral home in a converted house and separate church ceremony by combining both in a custom-built structure shaped like a large prairie house.

Not all of Elmslie's late buildings maintained the forms and ornament of progressive midwestern architecture, however. Some of this work was in historical styles, although in his public writing he always condemned revivalism as inappropriate for the modern age. He satirized contemporary "make believe Gothic Churches" in his 1928 architect's statement for the Healy Chapel[92] while he was building the First Congregational Church of Western Springs, Illinois (1928–29, fig. 1.13), with its pointed gothic arches like those of an English parish church. Nonetheless, when he used historical forms, he interpreted them freely by stressing the underlying geometry of the masses, and often embellishing them with his distinctive use of ornament. His sources tended to be the buildings of northern European tradition, particularly from his native Great Britain.

Elmslie was never able to establish a flourishing practice of his own. The coming of the Great Depression diminished some of his most promising opportunities; for example, only a few large buildings were built of the several that he designed for Yankton College at Yankton, South Dakota. To survive he occasionally began to work in association with other architects. During the 1920s he designed for the Chicago architect Hermann V. von Holst three neighborhood offices in Chicago for the Peoples Gas Light and

1.14 Hermann V. von Holst, architect, and George G. Elmslie, associate architect, Maxwelton Braes Resort and Gold Club, rear wing, Baileys Harbor, Wis., 1930–31.

Coke Company,[93] as well as other buildings such as the Maxwelton Braes resort hotel (1930–31, fig. 1.14) at Baileys Harbor, Wisconsin, with its exceptional stonework on the first story, like an enlarged vernacular cottage in the British Isles. During the late 1930s Elmslie worked for William S. Hutton of Hammond, Indiana. These would be Elmslie's last designs to be built and included four schools in the Hammond, Indiana-Calumet City, Illinois, area (fig.1.15) and a group of dormitory "cottages" (1938–39) for the Indiana Boys' School in Plainfield.

Although the full story of Elmslie's late work will not be undertaken herein, it is of interest to examine the occasional correlation between Elmslie's and Wright's architecture in the late 1930s. In a 1938 project for a house, Elmslie offered two alternative elevations. One is dominated by a large gable roof in the English domestic tradition (fig. 1.16), which Purcell and Elmslie had often used for Prairie School houses in the 1910s. In the second elevation the gable is gone, and the roof is flat (fig. 1.17). Was Elmslie responding to Wright's 1930s update of the prairie house, the Usonian house?

Like Wright, Elmslie became fascinated with the architectural possibilities of the hexagon, a form found in the ornament of Sullivan. Elmslie and Hutton would make it the central ornamental motif of the entrance pavilions of their Thornton Fractional Township High School (1934–35) in Calumet

1.15 William S. Hutton (and George G. Elmslie, associate), Thomas A. Edison School, Hammond, Ind., 1935–37.

1.16 George G. Elmslie, "Seven Room House," project, March 1938. (William G. Purcell Papers, Northwest Architectural Archives, University of Minnesota Libraries, Minneapolis)

1.17 George G. Elmslie, house project, ca.1938. (William G. Purcell Papers, Northwest Architectural Archives, University of Minnesota Libraries, Minneapolis)

City and the Thomas A. Edison School (1935–37, fig. 1.15) in Hammond. In a 1937 article Elmslie rhapsodized about the polygon: "This wonderful form is the hexagon, a perfect organization in every sense of the word. Its beginning, at the dawn of the crystalline age, at the first steps in evolution, was ultramicroscopic and developed in one of its phases in the course of time into the majestic form of the three dimensional honeycomb, or more properly speaking, four dimensional."[94]

In 1938, Elmslie saw in a periodical Wright's use of the hexagon in his "honeycomb house," the Hanna House (1936) in Palo Alto, California. Elmslie was fascinated by, yet critical of, the design and felt that he had realized the importance of the hexagon before Wright.[95] Nonetheless, Wright had taken a major step beyond Sullivan by taking the organic geometry of Sullivan's ornament and using it as the generating module for the plan of a building. Elmslie would follow this lead in his 1939 "Sketch of Taberna-cle for Chicago Congregation" (fig. 1.18). However, for this unbuilt project Elmslie used just one large hexagon for the church's auditorium; the rest of the building's plan is fairly standard in its institutional rectilinearity. This hexagonal plan of Elmslie's church parallels and possibly follows that of Wright's contemporary Ann Pfeiffer Chapel (1938) at Florida Southern College in Lakeland.[96]

A possible capstone to Elmslie's architectural career was an article by Talbot Hamlin that appeared in *Pencil Points* in September 1941, "George Grant Elmslie and the Chicago Scene."[97] The well-written tribute to Elmslie's long career also unintentionally showed the dilemma of attempting to focus upon his individual contributions. His most important efforts were often intertwined with the talented work of his associates. Colleagues such as Purcell and Hutton were mentioned in the article, but all buildings were not attributed fully, and some mistakes were made. Egos were bruised, and Elmslie tried to mollify his friends.[98] The article created a situation similar to Elmslie's complaint about the underrating of his contribution to Sullivan's work: all who had an important role want to be properly acknowledged.

During his late career, Elmslie did more writing and published a number of articles in a regional newsletter, the *Illinois Society of Architects Monthly Bulletin*, between 1934 and 1940. Much of his writing is an attempt to continue spreading the word about the Sullivan idea and how it was still vital. In one article, Elmslie stated his concern that "functionalism" in the world of the International Style had become a cold, utilitarian concept. Elmslie believed that "It is not a formula. It is an inspiration—fluent, plastic, and clothed in garments of romance." The concept of an International Style held no appeal for Elmslie; architecture should be "regional, local, communal and personal." He did not relish a future of "functionalized houses" that were "merely dehumanized glass enclosures, harshly and bitterly formed," or art museums that were "merely glorified machine shops."[99] Between 1935 and 1938, Elmslie would continue to make such pronouncements as Chicago received such speakers as Le Corbusier, Walter Gropius, and Mies van

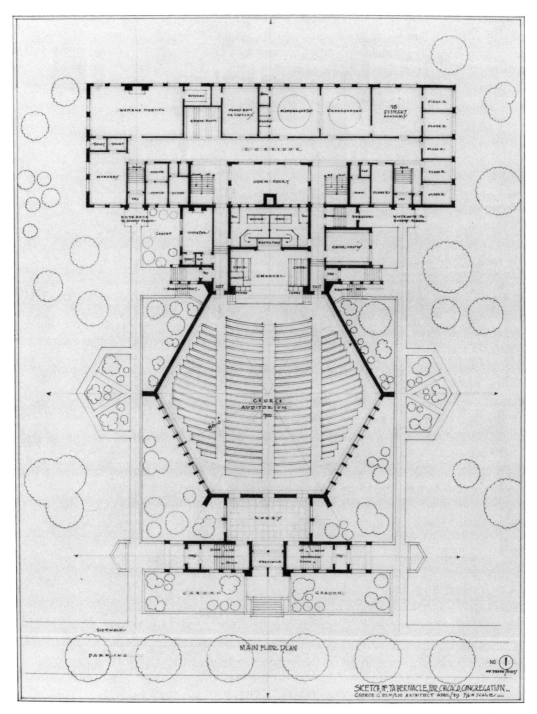

1.18 George G. Elmslie, "Sketch of Tabernacle for Chicago Congregation," project, April 1939. (William G. Purcell Papers, Northwest Architectural Archives, University of Minnesota Libraries, Minneapolis)

der Rohe, all of whose speeches were duly covered by the *Illinois Society of Architects Monthly Bulletin*.[100]

In his literary fight against evolving architectural values, Elmslie would write such articles as "Do Principles of Architecture Change?" wherein he decried the architect who had become a "dry mechanical" technician rather than "poet assembler."[101] What perhaps most disturbed Elmslie, one of the greatest designers of architectural ornament in American architecture, was that applied ornament was no longer in favor: "The absence in what is called modern architecture of decoration as the integral enrichment of structure is painful at times, and especially so when one considers how far a modicum of genuine enrichment would go to vitalize a structure, to humanize it, and at such trivial expenditure in relation to the cost of the whole work."[102] In attempts to stimulate those organic principles that seemed lost to the generation of the 1930s and 1940s, Elmslie wrote articles on "Sullivan Ornamentation," "Reflections on Rhythm," and "Organic Life and Architecture."[103]

However, other than Wright, few architects promoted a romantic vision of an organic and regional architecture by the late 1930s. Elmslie's philosophy was becoming more a part of history. The passage of time must have struck Elmslie (fig. 1.19) when he was asked in 1939 to present a paper at a symposium on "The Chicago School," which was seen as a past epoch. In his paper, Elmslie articulated a deep understanding of the roots of modernism going back to Pugin, Morris, and Viollet-le-Duc and traced its development through Wright. The keystone in this development was naturally Louis Sullivan: "The first prophetic utterance in prefiguring the future of architecture in America was disclosed by the generator of all real thinking on Architecture in America, at that time, and with rare exceptions since, Louis H. Sullivan, . . ."[104]

During the 1930s, Elmslie had tried to continue building and writing in a manner respectful to the Sullivan tradition. Despite the worthiness of Elmslie's efforts, the most important way he could affect the historical assessment of Sullivan would be the manner in which he dispensed the archive of Sullivan material he had gathered. Certainly, assisting Hugh Morrison in producing an important monograph was one of Elmslie's most important contributions in guiding the historical account of Sullivan.

Another project of great significance to Elmslie was to get Sullivan's most important writings into print, particularly *Kindergarten Chats*, which originally had been published in fifty-two installments in an obscure periodical, the *Interstate Architect and Builder* (February 16, 1901–February 8, 1902) and by the early 1930s had been essentially lost to the general public. Throughout 1933–34, Elmslie made efforts to bring *Kindergarten Chats* out in book form.[105] Plans fell through with a major publisher, but a limited edition of the book, edited by Claude F. Bragdon, was published by the Scarab Fraternity Press in 1934. In the Foreword, gratitude was expressed to Elmslie as Sullivan's "pupil and friend, in whose sympathetic care have been

1.19 George G. Elmslie, 1932. (William G. Purcell Papers, Northwest Architectural Archives, University of Minnesota Libraries, Minneapolis)

intrusted his philosophic writings and drawings."[106] Elmslie had assumed the role of Sullivan's "literary executor," a position in which he felt he could have the largest impact in preserving and continuing the Sullivan legacy: by once more putting the master's words and ideas before the public.

As the full manuscript of Sullivan's 1918 revision of *Kindergarten Chats* came to light, Elmslie wanted to see this definitive version in print.[107] It was finally published in what has become the standard work, the 1947 edition edited by Isabella Athey and published by Wittenborn, Schultz, Inc. At

Elmslie's suggestion, several major essays by Sullivan from 1885–1906 were included at the back of the book.[108] The resulting volume, coupled with Sullivan's *The Autobiography of an Idea*, has introduced generations of students of architecture to the lyrical philosophical world of Sullivan's architectural vision.

One large book of Sullivan's, which had remained unpublished during his own lifetime, was *Democracy: A Man-Search* (1906–8). Elmslie also longed to see this work published; he considered it Sullivan's "magnum opus."[109] He was able to get two short sections of the book published in the magazine *Twice a Year* in the early 1940s.[110] Before Elmslie's death, the entire manuscript of *Democracy* was made available to the public in microcard form. Elmslie was pleased to give permission for this edition in 1949 to a young professor from the University of Louisville, Walter L. Creese. He wrote Creese that Sullivan had "read all of 'Democracy' and his other writings to me as the books were written chapter by chapter."[111] The literary legacy of Sullivan was perhaps the one aspect of the master most dear to Elmslie. After his own death, *Democracy: A Man-Search* was finally published in book form in 1961.[112]

Along with being Sullivan's "literary executor," Elmslie also had the responsibility of depositing in appropriate institutions those Sullivan items which he considered to have historical importance. During the 1930s and 1940s, he gave numerous drawings, photographs, medals, manuscripts, and other material of Sullivan's to the Burnham Library at the Art Institute of Chicago.[113] Other gifts were made to the University of Michigan, where Emil Lorch (Elmslie's brother-in-law) taught, and Columbia University, where Talbot Hamlin (author of the 1941 *Pencil Points* article on Elmslie) headed the Avery Architectural Library.[114]

However, Elmslie was selective in the archival material to which future scholars would have access. Such items as the drawings and manuscripts that helped to define Sullivan's genius were carefully saved. Other more prosaic artifacts of Sullivan's life such as business letters and datebooks were discarded. Elmslie had no interest in passing Sullivan's everyday affairs on to others. In 1938 he wrote Purcell: "I have 300 or so [of Sullivan's letters] in an old business letter book—will throw away someday. I had all his diaries from 1909 to 1922, and threw them all away but 1909. In the 1909 one there is a note "George quit Berry stays" Dec. 4/. The diaries were business notes only and many indications of meeting this mistress and that, so out they went—after each visit was a curious symbol, *an algebraic formula: . . .*"[115]

Elmslie was doing what he wished Wright had done, dropping a veil over Sullivan's personal life in order to not detract from Sullivan's important accomplishments in architecture. What was lost was a detailed historical record of Sullivan's life and practice. The diaries were essentially datebooks listing such things as business meetings and contacts.[116] The diaries from 1909–22 would have provided a clear picture of how Sullivan pursued commissions during those last desperate years, what leads he had, where he trav-

eled, and whom he met. Elmslie simply noted about the diaries: "I read most of them for interesting historical memoranda, but nothing of any value."[117]

A great deal of this Sullivan miscellanea was probably destroyed, such as Sullivan's list of "many 'loans' aggregating $16,500 when he passed on. C. R. Crane's was the largest sum. I tore up his list."[118] In his defense, Elmslie wrote that "My idea was to distribute as seemed fitting, real things of the man as an operating genius. *The real* L.H.S. passed out with the two buildings in Cedar Rapids [ca.1910]."[119] Were possibly drawings of unbuilt projects from Sullivan's last years destroyed by Elmslie? He wanted Sullivan to "be expressed as he was and not as expressed in lapses in later years. Let us preach the real man. I would regret the perpetuation of anything in the shape of drawings that vitiated what he so ardently and eloquently expressed in *Kindergarten Chats*, which by the way would never have been published except through my efforts." Elmslie did tell Purcell that "I destroyed nothing that bore the L.H.S. signature."[120] Nonetheless, Elmslie felt he had acted like a writer who throws away all the rough drafts when the final manuscript is completed.

Much of this editing of Sullivan's historical record occurred when Elmslie retired and cleaned out his office. Purcell, who fastidiously preserved anything that might have some historical importance, was livid at what Elmslie had done. Elmslie, however, had always been one to throw things away. As early as 1913 Purcell was taking his partner to task: "I still continue to hope that some day I may either scare you or tease you or educate you into not throwing valuable data away. It seems to be a habit with you." Even during his days with Sullivan, Elmslie was by his own admission "too familiar with throwing things away," and Sullivan would command: " 'Keep them. Keep them all; they have a meaning, *don't you see. . . .*' "[121] However, Sullivan himself had not carefully preserved his office effects. Other than the selected drawings given to Wright, the saving of any of the rest of Sullivan's things was due to Elmslie's trip to Crystal Lake. During that visit Elmslie was surprised at how much was missing: "It would appear that the master threw away many documents of A. and S. and L.H.S." Even when Elmslie was with Sullivan: "He had destroying spells at times, especially when a 'bit under.' Tore up all his life insurance policies one day, quite a chore to reconstitute."[122]

Despite what Elmslie had destroyed, he saved and passed on to major research libraries a core collection of Sullivan material that has played a central role in shaping the historical perception of Sullivan. What Elmslie wanted to promote was Sullivan's ideas, not the man. Even Sullivan's buildings were not the most important, although Elmslie had to painfully watch many of the master's works be abused and remodeled as the years passed.[123] "Sullivan is NOT going to be known, in ages to come, as an architect," Elmslie wrote, "but as a GREAT philosopher, teacher + preacher, of a way of life in architecture + the arts. Remembered for the things he said much more than for the things he did . . ." This was the Sullivan legacy that Elmslie carefully

tried to orchestrate. This legacy was perhaps Elmslie's greatest burden: "I have thought so much about Sullivan all my life. . . . I am sick and tired about the whole business."[124] At other times it was Elmslie's greatest glory that he did not want to do anything to diminish: "I have no desire to detract from the supremacy of the master while I was there or afterward. . . . While I was there I was a draughtsman[.] If I did anything as of P and E or G.G.E[.] that is all another story[.] I hope some of it is basic architecture."[125]

Elmslie retired from architecture in the early 1940s and, in declining health, continued to live with his sisters in Chicago until he died in 1952, nearly three decades after his master's death. Financially, he never experienced true security. Like Sullivan before him, Elmslie would accept financial support from a friend; Purcell often sent him checks. Elmslie's letters often reflect a morose pessimism and gloom. Life was never as good as before the passing of his Bonnie in 1912. Yet by the late 1940s he was completing a mission, the passing of the architectural ideas of Louis Sullivan to the next generation.

The architectural profession recognized both Sullivan and Elmslie at this time, when the American Institute of Architects posthumously awarded their Gold Medal of 1944 to Sullivan in 1946 (World War II delayed the ceremony). Elmslie was selected to receive the award because "It might be said that Mr. Elmslie was originally instrumental in calling the attention of the architects to the fact that Sullivan was the world's first truly great modernist."[126] Elmslie both was honored by and reproachful of the award because it was presented more than two decades after Sullivan's death.[127] Because of his health Elmslie did not attend the ceremony at Miami Beach, but in his acceptance speech, which was read, he emphasized the writings and thoughts of Sullivan as "a lyric poet."[128]

The next year, 1947, the aging Elmslie received his own belated tribute by being advanced to "Fellowship" in the American Institute of Architects.[129] When Elmslie died in 1952, his obituary in the *Journal of the Society of Architectural Historians* erroneously described him as a "former partner of Louis Sullivan."[130] Elmslie had never served such a role in the strict business sense of the term, but spiritually it was a role that had absorbed him for most of his adult life.

NOTES

Research for this chapter has been generously supported by a Research Initiation Grant from The Pennsylvania State University and a Faculty Research Fellowship from the Institute for the Arts and Humanistic Studies at Penn State. I would like to extend special thanks to my graduate assistant (1987–88) Jay Barshinger for his diligent searching of materials, and to Linda Wheeland for her word-processing skills. The bulk of the research for this chapter was done at the Northwest Architectural Archives at the University of Minnesota Libraries, which has granted permission for publishing quotations and photographs from their William Gray Purcell Papers. I am

grateful for the extensive assistance that I received at this archive from Alan K. Lathrop, Vivian Newbold, and Mark Hammons. I would also like to express my gratitude to Mary K. Woolever and Jane A. Kenamore at the Art Institute of Chicago, the staff of the Ryerson and Burnham libraries at the Institute, Karen M. Mason of the Bentley Historical Library at the University of Michigan, the library staffs at Penn State and the University of Illinois at Urbana-Champaign, Tim Samuelson, David Gebhard, and the many individuals who kindly showed me buildings by Elmslie when I toured the Midwest during the summer of 1988. Finally, I would like to express my deep debt to and admiration of Walter L. Creese, whose enthusiasm about the architecture of the Midwest first inspired my interest in George Grant Elmslie.

1. George G. Elmslie to Frederick A. Strauel, April 15, 1924, William Gray Purcell Papers, Northwest Architectural Archives (hereafter, NAA), University of Minnesota Libraries, Minneapolis. Many of Elmslie's letters in the Purcell Papers are signed and addressed with just first names or nicknames; for clarity in this chapter, the individual's full name will be used in the first reference and the last name thereafter. The letters addressed to both William Gray Purcell and his wife will be referred to as "to Purcell." Elmslie's distinctive handwriting presents difficulties in quoting his letters; his use of commas versus periods was often ambiguous, as was his capitalization. I have attempted to transcribe these quotes as accurately as possible within the context of each letter, although all interpretations of sentence structure may not be absolute. Such idiosyncracies are evident only in Elmslie's handwritten correspondence, not in his typed letters.

2. Frank Lloyd Wright, *Genius and the Mobocracy* (New York: Duell, Sloan and Pearce, 1949), p. 77. Also see Frank Lloyd Wright, *An Autobiography* (New York: Longmans, Green, 1932), p. 265. The first edition (1932) of Wright's autobiography will be used herein because it had the most impact upon Elmslie.

3. Elmslie to William Gray Purcell, July 2, 1946, NAA.

4. George Grant Elmslie, preliminary draft of "Autobiographical Sketch," [ca.1939], p. 1, NAA.

5. For other discussions of Elmslie's biography see David Gebhard, "William Gray Purcell and George Grant Elmslie and the Early Progressive Movement in American Architecture from 1900 to 1920," Ph.D. diss., University of Minnesota, 1957; David Gebhard, "Purcell and Elmslie," in *Macmillan Encyclopedia of Architects*, ed. Adolf K. Placzek, (New York: Macmillan, 1982) vol. 3, pp. 500–503; Larry Millett, *The Curve of the Arch: The Story of Louis Sullivan's Owatonna Bank* (St. Paul: Minnesota Historical Society Press, 1985), pp. 56–63, 124–34, 148–52; and Mark Wayne Hammons, "Historical Considerations," in MacDonald and Mack Partnership, "Historic Structures Report for the Edna S. Purcell House Restoration" (prepared for the Minneapolis Society of Fine Arts, August 1987), pp. 18–27, NAA.

6. G. Trapp, "George Grant Emslie," April 23, 1956; [William G. Purcell], "Notes concerning the G. G. Elmslie biography" [ca.1952], and Elmslie to Purcell, February 17, 1941, NAA; and Thomas S. Hines, Jr., "Frank Lloyd Wright—The Madison Years: Record versus Recollection," *Wisconsin Magazine of History* 50 (Winter 1967): 109–11.

7. Trapp, "Emslie."

8. Elmslie to Purcell, October 18, 1939, NAA.

9. Elmslie to Purcell, August 2, 1938, NAA.

10. Elmslie to Frank Lloyd Wright, October 30, 1932, NAA.

11. Elmslie to Purcell, May 12, 1939, NAA.

12. Trapp, "Emslie"; Elmslie to Talbot Hamlin, June 25, 1941, NAA.

13. [Elmslie] to Reverend Joseph L. McCorison, April 30, 1941, NAA.

14. Louis H. Sullivan, *Kindergarten Chats and Other Writings*, ed. Isabella Athey (1947, repr. New York: Dover Publications, 1979), p. 68.

15. Elmslie to Hamlin, June 25, 1941, NAA.

16. Elmslie, "Autobiographical Sketch," p. 3, NAA.

17. Wright, *Autobiography*, p. 96.

18. Wright, *Genius*, pp. 46–47; and David Gebhard, "Louis Sullivan and George Grant Elmslie," *Journal of the Society of Architectural Historians* 19 (May 1960): 62–63.

19. Elmslie to Hamlin, June 25, 1941, NAA; for a discussion of Sullivan's relationship with his chief draftsmen see Paul Edward Sprague, "The Architectural Ornament of Louis Sullivan and His Chief Draftsmen," Ph.D. diss., Princeton University, 1968.

20. Wright, *Autobiography*, p. 99.

21. [Elmslie] to Wright, October 30, 1932, NAA.

22. [Elmslie] to Wright, June 12, 1936, NAA; published in Mark L. Peisch, "Letter," *Journal of the Society of Architectural Historians* 20 (October 1961):140–41.

23. Gebhard, "Sullivan and Elmslie," pp. 63–66; Sprague, "Ornament of Sullivan," pp. 119–59.

24. Elmslie to Purcell, July 17, 1938, NAA.

25. David Gebhard, "Letter," *Prairie School Review* 4 (Third Quarter 1967):33–36; Craig Robert Zabel, "The Prairie School Banks of Frank Lloyd Wright, Louis H. Sullivan, and Purcell and Elmslie," Ph.D. diss., University of Illinois at Urbana-Champaign, 1984, pp. 160–66; Millett, *Curve of the Arch*, pp. 61–63; and Wright, *Autobiography*, p. 102.

26. Elmslie to Purcell, August 30, 1946, NAA. In neither version of this article does Elmslie refer to his own contributions; see George G. Elmslie, "Sullivan Ornamentation," *Illinois Society of Architects Monthly Bulletin* 19–20 (June–July 1935):6; and *Journal of the American Institute of Architects* 6 (October 1946):155–58.

27. Elmslie to Purcell, March 7, 1939, NAA.

28. See Robert Twombly, *Louis Sullivan: His Life and Work* (New York: Viking Press, 1986), pp. 333–406.

29. [Elmslie] to Mumford, May 29, 1931, NAA.

30. [Elmslie] to Wright, June 12, 1936, NAA.

31. Elmslie to Purcell, October 6, 1944, NAA.

32. Elmslie to Purcell, January 25, 1909, and August 30, 1909, NAA.

33. Millett, *Curve of the Arch*, p. 126; and Elmslie to Purcell, July 20, 1908, NAA.

34. Elmslie to Purcell, August 7, 1939 [a response written on a letter from Purcell], NAA.

35. Elmslie to Purcell, October 15, 1909, NAA.

36. Ibid.

37. Elmslie to Purcell, November 21, 1909, NAA.

38. Elmslie to Purcell, November 17, 1909, 1st letter, NAA.

39. Elmslie to Purcell, December 22, 1909; November 17, 1909, 1st letter; November 17, 1909, 2d letter; and November 21, 1909, NAA.

40. Ibid.; quoted in Elmslie to Purcell, August 13, 1938, NAA.

41. Elmslie to Purcell, December 6, 1909, NAA.

42. Millett, *Curve of the Arch*, p. 127–29.

43. Elmslie to Purcell, April 15, 1946, NAA.

44. Elmslie to Purcell, January 14, 1913, NAA.

45. Millett, *Curve of the Arch*, pp. 124–34; H. Allen Brooks, *The Prairie School: Frank Lloyd Wright and His Midwest Contemporaries* (New York: W. W. Norton, 1972), pp. 187–92, 200–227, 295–306; and Gebhard, "Purcell and Elmslie," Ph.D. diss.

46. Elmslie to Purcell, January 14, 1913, NAA.

47. Elmslie to Purcell, February 29, 1913, NAA.

48. Zabel, "Prairie School Banks," pp. 227–40.

49. Elmslie to Purcell, June 26, 1917, and August 20, 1918 [a response written on the back of a letter from Purcell], NAA.

50. Kenneth W. Severens, "The Reunion of Louis Sullivan and Frank Lloyd Wright," *Prairie School Review* 12 (Third Quarter 1975):5–21.

51. Louis H. Sullivan, "Concerning the Imperial Hotel, Tokyo, Japan," *Architectural Record* 53 (April 1923):332–52, and "Reflections on the Tokyo Disaster," *Architectural Record* 55 (February 1924):113–17.

52. Gebhard, "Purcell and Elmslie," Ph.D. diss., p. 274; Hammons, "Historical Considerations," pp. 24–25, 36–38.

53. Elmslie to Purcell, October 9, 1918, NAA.

54. [Purcell] to Elmslie, March 9, 1921, and Elmslie to Purcell, July 26, 1938, NAA.

55. For a fuller discussion, see Craig Zabel, "George Grant Elmslie: Turning the Jewel Box into a Bank Home," in *American Public Architecture: European Roots and Native Expressions*, ed. Craig Zabel and Susan Scott Munshower, vol. 5, Papers in Art History (University Park: Pennsylvania State University, 1989), pp. 228–70.

56. "Portfolio: Current Architecture," *Architectural Record* 54 (December 1923): 521; K. J. Crist and Lawrence A. Fournier, "Combining Utility and Beauty in the Bank Building," *Bankers Monthly* 41 (February 1924):72–74; Roy H. Conklin, "Bank Building Adds Much to Looks of City," *Aurora Beacon-News*, September 5, 1923; and "Some Recent Bank Building Operations," *Bankers Magazine* 108 (May 1924):847–49.

57. Lawrence A. Fournier to Strauel, July 24, 1922, NAA [typographical errors have been corrected in the words in brackets].

58. Elmslie to Purcell, July 2, 1938, NAA.

59. Ibid.

60. Elmslie to Purcell, August 26?, 1951, NAA.

61. Wright, *Autobiography*, p. 264; Wright, *Genius*, p. 76 and unnumbered plates between pp. 98–99; also see Paul E. Sprague, *The Drawings of Louis Henry Sullivan: A Catalogue of the Frank Lloyd Wright Collection at the Avery Architectural Library* (Princeton: Princeton University Press, 1979).

62. Elmslie to Purcell, August 3, 1942, and August 26?, 1951, NAA.

63. Elmslie to Emil Lorch, September 12, 1925, Emil Lorch Papers, Bentley Historical Library, University of Michigan, Ann Arbor.

64. "The Louis H. Sullivan Memorial," *Pencil Points* 9 (May 1928):305.

65. Elmslie to Lorch, n.d. [a response written on a letter from Lorch dated June 13, 1929], Emil Lorch Papers; and Lenore Pressman, "Graceland Cemetery: Memorial to Chicago Architects," *Prairie School Review* 12 (Fourth Quarter 1975): 15–17.

66. George G. Elmslie, "The Evolution Toward Modern Architecture," *Illinois Society of Architects Monthly Bulletin* 24 (February–March 1940):7; and Thomas E. Tallmadge, *The Story of Architecture in America* (New York: W. W. Norton, 1927),

pp. 214–33. In the 1936 edition of Tallmadge's book, he retitled the chapter "Louis Sullivan, Parent and Prophet."

67. Lewis Mumford, "The Brown Decades: Architecture," *Scribner's Magazine* 89 (April 1931):385–95. Elmslie had also read other writings by Mumford on architecture.

68. Elmslie to Mumford, April 20, 1931, NAA.

69. Ibid.

70. [Elmslie] to Mumford, May 29, 1931, NAA.

71. Lewis Mumford, *The Brown Decades: A Study of the Arts in America, 1865–1895* (New York: Harcourt, Brace, 1931), p. 162; also see Mumford to Elmslie, April 27, 1931, NAA.

72. Elmslie to Mumford, October 30, 1931, NAA.

73. [Elmslie] to Wright, October 30, 1932, NAA; Wright, *Autobiography*, pp. 262, 265.

74. [Elmslie] to Wright, October 30, 1932, NAA.

75. Elmslie to Purcell, December 20, 1933, NAA.

76. [Elmslie] to Wright, October 30, 1932, NAA.

77. Hugh Morrison, *Louis Sullivan: Prophet of Modern Architecture* (1935, repr. New York: W. W. Norton, 1962), p. xix.

78. Elmslie to Purcell, June 20, 1934, NAA.

79. Hugh Morrison to Elmslie, January 29, 1937, NAA.

80. Elmslie to Purcell, June 28, 1939, NAA; sketches for the Morrison House exist at the NAA.

81. Frank Lloyd Wright, "Form and Function," *Saturday Review of Literature*, December 14, 1935, p. 6.

82. [Elmslie] to Wright, June 12, 1936, NAA.

83. Wright, "Form and Function," p. 6; Elmslie, "Evolution Toward Modern Architecture," p. 2.

84. Elmslie, "Evolution Toward Modern Architecture," p. 2; [Elmslie] to Wright, June 12, 1936, NAA.

85. Elmslie to Purcell, April 15, 1946, and Elmslie to Purcell, Feick and Elmslie office, February 17, 1913, NAA.

86. Elmslie to Purcell, July 10, 1928, NAA.

87. Elmslie to Strauel, October 23, 1926, and [Elmslie] to Wright, October 30, 1932, NAA.

88. Elmslie to Purcell, April 10, 1945, and April 6, 1951, NAA.

89. Wright, *Genius*, pp. 46, 72, 77; Wright's account of Elmslie had not changed in the 1943 edition of *An Autobiography*; Elmslie to Purcell, September 30, 1949, NAA.

90. Brooks, *Prairie School*, pp. 306–9. Interest in Elmslie's late work is growing; Richard Guy Wilson presented a paper, "George Grant Elmslie and American Architecture of the 1920s and 1930s," at the annual meeting of the Society of Architectural Historians in Chicago, April 14, 1988. The following discussion of Elmslie's late work is based upon Elmslie's "Job List" and other materials at the NAA, visits to Elmslie's buildings during the summer of 1988, and other sources as noted.

91. See Zabel, "Elmslie: Jewel Box into Bank Home."

92. "Healy Undertaking Company Announces Opening of the New Healy Chapel" [advertisement], *Aurora Daily Beacon-News*, August 17, 1928.

93. Commission on Chicago Historical and Architectural Landmarks, "Peoples

Gas Light and Coke Co. Neighborhood Offices: Irving Park Store, South Chicago Store; Preliminary Summary of Information" (April 1985), copy in Ryerson and Burnham Libraries, The Art Institute of Chicago.

94. George G. Elmslie, "Reflections on Rhythm," *Illinois Society of Architects Monthly Bulletin* 22 (August–September 1937):6.

95. Elmslie to Purcell, July 20, 1938, NAA.

96. For a plan of Wright's chapel see Henry-Russell Hitchcock, *In the Nature of Materials, 1887–1941: The Buildings of Frank Lloyd Wright* (New York: Hawthorn Books, 1942, repr. New York: Da Capo Press, 1975), fig. 408.

97. Talbot F. Hamlin, "George Grant Elmslie and the Chicago Scene," *Pencil Points* 22 (September 1941):575–86.

98. [Purcell] to Hamlin, September 30, 1941; Elmslie to Purcell, September 30, 1941, October 2, 1941; and Kenneth Reid [editor, *Pencil Points*] to William L. Steele, October 2, 1941, all in NAA.

99. George G. Elmslie, "Functionalism and International Style," *Illinois Society of Architects Monthly Bulletin* 19 (December 1934–January 1935); also published in *Architect and Engineer* 120 (February 1935):69–70.

100. Gilmer V. Black, "Le Corbusier: Veni Vidi—but Did I Conquer," *Illinois Society of Architects Monthly Bulletin* 20 (December 1935–January 1936):1–2; Dorothy G. Wendt, "Walter Gropius Addresses Chicago Audience," *Illinois Society of Architects Monthly Bulletin* 22 (December 1937–January 1938):7; and Dorothy G. Wendt, "Expound Architectural Philosophies: Mies van der Rohe Honored by Profession and Armour Institute," *Illinois Society of Architects Monthly Bulletin* 23 (December 1938–January 1939):1–2.

101. George G. Elmslie, "Do Principles of Architecture Change?" *Illinois Society of Architects Monthly Bulletin* 23 (February–March 1939):1–2.

102. George Grant Elmslie, "Architecture and the People," *AIA Journal* 36 (August 1961):33. This essay was published after Elmslie's death by David Gebhard; the manuscript in the NAA is dated 1942.

103. Elmslie, "Sullivan Ornamentation"; Elmslie, "Reflections on Rhythm," p. 6; and George G. Elmslie, "Organic Life and Architecture," *Illinois Society of Architects Monthly Bulletin* 25 (August–September 1940):7.

104. Elmslie's paper from that symposium was published twice; Elmslie, "The Evolution Toward Modern Architecture," p. 2; and George Grant Elmslie, "The Chicago School: Its Inheritance and Bequest," *Journal of The American Institute of Architects* 18 (July 1952):36.

105. Elmslie to Purcell, January 9, 1933; December 12, 1933; May 25, 1934, NAA.

106. Harry R. Gamble, Foreword to Louis H. Sullivan, *Kindergarten Chats on Architecture, Education and Democracy*, ed. Claude F. Bragdon (Lawrence, Kansas: Scarab Fraternity Press, 1934), p. iii.

107. Elmslie to Purcell, February 9, 1939, April 25, 1940, NAA. For a chronology of the "manuscripts and editions of *Kindergarten Chats*" see Appendix E of Sullivan, *Chats* (1947), p. 251.

108. Isabella Athey, "Editorial Note," in Sullivan, *Chats*, p. 6.

109. Elmslie to Purcell, n.d., NAA.

110. Louis H. Sullivan, "From: Democracy: A Man-Search—1908," *Twice a Year* 5–6 (Fall–Winter 1940/Spring–Summer 1941):17–28; and Sullivan, "From an Unpublished Manuscript: Democracy a Man Search—1908," *Twice a Year* 12–13 (Spring–Summer 1945/Fall–Winter 1945):217–26.

111. Elmslie to Walter L. Creese, October 22, 1949, NAA. The microcard edition was published by the Free Public Library of Louisville, Kentucky, in 1949, and has an introduction by Hugh Morrison.

112. Louis H. Sullivan, *Democracy: A Man-Search*, ed. Elaine Hedges (Detroit: Wayne State University Press, 1961).

113. "Gifts of Mr. George G. Elmslie to Burnham Library: Sullivan Material," April 8, 1947, Archives, The Art Institute of Chicago.

114. Elmslie to Purcell, August 3, 1942, NAA.

115. Elmslie to Purcell, August 13, 1938, NAA.

116. There are a few surviving fragments of Sullivan's diaries at the NAA.

117. Elmslie to Purcell, August 13, 1938, NAA.

118. Elmslie to Purcell, May 24, 1944, NAA.

119. Elmslie to Purcell, August 3, 1942, NAA.

120. Ibid.

121. Purcell to Elmslie, April 9, 1913, and Elmslie to Purcell, April 26, 1939, NAA.

122. Elmslie to Purcell, August 26?, 1951, and August 17, 1942, NAA.

123. George G. Elmslie, "Garrick, Theater Addition—A Criticism," *Illinois Society of Architects Monthly Bulletin* 19 (August–November 1934):8.

124. Elmslie to Purcell, July 31 [1940s?], and September 11, 1944, NAA.

125. Elmslie to Purcell, March 28, 1948, NAA.

126. "To Louis Henri Sullivan: The Gold Medal of the American Institute of Architects," *Journal of the American Institute of Architect* 6 (July 1946):4.

127. Elmslie to Purcell, March 30, 1944, NAA.

128. "To Louis Henri Sullivan," pp. 4–5.

129. "Advanced to Fellowship," *Journal of The American Institute of Architects* 7 (March 1947):236.

130. Charles Peterson, ed., "American Notes," *Journal of the Society of Architectural Historians* 11 (May 1952):25.

2.1 Dankmar Adler (1844–1900). (The Chicago Historical Society)

2

GERMAN DESIGN INFLUENCE IN THE AUDITORIUM THEATER

ROULA MOUROUDELLIS GERANIOTUS

The Chicago School of commercial architecture and the Prairie School of domestic architecture have played a vital role in the development of modern architecture yet were until recently considered—despite their widely acknowledged international significance—largely indigenous phenomena, rooted almost exclusively in Chicago's own architectural and building traditions. An international exhibition sponsored by the Art Institute of Chicago and shown in 1987–88 was the first step toward placing Chicago's architectural development in its proper international context.[1] Chicago architects were surprisingly aware of contemporary European architectural developments and frequently attempted to emulate in their own work what they considered the most important aspects of European architecture and design. Such an attitude was naturally even more characteristic of Chicago's immigrant architects, who had a more intimate knowledge of the architectural developments in the Old World. The work of German-born or German-educated architects of Chicago is a case in point.[2] This chapter examines the structural and architectural qualities of one of Chicago's architectural masterpieces, the Auditorium Theater by Dankmar Adler (fig. 2.1) and Louis H. Sullivan, and explores its relationship to contemporary German theater design.

The history of the construction of Auditorium Theater in Chicago was well documented in the popular and professional press and in subsequent studies of the firm of Adler and Sullivan. The commission was awarded in 1886, construction began in 1887, and the theater was dedicated ceremonially on December 9, 1889. It immediately received unanimous acclaim for its design and acoustical properties.[3]

The architectural and technical excellence of the theater derived from

the manner in which it synthesized the most important developments in contemporary theater design, which largely originated in German-speaking countries. While the building was under construction, Adler traveled to Europe to examine European theaters and their facilities firsthand. He reported on his experience to the Illinois State Association of Architects on February 18, 1889.[4] First, he spoke of the conditions he had encountered in London, where he had seen five theaters being erected. To his amazement, they all had fireproof auditoriums, but their stages were wood and vulnerable to fire. Moreover, no heating, cooling, and ventilating devices were employed for either the stages or the auditoriums. On the Continent the situation was different; issues of safety and comfort were decisive factors in theater design, especially in Germany and Austria, where Adler spent most of his time. In those countries, he explained, intensive efforts had been undertaken to construct safe, fireproof theaters following the 1881 destruction by fire of the Ring Theater in Vienna.[5] At the time of Adler's visit, the most efficient stage equipment was designed by the Austrian *Asphaleia-Gesellschaft* and patented by the firm of Dengg, Gwinner, Kautsky, and Roth. The Asphaleia stage was already being used successfully in several German and Austrian theaters. Its floor consisted of sections capable of upward and downward movements and of rocking motions. The machinery was made entirely of iron and operated by hydraulic power. In full accordance with the increased demand for scenic realism, the new and highly efficient system enabled stage sets and effects of unprecedented elaboration. Adler, who apparently was already aware of the advantages of the system, after meeting its inventors and inspecting its applications, decided to order it for the Auditorium.[6]

The theaters that Adler saw included three that already had fully working Asphaleia stages. These were the National Opera House in Budapest (1884) by Miklós Ybl; the Municipal Theater in Halle (1884–86) by Heinrich Seeling; and the German Theater in Prague (1886–87) by Ferdinand Fellner and Hermann Helmer.[7] In addition, Adler visited the Imperial Opera House in Vienna (1861–69) by Edward van der Null and August Siccard von Siccardsburg; the Court Opera House in Dresden (1871–78) by Gottfried Semper and Mandfred Semper; the Opera House in Frankfurt (1873–80) by Richard Lucae; the Hofburg Theater in Vienna (1873–88) by Gottfried Semper and Karl von Hasenauer; the Lessing Theater in Berlin by Heinrich von der Hude and Julius Hennicke completed in 1888; and finally Karl Friedrich Schinkel's 1818 Schauspielhaus in Berlin, whose stage was being remodeled at the time of Adler's visit.

Adler's selection of theaters to visit reveals a remarkable knowledge of the best that Germany and Austria had to offer, because each enjoyed a particular distinction. The Imperial Opera House in Vienna was famous for its heating and ventilating system, which had introduced and set new standards of comfort.[8] The Opera House in Frankfurt was the next to employ this heat-

ing and ventilation system and was considered exemplary by the theatrical standards of the 1870s. Its stage equipment had been designed by the famous theatrical engineer Carl Brandt of Darmstadt, with whose work Adler was well acquainted. Although constructed largely of wood, the theater had an impressive fire-fighting apparatus operated under the supervision of its manager Carl Rudolph, whom Adler must have met personally.[9] Two other theaters that Adler saw were technically outmoded but widely considered theatrical landmarks: the Court Opera House in Dresden by Gottfried Semper, the preeminent German authority in theater design,[10] and Schinkel's Schauspielhaus in Berlin.[11]

The more recent theaters that Adler visited, such as the Municipal Theater in Halle, the German Theater in Prague, the Hofburg Theater in Vienna, and the Lessing Theater in Berlin, were all exemplary works incorporating the latest developments in theater technology, equipment, and materials. They were of fireproof construction and had iron stages operated by hydraulic power, plus sophisticated systems of electric illumination.[12] A description of the Halle Theater will demonstrate their common merits. It was the first to be lighted exclusively by electricity, the first completely fireproof German theater, and the first in Germany to use the Asphaleia stage. According to a contemporary account, it exemplified a prototypical design that should be studied by all theater designers.[13] Its fireproof construction consisted of stone masonry for the exterior walls, iron for all interior structural members, roofs, and the bearing framework of the boxes. The voids were filled with fireproof plaster on wire netting for the first time, the so-called *Rabitz-Masse*, which was constructed and installed under the personal supervision of its inventor, whose name was Rabitz. The same material was used for covering the iron members, for most of the ceilings, for all interior partitions, as well as for all pipes and conduits. In this theater, wood was relegated to secondary use as floor and stage covering and to parts in immediate physical contact with the audience, such as the seating and the paneling. It was a fortunate decision to use the fireproof plaster on wire netting because the flexible material could be manufactured and installed easily and, most important, had excellent acoustical properties.[14]

The Auditorium Theater in Chicago profited substantially from all this expertise. Its stage was designed by the *Asphaleia-Gesellschaft*. Its heating and ventilating system was patterned after that of the Imperial Opera House in Vienna and used for the first time in this country in 1883 in the Metropolitan Opera House in New York.[15] The Auditorium was the first theater in the United States to be lighted exclusively by electricity.[16] It was of fireproof construction with the stage and auditorium built of iron, rolled steel, plaster, and metal laths. The theater was contained in a masonry shell separating it from the surrounding hotel section. Indeed, its remarkable success was due to the fact that it combined the Chicago School's structural expertise in fireproof metal-frame office buildings with the most recent German advances in

theater technology. In this way it became a theater that was technically and structurally in harmony with the business portion of the building and with the prevailing design tendencies in Chicago.

Adler's choice of Germany and Austria as a source of theater design was an obvious one. An experienced engineer himself and alert to issues of public safety and advanced technology, he turned to countries in which such issues had received earlier attention. Moreover, a German by birth, Adler was well informed about the development in his native country, as is attested by his knowledge of its theaters and architects. The fact that scholarship has failed to take into account his intellectual and ethnic background, together with the relative obscurity that surrounds his personality as a whole, has led to numerous misconceptions regarding his design abilities and his contribution to the work of the firm of Adler and Sullivan. Adler possessed the ability for original thinking and for synthesizing elements from numerous sources into something new. This ability is splendidly exemplified in the Auditorium, whose technical and structural elements originated in Germany.

Visitors to the Auditorium Theater were greatly impressed by its openness and its innovative plan from the very moment it was revealed to the public. Their impressions were faithfully reported:

> In the interior of the great hall itself, the sight is one of the most remarkable of its kind in the world. This is due not so much to the beauty of the decoration, for that is comparatively simple, but is almost entirely the result of the splendid architectural lines and the vast sweep that one gets, not shut in by boxes, tier above tier as in the European opera house, but with the exception of a very limited number of boxes, all parts are open, free, and light, with the three galleries showing themselves as part and parcel of the scheme of construction.[17]

The innovative layout was attributed to a desire to break with established traditions and customs:

> There are in this theater . . . no stage boxes. There are only 40 boxes . . . with chairs for 200 people. This was the president's idea for he has no belief in privileged classes, and regards the Metropolitan Opera House of New York, where the structure is sacrificed to the boxes, with infinite scorn and patriotic dislike. This was a repetition of effete European ideas, and if there was one thing that he impressed upon the architects, it was that *he wanted the Auditorium to represent the present and the future, not the corrupted past.*[18]

The spatial qualities of the theater distinguished it sharply from all other contemporary theaters, including those that Adler had visited in Austria and Germany. Indeed, these invariably employed one or the other of the two usual plans—the horseshoe plan and the lyre plan.[19] All of them contained a parquet, that is a main floor, with superimposed tiers of boxes and galleries

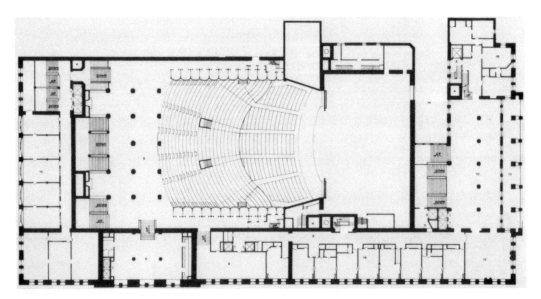

2.2 Adler and Sullivan, Auditorium Theater, Chicago, 1887–89; plan of ground floor. (John Vinci)

above; most of them had boxes already at the parquet level that started right at the proscenium. The entire auditorium was under one high ceiling.

By contrast, the Auditorium Theater consists primarily of a parquet (fig. 2.2) and an extensive balcony (figs. 2.3, 2.4). Both are approximately fan-shaped in plan, with roughly parallel rows of seats. The whole is inscribed in a rectangular room. There is a broad proscenium (fig. 2.5) and a series of four elliptical arches which expand successively until they reach the coved ceiling. There are only forty boxes in two tiers and two smaller galleries above.

The design scheme—unique when the building was erected—had its source in the theater-reform movement that had begun in Germany two decades earlier. The movement was initiated by two of the leading figures in German art and culture, the composer Richard Wagner and his long-time friend, the architect Gottfried Semper.[20] The two masters collaborated in 1865–67 on the design of a monumental festival theater to be erected in Munich under the patronage of King Ludwig II of Bavaria and to be used for the performance of Wagner's *Ring des Nibelungen*.[21] The project came to naught, but it naturally attracted a lot of attention because of the fame of its authors and its departure from established practices in theater design. The principal planning features of the project were realized later in the theater erected by the architect Otto Brückwald in Bayreuth in 1872–76 under Wagner's direct supervision.[22]

Adler did not include Bayreuth among the theaters he visited because the design principles of Bayreuth had already been published widely in Germany.[23] Moreover, the model of the Munich festival theater prepared by Semper for King Ludwig in 1866 was exhibited in the International Art Exhi-

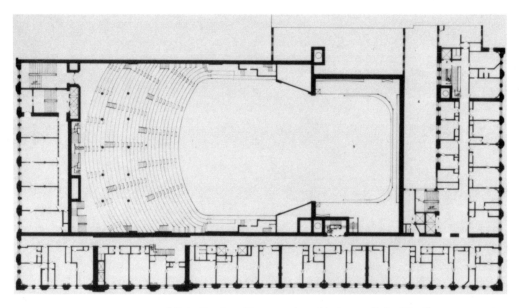

2.3 Auditorium Theater; plan of balcony. (John Vinci)

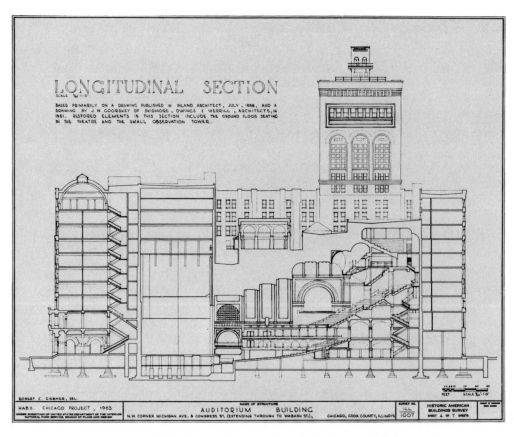

2.4 Auditorium Theater; longitudinal section. (John Vinci)

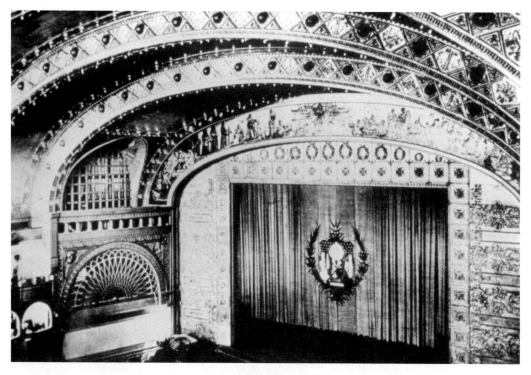

2.5 Auditorium Theater; view of proscenium and stage. (Harry Weese and Associates)

bition in Munich in 1888—the year of Adler's European journey—and was discussed extensively in the German press.[24] The principles that dictated the architectural layout of the Munich festival theater, and then of the Bayreuth Festspielhaus, had been worked out by Semper and Wagner during an intimate collaboration. As early as 1863, Wagner referred to his discussions with an "experienced, brilliant architect" regarding the plan of a temporary theater, plain as possible, but more functionally arranged inside.[25] This architect was Semper: indeed, the two had lived in the same social and intellectual milieu in Dresden in 1842–49 and again in Zurich between 1855 and 1859, at the time Wagner was composing the music to his opera-cycle *Ring des Nibelungen*. In 1864, Wagner was invited to Munich by King Ludwig and was promised a festival theater where his works would be premiered. Wagner insisted that Semper should have the commission.[26] This initiated a lengthy exchange of ideas between the two masters that led to the design of the theater and ceased only when it was finally realized that the project could not be carried out in Munich. The first condition Wagner set was that the orchestra should be hidden from the view of the spectators, and that all seats should have a commanding view of the stage. Semper's optical studies convinced him that this would be possible only if the orchestra was lowered and all rows of seats were laid parallel to the edge of the orchestra. Furthermore, stage and auditorium should be separated by a neutral ground. Of course,

this meant that the traditional theater plans with the box-tiers superimposed inside the cylindrical space of the auditorium had to be rejected.

These revolutionary ideas were put to trial by Semper in numerous studies and projects that led gradually to architectural discoveries of far-reaching consequence. Central to these were the amphitheatrical layout of the auditorium proper, the abolition of boxes, the sinking of the orchestra, and the insertion of a broad proscenium. Semper's letter to Wagner accompanying the final designs is revealing:

> The core of the building . . . is the great auditorium with its stage. The arrangement of both departs from the usual theatrical arrangement in important points. The following conditions imposed on the architect were determinant: 1. Complete separation of the ideal world of the stage from the reality represented by the audience. 2. Corresponding to this separation, an invisible orchestra, perceivable only through the ear. Of these two conditions, the latter is particularly decisive for the design of the entire work; . . . in order to withdraw the orchestra from the view of all spectators, without . . . disturbing . . . the absolutely necessary connection between the play on stage and the play of the orchestra, the only way remaining is to lay out the auditorium in the ancient manner with rising stepped rows of seats (cavea), while at the same time disregarding completely the modern box system.[27]

The intermediate zone between stage and auditorium acquired a new significance:

> The lowered position of the orchestra fulfills at the same time the important subsidiary purpose of contriving the desirable and decisive separation of the cavea from the stage. Between the two areas, so to speak, neutral intervening space emerges, whose termination in all directions—upward, downward, and to the side—cannot be followed, so that the true distance of the enclosure of the stage, which rises beyond this intermediate space, is not easily judged by the assessing eye due to the lack of fixed places; especially if the eye is deceived through appropriately added perspective or optical means. Partly due to these optical effects, but especially for the purpose of . . . completely separating the ideal world of the stage from reality . . . a new system of stage illumination had to be adopted. . . .
>
> With these ends in view, a second, wider, and higher proscenium is placed before the actual proscenium at a distance of 15 feet so as to create a powerful frame, . . . behind which . . . the gas pipes for the illumination of the actual stage are hidden. . . . The decoration of this front proscenium, in its motifs, orders, and proportions, is entirely identical with that of the rear proscenium, but differs from it in scale, from which derives a perspective illusion,

because the eye cannot distinguish the real differences in size from the perspective ones. . . . In this way the intended destruction of the measure of distance is realized and with it the separation of the ideal world of the stage from the real world of the audience.[28]

Architecturally, this was translated into an auditorium devoid of boxes and containing a fan-shaped parquet with parallel rows of seats rising on a regular incline, the whole being inscribed in a rectangular room (figs. 2.6, 2.7). In front of the stage was a sunken orchestra contained in a double proscenium.[29] The Bayreuth Festspielhaus, designed along these Wagnerian-Semperian principles, consisted of a fan-shaped parquet, a stage, a sunken, semicovered orchestra, and a broad, double proscenium, all forcing the latent perspective (fig. 2.8). The theater signified a new relationship of auditorium and stage, based upon unprecedented requirements for good vision and hearing, as well as on important aesthetic considerations that Wagner presented eloquently in his 1873 essay on the theater. As he explained, the invisibility of the orchestra necessitated its sinking and the exclusion of boxes from the auditorium proper. The double proscenium could accommodate the orchestra pit and offer the illusion of an apparent recession of the stage picture. As Wagner described the intended effect, "Between him [the spectator] and the image to be looked at, there is nothing clearly perceivable; only a distance between the two proscenia which is kept in suspension, as it were, through the mediation of architecture; which presents the withdrawn image to him with the remoteness of a dream, while the music sounding in a ghostly fashion from the 'mystical abyss,' . . . transposes him to such an enthusiastic state of clairvoyance, that the stage picture becomes for him the truest image of life itself."[30]

In the case of the Auditorium, a theater destined primarily for grand operatic performances, it is evident that all the above considerations have rematerialized in its design. Indeed, the repeatedly expressed intention of its designers to provide equally good sighting and hearing conditions from all seats, together with the need to accommodate the orchestra pit and to create an acoustically and aesthetically advantageous frame for the stage opening, were realized in emulation of the Bayreuth example. Thus the fan-shaped plan of the parquet and the balcony of the Auditorium Theater are an intelligent readaptation of the fan-shaped plan first introduced by Wagner and Semper in their Munich project and realized in the Bayreuth Theater. When faced with the problem of accommodating 4,200 people in what was going to be the largest theater in the world, Adler rejected the horseshoe and lyre plans and the box-tier system outright because these would have necessitated an abnormal elongation of the auditorium proper and an excessive height of the room, which would have then resulted in highly deficient sighting and hearing for large parts of the theater. Indeed, a good view of the stage would have been impossible for anyone seated off the central axis of the auditorium proper, and spectators seated along the sides would have

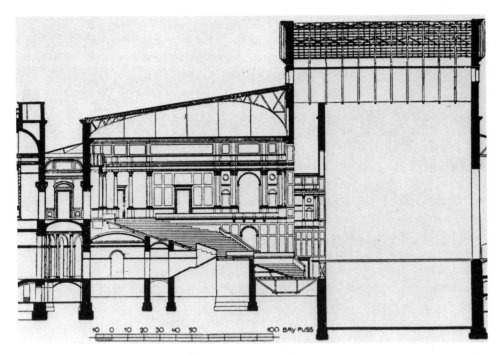

2.6 G. Semper and R. Wagner, project for a Monumental Festival Theater, Munich, Germany, 1866; plan of ground floor. (Franz Benedik Biermann, *Die Pläne für Reform des Theaterbaues bei Karl Friedrich Schinkel und Gottfried Semper* [Berlin: Selbstverlag der Gesellschaft für Theatergeschichte, 1928], fig. 49)

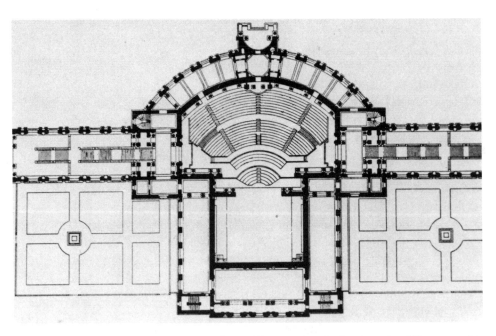

2.7 Project for a Monumental Festival Theater; longitudinal section (Biermann, *Die Pläne*, fig. 51)

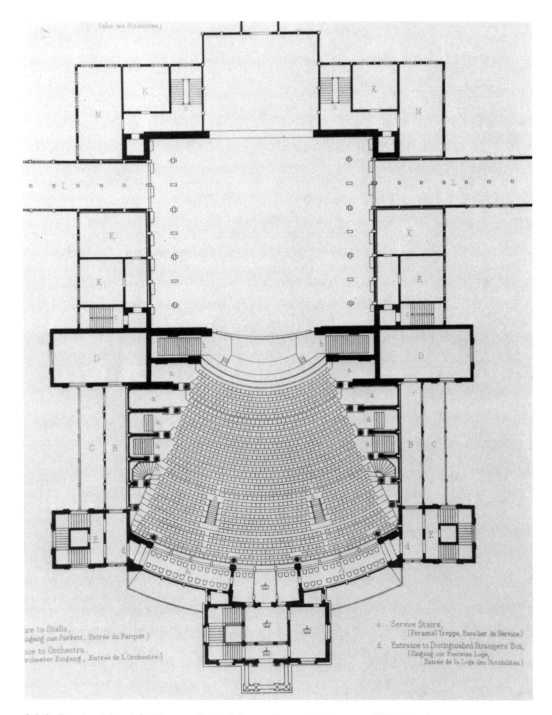

2.8 O. Bruckwald and R. Wagner, Festspielhaus, Bayreuth, Germany, 1872–76; plan of ground floor. (Edwin O. Sachs, *Modern Opera Houses and Theaters* [London: B.T. Batsford, 1897–98], vol. 1, pl. 42)

been forced to gaze at each other rather than at the stage; the tremendous volume of the room resulting from the great height would have had a disastrous effect on its acoustical properties, too. Thus Adler turned to the functionally appropriate fan shape introduced by Semper and Wagner and modified it to suit his needs. He placed an extensive, fan-shaped balcony above the fan-shaped parquet. The forty rectangular boxes at the sides and the two smaller galleries helped him reach the necessary seating capacity.

The stage opening and the orchestra pit are contained within a very broad proscenium, a striking feature that opens up toward the auditorium proper.[31] In this way it creates a strong perspective that compares favorably with that of the Munich project (fig. 2.9). In the Auditorium the effect is emphasized by the repetition of the expanding elliptical arches, which is also related to the Bayreuth Festspielhaus, where transverse partitions were placed on the lateral walls and diminished in size from the stage to the rear wall of the auditorium proper. As Wagner explained, the effect was an idea of Otto Brückwald, who drew the logical conclusion from the notion of a double proscenium; its functional purpose was primarily acoustical because by manipulating the walls of the auditorium, better distribution of the reflected sound was achieved.[32] Architecturally, it increased the perspective toward the stage. Aesthetically, however, it was not totally satisfactory because it failed to incorporate the ceiling into an organic unity with the walls. In the Auditorium this was done more successfully with greater acoustical and aesthetic advantages.

In the Bayreuth Festspielhaus, two galleries were placed directly behind and above the last row of seats. These were reserved for the royal court and Wagner himself. Of course, it was impossible to hide the orchestra from the view of those seated in the galleries, which is the case with the Auditorium as well, where two tiers of boxes are on the side walls and two small galleries above. Moreover, the plan of the Auditorium parquet and balcony combines the amphitheatrical fan-shape with a variation of the horseshoe, as a means of securing more seats. But the horseshoe has been flattened so that the Wagnerian principle, that all seats face the stage, remains in effect.

The broad proscenium had first been used by Gottfried Semper. The theater that established Semper's reputation was the first Court Opera House in Dresden, built in 1838–41. It was destroyed by fire in 1869 and replaced by the theater that Adler visited.[33] Semper publicized his ideas on theater planning in his 1849 monograph on this theater. The earliest design for it was prepared in 1835 and, although not executed, was included in the monograph. The most pronounced element of the design was the very broad proscenium opening from the stage (fig. 2.10). The issues of the proscenium and of the position of the boxes received particular attention in the monograph. Semper firmly rejected placing boxes on the proscenium itself, or adjacent to the proscenium arch.[34] Moreover, the proscenium, or rather the "enclosure of the stage opening," ought "not to deviate too much from the square in shape and, like the opening of a trumpet, should open up from the stage

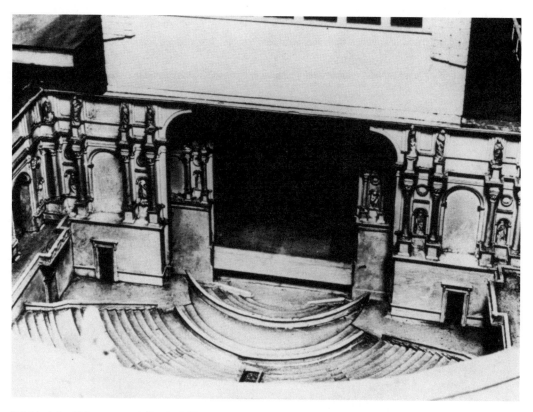

2.9 Model of Monumental Festival Theater; view of proscenium and stage. (Habel, "Die Idee eines Festspielhauses," in Detta Petzet and Michael Petzet, *Die Richard Wagner-Buhne Konig Ludwigs II: Munchen, Bayreuth* [Munich: Prestel-Verlag, 1970], fig. 750)

toward the auditorium, so that the sounds striking the walls of the enclosure at an oblique angle would fall into the auditorium."[35] The executed design also contained a broad proscenium, and the royal boxes were placed next to it and not on it, in contrast to the prevailing custom (fig. 2.11). The proscenium of the second Dresden theater was also relatively deep compared to the simple proscenium arches of all other German and Austrian theaters.

Adler's own views on the design of prosceniums were strikingly similar: "If the sounds produced upon the stage are, *as in the trumpet* or as in the speaking tube, held together at the proscenium opening, and are not permitted to diffuse themselves in any direction excepting that of the audience . . . then a greater number of people can hear distinctly." Another element of acoustical significance was the height of the proscenium. Adler's conviction was that the proscenium ought to be kept low, "not a foot higher than was necessary to permit full view of any possible grouping at the back of the stage from the last and highest seat in the house."[36] Semper was also aware of the principle: in his second Dresden theater, the ceiling of the proscenium was lower by a box-tier than that of the auditorium proper.

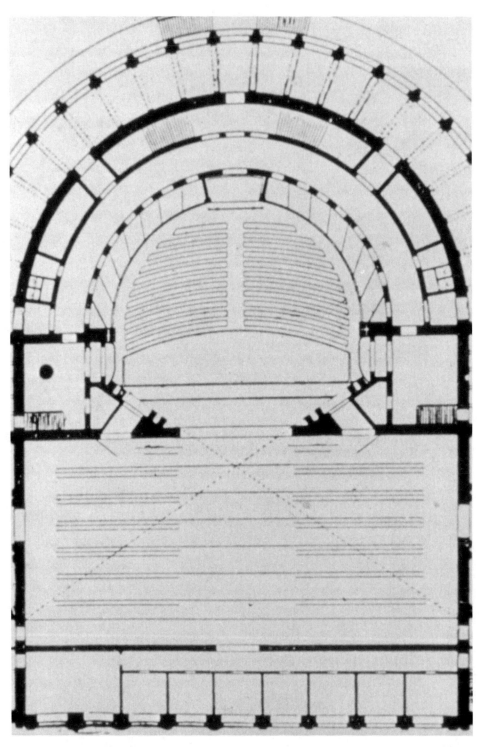

2.10 G. Semper, project for First Court Opera House in Dresden, Germany, 1835; plan of ground floor. Semper, *Das konigliche Hoftheater zu Dresden* (Braunschweig: Friedrich Vieweg und Sohn, 1849, fig. 2)

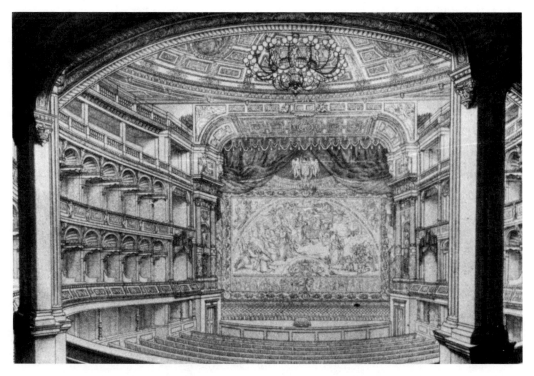

2.11 G. Semper, First Court Opera House, Dresden, Germany, 1838–41; view of auditorium and stage. (Semper, *Dresden*, pl. 3)

One major theatrical work by Semper had proved a failure, and it should be mentioned because Adler discussed it extensively in his report. It was the Hofburg Theater in Vienna, completed the year of Adler's trip.[37] An exquisite work of art otherwise, as Adler stressed, it had severe optical and acoustical defects that gave rise to numerous heated discussions. In this building, Semper had been forced by his collaborator, Karl von Hasenauer, and the building committee to accept a design that contradicted the principles he had himself established. Thus, the auditorium contained tiers of boxes stacked one above the other, the lyre plan was used with exaggerated frontal curvature, the ceiling was too high, and the proscenium was simply a narrow arch. Recent studies of the minutes of the building committee, now in the state archives, have elucidated the events of the early design phase of the theater. According to them, Semper's last attempt to impose a sound design solution was at an 1876 meeting, where he defended the need for at least a broad proscenium. He first tried on the basis of aesthetic reasons, namely that the broad proscenium with its strong perspective would destroy the sense of the real size of the persons and decorations on the stage, thus making them appear larger and more monumental. Then he tried optical and acoustical reasons as arguments such as that the broad proscenium would allow the illumination of the stage from above and from the sides, and that it would then act as the opening of the trumpet, which captured

and transmitted the sound. After the total rejection of all his suggestions, Semper withdrew from the project permanently.[38]

The beginnings of the theater-reform movement in Germany were rooted in Neoclassicism, and especially in the work of its leading representative, Karl Friedrich Schinkel.[39] Sometime before 1817, Schinkel prepared a project for the remodeling of the Royal Theater in Berlin built in 1802 by Karl G. Langhans after a fire destroyed the stage.[40] The focus of Schinkel's innovative design was the proscenium and the orchestra. The former was envisioned as a deep, "mighty enclosing frame," decorated with columns, which would be "not only a great ornament," but also "of the greatest value for the effect made by the sound through its flat ceiling and enclosed sides." As to the orchestra, "it had to be lowered by two feet, so that the instruments would blend better and issue forth as a total harmony."[41] Even more evocative were the sketches that he prepared and the accompanying notes (fig. 2.12). As Schinkel explained, the deep proscenium, articulated with four Corinthian columns carrying a flat ceiling, created an enclosure with great acoustical advantages.[42] But Schinkel was not given the opportunity to realize his ideas in permanent form; only once, and in a rudimentary way, was he permitted to do so. On May 26, 1821, when Schinkel's Schauspielhaus was opened ceremonially, one could see on the stage of the new building the Gendarmenmarkt flanked by two Corinthian colonnades to create the illusion of a deep proscenium (fig. 2.13).[43]

Schinkel himself learned much about theater design from his teacher, the brilliant Friedrich Gilly. Gilly prepared in 1798 several designs for the Berlin Schauspielhaus, all based upon highly innovative ideas regarding the planning of auditorium, proscenium, and stage, as well as exterior articulation.[44] A striking feature of the interior arrangement was the amphitheatrical layout of the parquet, whose circular rear wall was interrupted only by the royal box. Even more important was the use of a broad proscenium without boxes, which expanded toward the auditorium with the help of a sequence of three broad arches expanding toward the auditorium. The similarity with the Auditorium Theater is so striking that one is tempted to think that Adler knew the work of the earlier German masters and their theater reforms (fig. 2.14).

However, it was only in the 1880s that the theater reform movement in Germany became a popular issue. The impetus was given by a project for a "theater of the people," or *Volkstheater*, published by August Sturmhoefel first in the *Zeitschrift für Bauwesen* in 1888 and then as a booklet.[45] The project was not only exactly contemporary with the Auditorium, but also included the same seating capacity of 4,200 people. What was completely new about it—in the context of theater design of the time—was that it would be open to the broader public and that it would serve important educational, moral, and ideal functions.[46] Sturmhoefel's booklet naturally attracted considerable attention and was criticized extensively in the German press.[47] His major design considerations were twofold: greatest possible seating capacity

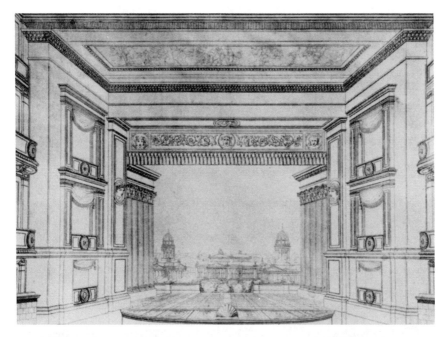

2.12 K. F. Schinkel, Royal Theater, Berlin, Germany, 1818–21; view of stage on opening night. (Biermann, *Die Pläne*, fig. 30)

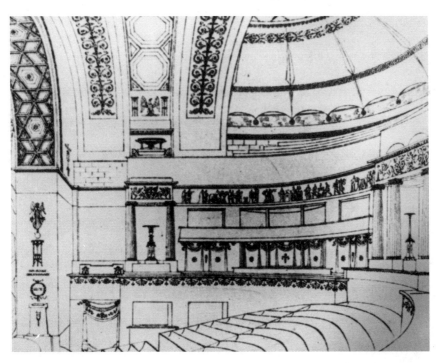

2.13 F. Gilly, project for the Berlin Schauspielhaus, 1798; view of auditorium (Posener, *Berlin auf dem wege zu einer neuen Architektur* [Munich: Prestel-Verlag, 1979], fig. 17)

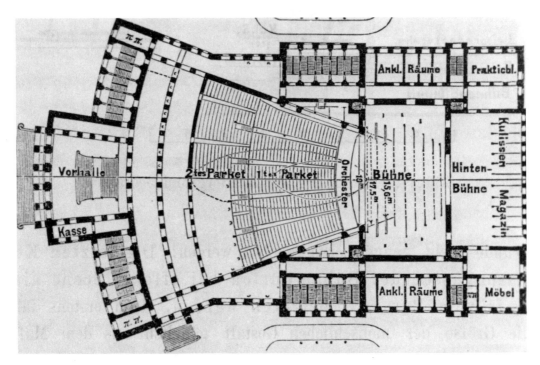

2.14 A. Sturmhoefel, Volkstheater Project, 1888; plan of ground floor. (Sturmhoefel, "Scene der Alten und Buhne der Neuzeit," *Zeitschrift fur Bauwesen*, 38, 1888, fig. 4)

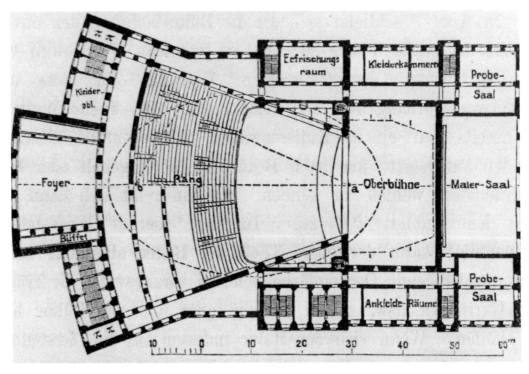

2.15 Volkstheater Project; plan of balcony. (Sturmhoefel, "Buhne der Neuzeit," fig. 5)

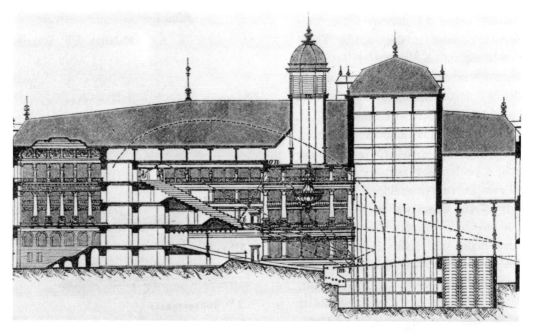

2.16 Volkstheater Project; longitudinal section. (Sturmhoefel, "Buhne der Neuzeit," fig. 6)

and equally good sighting and hearing conditions from all seats. For this, he proposed a fan-shaped parquet and a fan-shaped balcony contained in a similarly shaped auditorium (figs. 2.15, 2.16). The walls of the room were lined with boxes starting at the proscenium arch. In front of the stage was a sunken, semicovered orchestra. And all of this, as Sturmhoefel explained, was based upon Wagner's great reform ideas.[48]

Conceptually, the Auditorium Theater and Sturmhoefel's project appear very similar: both consisted primarily of a fan-shaped parquet and a similarly shaped balcony; both made limited concession to the box-tier system; both were intended to accommodate more than four thousand people;[49] both had a lowered orchestra in front of the stage; and both used "vomitoria," that is, passageways to the front and rear parts of the parquet and the balcony from foyers at various levels. But insurmountable deficiencies in Sturmhoefel's plan contrast sharply with Adler's masterpiece. Heinrich Seeling, the architect of the Halle Theater and a noted theatrical specialist, pointed out that in such an ideal project no boxes ought to be placed next to the proscenium arch because sighting and hearing were defective there, and because this destroyed the aesthetic effect of the "mystical abyss" possible with a sunken orchestra. Moreover, the arrangement allowed no space for a prominent proscenium architecture. Then he criticized the direct superimposition of parquet and balcony, which resulted in having about 1,200 persons seated in a space whose average height was only twelve feet.[50]

The preceding remarks may serve as the basis for a comparison of the Sturmhoefel project with the Auditorium Theater. In the former, the boxes

were absurdly placed on walls slanting outward, which meant that patrons seated in them would have to lean forward in order to be able to see the entire stage. By contrast, in the Auditorium, the boxes are on walls that parallel the main axis of the theater. In the former, the proscenium was a plain arch that surrounded the stage opening and was not connected architecturally with the sunken orchestra or with the auditorium proper beyond it. Moreover, boxes were attached to it. In the Auditorium, the boxes begin after the broad proscenium, which—in full accordance with Semperian–Wagnerian principles—contains the orchestra pit and creates a mighty architectural frame for the stage picture to the greater advantage of the acoustics of the hall. Moreover, in the Auditorium there is minimal overlapping of parquet and balcony, and the ceiling follows the rake of the parquet and the balcony in a broken rise so that an excessive height in the auditorium is avoided. By contrast, in Sturmhoefel's project, proscenium, parquet, and balcony were all under an unbroken horizontal ceiling with detrimental consequences to the acoustics of the room.

That the Auditorium Theater resulted from particular functional and ideal considerations becomes apparent when one compares it to Adler's other theater designs. These included remodelings as well as original works, such as his Central Music Hall in Chicago, built in 1879 and destroyed in 1900; the temporary theater in the Interstate Exposition Building in Chicago (1885) by Adler and Sullivan; the Pueblo Opera House in Pueblo, Colorado, built by the firm in 1889–90 and destroyed in 1922; and the Schiller Theater in Chicago, built in 1892 by Adler and Sullivan and destroyed in 1961.[51]

Of course, only the original designs are of major interest because in the remodelings the architect was restricted by existing conditions. Adler's first original theatrical design was the Central Music Hall. However, its seating capacity of only 1,800, and its purpose as an orchestra hall without facilities for theatrical performances, posed basically different architectural problems. Consequently, its plan was a variation of the lyre plan, and it had no orchestra pit. The walls flanking the stage opened toward the auditorium, but in no way did they form a coherent proscenium; instead, the actual enclosure of the stage opening was a simple arch.[52]

The only Adler and Sullivan scheme that bears comparison with the Auditorium is that of the temporary theater erected in 1885 inside the shell of the Interstate Exposition Building. This was a vast theater seating 6,200 persons.[53] At the ground-floor level was a parquet and a dress circle that combined to seat 3,724; then came the main balcony that seated 652 more. There was minimal overlapping of parquet and balcony as the latter extended only twenty-five feet over the dress circle. An important feature of the interior was, according to a contemporary description, the transition from the proscenium to the auditorium: "The walls of the proscenium open out fan-like, and spread forward into the parquet, a distance of sixty feet, thus forming an immense sounding board. The monotony of these diagonal surfaces is broken up by the private boxes."[54]

Adler experimented for the first time with innovative theater planning in this temporary theater, where the functional requirements rendered all customary planning schemes obsolete. On this occasion Adler may well have relied on German expertise. It is possible that in planning the temporary theater he came up with the plan solely in response to the functional demands. But it is also reasonable to assume that, when confronted with the unprecedented design problem, he exploited the best solution available, the one realized at the renowned Festspielhaus in Bayreuth, after modifying it to suit his needs. Such an attitude complied fully with Adler's predilection for creative thinking, his preference for the innovative and the functional, as well as his own remarkable knowledge of the best that Germany had to offer in theater design.

However, there were some flaws in the temporary theater that, fortunately, were not repeated in the Auditorium. It is impossible to judge today whether they were due to the very peculiar circumstances of this structure or to a lack of understanding on Adler's part about certain principles, or to both. Thus, in the temporary theater the tiers of boxes were started right next to the stage opening and extended along the entire width of the proscenium in a manner similar to the Sturmhoefel project; whereas in the auditorium, the broad proscenium was left barren to serve its acoustical, aesthetic, and ideal purposes—together with the lowered orchestra—and to form an impressive frame for the stage.

A comparison with still another work by Adler and Sullivan, the Schiller Theater, can also be revealing. Intended only for theatrical performances and quite small in size (it seated 1,270 persons), it posed none of the complex functional requirements of the Auditorium. Therefore, its plan was only a variation of the usual plans. There was no broad proscenium—only a simple proscenium arch—from which extended a series of semicircular arches widening gradually until they reached the side walls. The boxes were placed on them and started adjacent to the proscenium arch because no optical, acoustical, or ideal considerations were involved (fig. 2.17).[56]

Adler himself never spoke of any sources for his theatrical designs. Instead, he emphasized that they had resulted in direct response to functional requirements. Scholarship has subsequently repeated Adler's statements without subjecting them, or the theaters themselves, to more careful scrutiny. Yet what Adler said in his article, "Theater-Building for American Cities," was revealing:

> I feel myself justified in maintaining that success in theater building
> is no more difficult of achievement than in any other branch of architectural practice, provided one's action is based, not merely upon
> recorded precedent and tradition, but also upon *extensive and careful original observation and independent thought*. For these reasons
> I shall not make this article a *repository of historical information
> about the theaters of the past, nor yet a compendium of scientific*

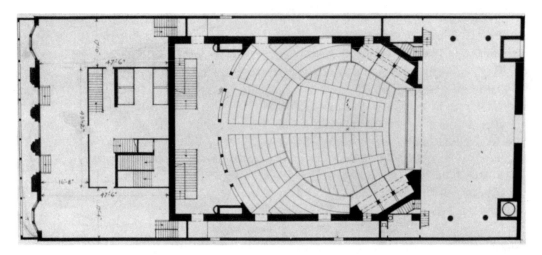

2.17 Adler and Sullivan, Schiller Theater, Chicago, 1892; plan of ground floor. (The Art Institute of Chicago)

formulae for solving the various problems of theater-design. With a view to stimulating original and independent thought and action, I shall call attention to certain facts and conclusions, the recognition and formulation of which are within the reach of every intelligent observer and of *every industrious student of objects and events.*[57]

These carefully formulated statements do not refute the need to study the best works of the past and the present. What they do emphasize is the need to combine such study with original and independent thinking. And it was because he wanted to stimulate true creativity and maximize credit to himself that Adler preferred to present principles of design, issues of function and comfort, and expertise in materials and equipment rather than cite specific theaters.

In the Auditorium, Adler used his own experience with theater design and combined it effectively with the experience of his native Germany, together with much creative thinking. Certainly, it was to his advantage that he was partaking actively in two cultures. His disinclination to speak directly of his sources is understandable: his transformation of them had led to a new synthesis. It was also understandable that he wanted to emphasize the originality of his work, as it might otherwise be undeservingly overshadowed by the prestige of its illustrious predecessors.

An issue that remains to be resolved is the contribution of each partner in the design of the Auditorium. The credit for the planning scheme should be given to Adler. He was, after all, the specialist in theater design and a master of acoustics; his reputation rested on his 1879 Central Music Hall. Adler alone went to Europe to study the European examples. He was the sole author of the article on the Auditorium published in the *Architectural Record* in 1892 at the time when the firm was still in existence.[58] But there

is more direct evidence of authorship. Frank Lloyd Wright, who was working for the firm at the time the building was erected, wrote in 1940 that "The Chicago Auditorium was entirely Adler's commission and more largely Adler's own building than Sullivan's—where its constitution and plan were concerned."[59]

There is no doubt, however, that Sullivan could have collaborated fruitfully on the project, because he shared an interest in German and Austrian theaters, as testified by the fact that he owned lavish monographs on the Imperial Opera House in Vienna and the Opera House in Frankfurt.[60] Furthermore, being an admirer of Richard Wagner, Sullivan must have endorsed wholeheartedly the effort to base the design of the Auditorium upon the principles of his idol. This was strengthened by his esteem for German culture and ideas, with which he was familiar through the Germans Dankmar Adler, Frederick Baumann and John Edelmann, whom he acknowledged as intellectual mentors.[61]

As for Sullivan's own design contribution, he should be credited primarily with the *refinement* of the basic lines of the theater. His unquestionably superior artistic sensitivity influenced it in the directions of greater subtlety or increased dramatic expression.[62] Moreover, it is Sullivan's highly personal and innovative style of decoration that characterizes the interior, because he had the responsibility for distributing the ornamentation, for designing all decorative patterns, and for providing the themes for the mural decoration. In this way, he helped turn the ingeniously conceived and designed work into a true *Gesamtkunstwerk*.[63]

The Auditorium established a design standard for Chicago that had to be followed by subsequent theaters. Thus the Chicago Civic Opera House by Graham, Anderson, Probst, and White (1928–29) had to vie with its famous predecessor for acoustical brilliance and therefore partially was patterned after it. Indeed, it uses the spatulate plan—a variation of the fan shape—and the auditorium ceiling is broken into equal parts, gradually ascending from the stage outward, following the rake of the floor (figs. 2.18, 2.19).[64] The most remarkable feature of the interior is an excessively broad proscenium that contains the stage opening and the large orchestra pit (fig. 2.20), its architectural treatment with its strong perspective effect and classicizing flavor, make it strikingly similar to Schinkel's remodeling project of the Royal Theater in Berlin (fig. 2.12). Moreover, every detail of design and construction, from the use of a broad proscenium consisting of multiple arches and a spatulate plan to the use of an iron proscenium curtain and stage machinery of the Asphaleia type, was based on the Auditorium Theater and the best German theaters that had preceded it.

The Auditorium Theater was an American product of the joint effort by an architect from Germany who was well acquainted with the intellectual and architectural traditions of the country of his birth and a highly talented American who had appreciation and understanding of these traditions. Chicago, which in the nineteenth century was a crossroads of immigrant cul-

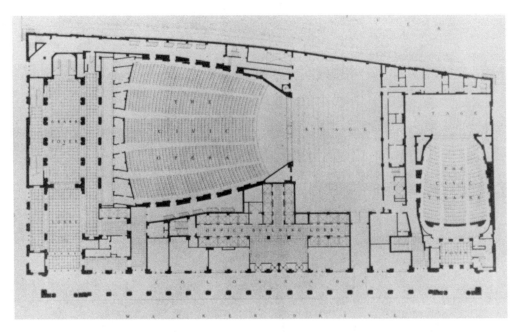

2.18 Graham, Anderson, Probst, and White, Civic Opera House, Chicago, 1928–29; plan of ground floor. (Sabine, "The Acoustics of the Chicago Civic Opera House," *Architectural Forum* 52 [April 1930]: 496)

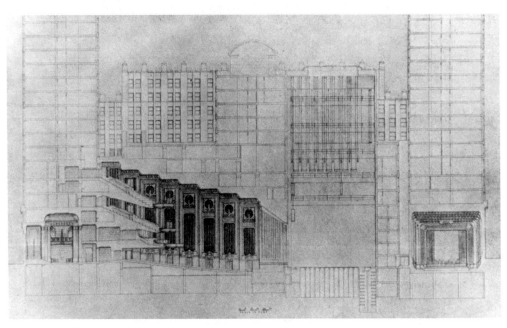

2.19 Civic Opera House; longitudinal section. (Sabine, "The Chicago Civic Opera Building," p. 496)

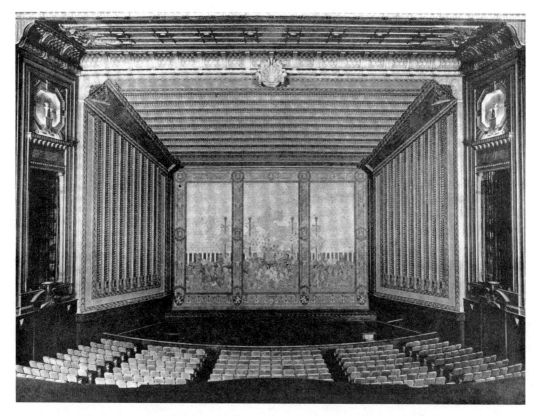

2.20 Civic Opera House; view of stage. (Sabine, "The Chicago Civic Opera Building," p. 496)

tures and ideas, provided the setting. The need arose for a large theater as a public statement and cultural symbol; its erection proved feasible because of the prevalent enterprising spirit and the technical expertise derived from skyscraper construction. Architects would be freed from established canons about theater planning and a willingness would exist to experiment with new architectural forms. Thus Chicago became the place where the best German tradition could be transformed to create a true theatrical masterpiece like the Auditorium Theater.

NOTES

1. John Zukowsky, ed., *Chicago Architecture: 1872–1922. Birth of a Metropolis* (Munich: Prestel-Verlag, 1987).

2. Roula Mouroudellis Geraniotis, "An Early German Contribution to Chicago's Modernism," in *Chicago Architecture*, ed. Zubowsky, pp. 91–105, and "German Architectural Theory and Practice in Chicago 1850–1900," *Winterthur Portfolio* 21 (Winter 1986):293–306; for the influence of German architectural education on architectural education in the Midwest see Geraniotis, "The University of Illinois and German

Architectural Education," *Journal of Architectural Education* 38 (Summer 1985):15–21. Several of these citations as well as this chapter draw upon my Ph.D. dissertation, "German Architects in Nineteenth-Century Chicago," University of Illinois at Urbana-Champaign, 1985.

3. Dankmar Adler, "The Chicago Auditorium," *Architectural Record* 1 (April–June 1892):415–27; *Auditorium* (New York: Exhibit Publishing, 1891); "Chicago. The Auditorium Building—Its Component Parts—the Interior Decoration," *American Architect* 26 (December 28, 1889):299–300; "The Chicago Auditorium," *Building* 11 (December 14, 1889):211–12. See also Hugh Morrison, *Louis Sullivan: Prophet of Modern Architecture* (1935, repr. New York: W. W. Norton, 1962), pp. 80–110; and Wilbert R. Hasbrouck, "Chicago's Auditorium Theater," *Prairie School Review* 4, no. 3 (1967): 7–21.

4. The dates of his trip were August–September 1888, as shown by a few surviving letters to his family, now in the manuscript collection of the Newberry Library in Chicago. Adler's report, "Stage Mechanism," was recorded in the *Inland Architect* 13 (March 1889):42–43, and with some inaccuracies in the *Building Report* 5 (February 1889):21–22. All subsequent references will be to the former report. Adler mentioned his trip again in a later article, "Theater-Building for American Cities," *Engineering Magazine* 7 (August 1894):728.

5. "Der Brand des Ring-Theaters in Wien," *Deutsche Bauzeitung* 15 (December 14, 1881):561–62. This disaster initiated in Germany and Austria a prolonged discussion on fire safety in theaters; see "Maassregeln zum Schutz gegen Theaterbrände," *Deutsche Bauzeitung* 15 (December 17, 1881):565–66; "Ueber Feuerschutz-Maassregeln in Theatern," *Deutsche Bauzeitung* 16 (January 28, 1882):39–41, (February 4, 1882):51–53, and (March 1, 1882):95–97; and later on again, "Ueber Feuerschutz Maassregeln in Theatern," *Deutsche Bauzeitung* 16 (October 21, 1882): 492–97, and (October 28, 1882):504–8. This discussion embraced every aspect of theater planning and construction, such as the number and location of exits, the arrangement and size of corridors and stairways, the location of storage rooms and auxiliary spaces, the construction of stage and auditorium, ventilation, fireproofing, regular and emergency illumination, and fire-fighting equipment.

6. For a detailed description of this system see Adler, "Stage Mechanism," p. 42; "Ueber Feuerschutz-Maassregeln in Theatern," *Deutsche Bauzeitung* 16 (October 28, 1882):505–6; Edwin O. Sachs, *Modern Opera Houses and Theaters*, 3 vols. (London: B. T. Batsford, 1897–98), vol. 3, pp. 1–2, 6, supp. 1, pp. 42–45, 48–50. For its application in the Auditorium see Adler, "Stage Mechanism," p. 43; *Auditorium*, pp. 133–35; Sachs, *Modern Opera Houses*, vol. 3, supp. 1, p. 54; and Morrison, *Louis Sullivan*, pp. 105–7.

7. The National Opera House in Budapest was the first theater to use the Asphaleia machinery. Designed as early as 1873, it was nearly complete in 1881 when the Ring disaster occurred; under the impact of the events it was decided that an Asphaleia stage would be introduced in the completed shell. A description of this stage is in Sachs, *Modern Opera Houses*, vol. 3, supp. 1, pp. 50–53 and Adler, "Stage Mechanism," pp. 42–43. For the stage of the Halle Theater, consult Sachs, *Modern Opera Houses*, vol. 3, supp. 1, pp. 45–47; "Die Buhnen-Einrichtungen des Stadttheaters in Halle a. S.," *Deutsche Bauzeitung* 21 (June 25, 1887):301–2; and [K. E. O. Fritsch], "Das neue Stadttheater in Halle a. S.," *Deutsche Bauzeitung* 20 (December 4, 1886):577–80. This acclaimed theater was described and illustrated extensively in the German press; see Fritsch, *Deutsche Bauzeitung* 20 (November 20, 1886):553–55,

(December 1, 1886):573–74, and 21 (February 26, 1887):97–99; "Das Stadttheater zu Halle a. S.," *Deutsche Bauzeitung* 21 (September 17, 1887):445–47. For the German Theater in Prague, see Sachs, *Modern Opera Houses*, vol. 1, pp. 17–18.

8. This apparatus first introduced air into the building with the help of fans, subjected it to a spray for washing away the soot, warmed it in the winter and cooled it in the summer, and then introduced it into the theater. The used air was removed again with the help of fans. It had been designed by Dr. Carl Böhm and caused a sensation at the time; see C. Hesse, "Über einige Einrichtungen des Wiener Opernhauses," *Deutsche Bauzeitung* 7 (December 24, 1873):402. It naturally attracted considerable attention in the United States; see M. Herscher, "The Vienna Opera House: Heating and Ventilating," *American Engineer* 2 (October, 1881):191–93; and John S. Billings, "Letters to a Young Architect on Ventilation and Heating, No. XXXVI," *Sanitary Engineer* 5 (December 1, 1881):6.

9. Adler, "Stage Mechanism," p. 42. The architectural, technical, and structural features of this theater are discussed in Conrad Steinbrecht, "Das neue Opernhaus in Frankfurt a. M.," *Deutsche Bauzeitung* 14 (November 27, 1880):507–8 and (December 4, 1880):519–20; and J. A. Becker and E. Giesenberg, "Das Opernhaus zu Frankfurt a. M.," *Zeitschrift für Bauwesen* 33 (1883):cols. 1–12.

10. The Dresden theater was the second one that Semper erected on the site. The first was built in 1838–41 and destroyed by fire in 1869. Both incorporated planning features of paramount significance that will be discussed subsequently. Semper's theaters were discussed in detail in the contemporary press. For the second theater, see "Semper's Plan zum neuen Hoftheater in Dresden," *Deutsche Bauzeitung* 5 (February 16, 1871):49–50 and (February 23, 1871):57–58; [K. E. O. Fritsch], "Das neue Hoftheater zu Dresden," *Deutsche Bauzeitung* 12 (April 13, 1878):145–46, (April 27, 1878):167–68, and (May 4, 1878):179–81; and "The New Court Theatre, Dresden," *Builder* 36 (May 25, 1878):536–41.

11. As Adler reported, its stage was being modernized at the time of his visit. An extensive report on the remodeling operations is in A. Heydemann and E. Kasch, "Der Bühnen-Umbau des Königlichen Schauspielhauses in Berlin," *Zeitschrift fur Bauwesen* 42 (1892):cols. 483–512; and Sachs, *Modern Opera Houses*, vol. 3, supp. 1, pp. 62–67.

12. This comprised sophisticated provisions for preventing all lights from going out simultanesouly, for the creation of particular lighting effects, for the gradual diminishing of lights in the auditorium and on the stage, and for emergency lighting. The German-speaking countries had pioneered in the use of electricity. By 1884, a full-scale theatrical model was exhibited at the International Electric Exhibition in Vienna, illuminated with incandescent and arc lamps; see "Das Theater auf der internationalen elektrischen Ausstellung in Wien," *Deutsche Bauzeitung* 17 (July 14, 1884):335–36.

13. To quote a contemporary critic in *Deutsche Bauzeitung* 20 (November 20, 1886): "[dieser Theater] bietet . . . das erste in Deutschland zur Vollendung gelangte Beispiel einer Theater-Anlage, bei welcher man bestrebt war, jene technische Einrichtungen *vereint* und in möglichst vollkommener Gestalt zur Anwendung zu bringen, welche in neuerer Zeit zum Schutze und zur Annehmlichkeit des Theaterpublikums sowie zur Verbesserung des Bühnen-Betriebes ersonnen worden sind. Wer fortan einen Theater-Neubau zu planen hat, wird kaum umhin können, das Stadttheater von Halle zum Gegenstande seines eingehenden Studiums zu machen" (p. 553, emphasis in the original).

14. The other theaters that Adler saw, such as the Lessing Theater, the Hofburg Theater, and the German Theater, were built along similar lines. The Lessing Theater was the newest and the most fully equipped, according to contemporary descriptions: Hermann von der Hude and Julius Hennicke, "Das Lessing-Theater in Berlin," *Zeitschrift für Bauwesen* 39 (1889):cols, 170–76; [K. E. O. Fritsch], "Das Lessing-Theater," *Deutsche Bauzeitung* 22 (February 8, 1888):65–67; "Heiz- und Lüftungs-Anlage im neuen Lessing-Theater zu Berlin," *Deutsche Bauzeitung* 22 (March 10, 1888):113–15. On the Imperial Opera House in Vienna, see "The New Imperial Court Theatre in Vienna," *Builder* 35 (February 3, 1877):106. On the Hofburg Theater, see [K. E. O. Fritsch], "Das neue Hofburgtheater in Wien," *Deutsche Bauzeitung* 30 (December 5, 1896):613–15, (December 16, 1896):633–35; and Sachs, *Modern Opera Houses*, vol. 1, pp. 7–14, and vol. 3, supp. 1, pp. 53–61. The extremely elaborate stage machinery of this theater, which combined several systems, had proved to be totally inefficient, Adler reported in "Stage Mechanism," p. 43.

15. At the time of its completion, the Metropolitan had the best theater heating and ventilation in the United States, as emphasized in the contemporary article "The New Metropolitan Opera House," *Sanitary Engineer* 9 (January 10, 1884): "No theater or opera-house in London or Paris is equal to it in this respect; and in fact, *the opera-houses of Vienna and of Frankfort-on-the-Main are the only ones we have seen in which the arrangements for ventilation and heating are equally elaborate and satisfactory*" (p. 135, emphasis added).

16. The electric plant of the Auditorium was by the Edison Company, the German branch of which had manufactured the electric plant of the theater in Halle. In 1892 the Auditorium plant was replaced by a larger one constructed by the German firm of Siemens and Halske; see *Engineering News* 28 (October 6, 1892):313.

17. *American Architect* 26 (December 28, 1889):300.

18. *Auditorium*, p. 102, emphasis added.

19. The Imperial Opera House in Vienna had the horseshoe plan and so did the Opera House in Frankfurt a. M., the German Theater in Prague, and the Lessing Theater in Berlin. The National Opera House in Budapest had the lyre plan, as did the Hofburg Theater in Vienna, the Court Opera House in Dresden, and the Municipal Theater in Halle.

20. Richard Wagner, *Mein Leben*, 2 vols. (Munich: F. Bruckmann, 1911), passim; Friedrich Pecht, *Deutsche Künstler des neunzehnten Jahrhunderts*, 1st series (Nördlingen: Beck, 1877–79), passim; Heinz Quitzsch, *Die aesthetischen Anschauungen Gottfried Sempers* (Berlin: Akademie-Verlag, 1962), passim.

21. Heinrich Habel, "Die Idee eines Festspielhauses," in Detta Petzet and Michael Petzet, *Die Richard Wagner-Bühne König Ludwigs II: Müchen, Bayreuth* (Munich: Prestel, 1970) pp. 297–316; Franz Benedikt Biermann, *Die Pläne für Reform des Theaterbaues bei Karl Friedrich Schinkel und Gottfried Semper* (Berlin: Selbstverlag der Gesellschaft für Theatergeschichte, 1928), pp. 63ff; and Constantin Lipsius, "Gottfried Semper," *Deutsche Bauzeitung* 14 (March 27, 1880):130.

22. Otto Brückwald, "Das Bühnenfestspielhaus zu Bayreuth," *Deutsche Bauzeitung* 9 (January 2, 1875):1–2; Habel, "Die Idee," pp. 314–15; Biermann, *Die Pläne*, pp. 91ff; "The Wagner Theatre, Bayreuth (Bavaria)," *Builder* 34 (July 1, 1876):646; and "The Wagner Theatre," *Building* 11 (December 21, 1889):221–22.

23. It was Wagner himself who had introduced this theater to the public, as early as 1873, with his famous essay "Das Bühnenfestspielhaus zu Bayreuth," published

in *Gesammelte Schriften und Dichtungen*, 10 vols. (Leipzig: E. W. Fritzsch, 1871–83), vol. 9, pp. 384–408, and accompanied by a complete set of drawings. Chicago's fascination with Wagner is well known, and so is Sullivan's, for whom Wagner was an idolized hero, a "Mighty Personality—a great Free Spirit, a Poet, a Master Craftsman"; see Louis H. Sullivan, *The Autobiography of an Idea* (1924, repr. New York: Dover, 1954), p. 208.

24. See, for example, the description in "Die Architektur auf der internationalen Jubiläums-Kunst-Ausstellung in München," *Deutsche Bauzeitung* 22 (August 8, 1888):377. The model was destroyed in World War II; only photographs survive.

25. Published in Richard Wagner, *Die Dichtung des Bühnenfestspieles "Der Ring des Nibelungen"* (Leipzig, 1863); quoted in Biermann, *Die Pläne*, p. 63.

26. Biermann, *Die Pläne*, p. 66.

27. Ibid., p. 77, and Manfred Semper, *Theater*, div. 5 of *Gebäude fur Erziehung, Wissenschaft und Kunst*, vol. 6 of *Entwerfen, Anlage und Einrichtung der Gebäude*, part 4 of *Handbuch der Architektur* (Stuttgart: Arnold Bergsträsser Verlagsbuchhandlung [A. Kröner], 1904), p. 193:

> Der Kern des Gebäudes . . . ist der grosse Hörsaal mit der ihm zugehörigen Bühne. Die Einrichtung beider Teile weicht in wichtigen Punkten von der herkömmlichen Theatereinrichtung ab. Folgende dem Architekten gestellte Bedingungen waren dabei massgebend: 1. Vollständige Trennung der ideellen Bühnenwelt von der durch den Zuschauerkreis vertretenen Realität. 2. Dieser Trennung entsprechend ein nicht sichtbares, nur durch das Ohr wirksames Orchester. Von diesen beiden Bedingungen ist besonders die letztere für die Einrichtung des Hörsaales wie für die Gestaltung des ganzen Werkes entscheidend. Denn um die Orchestra den Augen aller Zuhörer zu entziehen, ohne . . . den durchaus notwendigen Zusammenhang zwischen dem Bühnenspiele und dem Orchesterspiele zu stören . . . bleibt nur die einzige Auskunft, das Auditorium nach antiker Weise anzulegen, als ansteigenden Sitzstufenbau (Cavea), zugleich von der modernen Logeneinrichtung vollständig abzusehen.

(Unless otherwise indicated, all translations from the German in this study are my own.)

28.

> Die vertiefte Lage der Orchestra erfüllt zugleich den wichtigen Nebenzweck, die verlangte entschiedene Trennung der Cavea von der Bühne zu bewerkstelligen. Es entsteht zwischen beiden ein gleichsam neutraler Zwischenraum, desssen Abschluss nach allen Seiten hin, nach oben, unten und seitwärts, vom Auge des Zuschauers nicht verfolgt werden kann, so dass die wahre Entfernung der Einfassung der Bühne, die sich jenseits dieses Zwischenraumes erhebt, für das abschätzende Auge aus Mangel an Haltepunkten nicht wohl ermessbar ist, besonders wenn letzteres noch ausserdem durch passend angebrachte perspektivische oder optische Mittel über diese Entfernung getäuscht wird. Zum Teile wegen dieser optischen Wirkungen, besonders aber zum Zwecke der . . . vollständigen Trennung der idealen Bühnenwelt von der Realität musste . . . ein neues System der Buhnenbeleuchtung angenommen werden . . . Diesen . . . Absichten entspricht ein zweites, weiteres und höheres Proszenium, das in einer Einfassung von 15 Fuss dem eigentümlichen Bühnenproszenium vorgestellt ist und einen mächtigen Rahmen . . . bildet, hinter der . . . die Gasröhren zur Be-

leuchtung der eigentlichen Bühne versteckt liegen . . . Die Dekoration dieses vorderen Bühnenproszeniums ist den Motiven, Ordonnanzen, und Verhältnissen derjenigen des hinteren Bühnenproszeniums Vollkommen gleich, aber in den Grössenverhältnissen davon verschieden, voraus eine perspektivische Täuschung ensteht, weil das Auge die wirklichen Grössenverschiedenheiten nicht von den perspektivischen zu unterscheiden vermag. . . . So wird die beabsichtigte Vernichtung des Massstabes der Entfernungen un somit die Trennung der ideellen Bühnenwelt von der Realität der Zuschauerwelt vervollständigt."

Quoted in Biermann, *Die Pläne*, pp. 80–81, and Semper, *Theater*, pp. 193–94. The double proscenium together with the sunken orchestra created this neutral zone between auditorium proper and stage, which Wagner and Semper named "mystischer Abgrund," or "mystical abyss," see Wagner, "Das Bühnenfestspielhaus," p. 401.

29. "Zwischen ihm und dem zu erschauenden Bilde befindet sich nichts deutlich wahrnehmbares, sondern nur eine, zwischen den beiden Proscenien durch architektonische Vermittelung gleichsam im Schweben erhaltene Entfernung, welche das durch sie ihm entrückte Bild in der Unnahbarkeit einer Traumerscheinung zeigt, wahrend die aus dem 'mystischen Abgrunde' geisterhaft erklingende Musik . . . ihm in jenen begeisterten Zustand des Hellsehens versetzt, in welchem das erschaute scenische Bild ihm jetzt zum wahrhaftigsten Abbilde des Lebens selbst wird." Ibid., pp. 337–38.

30. Later in his article "Theater-Building for American Cities," Adler reiterated his preference for a scheme "approximately fan-shaped in plan" that "cuts off a number of front side seats from which but an unsatisfactory view of the stage can be obtained" (p. 724). Both the Auditorium Theater and the Bayreuth Festspielhaus had an improvement over the Munich project: in the latter, the lateral sight lines converged on, or near, the front edge of the stage, whereas in the other two the convergence was closer to its rear wall, which meant that only in these was an uninhibited view of the entire stage possible.

31. Following Bayreuth, most German theaters had adopted the orchestra pit, although stripped of its ideal and architectural implications. The Opera House in Frankfurt had one and so did the Court Opera House in Dresden and the Municipal Theater in Halle. In the Lessing Theater, which was destined for a variety of spectacles from light shows to grand operatic performances, provision was made for the creation of an orchestra pit.

32. Wagner, "Das Bühnenspielhaus," p. 403.

33. Biermann, *Die Pläne*, pp. 54ff; Gottfried Semper, *Das Königliche Hoftheater zu Dresden* (Braunschweig: Friedrich Vieweg und Sohn, 1849).

34. Semper, *Dresden*, pp. 5, 8.

35. "Ihrer Form nach muss sie [die Bühneneinfassung] vom Quadrate sich nicht zu weit entfernen, und wie die Oeffnung einer Trompete von der Bühne aus nach dem Saale zu sich erweitern, damit die an die Wände der Einfassung stossenden Schallstrahlen in schrägem Winkel in den Saal fallen." Ibid., p. 9.

36. Adler, "Theater-Building," p. 724, emphasis added.

37. Adler, "Stage Mechanism," pp. 42–43; Sachs, *Modern Opera Houses*, pp. 7–14; "The New Imperial Court Theater in Vienna," *Builder* 35 (February 3, 1877):106; "New Court Theater in Vienna," *American Architect* 2 (February 24, 1877):57; [K. E. O. Fritsch] "Das neue Hofburgtheater in Wien," *Deutsche Bauzeitung* 30 (December 5, 1896):613–15, and (December 16, 1896):633–35; Klaus Eggert, *Gottfried Semper; Carl*

von Hasenauer, part 2 of *Die Bauten und ihre Architekten*, vol. 8 of *Die Wiener Ringstrasse: Bild einer Epoche*, ed. Renate Wagner-Rieger (Wiesbaden: Franz Steiner, 1978), pp. 198–210.

38. Eggert, *Gottfried Semper*, pp. 209–10. Semper withdrew from all Ringstrasse projects in 1876. Following his death in 1879, many efforts were undertaken to deny his design contribution. As soon as the shortcomings of the Hofburg Theater were discovered, he was grotesquely made responsible for them. Semper's sons and pupils, however, as well as other distinguished contemporary scholars, defended him vigorously. See Arnold Cattani, Albert Müller, and Hans Pestalozzi, "Professor Semper's Antheil an den Wiener Monumental-Bauten," *Deutsche Bauzeitung* 19 (August 8, 1885):379–80; O. Tenge, "Hasenauer und Semper," *Deutsche Bauzeitung*, 29 (February 27, 1895):101–4, (March 2, 1895):106–8, (March 6, 1895):113–16 and 118–19; Otto Schultze, "Dem Andenken Gottfried Sempers," *Deutsche Bauzeitung* 15 (October 15, 1881):460–61; and Josef Bayer, *Das K. K. Hofburgtheater vor und nach der Reconstruction* (Vienna: Gesellschaft für vervielfältigende Kunst, 1900), which also contains an interesting account of the theater's reconstruction process.

39. Schinkel's theatrical projects are discussed exhaustively in Biermann, *Die Pläne*, pp. 29–50, the primary source for the following discussion.

40. In 1817 this theater was burnt down, and Schinkel received the commission to design it anew.

41. "Das tiefe, mit Säulen verzierte Proszenium wird nicht allein dem ganzen Innern des Theaters ein grosser Schmuck werden, sondern für die Wirkung des Schalls durch die flache, breite Decke und die Abgeschlossenheit an den Seiten von dem grössten Nutzen sein." Regarding the orchestra, "Die Senkung des Orchesters um zwei Fuss tiefer ist für die Wirkung der Musik von grösstem Nutzen, die einzelnen Instrumente schmelzen durch den eingeschlossenen Raum . . . mehr zusammen und kommen als eine vollständige Harmonie heraus. . . ." Quoted in Biermann, *Die Pläne*, p. 35, from the memorandum accompanying the project.

42. Ibid., p. 37. Schinkel's interest also extended to the auditorium, as is shown in some of his sketches, in which a fan-shaped auditorium was placed in front of a sunken orchestra. Ibid., pp. 39–40.

43. Ibid., pp. 42–43.

44. For a discussion of Gilly's theatrical designs see Julius Posener, *Berlin auf dem Wege zu einer neuen Architektur* (Munich: Prestel-Verlag, 1979), pp. 406ff.

45. August Sturmhoefel, "Scene der Alten und Bühne der Neuzeit," *Zeitschrift für Bauwesen* 38 (1888):cols. 307–40 and cols. 453–96.

46. Sturmhoefel, "Scene der Alten," col. 307.

47. Heinrich Seeling, "Ein Beitrag zur Lösung der Volkstheater-Frage," *Deutsche Bauzeitung* 23 (March 9, 1889):115–18, (March 16, 1889):127–30, (March 23, 1889): 139–42; August Sturmhoefel, "Ein Beitrag zur Losung der Volkstheater-Frage: Richtigstellung der Besprechung des Herrn H. Seeling," *Deutsche Bauzeitung* 23 (April 6, 1889):166–68; Heinrich Seeling, "Noch einmal der neueste 'Beitrag zur Lösung der Volkstheaterfrage," *Deutsche Bauzeitung* 23 (April 13, 1889):174–75; Maertens, "Zur Lösung der Volkstheaterfrage," *Deutsche Bauzeitung* 23 (May 4, 1889):214–16; and August Sturmhoefel, "Der optische 'Maassstab' in der Volkstheaterfrage," *Deutsche Bauzeitung* 23 (May 18, 1889):236–38.

48. Sturmhoefel, "Bühne der Neuzeit," col. 311. Sturmhoefel justified the use of boxes, fundamentally irreconcilable with the reform theater, on the basis of the de-

mand that would always exist for them from affluent visitors, and as a means of enlivening and articulating the walls. Ibid., col. 460.

49. Apparently this signified an upper limit in the possible size of the auditorium. It is interesting that in both theaters the large seating capacity was also seen as a means of securing satisfactory financial gains.

50. Another important ommission in Sturmhoefel's book was, as Seeling remarked, the fact that Semper's name was not mentioned, even in connection with Wagner and the Bayreuth Festspielhaus. This was inexplicable, Seeling emphasized, because Semper was the leading German theatrical authority and the actual designing genius behind the work. See Seeling, "Volkstheater-Frage," p. 128.

51. His remodeling works included the remodeling of the Grand Opera House in Chicago in 1880, of Hooley's Theater in Chicago in 1884–85, and of McVicker's Theater first in 1885 and again in 1890–91.

52. The rental pamphlet *Central Music Hall, Cor. Randolph and State Streets* (Chicago: n.d.) at the Chicago Historical Society provides ample illustration of the interior of the theater, as well as plans at the levels of the parquet and the balconies.

53. "A Mammoth Opera House," *Inland Architect* 5 (March 1885):25; Morrison, *Louis Sullivan*, pp. 67–71.

54. "A Mammoth Opera House," p. 25. Notice that in this description the boxes' presence is explained as a means of enlivening the walls, an argument Sturmhoefel also used.

55. Later it was used to accommodate the organ. Adler made it clear in "Auditorium" (p. 414) that the addition of a large organ in this place was made at the last minute, after the plans had been drawn and the building was under way.

56. Description and illustration in Morrison, *Louis Sullivan*, p. 160, and "Chicago," *American Architect* 39 (February 4, 1893):72.

57. "Theater-Building," p. 717, emphasis added.

58. The verbose tone that Adler occasionally assumed in this article contradicted his usual modesty and should be attributed to the pride that he took in this work.

59. Frank Lloyd Wright, "Chicago's Auditorium Is Fifty Years Old," *Architectural Forum* 73 (September, 1940):12. As he explained, "Sullivan . . . was novice in those days . . . Adler, *master of that plan for The Auditorium*, was Sullivan's best critic" (emphasis added). Or, as Thomas T. Tallmadge wrote in *Architecture in Old Chicago* (Chicago: University of Chicago Press, 1941), p. 157, "I like to think of the building as more the creation of the senior partner."

60. As shown in the *Auction Catalogue: Catalogue of Auction of Household Effects, Library, Oriental Rugs, Paintings, etc. of Mr. Louis Sullivan; November 29, 1909. Williams, Barker & Severn Company* (Chicago, 1909).

61. In his *Autobiography*, passim, Sullivan paid tribute to them all.

62. Supporting testimony is provided by Wright, who wrote in "Auditorium," "The dramatic expression of the interior was Sullivan's. . . . The receding elliptical arches spanning the great room were a development by Sullivan of Adler's invention of the sounding board of sloping ceiling above the proscenium" p. 12.

63. He actually published an essay on it, see Louis H. Sullivan, "Ornamentation of the Auditorium," in *Industrial Chicago*, 3 vols. (Chicago: Goodspeed Publishing, 1891), vol. 1, pp. 490–91.

64. The Chicago Civic Opera building was discussed in detail in a series of

articles all published in *Architectural Forum* 52 (April 1930): see Anne Lee, "The Chicago Civic Opera Building" (pp. 491–66); "The Color and the Curtain" (pp. 497–98); "Chicago Civic Opera Building" (pp. 499–514); Magnus Gundersen, "The Structural Design of the Chicago Civic Opera Building" (pp. 595–98); Paul E. Sabine, "Acoustics of the Chicago Civic Opera House" (pp. 599–604); R. E. Berry, "Stage Equipment and Lighting" (pp. 605–8); F. Loucks, "Electrical Installations, 20 Wacker Drive Building" (pp. 608–9); and C. A. Frazier, "Mechanical Equipment of the Chicago Civil Opera Building" (pp. 610–14).

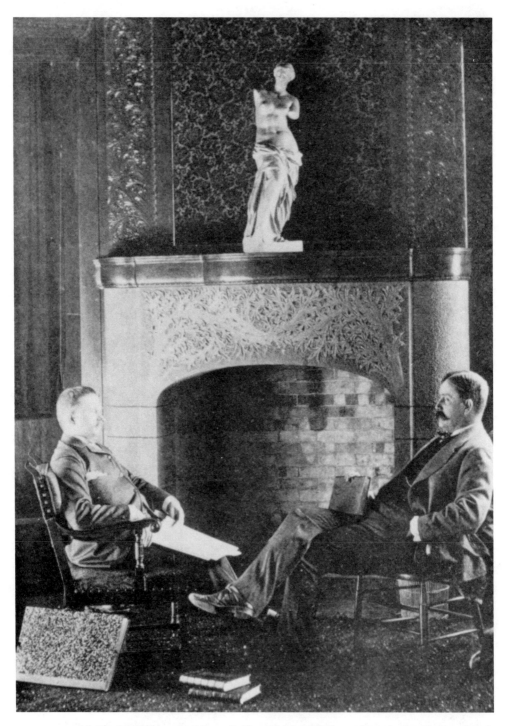

3.1 Daniel Hudson Burnham (left) and John Wellborn Root in the library of their offices at the Rookery Building. At this writing, the eleventh-floor, southeast corner office with its ornate mantle is still extant. (Donald Hoffmann, *The Architecture of John Wellborn Root* [Baltimore: Johns Hopkins University Press, 1973], fig. 56, and attributed to *Inland Architect*.)

3

Burnham and Root and the Rookery

Deborah Slaton

Architecture is, like every other art, born of its age and environment. So the new type will be found by us, if we do find it, through the frankest possible acceptance of every requirement of modern life in all of its conditions, without regret for the past or idle longing for a future and more fortunate day; this acceptance being accompanied by the intelligent and sympathetic study of the past in the spirit of aspiring emulation, not servile imitation.[1]

—John W. Root

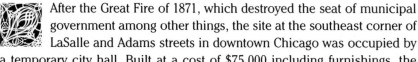 After the Great Fire of 1871, which destroyed the seat of municipal government among other things, the site at the southeast corner of LaSalle and Adams streets in downtown Chicago was occupied by a temporary city hall. Built at a cost of $75,000 including furnishings, the two-story brick building surrounded an old iron water tank that had once supplied lake water through wooden pipes from a pump at the foot of Lake Street. Its roof was replaced with a skylight, and the empty tank became the first public library reading room in Chicago after the fire. The temporary city hall and its water tank also provided a roosting place for hundreds of pigeons and thus acquired the name "The Rookery."

By 1885, a new city hall was completed, and the site at LaSalle and Adams streets was again available for construction. On December 3, 1885, the lot was leased to Edward C. Waller, a prominent Chicago real estate agent representing a group of investors. Waller acquired the lot with a ninety-nine-year lease for an annual rent of approximately $35,000.[2] He and his clients were investors in the Central Safety Deposit Company, for whom a new building was to be constructed on the site.

Among the original stockholders of the company were Owen F. Aldis and Peter E. Brooks and Shepard Brooks of Boston. In 1881, Aldis had acted as agent for Peter Brooks in the development of the Montauk Block in Chicago. Brooks proposed to Aldis in October of 1885 that Burnham and Root be hired to design the new building for the Central Safety Deposit Company.[3] John Root had designed a house for Aldis on Walton Place near Dearborn Street in Chicago and a residence for Edward Waller in River Forest. Daniel Burnham and Waller had been friends since their youth (fig. 3.1).

Born in Henderson, New York, in 1846, Daniel Hudson Burnham was the son of shopkeeper parents. In 1854 the family moved to Chicago, and Burnham was later sent back East to attend school. Having failed the admissions examinations for Harvard and Yale universities, he returned to Chicago and accepted employment with Loring and Jenney in 1868. However, he soon left the firm to spend two years silver mining in Colorado with his friend Edward Waller. Upon his return to Chicago in 1870, he worked with the architects John M. Van Osdel, H. B. Wheelock, and Gustave Laureau before taking a position as draftsman with Carter, Drake and Wight in 1872.[4]

John Wellborn Root was born in Lumpkin, Georgia, in 1850. His father, a prosperous merchant, had always wanted his son to become an architect. The younger Root was sent by his family to Liverpool, England, at the onset of the Civil War. There he studied music and art, gathering impressions of Liverpool's iron, glass, and brick industrial buildings. Returning to his family's new home in New York in 1866, Root received a degree in civil engineering from New York University three years later. In New York he worked for architects James Renwick and J. B. Snook. Root traveled to Chicago in 1872, where he became head draftsman for Carter, Drake and Wight.[5]

In the bustling economic climate of postfire Chicago, Burnham and Root found the opportunity to establish a new architectural firm in 1873. Although the national economic depressions of 1873 and 1874 slowed construction, both partners took on outside drafting work for other firms, and the new office survived. By late 1874, Burnham and Root were receiving numerous commissions for residences and other small structures. They also received a commission for a large house on Prairie Avenue in Chicago for John B. Sherman, owner of the Chicago stockyards.

The firm of Burnham and Root experienced a remarkable rise to prominence in the decades of the 1880s and 1890s, which have been called "the golden age of building in Chicago."[6] More than two dozen of their buildings were under construction in downtown Chicago in the 1880s and early 1890s. Their office, more than any other, helped rebuild downtown Chicago. By the time the Rookery was under construction in 1886, the Montauk Block, Rialto, Commerce, Phenix, McCormick, and Art Institute buildings had all been completed by the firm.

When Burnham and Root received the commission for the Rookery design, they were well-established leaders within the profession. After the building was completed in 1888, the firm moved its offices from the Mon-

tauk Block to the southeast corner of the eleventh floor of the Rookery. Contemporary periodicals attributed Burnham and Root's success in part to the organization of their office, the plans for which were published in the *Engineering and Building Record* and in the French journal, *Semaine des constructeurs*. In addition to offices and drafting rooms, the office featured a library, gymnasium, and baths. The rooms were lighted by natural light from windows along the exterior wall and the interior light court. The staff consisted of designers, draftsmen, and consultants including structural experts John M. Ewen and Charles L. Stroebel, and plumbing, heating, and ventilation expert William S. McHarg. A contemporary review stated that Burnham and Root "have endeavored to insure that each part of the work be done with precision and dispatch, making a working organization perhaps not hither-to attempted in an architectural office" (fig. 3.2).[7]

Burnham and Root's designs of this period have been recognized as a progression of a distinct building type, culminating in the Rookery and the Monadnock of the late 1880s.[8] The Rookery and its predecessors were all designed for commercial use, were primarily of masonry construction, and were approximately ten stories in height. The height of the buildings was limited by the bearing capacity and stability of solid masonry walls, but the development of the elevator opened up an entire new realm for development and construction. As one reviewer mused, "Not long ago people would have ridiculed the idea of building an eleven-story edifice; but times have changed, and the elevator, at first a great luxury, now an absolute necessity, has entered the field of industry and usefulness, and had its potent influence in increasing the values of real properties."[9]

New technology in plate-glass manufacture facilitated the use of large windows to provide maximum daylight for offices. Advancements in mechanical systems made all sorts of new amenities available to the occupants. Perhaps most important, the development of a means of fireproofing the construction components of a building put the owners and occupants at ease. All of these factors, critical to the development of tall building construction, are present in the Rookery and were developed in its predecessors.

Several of the buildings designed by Burnham and Root in the 1880s are readily recognizable as prototypes for the Rookery. The Calumet Building, which stood on LaSalle Street near Adams from 1883 to 1913 and which has been compared to the earlier Montauk, resembled the Rookery in its massive brick piers and grouped window openings. The Counselman, built on LaSalle at Jackson in 1884 and demolished in 1920, also showed some similarities to the Rookery facades. The Insurance Exchange Building at La-Salle and Adams, constructed in 1885 and torn down in 1912, resembled the Rookery in its masonry-bearing walls, interior-iron framing, and organization of the facades. Like the Rookery, the Insurance Exchange featured large entrance arches and decorative tourelles. Its exterior light court had an attached oriel stair. The Phenix, constructed on Jackson Boulevard in 1886, featured a similar plan with projecting entrance bays and a light well

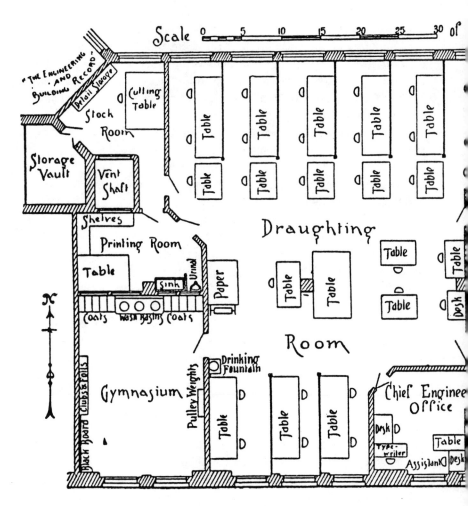

Scale 0 5 10 15 20 25 30 of

"THE ENGINEERING AND BUILDING RECORD"

Detail Storage

Stock Room

Culling Table

Table Table Table Table Table

Table Table Table Table Table

Storage Vault

Vent Shaft

Shelves

Printing Room

Draughting

Table

Table

Table

Table

Table Table

Desk

Table

Table

Sink Urinal

Paper

Coats Wash Basins Coats

Room

N

Gymnasium

Black Board Clubs & Poles Pulley Weights

Drinking Fountain

D D D

Table Table Table Table

D D D

Chief Engineer Office

Desk D

Type-writer

Assistant D Desk

Table

3.2 This plan of Burnham and Root's offices in the Rookery was published in the *Engineering and Building Record* in January 1890. In addition to offices, drafting space, storage rooms, and vaults, the office featured an elegant library where the partners reportedly kept a complete set of Piranesi's writings. Employees could also

with skeleton framing and enameled brick and tile walls. Its two-story vestibules, with winding marble stairways, balconies, coffered ceiling, and mosaic floors, all foreshadow the design for the Rookery. With the demolition of the Phenix in 1959, the Rookery and Monadnock became the only surviving Burnham and Root commercial buildings in Chicago.

Work on the design for the Rookery had begun even before the commission was formally awarded, as newspapers announced that "though the architect has not been definitely appointed, sketches have been drawn."[10] The eleven-story building is organized in a hollow-square plan, like the earlier building on the site, with principal entrances and lobbies on LaSalle and Adams streets. A two-story lobby at each entrance emphasized the prestige of the second story for offices, shops, and rental space. The sixty-two-

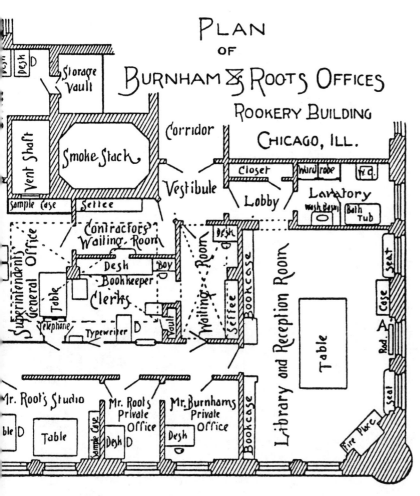

PLAN
OF
BURNHAM & ROOTS OFFICES
ROOKERY BUILDING
CHICAGO, ILL.

take advantage of the gymnasium, which was outfitted with Indian clubs, weights, and fencing equipment. According to *Engineering and Building Record*, Burnham and Root only conducted business with contractors between 11 A.M. and 1 P.M. each day. (*Engineering and Building Record*, January 11, 1890, p. 84)

by-seventy-one-foot central light court, which can be reached from either lobby, is covered by a glass skylight above the second-floor level. Above the light court, an open light well extends the full height of the building. At the second story, open balconies overlook the light court. Double-loaded corridors on the upper floors provide offices with windows on the light well or street facades (fig. 3.3).

The need to admit as much natural light as possible to the interior of the building was a governing factor in the design of the Rookery. The problem was solved by the skylighted central court and the continuous light well above. The organization of the exterior walls with round granite columns at the base permitted the ground-floor shops in between to have large expanses of glazing. The shops received natural light, and goods and activities within

The Rookery/Slaton

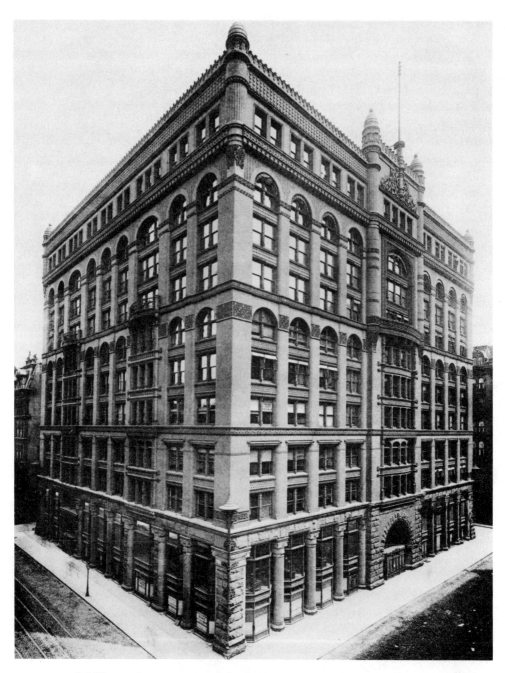

3.3 The northwest corner of the Rookery, photographed soon after completion in 1888. The LaSalle Street elevation is organized symmetrically around a central entrance bay surmounted by ornamental terra-cotta tourelles and a flagpole. The Adams Street elevation has two projecting bays; the entrance is located at the base of the east projecting bay. The two lower stories on the street elevations are granite, with cast iron and glass shop fronts. The upper stories are pressed red brick and ornamental terra cotta. (*The Architectural Record*, December 1895, p. 51)

could be seen from the street. Curtain-walls of glass on the lower floors along Rookery Court and Quincy Street permitted light to enter the alley elevations. When completed, the building prompted a reviewer to write "There it stands, the admired of all office buildings. Lighted on four sides from street and alleys and in the center from a great court, it is a thing of light. . . ."[11] Reflecting upon the Rookery in later years, Edward Waller noted that its design represented the development of the modern office building plan.[12] The architectural historian Henry-Russell Hitchcock noted that in this building Root created "the first valid solution" in the planning of a modern office building.[13] The design of the facades and interior spaces has occasioned as much comment as the plan.

In developing the facades and interior public spaces of the Rookery, Root was faced with an unusual design problem. He was required to create an aesthetic that would combine glass and iron with the more familiar brick and stone. The ornament of the Rookery has been called "Romanesque Commercial," Indian, Venetian, Arab, Islamic, Moorish, and "Moresque." The patterns in the exterior terra cotta and interior ironwork may be compared to the decorative motifs of Owen Jones's *Grammar of Ornament* (1856).[14] On the exterior, patterns were realized in glazing, granite, brick, and terra cotta. On the interior, decorative materials included Italian marble, dark oak, maple, glass block, and mosaic tile.

Root's biographers have noted that he wondered whether his design of ornament for the Rookery would withstand the test of time,[15] Hoffmann having felt that "while the range of details of plan, structure, and color might be justified rationally, the range of expression was imaginative and even perilous."[16] In the Rookery elevations, Root appears to have been moving away from the more Richardsonian character of his earlier designs such as the Union Depot in Burlington, Iowa (1882–83), and the Art Institute of Chicago (1885–87). It has been argued that the subordination of detail and texture to the regular vertical and horizontal massing of the Rookery's exterior facades permitted Root's design to succeed. The granite and terra-cotta arches, terra-cotta courses, projecting balconies, and tourelles above each entrance arch create an intricately detailed surface made even more inviting to the eye by the relief work in the terra-cotta surfaces and the varying textures of the granite and brickwork. The inviting decoration extends from the parapets to the pedestrian's eye level, where terra-cotta panels carry the street names at the corners of the building, originally lighted by bronze fixtures (fig. 3.4).

The walls of the light well are simpler than those of the exterior and represent a different aesthetic. The smooth horizontal bands of enameled brick, glazed terra-cotta courses, and large ribbon windows create light-colored, reflecting surfaces that enhance the light-filled quality of the space. The remarkable cast-iron oriel stair projects from one side of the well, presenting an interesting view for office workers around the court. In fact, even the stair

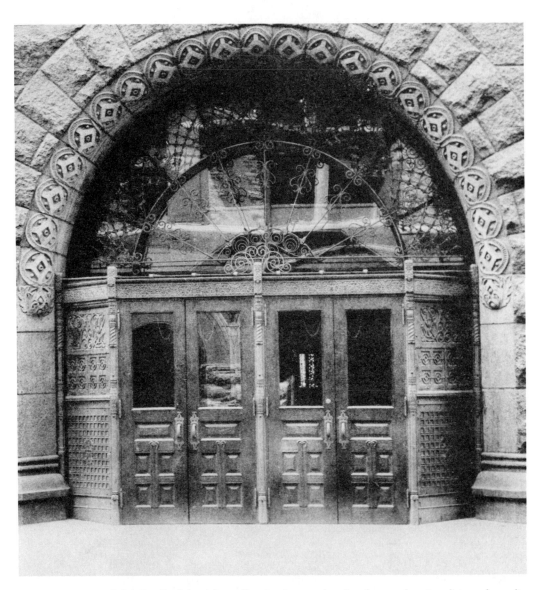

3.4 A detail of the Adams Street entrance showing the rough-cut and carved granite arch. The original door system was wood and ornamental cast iron, with an iron grill in front of the semicircular window above. Note that the entrance lobbies were originally two-story interior spaces. (*The Inland Architect and News Record*, July 1888)

risers are open-work cast iron, so that light filters through as well as around the stairway (fig. 3.5).

The early visitor to the Rookery passed through its massive arched portals into a light, elegant two-story lobby. Continuing past the elevator banks through a darker passageway, he or she entered the open, airy, light-filled space of the central court. When the Rookery was new, a reviewer commented that "there is nothing bolder, more original, or more inspiring in

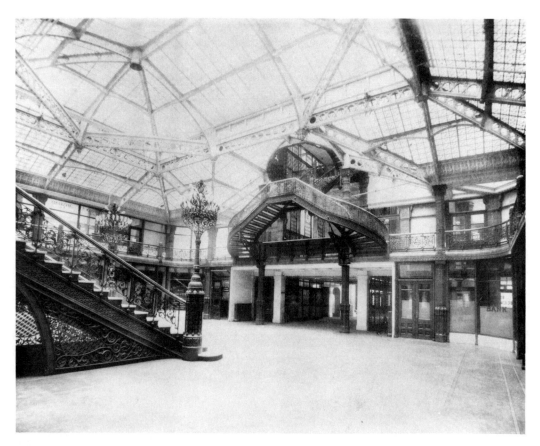

3.5 A view of the central light court soon after construction. The space is flooded with light from the cast-iron and glass skylight, filtering through the open-work stairways, balustrades, and elevator shafts. The curvilinear, ornamental ironwork was finished by the Bower-Barff process, which provided bronze highlights and further enlivened the space. The clerestory windows were operable, providing natural ventilation to the space. Note the cantilevered double stairs that lead to the base of the oriel, spiral stairway. (*The Inland Architect and News Record*, July 1888)

modern civic architecture either here or elsewhere than its glass-covered court."[17] Within the court, cast iron, marble, and the green, gold, brown, and white mosaic-tile floor captured and reflected the light. From the colorful floor to the intricately patterned, delicately framed skylight, the entire court was truly a "thing of light" (figs. 3.6, 3.7).[18]

Construction of the Rookery began in March of 1885 and continued through 1887. Revisions to the original scheme were made as construction continued: the original drawings show that additional stories were inserted in the middle of the building. The first construction drawings were labeled "The Central Building," but gradually the name "Rookery" became affixed to the structure.

Noteworthy for its design and planning, the Rookery also achieved rec-

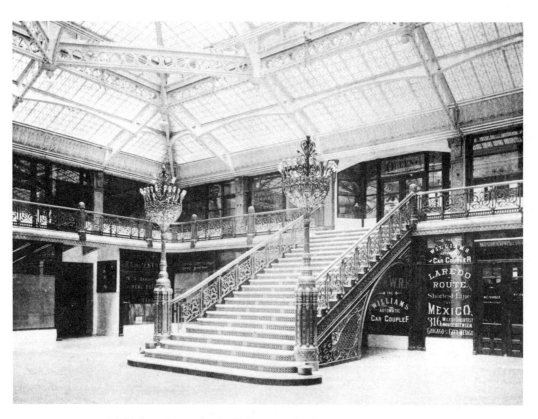

3.6 Main staircase in the light court, leading to the mezzanine level. Like the first floor, the mezzanine was a desirable commercial space. Note the advertising in the various glazed shop fronts. The electroliers at the base of the stairs celebrated the new technology of electric light and the ornamental possibilities of its fixtures. (Library of Congress)

ognition for its revolutionary construction techniques. In order to build large and heavy structures on Chicago's clay soils, Root had developed a "floating foundation," also known as the rail-grillage system. This was a grid constructed of railroad rails and iron or steel beams imbedded in a concrete slab, which carried the weight of the building as if on a raft. The system, developed by Root for the Montauk Block and used in the Rialto and the Phenix, worked equally well for the Rookery. Here Root located the basement floor at only 9 feet 8 inches below grade, with footings no deeper than thirteen feet below grade. While huge stone footings required a greater depth of excavation and filled up the basement space in other buildings, the raft foundation was more easily excavated and left greater area for usable space.

The raft foundation also permitted contractors to build tall structures more quickly because construction of foundations could continue in cold weather. During the winter of 1885–86, foundations were built under enormous sheds heated by boilers, and "instead of great derricks handling immense stones, the astonished people of Chicago saw on these lots low

3.7 Two-story LaSalle Street lobby, as designed by Burnham and Root. Symmetrical stairs on either side of the space led to the mezzanine level. The walls, ceilings, stairs, and balustrades were clad in white marble. At the entrance to the mezzanine elevator lobby, the marble was ornamented with gilded, incised designs. (*The Inland Architect and News Record*, July 1888)

wooden floors pierced by numerous chimneys, under which were being laid quietly and comfortably the foundations for eleven-story buildings."[19]

Above the foundation on the lower floors of the building, the structure consisted of granite columns with granite piers at the corners and supporting the entrance arches. On the alley elevations, the lower floors are supported by cast-iron columns and wrought-iron beams similar to those of the central light court. The exterior walls on the upper floors and the parapet are brick and terra cotta. Inside the building are rows of cast-iron columns spaced at about twenty feet on center, spanned by pairs of fifteen-inch-deep wrought-iron beams. The floor framing consists of wrought-iron beams spaced at seven feet on center, framed from the piers to the interior columns.

The interior light well, considered an advancement over Jenney's Home Insurance Building,[20] was constructed with a system of iron beams and channels. These structural members are independent of the supporting structure of the exterior walls. The walls of the light well are faced with enameled brick and terra cotta, and the lightweight structure permitted large ribbon

windows at each floor. The glazed roof of the skylight has an iron frame. Root designed the skeletal frame slightly shorter than that of the masonry bearing walls to allow for differential settlement.[21]

The increasing use of structural metal permitted buildings to achieve greater height, lightness of structure, and openness of wall. All of this would have been far less attractive to the designers after the fire of 1871 had not fireproofing been readily available. All structural metal in the Rookery is encased in fireproof clay tile, and the floors are constructed of hollow, flat-arched, nine-inch structural clay tile. The tile was laid by the Pioneer Fire-Proof Construction Company of Chicago, established in 1873. The importance of fireproofing in construction by 1888 was recognized in a contemporary review of the building: "The constructional part of the building is thoroughly incombustible, all ironwork performing any constructional purpose being covered with fireproof material, and the floor laid on hollow tile, . . . Any iron mullions in windows or elsewhere about the building which are exposed serve no constructional purpose."[22]

Contractors for the construction effort included the Chicago Andersen Pressed Brick Company, which supplied common, face, and ornamental pressed brick for the building, and the Northwestern Terra Cotta Company, which was responsible for a great proportion of the structural and ornamental terra cotta in use at the time. The James H. Rice Company of Chicago, said to have been the largest plate-glass manufacturer in the country, provided more than eighty thousand square feet of glass at cost of about $50,000. This was more glass than required for any other single building in the country at that time. Davidson and Son of North Market Street provided marble for the interior finishes.

Metal was provided by the well-known Hecla Iron Works, a firm associated with the Winslow Brothers, later patrons of Frank Lloyd Wright. The Rookery represented the most extensive use of ornamental iron to date in a single project, as well as the first independent contract let only for ornamental iron. The iron was finished using the Bower-Barff process, patented in 1881 and similar to bronze-plating or gilding for metal. A special furnace was used to produce superheated steam. The decorative ironwork was placed in a cast-iron chamber, where the surface was coated with magnetic oxide. This permitted the desired metal coating, applied with a brushlike device with metal filaments, to adhere to the surface. The magnetic oxide colored the surface black, while the bronze appeared as highlights.

Only the finest and safest mechanical systems and fittings were considered for the Rookery. The plumbing and gas-fitting system by E. Baggott incorporated the "Durham system of sewage," called "the only perfect system in use."[23] The Hale hydraulic elevators transported visitors from the lobby to the eleventh floor in fewer than fifteen seconds, and a rapturous commentator remarked that "no office building in the world will have such perfect elevator facilities for carrying tenants and clients . . . up and down."[24] Not only were the Rookery occupants able to speed to their vertical desti-

nations, but the open wrought-iron cages also admitted light and provided views from within during the trip. Another interesting feature of the Rookery was the vaults of the Central Safety Deposit Company, managed by the Illinois Trust and Savings Bank and opened on May 15, 1889. In addition to vaults in the basement, four large vaults are located on each upper floor for use by individual offices. The Central Safety vaults provided the first safe deposit boxes for rent by individual or small firms and were advertised as private, safe, and fireproof.

The Rookery was completed in early 1888. Called "the largest office building in the world" upon completion, it measures 177 feet 8 inches by 167 feet 6 inches upon its nearly square site. Its eleven stories, attic, basements, and light court comprise more than 350,000 square feet of space. Built at a cost of approximately $1,500,000, it remained the most expensive building constructed in Chicago until the twenty-one-story Masonic Temple, also by Burnham and Root, was completed in 1892.

The Rookery's six hundred offices housed some noteworthy tenants. In 1889, the Northern Trust Company held offices on the second floor. The North American Accident Insurance Company and John Nuveen and Company retained their Rookery offices until the present day. The glass-fronted offices around the light court were popular with travel and real estate firms, which advertised their services on the glazing. The Winslow Brothers, publishers of *Ornamental Iron*, opened offices in the Rookery in 1893, with a showroom on the seventh floor. The American Luxfer Prism Company opened an office there in the 1890s, as did Chicago attorneys and mayors Carter Harrison, Sr., and Carter H. Harrison, Jr. Samuel Insull, John W. Gates, and Judge Elbert H. Gary of U.S. Steel all had offices in the Rookery in the early years.

Thomas E. Tallmadge, who worked as a draftsman in Burnham's office, reflected that "the Rookery is John Root at his very best. An improvisation in tones and harmonies both delicate and strong, spontaneity of expression with profundity of thought, all fashioned with the inspiration of genius."[25] *Inland Architect*, *Architectural Record*, and *Engineering Record and Building News* all presented glowing reviews of the building in its early years. Perhaps the most poetic response came from the author of *Industrial Chicago*, who wrote: "It is a marvellous invention, winning admiration even from those who know its eccentricities and infirmities, charming every one like good music and gladdening the citizen who sees in it a palace, . . ."[26]

Well-received from the moment of its completion, the Rookery remained an exceedingly popular commercial structure for its first several decades. Perhaps in response to competition from newer office structures, however, the owners determined to remodel the interior public spaces after the turn of the century. Between 1905 and 1907, Frank Lloyd Wright was called upon to "modernize" these public spaces and bring them into accord with current tastes (fig. 3.8).

The Rookery was not Wright's only venture in altering his predecessors'

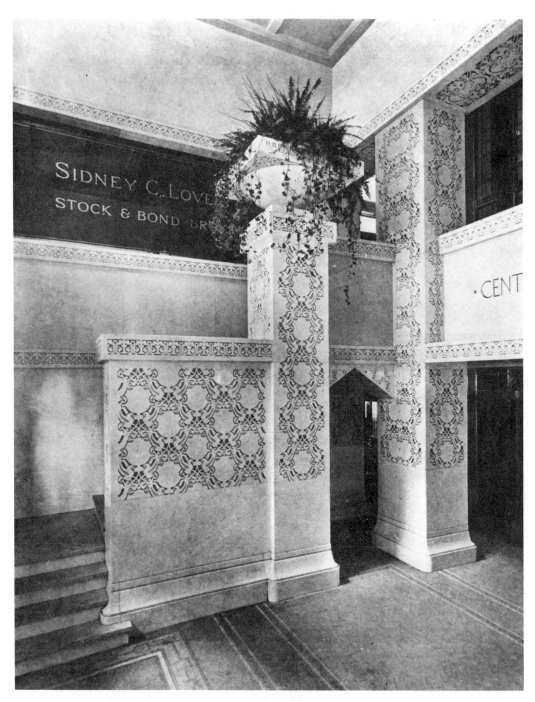

3.8 When Frank Lloyd Wright remodeled the Rookery lobbies in 1905, he altered the surface finishes of the space. The Adams Street lobby, shown here soon after the remodeling, exhibited Wright's redesign of the marble wall cladding and balustrades. Wright also added his characteristic urns. (*The Inland Architect and News Record*, September 1907)

designs; he also remodeled Root's house for Edward Waller in River Forest. Both Waller and his son, Edward C. Waller, were patrons of the younger architect. This also was not Wright's first experience with the Rookery; he had occupied offices there in 1898 and 1899 and was certainly familiar with the building. By 1905–6, Wright's studio had designed at least twenty Prairie houses as well as several major nonresidential designs, with construction of Unity Temple well underway in Oak Park. By this time, Wright had begun to turn his attention to new areas of design such as retail shops and interior design for commercial spaces.[27]

Although Root's ironwork and marble ornament may have been no longer stylish, Wright did not attempt to impose an entire Prairie-style interior upon the Rookery's public spaces. Instead, he straightened and made square the forms and surfaces of the lobbies and light court. Root's curvilinear iron tracery of balusters and stairways was replaced with strong geometric planes and courses of white marble. The decorative cast-iron columns of the light court were encased in marble. Root's electroliers were replaced with marble urns, and Prairie-style lighting fixtures were suspended from the light court ceiling (fig. 3.9).

In the LaSalle and Adams Street lobbies, the walls and columns were encased in marble, and ironwork was removed or enclosed. The curved lobby balconies were made straight. Urns were added to the Adams Street stairway, with trailing plants contributing to the Viennese effect. Wright also redesigned Root's open-work elevator doors with new, more rectilinear patterns. Details and surfaces were generally made simpler, lighter, flatter, and more "modern," although the marble surfaces Wright added to the space were finished with an incised, gilded pattern. A source for the patterns Wright developed may be found in the incised patterns of some of Root's details in the original lobbies. It has also been suggested that Wright's application of intricate patterns to surfaces that were otherwise made so much simpler than their predecessors was a reversion to the influence of Louis Sullivan (fig. 3.10).[28]

To some extent, Wright was respectful of Burnham and Root. He retained the configuration of the light court and lobbies. Particularly in the upper reaches of the light court and its skylight, some of Root's work remained untouched. It may be argued that the younger architect could have gone a great deal further in revising the interior. However, there can be no question that Wright left the mark of his own aesthetic on the Rookery through the remodeling design.

Twenty-five years after Wright had placed the stamp of his personality upon the Rookery lobbies and light court, one of his pupils received a commission to again alter the public spaces of the building. William Drummond came to Wright's studio in 1899 and remained at work there until Wright left for Europe ten years later. During this period, Drummond also worked for the offices of Daniel Burnham and Richard Schmidt. After working in

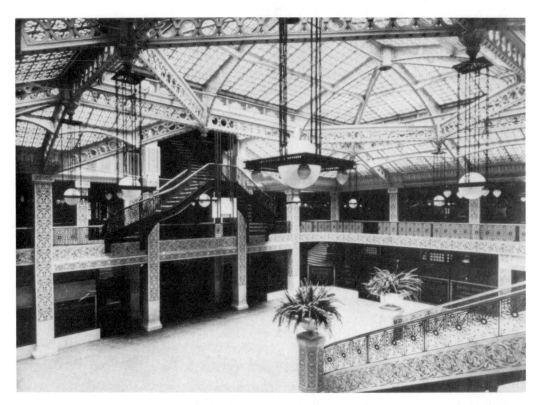

3.9 The light court is shown here after Wright's 1905 remodeling. The ornamental cast iron columns were encased in rectilinear marble panels, incised and gilded similarly to the ornamentation designed by Root for the LaSalle Street lobby. Wright designed a new, rectilinear cast-iron balustrade that simplified Root's design for the balustrade in the oriel stairs. He also removed Root's electroliers and added Prairie-style bronze suspended light fixtures. The organization of the space, and the decorative structure of the skylight, were retained. (The Barnes-Crosby Collection, Chicago Historical Society)

partnership with Louis Guenzel from 1912 through 1915, Drummond's link with Wright was reestablished as he received commissions to remodel the Isabel Roberts House, the River Forest Tennis Club, and the J. Kibben Ingalls House in the 1920s.

In 1931, Drummond won a competition for the redesign of the Rookery lobbies, together with the offices of the Halsey Stuart Company on the upper floors. The work resulted in dramatic changes to both lobbies. The double stairway and balcony in each lobby was removed, and the twenty-eight-foot-high spaces were converted into separate first and second floors. The arched windows over the main entrances were painted over, perhaps to disguise the new floor structure behind. Ornamental plaster cornices were added to each lobby, and the walls were sheathed in white marble. Bands of incised and gilded marble with patterns of birds were placed over the lobby entrances, and bronze elevator doors with incised patterns of birds and plants

3.10 Wright also designed new elevator enclosures of ornamental metal. As in the light court, he adapted a rectilinear, geometric pattern in place of Root's curvilinear, floral designs. (Photograph from a catalog of the Winslow Brothers Ornamental Iron Company, reproduced in Harry J. Hunderman and Deborah Slaton, for Continental National Bank and Trust Company of Illinois, *The Rookery: Program for the Restoration and Preservation of the Designated Features*)

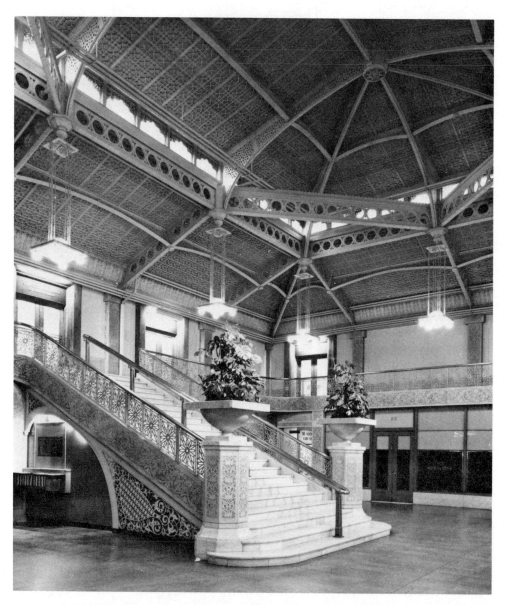

3.11 The light court as it appeared several years before the current restoration program began. Many of the shop fronts were enclosed and altered; the mosaic floor was covered with marble, and the skylight was painted and roofed over. However, many of Wright and Root's design elements remain intact. (Library of Congress)

replaced the open-work screens. Wright's wall fixtures were replaced with smaller, simpler lamps. In the light court, one of a pair of matching staircases was constructed, leading from the court floor to the mezzanine. This was perhaps added to replace the stairs that were removed from each of the entrance lobbies. The doorways and storefronts were framed in thick wood, and similar alterations were made to the upper-story hallways.[29]

The reasons for the remodeling are not entirely clear. In the early years of the depression, remodeling represented a lower-cost alternative to new construction. Perhaps the remodeling program was undertaken to bring the building into conformance with modern code requirements such as enclosed elevators. Perhaps each lobby was converted to two, single-story spaces in order to create more rentable space. At any rate, although remnants of Wright's work and Root's work remained, the character of the lobbies was changed irrevocably.

Since 1931, the Rookery has patiently endured various other alterations. Many individual offices and corridors have been modified to meet the needs of new tenants. The ornamental ironwork of the oriel stairs has been painted black. The mosaic floor of the light court has been covered by sheets of marble; the wood and glass walls have been obscured by drywall and plaster; and the ironwork and light fixtures have been painted. The skylight of the light court was painted over on the underside, possibly during the black-outs of World War II, and covered by roofing from above. The intricate framework of Root's skylight remains visible, but natural light no longer enlivens the space below (fig. 3.11).

The Rookery was purchased by Continental Illinois National Bank and Trust Company of Chicago in 1983, with the intention of rehabilitating the building and restoring its exterior facades, light court, and lobbies. The exterior of the building was cleaned, and a study for the restoration completed.[30] As co-author of that study, I agree with the essayist who in 1891 remarked of the Rookery that "The whole building is a study from basement to attic, one in which the architectural student may revel for a long period in interesting and instructive research."[31] The restoration study entailed detailed historical and technical research, physical investigation, and materials conservation analysis. Structural investigations and load testing were underway in the fall of 1988, when Continental Bank arranged the sale of the property to a new owner who was to continue the rehabilitation program guided by a preservation easement.

At their inception, the Rookery and its contemporaries epitomized an era of boldness and prosperity. Today the Rookery is the only survivor of that distinguished list that included the Calumet, Insurance Exchange, and Phenix, among others. The Chicago preservation community is acutely aware of its losses, including Adler and Sullivan's Schiller Theater (1891–92) demolished in 1961, and the Stock Exchange (1894) demolished in 1972. Equally disturbing are the less acknowledged buildings that have fallen to the wrecking ball: Adler and Sullivan's Troescher Building (1894), Frost and Granger's Northwestern Station (1911), and Jarvis Hunt's 900 North Michigan Avenue (1927) were all demolished during the 1980s. On the horizon is the threatened demolition of John M. Van Osdel's McCarthy Building (1872), Peter B. Wight's Springer Building (1872, remodeled by Adler and Sullivan in 1887), and John J. Egan's St. Benedict's Flats (1882).

The Rookery has been able to engender the support and respect it has

needed to survive its first hundred years with dignity and grace, intact and generally in good repair. The careful design of this "most modern" office building assured that the building would meet the needs of its occupants and owners for far longer than many of its contemporaries. The superior engineering and fastidious detailing of the facades helped to sustain the building in good repair. Finally, the imagination and remarkable aesthetic sensitivity invested in the Rookery have enhanced its meaning to generations of occupants since its construction, making it that much more valuable as an object of preservation.

With its restoration, the Rookery may again come to exemplify the vital spirit with which it was conceived. Writing in 1929 on Chicago and its buildings, the editor Paul Thomas Gilbert concluded that "if the reader of these pages will merely cherish the old traditions and make use of the past as a foundation for the structure of the future; if the reader will catch something of the spirit of the pioneers who have made this modern miracle possible; if he will carry on and bear the torch, the coming generations will have nothing to fear. . . ."[32] Frank Lloyd Wright confronted the responsibility of altering the design of Burnham and Root, and William Drummond faced the challenge of modifying the work of both Root and Wright. The present owners will surely find inspiration in the building as it embodies the spirit of an era and the character of its creators. Standing dignified and, one hopes, secure among its taller and newer neighbors on LaSalle Street, the Rookery awaits a renascence in its second hundred years.

NOTES

1. Harriet Monroe, *John Wellborn Root: A Study of His Life and Work* (Chicago: Riverside Press, 1896), p. 95. Monroe cites a paper that Root read to a class at the Art Institute of Chicago, and which was later published in *Inland Architect*.

2. "The Rookery Building," *Inland Architect* 5 (May 1885):69.

3. Carl Condit, *The Chicago School of Architecture* (Chicago: University of Chicago Press, 1964), p. 52.

4. Donald Hoffmann, *The Architecture of John Wellborn Root* (Baltimore: Johns Hopkins University Press, 1973), p. 11.

5. Hoffmann, *The Architecture of John Wellborn Root*, p. 10.

6. Frank A. Randall, *History of the Development of Building Construction in Chicago* (Urbana: University of Illinois Press, 1949), p. 93.

7. "The Organization of an Architect's Office, Number 1," *Engineering Record* 21 (January 11, 1890):84.

8. See Condit, *The Chicago School of Architecture*, pp. 56–58.

9. "A Great Office Building," *The Graphic* 8 (January 11, 1888):227, 282.

10. "The Rookery Building", p. 69.

11. *Industrial Chicago* (Chicago: Goodspeed Publishing, 1891) vol. 1, p. 188.

12. Thomas E. Tallmadge, *Architecture in Old Chicago* (Chicago: University of Chicago Press, 1941), p. 150.

13. Henry-Russell Hitchcock, *Modern Architecture: Romanticism and Reintegra-*

tion (New York: Payson and Clark, 1929, repr. New York: Hacker Art Books, 1970), p. 108.

14. See Owen Jones, *A Grammar of Ornament* (London, 1856, repr. New York: Van Nostrand Reinhold, 1982).

15. Condit, *The Chicago School of Architecture*, p. 65.

16. Hoffmann, *The Architecture of John Wellborn Root*, p. 68.

17. Henry Van Brunt, "John Wellborn Root," *Inland Architect and News Record* 16 (January 1891).

18. *Industrial Chicago*, vol. 1, p. 188.

19. Monroe, *John Wellborn Root*, p. 116.

20. Condit, *The Chicago School of Architecture*, pp. 80–88.

21. Ibid., pp. 64.

22. "The Rookery Building," *Inland Architect* 7 (June 1886):81.

23. "A Great Office Building," p. 282. The Rookery received a great deal of laudatory attention from contemporary reviewers. Boston architect C. H. Blackall, a graduate of the University of Illinois, recorded the Rookery in his "Notes of Travel—Chicago" in *The American Architect and Building News* in 1887 and 1888. In January 1888, *The Graphic* published an article on the Rookery entitled "A Great Office Building," and in March of the following year included a description of the Central Safety Deposit vaults. *Architectural Record* featured the building early in 1892 (and considered the Wright-modified interior in July 1925). *Ornamental Iron* published illustrations of the interior ironwork in November 1893. Numerous architectural writers gave the Rookery their attention in the 1890s, including Chicago's John M. Van Osdel in *A Quarter Century of Chicago Architecture* (Chicago: R. E. Swift and Company, 1895).

24. "A Great Office Building," p. 282.

25. Tallmadge, *Architecture in Old Chicago*, p. 151.

26. *Industrial Chicago*, vol. 1, p. 188.

27. Grant Carpenter Manson, *Frank Lloyd Wright to 1910: The First Golden Age* (New York: Van Nostrand Reinhold Publishing, 1958), p. 168.

28. Manson, *Frank Lloyd Wright*, p. 168.

29. Drummond was assisted in the project by Francis Barry Byrne, who completed the working drawings for the design, and Annette Byrne, who designed the ornamental motifs. I had the opportunity to walk through the Rookery with Mrs. Byrne in 1984, and to discuss the 1931 design for remodeling of the lobbies.

30. See Harry J. Hunderman and Deborah Slaton, *The Rookery: Program for the Restoration and Preservation of the Designated Features* (Chicago: Continental National Bank and Trust Company of Illinois, 1985). Research for the study was facilitated by the Burnham Library of the Art Institute of Chicago, which includes in its collection Daniel Burnham's sixteen-volume *Diaries* of 1895–1912; twenty-one volumes of his letters from 1890–1912; and, in original and on microfilm, several of the design drawings for the Rookery. Eleven sheets of Frank Lloyd Wright's architectural drawings for the alterations, dated November 1905, are in the collection of the Frank Lloyd Wright Foundation. We discovered copies of Drummond's architectural working drawings for the Rookery Building alterations dated July–October 1931, in an electrical closet in the basement of the Rookery during the site inspection.

31. *Industrial Chicago*, p. 188.

32. Paul Thomas Gilbert and Charles L. Bryson, *Chicago and Its Makers* (Chicago: Felix Mendelsohn, Publisher, 1929), p. 280.

4.1 Louis Sullivan (1856–1924) painted by Frank Werner for the Illinois Chapter of the American Institute of Architects, 1918. (The Chicago Historical Society)

4

SULLIVAN'S BANKS: A REAPPRAISAL

NARCISO G. MENOCAL

 The banks Louis Sullivan (fig. 4.1) designed late in life were trapped in a paradox until recently. They were universally accepted as major works of architecture, but were consistently dismissed as an epilogue to his work. That paradox was sustained by a persistent influence of progressivist architectural historians. Sullivan's banks never fitted the canonical progression of modern architecture as it was defined forty or fifty years ago. Siegfried Giedion, Nikolaus Pevsner, and Bruno Zevi, for example, ignored them completely.[1] The banks, many thought, were the sad end of a once brilliant career that had given us nothing less than the modern skyscraper. Kenneth Frampton's statement that the banks were "the swan song of a culture that somehow never fully matured" would have diminished their importance half a century ago.[2] Today we accept Frampton's point in its true implication. We recognize that the banks are major works of art regardless of their remote location and modest function, despite their "relatively late date" in the history of the modern movement, and not withstanding that they left no stylistic legacy except for a handful of banks by George Grant Elmslie and a few other buildings in the Midwest. Progressivist architectural historians, including many Sullivan scholars (with the exception of John Szarkowski),[3] failed to see that the importance of Sullivan's banks is intrinsic, not relative.

My reassessment of the banks rests upon four considerations: 1) rejecting traditional assumptions about supposed exclusive stylistic links between the banks and Sullivan's earlier designs for tombs; 2) recognizing the heretofore neglected (and far more important) relationship between the banks and Sullivan's skyscrapers of the 1890s; 3) understanding the relationship of the banks to a new conception of design that he enunciated in 1910, but had begun to practice before then; and, 4) appreciating the sexual signification of

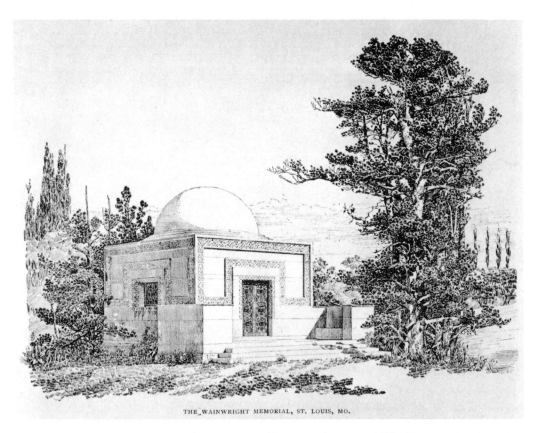

THE WAINWRIGHT MEMORIAL, ST. LOUIS, MO.

4.2 Adler and Sullivan, Wainwright Tomb, St. Louis, 1892. (*Engineering Magazine*, August 1892)

the coloring of the banks. These considerations make it possible to discern a broadening of Sullivan's Swedenborgian metaphysics toward the end of his career. Concurrently, the architecture of his banks has meanings richer than those in his previous work. This growth was nonlineal. It developed by trial and error, success and lapse. The banks are products of a brilliant change in Sullivan's conception of architecture that enabled him to surpass his earlier goals and achievements.

My argument requires challenging the conventional wisdom that Sullivan's banks are stylistic variations of his tombs and other works of 1886–92—of which the Wainwright Tomb (1892, fig. 4.2) may be cited as a generic example. Consider two of the common characteristics among Sullivan's buildings from those years. First, they are rendered primarily in smooth ashlar, which establishes a degree of planar abstraction on their surfaces. Second, their decorations are usually constructed out of the same materials as their walls. This treatment reinforces homogeneity and allows for stronger relationships between ornamentation and walls than between ornamentation and voids, such as doors and windows.

The banks are much different. Instead of a monochromatic treatment,

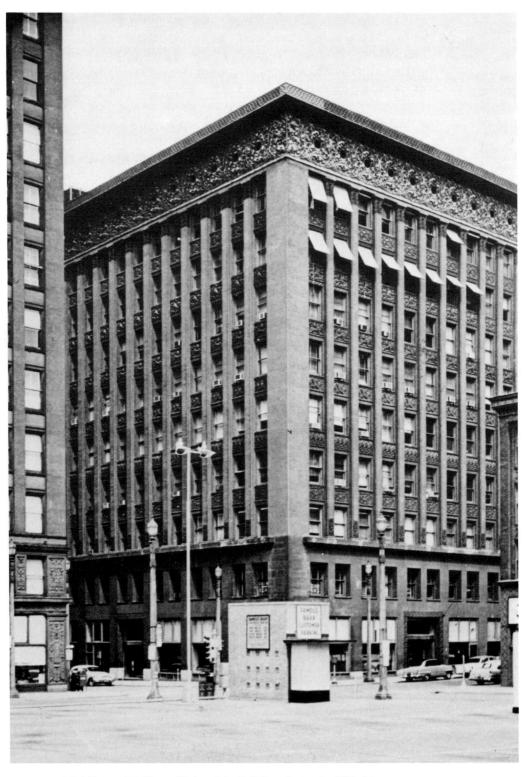

4.3 Adler and Sullivan, Wainwright Building, St. Louis, 1890–91.

there is a rich polychromy; instead of a smooth surface, a rich texture; instead of a geometric abstraction, a lyrical evocation of the landscape; instead of a homogenized relationship between wall and ornament, a contrast in colors and materials that produces a richer plasticity; instead of ornamentation related to the compositional masses, decoration that focuses attention on the doors and windows and is a framing element regardless of its location; and instead of ornamentation that creates an exclusively downward tectonic effect, ornamentation that helps to establish compositions in which symbolic, upward pulls seemingly defy gravity. In particular, the last item suggests that Sullivan's banks are closely related to his skyscraper style, its meaning, and its ties to the Gothic.

The Gothic was a central factor in Sullivan's skyscraper designs beginning with the first in the series, the Wainwright Building in St. Louis (1890–91, fig. 4.3). For its facade Sullivan relied heavily on his recollections of the interior west wall of the Cathedral of Reims and of the nave elevation of Notre-Dame in Paris.[4] Concurrent with those associations with the Gothic, he used piers and mullions to suggest an effect of slim trees standing close together. Such iconography related the building to organic growth and fulfilled his desire for the building to be "tall, every inch of it tall."[5] From these beginnings he went on in subsequent designs to add anthropomorphic meanings to the standard romantic conception of the vegetal origins of the Gothic, in which a cathedral would be compared to a grove, and vaults to branches interlacing high above the ground.

The Bayard Building in New York (1897–98, fig. 4.4) is the clearest example of that trend.[6] The Bayard may be compared with an enormous Gothic clerestory, complete with plate tracery and elongated colonnettes. It also reveals a deeper kinship with the organic than any of Sullivan's previous designs. The idea of an eternal becoming, of the "Rhythms of Life and of Death" (as Sullivan put it), is evident in the polarities he ascribed to the symbolic rhythm of the piers.[7] In an iconographic ambiguity Sullivan sought passionately, death supports life and evolution issues out of dissolution in the Bayard Building. Its piers make this idea clear by establishing a closed circuit with the moldings that decorate them. Beginning at any point on any pier, one can follow the design down, proceed without interruption across the second-floor sill, ascend the next pier, and close the cycle by rounding the arch beneath the attic. As this circuit may be traveled clockwise or counterclockwise, it compromises neither the subjective expression of upward movement nor the objective one of downward physical pressure.

Sullivan identified the subjective expression of upward movement with "Life," and with the growth of a tree, the pier's natural archetype. Objective compression—the downward movement—was "Death." To give richer meaning to the subjective connotation of "Life" in the piers, Sullivan extended their phytomorphic association into an anthropomorphic level. The piers give the impression that even though they carry the weight of the structure down to the floor, they are also capable of leaping, as if they belonged

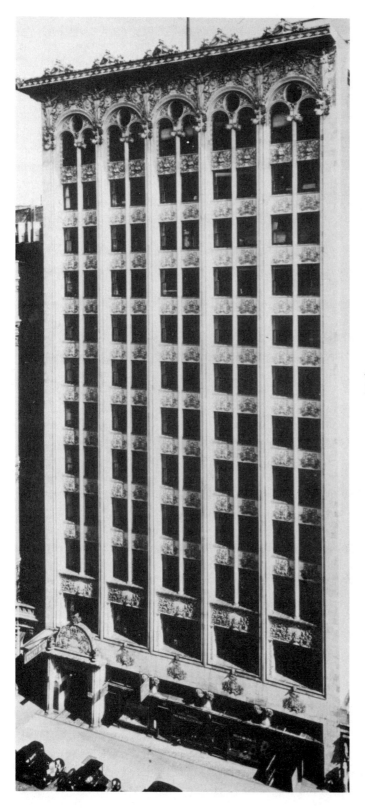

4.4 Louis H. Sullivan, Bayard
Building, New York, 1897–98.

to a human frame. This anthropomorphic scheme was reinforced by the opposing character of the first-floor supports, which before their unfortunate mutilation, showed no ambiguity. Structural elements at the street level expressed only their supporting function; their design showed no evidence that Sullivan wished them to evoke a sense of growth. The lintel, still, works as a summer beam in its etymological sense of *sagma,* or pack-saddle, visually carrying the weight of the superstructure. The original squat columns below it translated into architecture the muscular strain of an Atlas-like feat, supporting the colossal weight of the building. To create an even greater contrast between the supportive character of the base and the soaring ascent of the piers, Sullivan decreased the height of the floors as the building rose, establishing an optical correction that increases the vertical perspective and exaggerates the apparent height of the building.

The Bayard Building reveals the breadth of connotation of Sullivan's assessment of the Gothic, and also the small importance he attached to it as a historical style. To him, copying the Gothic per se was as much of an aberration as the imposition of any other historicism on a building. "The American architecture of today is the offspring of an illegitimate commerce with the mongrel style of the past," he once wrote.[8] The new architecture would be based on nature. It would simultaneously evoke the movement of the anthropomorphic, the growth of the phytomorphic, and the stress and strain of the geomorphic, as the Bayard Building did. The height of commercial buildings and the elastic characteristics of their metallic structures suggested such an iconography at the essential level. In *Autobiography*, Sullivan suggested that "The appeal and the inspiration [of a skyscraper] lie, of course, in the element of loftiness, in the suggestion of slenderness and aspiration, the soaring quality as of a thing rising from the earth as a unitary utterance, Dionysian in beauty."[9]

Sullivan's method of design shows influence from French romantic rationalism and Viollet-le-Duc's structuralism. His iconography had different origins; it was largely determined by American transcendentalism and romanticism, which coalesce into his architecture and can only be separated for art historical analysis. On the one hand, he followed French example and used classical forms in unclassical ways. He also found useful Viollet-le-Duc's endorsement of the Gothic as a point of departure for a modern architecture devoid of historicist connotation.[10] The other side of his architecture is as American as it is intensely personal. In his skyscrapers he translated what he considered to be the essence of the Gothic as a system of forces in equilibrium into his own transcendentalist language. In so doing, he extended his method of architecture beyond limits acceptable to his peers, American or not. To Sullivan, the intimation of organic life in architecture and the suggestion that certain structural elements were capable of movement were more important factors than the physical functions of buildings, methods of construction, or the needs of clients. He considered these issues to be pedestrian problems easily solved by anyone of normal intelligence.[11] Com-

position and ornamentation were primary to Sullivan's method during his skyscraper period.

New economic relationships between "progressive" midwestern bankers and farmers created a need for the rural bank as a new building type in the early twentieth century, as Wim de Wit has shown.[12] Most of Sullivan's work from 1906 onward fell into this category. As commissions trickled into his office, he refined by degrees a building type that had little in common with the tall office buildings he had been designing for more than twelve years. In the process, he redefined his concept of architecture, and in 1910 he made his new opinions public in *Suggestions in Artistic Brick*, bringing his thought full circle.[13]

After holding for many years that plan and function were secondary elements of architecture, Sullivan, probably impressed by the new definition of architecture advanced by the Prairie School movement, gave them new emphasis. Yet, his change of mind constituted no full embrace of the new midwestern ideas. Drawing upon the rationalism he had learned at the Ecole des Beaux-Arts, he argued that the new architecture was an adjustment to new possibilities of construction. Thanks to the "modern mechanically pressed brick [or tapestry brick, the architect] began to feel more sensible of the true nature of a building as an organism or whole." He also suggested that "this new material, brick, has led to a new development, namely that in which all the functions of a given building are allowed to find their expression in natural and appropriate forms—each form and the total shape evidencing, instead of hiding, the working conditions of the building as exhibited in its plan."[14] More economically and efficiently than before, the plan of a building could serve as the basis for designing its masses. A new organic unity could be brought into composition by rendering all exterior surfaces of a building in the same texture, one that brought with it the added advantage of a rich polychromy. Gottfried Semper's ideas on the textile origins of the wall and its ornamentation may have influenced his new conception. In *Artistic Brick*, Sullivan wrote of the new wall: "Manufacturers, by grinding the clay of the shale coarse and by use of cutting wires, produced on its face a new and most interesting texture, a texture with a nap-like effect, suggesting somewhat an Anatolian rug; a texture giving innumerable highlights and shadows, and a moss-like softness of appearance."[15]

Sullivan adapted his new beliefs to his standard transcendentalist pattern of thought. He anthropomorphized buildings and spoke of their yearning, resulting from a fundamental law of nature, to have their plans revealed by their volumes. "The building plan," he wrote, "clamors for expression and freedom . . . in a way that will satisfy its desires, and thus, in so doing, express them unmistakably. This is, in essence, the natural basis of the anatomy and physiology of design."[16] Some of Sullivan's new convictions were based on ideas of Viollet-le-Duc. In *Suggestions*, Sullivan wrote, "This law is not only comprehensive, but universal. It applies to the crystal as well as to the plant, each seeking and finding its form by virtue of its work-

ing plan, or purpose, or utility."[17] Likewise, Viollet-le-Duc had written in his Sixth Discourse:

> Nature, in all her works, has style, because, however varied her productions may be, they are always submitted to laws and invariable principles. The lilies of the field, the leaves of the trees, the insects, have style, because they grow, develop, and exist according to essentially logical laws. We can spare nothing from a flower, because, in its organization, every part has its function and is formed to carry out that function in the most beautiful manner. Style resides in the true and well-understood expression of a principle; therefore, as nothing exists in nature without a principle, everything in nature must have style.[18]

After reassessing Viollet-le-Duc's ideas, as well as other principles of French architectural theory he had learned as a student in Europe and America, Sullivan accepted the Prairie School tenet that the new architecture should insist on an intimate relationship between plan, volume, and function. This reappraisal of his definition of architecture reinforced some of his old opinions while bringing new notions to the fore. The idea that each element of a design was a discrete entity that nobly expressed its own mechanical and, therefore, functional reality was consistent both with his French training and with his transcendentalist interests, but bringing floor plans into prominence was new for him. In the past he had considered the design of plans a "pedestrian" activity and, even, had difficulty devising them efficiently. (One remembers especially his problems with residential floor plans. Earlier, Adler had designed the floor plans of the office buildings commissioned to Adler and Sullivan. After the dissolution of the partnership Sullivan had few problems designing the plans of the tall buildings of the late 1890s. They were mostly of the "loft" or warehouse type, requiring no great study.)[19]

Turning a past weakness into a salient feature of design was no great struggle for Sullivan. Wim de Wit has shown how Sullivan's plans for banks derived from six solutions for "progressive bank floor plans" published in the February 1905 issue of *The Architectural Review* (which antedates Sullivan's first bank design by a year). De Wit's discovery explains why Sullivan once stated that "the requirements [for the banks were] given, and it only remained to jot them down on paper." He was as free of complicated decisions about planning as he had been for skyscrapers. He could devote as much attention to composition and ornamentation for the banks as he had for the tall office buildings of the 1890s; he was making their compositions evolve from plans he did not have to invent. This may account in large part for his successes with rural banks, especially in the light of his failures with residential work in the same period.[20]

The National Farmers Bank, Owatonna, Minnesota (1906–8), his first, was perhaps the most difficult to design for two reasons. Not only was Sul-

livan dealing with a new building type, but he was also devising a new aesthetic.[21] Central among his new artistic ideas was his appreciation of French symbolist poetry and impressionist music. Since the 1880s such poets as Mallarmé, Rimbaud, and Verlaine in France, and Maeterlinck in Belgium, expanding ideas first explored by the Parnassians and Baudelaire before them, had used the material universe to express the immaterial realities of thought and feeling through correspondences, allegories, and consciously invented symbols. Behind every incident, behind almost every phrase in this literature, lay a concealed universality, the adumbration of greater things. To Maeterlinck, for example, revealing the infinite as well as the grandeur and secret beauty of humanity was the supreme mission of art. He believed that artists were imbued with a special sensitivity to the universal, and that it was their task, through art, to give lesser beings a glimpse of that vision. Art, to Maeterlinck, was a metaphor because artists were unable to express directly the breadth and intensity of their intuition, and even if they could, people would not understand it.

Symbolist poets also sought to represent the unity of all feeling, and integrated into poetry effects from other arts. Their verses evoke the colors of the painter and the rhythms of the musician. These are all esthetic objectives that Sullivan recognized as close to his own, and his awareness of this movement is more than likely. These comments on symbolism are but a restatement of Richard Hovey's introduction to his two-volume translation of Maeterlinck's plays, a copy of which Sullivan kept in his summer cottage in Mississippi.

Musical associations were also important to Sullivan's new style. Debussy, Satie, Ravel, and other impressionist composers summoned to music what the symbolist poets sought in words. Debussy's pieces evoking color are well known; he based his only opera, *Pelléas et Mélisande* (1902) on Maeterlinck's play; and he translated Mallarmé's *L'après-midi d'un faune* into music in 1894. Sullivan's awareness of such links among color, rhythm, and allegory is manifest in an often-quoted letter he wrote to Carl Bennett, the vice president of the Owatonna bank, in which Sullivan states that he wishes to create "a color symphony." Bennett, who was highly sensitive to music (during his student days he had conducted the "Pierian Sodality," the Harvard symphony orchestra), presumably encouraged Sullivan to create an architectural composition that would symbolize a harmony with poetry and music through color and light. In 1911, Bennett wrote Sullivan a highly complimentary letter in which he said, "I have often likened your work to that of the great musicians or poets, and have thought of ourselves as though we possessed exclusively . . . one of the symphonies of Beethoven."[22]

In general, the lines of the Owatonna bank follow those of Sullivan's Golden Doorway of the Transportation Building in the Columbian Exhibition (1891–93, figs. 4.5, 4.6). In both designs a large spandrel came to rest on a plinth to define an important arch, and a thick cornice contributed to the monumental sturdiness of each composition. But there the similarities

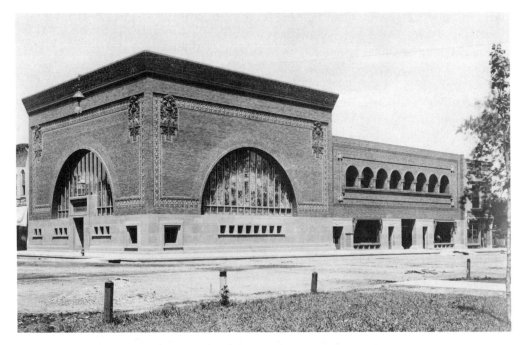

4.5 Louis H. Sullivan, National Farmers Bank, Owatonna, Minn., 1906–8.

4.6 Adler and Sullivan, Transportation Building, World's Columbian Exhibition, Chicago, 1891–93, "Golden Doorway." (*Campbell's Illustrated History of the World's Columbian Exposition*, Chicago, 1893)

ended. The coloristic effects of the Golden Doorway depended on applied plaster ornamentation and paint. Those of the Owatonna bank are integral to the materials. The buildings also differed in function and scale, but more important, in degree of picturesqueness. The rich polychromy of the Golden Doorway—a golden hue highlighted by "no less than forty tints of colours" seen against the red background of the rest of the building—must have created effects that black-and-white photographs cannot capture.[23] Other features increased its sumptuousness. Important among them were the telescoping arches, the inwardly turning plinths, the sculptural decorations, and the reliefs on the tympanum that the surrounding architecture framed. Large decorative motifs on the archivolts and exuberant ornamentation along the outer perimeter and on the cornice elaborated further the picturesqueness of the Golden Doorway.

Nothing so lavish appears in the Owatonna bank. True to his new conception of style, Sullivan allowed the materials to speak for themselves and kept applied decoration to a minimum. The plinth is stone, the spandrel brick, and the cornice, raked this time as befits its material, is also brick. Only a small band of terra cotta and two imposing cast-iron ornaments frame the large window on each street facade and establish a chromatic affinity between the tapestry brick and the stained glass. The proportions of the design are equally simple. Sullivan divided each facade horizontally into four approximately equal parts, each about the length of the radius of the window. The vertical module is more or less half of the horizontal, and he used it five times: once to the sill of the window (the height of the stone base); twice more to the crown of the arch; another to the top of the incised terra-cotta band; and the fifth to the top of the cornice.

Sullivan's goal was a "rich box in which to keep money and valuables."[24] The bottom of the box was identified by the stone plinth, and the lid was represented by the corniced tapestry-brick spandrel. The latter, in spite of its sturdiness, conveyed a sense of lightness because of the ample window it defined. Each part played its role efficiently. The historicist allusions of the Golden Doorway and its exotic associations with the Islamic world had no place in the Owatonna design.

Sullivan arrived at this design by a process of trial and error, as is well known. He first considered a facade with three narrow, arched windows, but following the suggestion of Elmslie, he changed them into the one sweeping arch of the final design.[25] It is generally accepted that Donn Barber's National Park Bank in New York, published by Montgomery Schuyler in the April 1905 *Architectural Record*, was a possible source for many features of the Owatonna bank, including the large semicircular window, albeit translated from an academic Beaux-Arts idiom into a progressive one (fig. 4.7). Perhaps Sullivan or Elmslie noted Schuyler's closing remark about the National Park Bank's central room being "a noble apartment, much in advance of anything for the same purpose we have hitherto had to show."[26]

Sullivan may have looked for still other sources to guide and inspire him

4.7 Donn Barber, National Park Bank, New York, 1905. (*Architectural Record*, April 1905)

to design his new bank. That statement may seem at odds with his dictum that "he made buildings out of his head," but considerable evidence suggests that whenever he confronted a new architectural problem, he usually looked for an existing design to serve as a foundation on which to build a new conception. Such cases usually ended in a transformation of the source into something completely different.[27]

For the first design of the Owatonna bank Sullivan may well have turned to the library of the Law School in Paris, designed by Louis-Ernest Lheureux in 1876–78 and enlarged in 1892–97 (fig. 4.8). It is more than likely that Sullivan knew this building through the photographs that Russell Sturgis published in an article entitled "Good Things in Modern Architecture," which appeared in 1898 in *The Architectural Record*. In the same article Sturgis praised Sullivan's Bayard Building and published a view of it.[28] If, indeed, Sullivan used the Law Library as a source for the Owatonna bank, he chose a model that was not new, but twenty years old. Sturgis's article may have misled him into thinking that the Law Library was a brand new building, for the text confuses the 1892–97 extension with the entire building. In any case, by placing Lheureux's design next to Sullivan's, Sturgis was offering both as examples of "Good Things in Modern Architecture."

Until it was torn down in the 1950s, the library stood on the rue Cujas as an extension of an earlier building by Soufflot across the square in front of his better-known Pantheon and diagonally across from Henri Labrouste's Bibliothèque Sainte-Geneviève, to which Lheureux's building was related stylistically because Lheureux had been a student in Labrouste's atelier. The facade of the library was in perfect accord with its internal structure, where metal struts transferred stresses from a metal-and-glass roof to masonry corner piers in a system that Hautecoeur characterized as a derivation from Viollet-le-Duc.[29] Exterior corner piers framed the composition and expressed clearly that the masonry at the corners withstood the thrust of the metal struts holding up the roof. At the center of the facade a recessed screen of three arches rested on a robust sill. That sill, in turn, helped to frame an inscription dating the foundation of the building. This epigraphic function reinforced the nonstructural character of the panel, which recalls the curtain walls under the windows of the Bibliothèque Sainte-Geneviève across the street. But there the similarities ended. Unlike the arches of the Bibliothèque Sainte-Geneviève, those of the Law Library did not support the structure. A recessed panel above the arches revealed that the masonry between the piers was nonsupporting. Following his teacher's example, Lheureux kept ornamentation to a minimum. Besides some standard carving on the imposts and other similar moldings, the most conspicuous ornaments were the arms of the city of Paris placed high on each of the corner piers.

The analytical quality of Lheureux's design matched Sullivan's new conception of an architectural composition issuing out of planning and construction. Sullivan may have thought that he was looking at a design of 1897, but the appeal of Lheureux's composition may have come not from

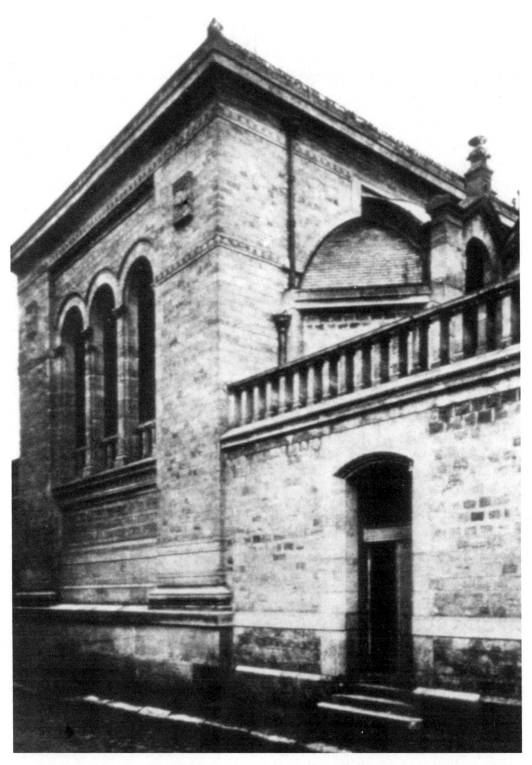

4.8 Louis-Ernest Lhereux, Law Library, Paris, 1876–78. (*Architectural Record*, July–September 1898)

its alleged modernity, but from its reflection of the lessons he had learned in Paris at the time this building was being designed.[30] From the three windows of the Law Library he may have gone to the three windows of the first design of the Owatonna bank; from the shields of each of the upper corners of the library facade, to the quasi-heraldic cast-iron ornaments on the upper corners of the Owatonna facade; and from Lheureux's structural system, to a load-bearing one. Regardless of how extensive Elmslie's collaboration on the Owatonna bank may have been, it remains Sullivan's work. By possibly transforming and fusing into his own vision elements from Lheureux and Barber, Sullivan came to synthesize a new idea for a building type.

Sullivan's new method of architecture was also similar to that of Ernest Flagg, another former student at the École des Beaux-Arts. According to Mardges Bacon, Flagg "showed respect for building process and legible parts —the very qualities inherent in the French models." Assessing the development of Flagg's commercial buildings, Bacon points out characteristics that also appear in Sullivan's banks, especially that "corners were closed and emphasized, allowing the middle to be opened up."[31] This typical French trait of considering a facade as a portal was to appear time and again in Sullivan's rural banks.

Sullivan's second bank, the People's Savings Bank in Cedar Rapids, Iowa (1910–11), is the most restrained and least lyrical in the series. It has a minimum of ornamentation and comes closest to his conception of the Prairie Style, in which the volumetric expression of the plan played an important role. The building consists of a narrow, oblong, two-story central banking room reinforced on the outside with corner pylons and surrounded by a single-story rectangle of offices, all in tapestry brick. Observing its stark appearance, Schuyler identified the main characteristics of Sullivan's new style in a passing remark that pointed out how the Cedar Rapids bank had been "clearly designed from within outward," and how "Mr. Sullivan had denied himself all the opportunities of doing what he can do so much better than any other living architect," namely creating "fantastic decoration."[32]

Personal tragedy may account partly for Sullivan's change of style. In 1909, ridden with debt, he was compelled to sell his summer cottage on Biloxi Bay, Mississippi, and forced to move his office from the Auditorium Tower to cheaper rooms below; he lost Elmslie's services, who long had worked on half-pay; filed for bankruptcy; and sold at auction his books and works of art. He retained only $100 from all this.[33] In a letter to Bennett, Sullivan complained that insomnia, poverty, worry, the auction, and the loss of Elmslie had driven him as if on a whirlwind "to the very verge of insanity or suicide, or nervous collapse."[34] Thanks to the care of a friend, Dr. George Arndt, Sullivan recuperated and declared that he was ready to start "a new life," although he was "living hand-to-mouth, on the bounty of a few warm friends who can ill afford the small advances they have made."[35] It was also in 1909 that Sullivan was first approached by the officers of the Cedar Rapids bank, to have his design rejected because it was much too expensive to

build.[36] Desperately in need of work, in 1910 Sullivan simplified his design to the point that Schuyler could characterize the final result as "a highly specialized machine."[37]

Perhaps Sullivan considered that this new style—which he developed practically out of necessity—was more in keeping with current ideas of progressive architecture, and reached new conclusions on design. The St. Paul Methodist–Episcopal Church in Cedar Rapids, and the Bennett House project in Owatonna, two of his most austere designs, followed in the wake of the Cedar Rapids bank. Sullivan's new emphasis on volume at the expense of decoration accords with his statements in *Artistic Brick*. These were not to be followed by new theoretical statements until 1918, when he revised *Kindergarten Chats* and subsequently published his *Autobiography* and *System of Architectural Ornament*. Thus, no written evidence other than *Artistic Brick* is available concerning Sullivan's ideas on design during most of his bank period. One must turn from its pages to the buildings to learn more about his intentions and preferences.

Sullivan did not maintain such a severe, stark style for long. In 1913, he had a change of heart and restored lyrical ornamentation to his esthetic. At the same time, he attempted to recapture the anthropomorphic quality of his turn-of-the-century skyscrapers, which owed so much to his conception of the Gothic as a paradigm of forces in equilibrium. At first he had difficulties recapturing the anthropomorphism of the skyscraper period because he allowed lyrical sentimentality to take the upper hand in bank design. In the Van Allen Store in Clinton, Iowa (1913–15), he applied three thin, pierlike decorations to only the facade of a corner building, giving the impression of an incomplete program (fig. 4.9). These vertical decorations were derived from the central piers of the Gage Building facade in Chicago (1898–99), but resulted in different expressions of structure and iconography from those at their source. In the Gage Building, the palmtreelike central piers responded to a need that was both physical (encasing a metallic support) and anthropomorphic (creating an upward visual thrust that contrasted with the downward visual movement of the outside piers), whereas the analagous elements in the Van Allen Store were reduced to unnecessary decorative staffs. Although the Clinton building is one of Sullivan's less inspired efforts, its historical importance is assured, for it is his first attempt to apply his skyscraper style to a small building.

Sullivan proceeded to give a new dimension to what he had previously learned from the Gothic in the Merchants' National Bank in Grinnell, Iowa (1913–14, fig. 4.10), his first load-bearing construction to show a mastery over a dynamic composition of upward-thrusting and downward-bearing forces, symbolic and real. Cautious at expressing anthropomorphism in load-bearing construction, he concentrated his dynamic effects exclusively on the ornamentation around the door and the rose window above it, creating an effect appropriate to the characteristics of terra cotta and establishing a clear distinction between construction and ornamentation. His

4.9 Louis H. Sullivan, Van Allen Store, Clinton, Iowa, 1913–15. (State Historical Society of Iowa)

new use of terra-cotta ornamentation made his small buildings rich with an anthropomorphic program that linked their aesthetic with the aesthetic of the skyscrapers, yet did no violence to their load-bearing construction. The sharply defined, boxlike shape of the banks accommodated his desire to express construction and to reveal the plan of a building in its volumetric composition. The use of tapestry brick allowed him to develop his new interest in exterior polychromy. In short, he achieved the synthesis of his mature bank style.

The facade of the Grinnell bank is masterful. For a wall of tapestry brick pierced by a door, a rose window, and two rectangular windows, Sullivan developed an extraordinary terra-cotta ornamentation. Concentric squares, diamonds (squares rotated 45 degrees), and circles surrounding the rose window seem to be supported by two piers framing the door. Outside of each pier Sullivan placed a heraldic winged lion *sejant érecte* and holding up a shield. Gothic-like finials stand atop the cornice above each pier.

The extraordinary elegance of the solution depends on Sullivan's command of geometry and proportion. What had been an approximation in

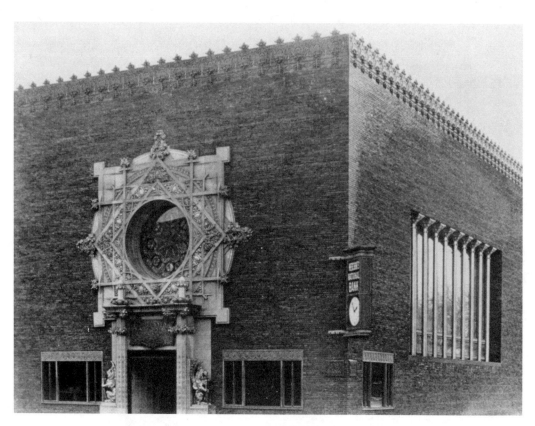

4.10 Louis H. Sullivan, Merchants' National Bank, Grinnell, Iowa, 1913–14. (Northwest Architectural Archives, University of Minnesota)

Owatonna became exact in Grinnell, where his design conforms to a modular system (fig. 4.11). Two important examples of his use of this system are the radius of the rose window (one module long), and the circles that decorate the cornice atop the building (each half a module wide). With that dimension in mind, Sullivan divided his facade into three vertical elements, three, five, and three modules wide, and into three horizontal bands each three modules high. The distance between the piers around the door is two modules, center to center. This distance matches exactly the diameter of the window above. Each side of the outer diamond around the rose window is three modules long, which is also the distance from the perimeter of the outermost terra-cotta ring to the edge of the building. The distance from the edge of the upmost square to the cornice is two modules, which is also the distance from the pavement to the rectangular window lintels. Although the pattern of circles, diamonds, and squares is concentric, its lower edge is cut off by the intrusion of the door. As a result, the ornamentation above the door can be inscribed in a five-by-four-module rectangle. It also defines an overall vertical rhythm of three, four, and two from bottom to top, whereas the rhythm from left to right is three, five, and three.

4.11 Grinnell bank. Diagram of proportions of facade.

The position of the side windows is also of interest. One may construct an isosceles triangle with 45-degree angles at the base and a 90-degree angle at the top by drawing lines from the centers of the side windows to the center of the rose window. Furthermore, the centers of the side windows are positioned at one-half the height of the cornice above the door. Thus, the base of the imaginary isosceles triangle bisects the door. The right angle of the triangle, in turn, parallels the upper corner of the diamond around the rose window; in fact, the triangle is generated from its center. With these proportions, the side windows, the rose window, and the door establish an almost magical buoyancy within the composition. The proportions of the perimeter of the building and those of the beautiful terra-cotta ornamentation harmonize with each other and with the rest of the composition in ways that, because they are geometrical, are also musical. What had been a fairly simple exercise for the Owatonna bank came to fruition in Grinnell. The side facade, a rectangle carrying a ten-light clerestory, is also modular. Its overall proportion is one to two (nine by eighteen modules), broken into a horizontal rhythm of four-ten-four and a vertical one of two-four-three.

The best proof of Sullivan's success in the Grinnell bank lies in the fact that until now no one had remarked about its geometry, in spite of how much the bank has been studied. The gorgeousness of the building

predominates the rational aspects of its design. The observer is captivated by the way in which the tapestry-brick wall becomes a subtle background for the terra-cotta ornamentation surrounding the door and the rose window, and by the chromatic contrast between one material and the other. One also notices how much of the ornamentation derives from the Gothic via the skyscrapers. This becomes evident not only in the motifs, but also in the anthropomorphic buoyancy with which the geometrical ornamentation surrounding the window seems to float above the piers and cornice surrounding the door, while, at the same time, being visually supported by them. In the Grinnell bank, furthermore, one encounters the synthesis of Sullivan's studies of Islamic architecture. One admires how beautifully he has concentrated all of the ornamentation around the entrance and window above it, like a medieval Moorish architect would have, controlling the observer's attention fully and not allowing it to wander, except to realize the harmony between what is highlighted and its background. Then, there is the final softening touch. The ornamented cornice, like those in the best Islamic buildings, somehow seems to tie everything together. It establishes a nervous skyline that echoes the vibrancy of the terra cotta below; it harmonizes in color with the tapestry brick and is therefore not overly assertive; thus, with extreme sophistication, it diffuses slightly the importance of the rose window, so that the building becomes the work of art one admires, and not only its central ornamentation.

Sullivan brought his bank style to maturity in his building for Grinnell primarily by incorporating into his method of design the anthropomorphism he had mastered in designing skyscrapers and by working out complex proportional relationships. Yet the evidence suggests that he did not immediately realize that he had found the best solution to the problem of the rural bank, for with his next such structure he experimented in a different vein. The Home Building Association Building in Newark, Ohio (1914–15, fig. 4.12) further investigates the stylistic possibilities suggested by the Van Allen Store. In the Newark bank Sullivan reinterpreted ideas from his late-nineteenth-century skyscrapers—the Gage, Bayard, and Schlesinger and Mayer buildings—on the scale of a two-story structure.

The Newark bank is different from all the others in that it is completely clad in terra cotta. On its two street facades Sullivan developed an anthropomorphic program in which the subjective and the objective struggle to become interchangeable. This bank represents a stylistic regression. It is even less successful than the Van Allen Store because Sullivan, still obsessed with the idea of a literal adaptation of his skyscraper style onto his banks (in spite of the esthetic success of Grinnell), compressed too many things into it: one of his winged lions, a mosaic (which by itself is beautiful), a terra-cotta staff that blossoms profusely in front of the mosaic for no apparent reason, decorative borders that divide the front into four rectangles, more ornamentation on the side, and all kinds of moldings. The Gage facade could not be grafted onto so small a building.

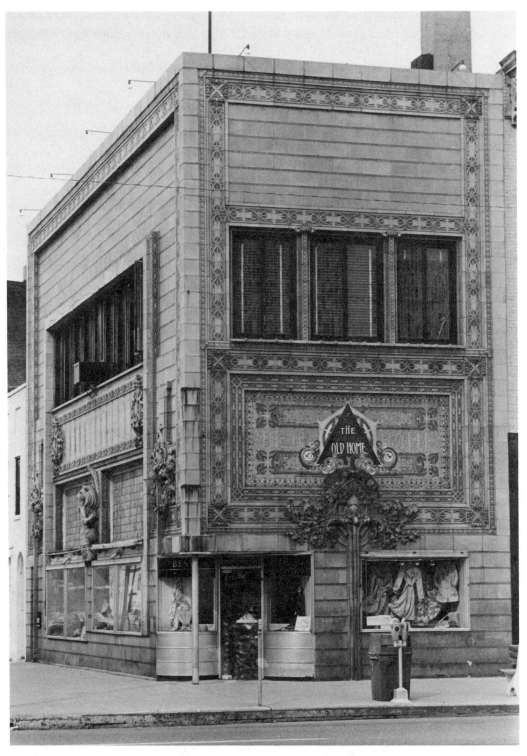

4.12 Louis H. Sullivan, Home Building Association, Newark, Ohio, 1914–15. (Licking County Historical Society, Newark)

The greenish-grey color of the Newark bank is important, however. It has a sexual signification of masculinity as opposed to the feminine creamy-white of the skyscrapers. In fact, sexual identification through color had been rooted in Sullivan's mind by the time he designed the Owatonna bank in 1906. Through color Sullivan was able to express the poetic signification of a building as much as its outward social function. Through color, the Owatonna bank evoked aspects of the midwestern landscape, and through associations with French symbolist poetry the polychromy of the building established a link with music. Just as important, its browns also expressed the idea that banking is a masculine activity.

Sullivan had expressed masculinity and femininity in design previously by associating them with abstract geometry and efflorescent ornamentation.[38] In 1897, he went further and extended anthropomorphic and gynecomorphic notions to color in the design of the Bayard Building. In a rental brochure he wrote for the Bayard he stated that it rose "creamwhite" and "maidenlike."[39] Sullivan, it would seem, applied to architecture the long-standing pictorial convention that assigned a dark hue to the male complexion and a light tone to the female: the Bayard Building was feminine because it was white. He also wrote that Richardson's Marshall Field Wholesale Store was "brown" and "virile," and characterized it as "a male comely in the nude."[40] For the Newark commission in 1912, Sullivan undertook a new experiment and changed the model of the creamy-white, gynecomorphic skyscrapers to the darker-hued, anthropomorphic terra cotta of the bank.[41]

Nevertheless, one may see the Newark bank, as well as of the other banks, in gynecomorphic terms as well. By the time Sullivan began designing banks, his ideas on the relationship of transcendentalism and architecture were set. In *Kindergarten Chats* he had stated that "The architecture we *seek* shall be as a man, active, alert, supple, strong, sane. A generative man. A man having five senses all awake; eyes that fully see, ears that are attuned to every sound; a man living in his present, knowing and feeling the vibrancy of that ever-moving movement, with heart to draw it in and mind to put it out. . . . To live, wholly to live, is the manifest consummation of existence."[42] The passage reveals much of Sullivan's thought, and eventually explains his identification of sex through color. "The vibrancy of that ever-moving movement" refers to nature's constant recreation of the universe. Sullivan had turned Herbert Spencer's mechanicist conception of the universe—where force produced motion, motion determined the diffusion of matter, and concentration of matter slowed down motion—into the awesome, transcendent rhythm all art was to echo.[43] The "heart to draw it in" refers to humanity's intuitive understanding of nature's process of creation; "the mind to put it out" alludes to the intellectual ability to express it in art. This process of "drawing in" and "putting out" is another way of saying that we are part of nature; "For all [of nature] is rhythm," as Sullivan had said earlier in "Inspiration."[44] That passage from "Inspiration" presents, perhaps more clearly than any other of his writings, Sullivan's belief that all that exists is but a

part and an expression of a primordial and all-sustaining cosmic rhythm. When humanity accepts this law, the result is "wholly to live"; the ultimate reward is a state of perpetual ecstasy.

Sullivan saw Swedenborgian sexual correspondences sustaining the cosmic rhythm. According to Swedenborg, love and wisdom are God's most important attributes. They emanate from Him and sustain the universe. He also believed that universal rationality, or wisdom, comes into harmony with the masculine principle of the cosmos, and emotion, or love, with the feminine. The physical and the spiritual were part of a transcendent totality for Swedenborg: hence, Sullivan posited that correspondences of wisdom–love, reason–emotion, and masculine–feminine existed between the two spheres of the physical and the spiritual.[45] Synthesizing Swedenborg with Spencer, Sullivan turned his work into an extension of the transcendent generative process with which nature sustained the universe. He extended Swedenborg's polarities into architecture and decoration and related them to geometric rigor and to organic abandon. The simple rectangular shape he favored for buildings expressed the inorganic through geometry, as well as the intellectuality of the masculine–rational. Ornamentation stood for the organic and for the lyricism of the feminine–emotional.

Such theories led Sullivan to pursue extreme polarities and architectural ambiguities. These were a result of his mixing ideas of Swedenborg and Spencer, and the mannerisms in design to which they led became the hallmark of his esthetic, as well as the source of much of the beauty of his architecture. Passionately, he sought to make the subjective interchangeable with the objective. The piers of the Bayard Building, for example, stand for the objective downward pressure of the weight of the structure. They also represent the upward subjective expression of the growth of a tree, the natural archetype of the pier.[46] The example of the "White City" of the Columbian Exposition also may have prompted Sullivan to pursue a sexual identification of buildings. The City Beautiful Movement gave rise to a new interest in an urban (and consequently urbane) architecture in Chicago and elsewhere. That trend may have encouraged Sullivan to soften the more virile aspects of his style, and in his typically transcendentalist manner he extended the sexual aspects of his design to cream white and terra-cotta brown.

One could argue as well that the functions of the Gage Building and the Schlesinger and Mayer Store may have been at the source of Sullivan's experiments in architectural gynecomorphism, inasmuch as he believed that a combination of light color and rich ornamentation would make a shop appeal to its female clientele.[47] Yet such argument is specious. However relevant the femininity of the function of these two buildings may have been to their gynecomorphic designs, the fact remains that they come after the Bayard Building, the first in Sullivan's gynecomorphic series, and, among the three, the one whose use would have been more readily associated with men than with women because it was an office building. Gynecomorphism at this point in Sullivan's career had, therefore, a deeper conceptual (and, for

4.13 Louis H. Sullivan, People's Savings and Loan Association, Sidney, Ohio, 1916–18. (Ohio Historical Society)

Sullivan, transcendentalist) meaning than the function of the building could dictate. Gynecomorphism was for him a step further in the architectural development of his Swedenborgian correspondence.

In the late skyscrapers Sullivan had shown the masculine and the feminine coupled, yet individually distinct. In the banks he took a further step and made them interchangeable through his use of color. The large areas of mosaic, of terra-cotta ornamentation, and of art-glass windows often gynecomorphize the brown, masculine boxiness of the buildings, themselves already softened by the polychromy of the tapestry brick. Without denying the masculinity of banking, the buildings become extensions of the ornamentation. Each bank becomes a piece of ornament by itself, a fact that was recognized very early; Sullivan's banks have always been called "jewel boxes," a term generally associated with femininity. An ambiguous interchange of opposites (masculine–feminine in this instance) was thus complete and involved whole buildings rather than only parts of them (as had been the case with the piers of the Bayard Building). In the banks, Sullivan's theory and method of design reached a climax.

In his two last executed banks Sullivan took the final, logical step beyond his achievements in Grinnell. He involved whole facades in anthropomorphic programs instead of depending exclusively on ornamentation.

The Midwest in American Architecture

Prudently, he limited himself to the tectonic possibilities of load-bearing construction. This is evident in the People's Savings and Loan Association Building in Sidney, Ohio (1916–18, fig. 4.13). There the great arch seems to carry the weight of the spandrels to nothing more substantial than a pair of windows, an imaginative exercise in ambiguity that makes ornamentation above an opening appear to support one of the most ponderous masses of the facade. The mechanical reality is different, however. At each of the lower sides of the elevation a marble base and the masonry flanking the windows rise up to receive the downward thrust of the arch. To paraphrase Sullivan's statement, "the subjective becomes the objective" and both are interchangeable in this composition, which, at the same time, calls attention to the entrance to the building, the focus of the facade.[48] To emphasize that effect, pillars flanking the door rise to support heraldic winged lions that become symbolic buttresses, propping up visually, although not supporting physically, the mosaic of the tympanum. They recall four symbols of the evangelists Victor Baltard placed against the tympanum on his church of Saint-Augustin in Paris (1860–71), a building of recent construction when Sullivan was in Paris (fig. 4.14).

The module of the Sidney bank is indicated by each of the hexagons decorating the cornice in a manner similar to that Sullivan used in Grinnell. The great arch, including the terra-cotta archivolt, is nine modules wide, and the brick at each side two and one-half. The distance from the crown of the extrados of the terra-cotta archivolt to the top of the staff decorating the cornice is five modules, and it is also five modules from the pavement to the wingtips of each lion. The distance from the center of one lion to the other is half that, two and one-half modules. Thus, on this facade, fourteen modules across and thirteen modules high, Sullivan continued the experiments in geometry that he had refined in Grinnell.

The anthropomorphic program of the Farmers and Merchants' Union Bank in Columbus, Wisconsin (1919–20, fig. 4.15) is even richer. Its success depends on its economy of means, on its good proportions, and on the dynamic qualities of its composition. The facade consists of three principal elements: a set of three piers, one huge lintel, and a tapestry-brick panel framing a telescoping arch decorated with terra-cotta archivolts. The openings—windows and door—are less important visually and read like spaces left in between these motifs. The loveliness of the facade depends in no small measure on symmetry and balance enriched by harmonious proportions between the parts. For example, the top of the lintel divides the facade in half; the radius of the arch equals one-sixth of the height of the building, and this is also the height of both the rectangular window and the marble panel of the lintel; the lintel itself may be divided into four squares; and the terra-cotta archivolt rises from the central axes of the two outer lintel squares. Thus, all the parts are proportional to each other and to the whole in a modular system.

A mannered treatment of form prepares the architectural elements for

4.14 Victor Baltard, Saint-Augustin, Paris, 1860–71. Detail of portal.

4.15 Louis H. Sullivan, Farmers and Merchants' Union Bank, Columbus, Wisconsin, 1919–20. (Jeffrey M. Dean)

their anthropomorphic roles. The thickness of the lintel is exaggerated; the relationship of the arch and the lintel is more important than that between the arch and the window; and the piers hold up the lintel at the ends, rather than at the points supporting the arch. Had Sullivan chosen to support the lintel at the springs of the arch, there would have been no need for a central pier; the door would have been on-center; the lintel could have been thinner; and the facade would have been static, academic, and banal.

Finally, there is the anthropomorphic program itself. The observer comes away with the impression that the building resulted from masses surging from below while others pressed from above. What one witnesses as architecture is the final dramatic moment of equipoise on the all-important lintel, which now justifies its thickness. One also realizes that the anthropomorphism of the Columbus bank springs from the essential tectonic characteristics of its load-bearing construction, while finding consonance with the Gothic-derived anthropomorphic and phytomorphic effects of the skyscrapers of the 1890s. Having the richest anthropomorphic program, the bank in Columbus vividly reveals Sullivan's architectural conception at the time. His French training is evident in the manner in which he used academic forms to underscore an antiacademic idea. The design epitomizes how his later banks and his later skyscrapers are like two different facets of

the same crystal, and how his concept of the Gothic, which had to do more with the behavior of form in dynamic composition than with style, is central to the relationship between the two building types.

Sullivan's architecture of 1906–22 unfolded, then, through trial and error, success and lapse, in a discrete, yet nonlineal development. He traveled a long road from the early banks, which turned away from the designs of the skyscrapers, to the later works, which were based on their lessons, and surpassed them. The 1906 commission from Owatonna opened a new chapter in his career. From memories of the Golden Door of the Transportation Building, and perhaps through his awareness of the Law Library building in Paris, he constructed in Owatonna a magnificent box that brought his architecture to a new level of kinship with music, color, and nature, just as the impressionist composers and the French symbolist poets had done. Sullivan, in the Owatonna bank, became the American architectural counterpart of Mallarmé, Rimbaud, Debussy, and above all, of Maeterlinck, whose work he greatly admired.[49]

The tour de force bore no immediate fruit. After Owatonna, Sullivan completed only two commissions between mid-1907 and May 1910, the Babson House in Riverside and the Bradley House in Madison, Wisconsin. In those designs he chose to explore the midwestern progressive style his clients expected of him in residential work. Even more important, he may have decided to use these commissions to broadcast his ability to design houses in the new style, and thus secure more work because he was in desperate need of money.[50] He reached new conclusions on design from these endeavors, and he published them in *Suggestions in Artistic Brick* while designing his most austere buildings: the Cedar Rapids Bank (1910), the St. Paul's Methodist-Episcopal Church in Cedar Rapids (1910), and the Bennett House project (1911).[51] The Purdue State Bank in West Lafayette, Indiana, designed in 1913, almost at the same time as the Grinnell bank, also falls into this category, but because it is so small and it had such a small budget, its simplicity and starkness may have been a product of financial consideration rather than an expression of esthetic desire.

Tired of an excessively severe geometry and possibly missing his characteristically luxuriant ornamentation, Sullivan designed the Land and Loan Office Building in Algona, Iowa (1913, fig. 4.16), one of his minor works. Its elevation, an adaptation of the facade of the Wainwright Tomb in three dimensions rather than two, reveals his new interest in plasticity after the austerity of his earlier work.[52] After these beginnings in using exterior ornamentation once more, he fell into the facile lyricism of the Van Allen Store and of the building in Newark, Ohio, both curiously separated in chronology by the superb design of the bank in Grinnell.

While the bank in Grinnell set the style for those in Sidney and Columbus, the Newark building, which was different from them because of its cladding of greenish-grey terra cotta, in time also found issue in the Krause Music Shop facade in Chicago (1922, fig. 4.17), Sullivan's last executed de-

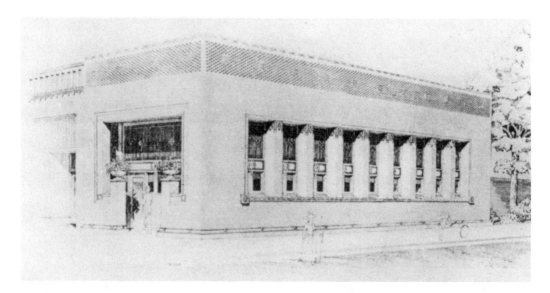

4.16 Louis H. Sullivan, Land and Loan Office, Algona, Iowa, 1913. (*Architectural Record*, May 1916)

sign for a building by William C. Presto.[53] The composition, also clad in greenish-grey terra cotta, reveals how deftly Sullivan simplified his excesses in Newark to establish a portal in ways that are proper because they create a lavish frame. Aside from these two efforts in Newark and Chicago, three among the later banks, the one in Grinnell and, above all, those in Sidney and Columbus reveal how Sullivan arrived at an extraordinary conception that owes no small debt for its success to his mastery of geometry and that becomes a synthesis of his philosophical ideas, theory of architecture, and method of design. In the banks Sullivan created a new architecture out of an amalgam. His new desire to express the plans of buildings volumetrically was part of it, as much as the lessons in anthropomorphism he had learned from the skyscrapers. His new use of color to express poetry, music, and sexual affinity, and the maturation and extension of virtually every idea he had entertained since the beginning of his career were also part of his new architecture. The process was completed when he adapted all of this to the scale, function, and method of construction of his new buildings. His method evolved laboriously as it came to include images of dark and light, of action and reaction, of the subjective and objective, of ambiguous and obvious, and of life and death. It was the portrait of a lyrically rural landscape that also expressed the awesome universality of the cosmos.

One of Sullivan's life-long interests was to master the architectural expression of Swedenborg's correspondences. His great aspiration had always been to allow the feminine element—the gorgeousness of the building— to dominate the composition completely and to conceal the masculine– rational sense of geometry that sustains it and gives it order. Likewise, the leaves and flowers of a shrub conceal the branches that give it order and

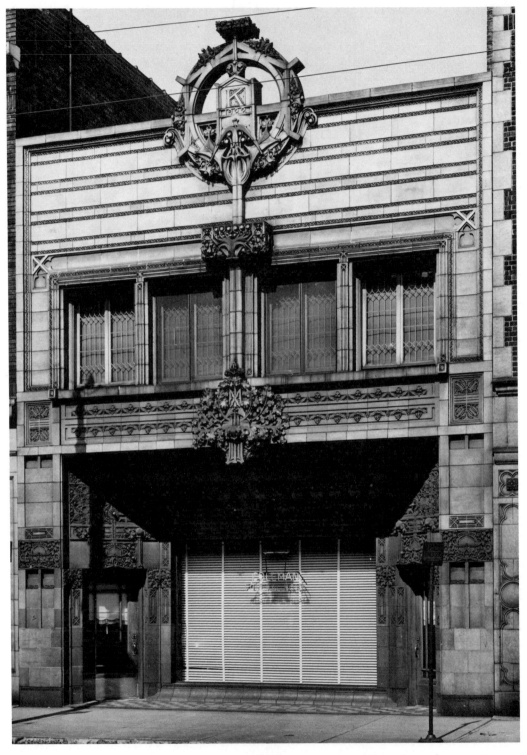

4.17 Louis H. Sullivan, facade of Krause Music Store, Chicago, 1922 (building de-
signed by William C. Presto).

rhythm. He achieved the goal first in his ornamental designs of the late 1880s, and later in his skyscraper designs of the 1890s; but in the banks, Sullivan went much further. In one of the most consciously ambiguous architectural iconographies ever devised, he forced elements of architecture to express their objectively functional character and at the same time symbolize opposing subjective meanings at a more profound level than ever before in his architecture. Because the signification of the elements of architecture in the banks shifts constantly from one meaning to another, the observer's understanding of each element alternates from the objective to the subjective, from the real to the imagined, from the ponderous to the soaring. All this, I emphasize, may be the result of analyzing only one element in a building.

The system is even richer than I have heretofore explained. On one level, ambiguities of meaning may be shifting from the objective to the subjective. At the same time, the subjective signification, within itself, may be changing meaning on another level. Such may be the case, for example, with a pier. Its meaning may fluctuate between the objective and the subjective, and it may express compression at the same time that it seems to soar. Yet, while that pier is acting simultaneously in both categories of the objective and the subjective, it may be expressing as well two other opposite subjective meanings. Its dominant color, brown, may express masculinity; the gorgeousness of the polychromy of its different hues, femininity. Making the iconographic ambiguity even richer, the browns of that pier also accord with a subjective representation of the midwestern landscape. The observer does not realize all these meanings at the same time, but one after another. Thus, appreciation of the banks becomes as rhythmic as Sullivan's adaptation of Herbert Spencer's theories. One thing becomes another to evolve into a third. Attaining such iconography was Sullivan's highest achievement. Imbedding symbol within symbol and change within change, Sullivan's banks stand for the essential rhythm that supports the cosmos; they rush toward "the mind's native land," as Mallarmé put it.

It is perhaps no coincidence that Sullivan's two last banks, in Sidney and Columbus, in which he best expressed his aesthetic conception of a bank as a building type, roughly coincide with the rewriting of the *Kindergarten Chats*, a task that required him to rethink his ideas on architecture. One endeavor reinforced the other, and after the years of search, spanning the period from Owatonna to Grinnell, he returned, renewed, to his basic concept of architecture, one that he expressed in a new style. *The Autobiography of an Idea* (1924) and *A System of Ornament According with a Philosophy of Man's Powers* (1924), which appeared after the banks, reaffirmed the implicit statements he had made through the design of his late buildings. To the last Sullivan evoked what he understood to be the rhythm of nature by using compositional contrasts of ornamentation and plasticity. His writings and his buildings are the two sides of a single coin. In both, he always returned to an ideal archetype pulsating with the tension of op-

posites, and he stood his teleological idea of architecture at the center of his work. His banks were the last and most complete expression of that vision. Far from being a sad epilogue to a once-brilliant career, they were its magnificent culmination.

N O T E S

I wish to express my warmest thanks to Steven Orso and to Robert Twombly for their generous criticism of this chapter.

1. Siegfried Giedion, *Space, Time and Architecture: The Growth of a New Tradition* (Cambridge: Harvard University Press, 1941); Nikolaus Pevsner, *Pioneers of Modern Design: From William Morris to Walter Gropius* (New York: Museum of Modern Art, 1949); and Bruno Zevi, *Storia dell'architettura moderna*, 2d ed. (Turin: Giulio Einaudi, 1953).

2. Kenneth Frampton, Foreword to Lauren S. Weingarden, *Louis H. Sullivan: The Banks* (Cambridge: MIT Press, 1987), p. viii. Studies of the banks within the context of Sullivan's life and work include Hugh Morrison, *Louis Sullivan: Prophet of Modern Architecture* (1935, repr. New York: W. W. Norton, 1962), pp. 205–27; Narciso G. Menocal, *Architecture as Nature: The Transcendentalist Idea of Louis Sullivan* (Madison: University of Wisconsin Press, 1981), pp. 128–45; Robert Twombly, *Louis Sullivan: His Life and Work* (New York: Viking, 1986), pp. 406–43; and Craig Robert Zabel, "The Prairie School Banks of Frank Lloyd Wright, Louis Sullivan, and Purcell and Elmslie," Ph.D. diss., University of Illinois at Urbana-Champaign, 1984. For works specifically on the banks, see Weingarden *Louis H. Sullivan*, and Larry Millet, *The Curve of the Arch: The Story of Louis Sullivan's Owatonna Bank* (St. Paul: Minnesota Historical Society Press, 1985).

3. John Szarkowski, *The Idea of Louis Sullivan* (Minneapolis: University of Minnesota Press, 1956).

4. Menocal, *Architecture as Nature*, pp. 45–51.

5. Louis H. Sullivan, "The Tall Office Building Artistically Considered," in Sullivan, *Kindergarten Chats and Other Writings*, ed. Isabella Athey (1947, repr. New York: Wittenborn, Schultz, 1968), p. 206.

6. Narciso G. Menocal, "The Bayard Building: French Paradox and American Synthesis," *Sites* no. 13 (1985):4–24. Sullivan often endorsed architectural anthropomorphism; for some examples, see *Kindergarten Chats*, pp. 23, 29–30, 45, 49, and 120–25. For an interpretation of Sullivan's anthropomorphism, see Menocal, *Architecture as Nature*, pp. 62–69.

7. For Sullivan's definition of the "Rhythms of Life and of Death," see *Kindergarten Chats*, p. 99.

8. Louis H. Sullivan, "The Young Man in Architecture," *Kindergarten Chats*, p. 220.

9. Louis H. Sullivan, *The Autobiography of an Idea* (New York: Press of the American Institute of Architects, 1924), pp. 313–14.

10. As did other architects. Leroy Buffington's claim to the invention of the skyscraper comes to mind. See Murial B. Branham, "How Buffington Staked His Claim," and Dimitri Tselos, "The Enigma of Buffington's Skyscraper," both in *Art Bulletin* 26 (March 1944):13–24 and 3–12, respectively.

11. Louis H. Sullivan, "The Tall Office Building Artistically Considered," *Kindergarten Chats*, p. 203.

12. Wim de Wit, "The Image of Progressive Banking," in *Louis Sullivan: The Function of Ornament*, ed. Wim de Wit (Chicago: Chicago Historical Society, 1986), pp. 159–97.

13. Louis H. Sullivan, *Suggestions in Artistic Brick* [St. Louis: Hydraulic-Press Brick Company (1910)], reprinted in *Prairie School Review* 4 (Second Quarter 1967): 24–26, the edition cited.

14. Sullivan, *Suggestions in Artistic Brick*, p. 24.

15. Ibid.; Frampton, Foreword, p. x, makes the same point. John Wellborn Root, a friend of Sullivan's, had translated Semper into English, *Inland Architect* 14 (December 1889):76–78, and 15 (February 1890):5–6. See also Donald Hoffman, *The Architecture of John Wellborn Root* (Baltimore: Johns Hopkins University Press, 1973), p. 91.

16. Sullivan, *Suggestions*, pp. 24–25.

17. Ibid., p. 24.

18. Eugene-Emmanuel Viollet-le-Duc, *Discourses on Architecture*, trans. Henry Van Brunt (Boston: James R. Osgood, 1875), p. 179.

19. For Sullivan's problems with residential floor plans, see Menocal, *Architecture as Nature*, pp. 102–27.

20. de Wit, *Louis Sullivan*, pp. 173–77.

21. I have previously advanced the explanation of Sullivan's new aesthetic that follows; Menocal, *Architecture as Nature*, pp. 128–29.

22. Ibid., p. 129.

23. For a good description of the Transportation Building, see "Colour Decoration at the Chicago Exhibition," *Builder* (London) 65 (August 26, 1893):151–52, my source for the quotation in this sentence.

24. Carl K. Bennett, "A Bank Built for Farmers: Louis Sullivan Designs a Building which Marks a New Epoch in American Architecture," *Craftsmen* 15 (November 1908):184.

25. Paul E. Sprague, "The National Farmers' Bank, Owatonna, Minnesota," *Prairie School Review* 4 (Second Quarter 1967):7–11. See also David Gebhard, "Louis Sullivan and George Grant Elmslie," *Journal of the Society of Architectural Historians* 19 (May 1960):66.

26. Montgomery Schuyler, "The New National Park Bank," *The Architectural Record* 17 (April 1905):319–28.

27. Examples are Sullivan correlating his early ornamentation to the work of French and English ornamentalists; his applying the lesson of Richardson's Marshall Field Wholesale Store to the Chicago Auditorium and to all his subsequent Richardsonian buildings; his deriving the general composition of two of his three tombs from the North African *al-qubba* type; his borrowing of Viollet-le-Duc's interior elevation of Notre-Dame and his adapting Duban and Coquart's courtyard of the Ecole des Beaux-Arts for the Transportation Building; his synthesizing the interior elevation of Notre-Dame and of the west wall of Reims into the facade of the Wainwright Building; his transforming Burnham's design of the Ashland Block into the Chicago Stock Exchange Building; his making the upper area of the bays of the Bayard Building facade dependent upon thirteenth-century English plate tracery; his designing the winged figures on the upper spandrels of that same building after those of Duban in the Salle

des Sept Cheminées at the Louvre; and his basing the final design of the Schlesinger and Mayer Store building on that of Paul Sedille's Le Printemps department store in Paris.

28. Russell Sturgis, "Good Things in Modern Architecture," *Architectural Record* 8 (July–September 1898):94–97, 100–101. Sturgis offered the Law Library as an example of his statement that "Things might be better if architects were allowed to build very plainly for awhile" (p. 93).

29. Louis Hautecoeur, *Histoire de l'architecture classique en France*, vol. 7: *La fin de l'architecture classique: 1848–1900* (Paris: Picard, 1957), pp. 108–9, 346, 348, 378.

30. Sullivan had been in Paris during the academic year 1874–75; construction of the Law Library began in 1876.

31. Mardges Bacon, *Ernest Flagg: Beaux-Arts Architect and Urban Reformer* (Cambridge: MIT Press, 1986), pp. 172–73.

32. Montgomery Schuyler, "The People's Savings Bank of Cedar Rapids, Iowa," *Architectural Record* 31 (January 1912):48.

33. Twombly, *Louis Sullivan*, p. 407.

34. Ibid.

35. Ibid., p. 408.

36. Ibid., p. 409.

37. Schuyler, "People's Savings Bank," p. 54.

38. Menocal, *Architecture as Nature*, pp. 17–31.

39. Louis H. Sullivan, *The Bayard Building*, real estate brochure (New York: Rost Printing and Publishing Company, n.d. [1898 or 1899]), n.p. I have located only one copy of this work, at the Avery Library, Columbia University.

40. Sullivan, *Kindergarten Chats*, pp. 29, 30, 187.

41. Weingarden, *Louis H. Sullivan*, pp. 98–99, proposes that the color of the Newark bank is Sullivan's response to the Second Empire-style Licking County Court House on the Newark Square. This interpretation is surprising inasmuch as Sullivan was no "contextualist." His buildings always assert themselves individually, different from the rest. For example, the Transportation Building at the World's Columbian Exposition is the textbook example of that attitude in design. Other examples would be the Auditorium Building, the Wainwright Building, the Guaranty Building, the Gage Facade, the Bayard Building, the Schlesinger and Mayer Store, and the other seven banks he built.

42. Sullivan, "Kindergarten Chats," p. 49.

43. Herbert Spencer, *First Principles of a New System of Philosophy*, 2d ed. (New York: Appleton, 1872), pp. 538–59. Sullivan began reading Spencer while he was quite young; see Sherman Paul, *Louis Sullivan: An Architect in American Thought* (Englewood Cliffs: Prentice-Hall, 1962), p. 18.

44. Louis H. Sullivan, "Essay on Inspiration," in Menocal, *Architecture as Nature*, p. 166.

45. Among Swedenborg's writings, see especially Emanuel Swedenborg, *Angelic Wisdom: Concerning the Divine Love and the Divine Wisdom* (New York: American Swedenborg Printing and Publishing Society, 1875), pars. 1–60; and *Marriage and the Sexes in Both Worlds: From the Writings of Emanuel Swedenborg*, ed. B. F. Barrett, vol. 9 of the Swedenborg Library (Philadelphia: Claxton, 1881), pp. 61–63.

46. For the transcendentalist connotations of the design of the Bayard Building, see Menocal, *Bayard Building*, pp. 4–24.

47. Morrison, *Louis Sullivan*, p. 201.

48. For Sullivan's belief that the subjective and the objective naturally transform themselves into one another, see *Kindergarten Chats*, p. 99.

49. Menocal, *Architecture as Nature*, p. 128.

50. For the basic literature on the Bradley and Babson houses, see ibid., pp. 216–17.

51. For the basic literature on these buildings, see ibid., pp. 213, 217.

52. For the basic literature on the Algona Land and Loan Office Building, see ibid., p. 213.

53. For the basic literature on the Krause Music Shop, see ibid., p. 214.

5

BAY VIEW, MICHIGAN: CAMP MEETING AND CHAUTAUQUA

ELLEN WEISS

Although the desire to acquire the good things of this world is
the dominant passion among Americans, there are momentary
respites when their souls seem suddenly to break the restrain-
ing bonds of matter and rush impetuously heavenward. . . .
Once they have broken through these limits, their minds do
not know where to settle down, and they often rush without
stopping far beyond the bounds of common sense.
> —Alexis de Tocqueville,
> *Democracy in America* (1831)

Many men who knew riches were there for the earning be-
lieved also that man and society were infinitely perfectible. The
American myth, even when it is materialistic, is idealistic.
> —Elinor Rice Hays,
> *Morning Star: A Biography of*
> *Lucy Stone* (1961)

Elinor Hays delineated "the great American conflict, sharper than
it is today, though it still exists" while writing about the mid-
nineteenth-century reformer Henry Blackwell, husband of Lucy
Stone. Tocqueville wondered about the peculiarly American phenomenon of
mass enthusiastic religion and its camp-meeting manifestation.[1] He under-
stood our "fierce spirituality" to be a reaction against intense materialism,
the obsession with wealth and comfort, which in turn was a reaction against
frontier privations. Both keen observers, Tocqueville and Hays saw a conflict
between the possibilities of great wealth and those of human perfection,
between luxury and spirituality, between individual success and social re-

sponsibility as the nation's dilemma, if viewed from Tocqueville's European vantage, or the era's, if from Hays's modern perspective. The views dovetail. The tensions Tocqueville and Hays describe cut a broad swath, leaving in its wake a variety of monuments of resolution including those peculiarly American communities, camp meetings/chautauquas/resorts. These were poignant semicollectives in which participants forged temporary transformational societies fueled by religious and intellectual forces let loose in the wilds of a nurturing, reflective nature. On a materialistic level, they were crafted out of new, second-home wealth. This chapter will examine one of the best of those special communities, which still dot the American landscape, Bay View, Michigan.[2]

Founded as a camp-meeting resort in 1876 and amended into a cultural assembly, or "independent chautauqua," a decade later, Bay View was neither the first nor the largest of its kind in the Midwest. Des Plaines, Illinois, is sixteen years older. Lakeside, Ohio, three years Bay View's senior, has almost twice the number of cottages, albeit smaller ones on smaller lots. Information about the landscapes of American camp meetings and independent chautauquas, the latter often evolving from the former, is uncollected and understudied. The following list of midwestern sites, culled from a variety of sources, is partial and meant only to suggest the field's richness: in Ohio: Sabina, Epworth Park, Lancaster, and Lakeside; in Indiana: Acton Park, Winona Lake, and Remington; in Illinois: Franklin Grove, Chautauqua, Lake Bluff, and Des Plaines; in Wisconsin: Monona Lake Association (boyhood home of Arthur E. Bestor, 1879–1944 historian of American utopias and chautauqua president, 1915–44); and in Iowa, Clear Lake. In this context, as well as that of the first great Victorian camp meeting, Martha's Vineyard, and the original chautauqua at Chautauqua, New York, Bay View seems to be the most fortunate of all in setting, design, and state of preservation.

Bay View occupies 326 acres, about half of which are undeveloped woods and half, the northern part, are platted and occupied.[3] It is located just east of the small city of Petoskey on the Lake Michigan side of Michigan's Lower Peninsula, thirty-seven miles below the Straits of Mackinac on a dramatic site of terraces stepping from two hundred feet down to Little Traverse Bay. The developed area's streets are arranged in a romantic plan, curving among the trees, along the terraces, enclosing parks, and binding these elements together with 439 cottages and 25 public buildings. Most of the cottages were built before 1914 and, in their exceptionally well-preserved state, constitute a remarkable collection of Victoriana. The community buildings, grouped together, include a Beaux-Arts auditorium and some Queen Anne structures that house a variety of educational, recreational, and religious activities, including a substantial music conservatory. The governing Bay View Association's bylaws prohibit winter cottage use because the community cannot provide essential services. This restriction has had the fortunate side effect of protecting the original building fabric from the material compromises of winterization. Bylaws also include controls similar to those

of locally mandated historic districts. All changes require permission from an architecture committee charged with enhancing historic character, and the ground supervisor must approve tree removal. The result is an extraordinarily attractive community that is a landmark of American residential architecture and planning.[4]

In the early nineteenth century, camp meetings spread into all parts of the country via Methodist circuit riders, who held small woodland revivals on temporary-lease sites. Rather than fading as the institutions of a settled society appeared, regional Methodist leadership typically appointed independent associations to purchase and found grand, permanent sites to serve the large population brought in by rail from surrounding cities and country. Thus Des Plaines, established in 1860 near Chicago, could draw a Sunday audience of twenty thousand in its first year. Des Plaines in 1860 was a great meeting of the "old style." Bishop Matthew Simpson of Garrett Biblical Institute "drove on in a chariot of great thoughts" for two hours while a hundred ministers wept.[5] A "Flying Artillery" of Garrett ministerial students nurtured the penitents, on their knees in the straw-filled altar, toward conversion. At night, thousands bedded down where they could—in the straw under the mourners' benches, under wagons, or in tents. The young Frances Willard was among them. The Reverend B. T. Vincent conducted a memorable children's meeting that everyone watched, and later did the same at other camp meetings throughout the Midwest. Vincent would aid the midwestern extension of his brother John Heyl Vincent's New York chautauqua by instituting Sunday school teachers' education programs and, eventually, adult education programs at camp meetings in his midwestern bailiwick. In 1860 John Heyl Vincent (1832–1920) was Ulysses S. Grant's pastor at Galena, Illinois. Four years later, he was in Chicago reforming the practice of Methodist Sunday school teaching from drill memorization into a more creative process which would allow the young of the denomination to absorb the new scientific and historical learning and thus help Methodism become a modern, liberal religion. Because of his work in Illinois, he was called to New York in 1866 and eight years later founded the first chautauqua.

Michigan Methodists had thought about a permanent camp meeting for at least six years following the Civil War, with various sites considered. In August 1875, Samuel O. Knapp, a Jackson businessman, approached the Grand Rapids and Indiana Railroad about a location just east of Petoskey, a lumbering outpost of 1,200, 250 miles into what others would call a "fearful wilderness."[6] In the summer of 1874, Knapp and his invalid wife found a fall of terraces that curved in on themselves to form a natural amphitheater. Knapp, generally credited with Bay View's foundation and success, presumably devised the scheme in which the railroad was to collect his chosen acres from their many owners, including Indians who had acquired the land by treaty only twenty years before. The railroad was also to persuade Petoskey citizens to fund the $3,000 purchase. The railroad would sign a warranty deed to the Michigan Camp Ground Association, which would have full

ownership of the property in fifteen years provided it improved the grounds to the cost of $10,000 within the first five years and held a camp meeting each year for the full fifteen. The willingness of the railroad and the town to enter into this complex arrangement, doing all of the Methodists' legwork and financing, is a testament to the perceived value of a camp meeting and resort to a region's development.

Much of Knapp's vision is preserved in a letter of August 1, 1875, from his pastor, the Reverend J. H. McCarty, to D. Darwin Hughes, a lawyer representing the railroad. The letter formalized ideas that Knapp had just presented to Hughes in person. After referring to Hughes's awareness of the great revival resorts in the East, Martha's Vineyard and Ocean Grove, McCarty argued that because Michigan Methodism had four hundred ministers and sixty thousand members it too could support a permanent camp meeting with recreation and devotion combined. "It would be in the west what Martha's Vineyard was to the east. . . . The proposition is to fit up the grounds with great care, to encourage the erection of permanent cottages where families may spend the hot season in whole or in part, the same as at Martha's Vineyard."[7] Knapp argued for the west side of the Michigan peninsula, as opposed to the east, for the fresh western breeze from the lake and for easy travel from Chicago and Milwaukee. Thus he envisaged a regional operation from the first. The proposed campground would, McCarty continued, bring great profits to the railroad, increasing from year to year. McCarty asked Hughes to put this proposal to the company officers soon so that McCarty could present their anticipated proposition to his ministerial colleagues at their annual conference in early September.

The ministerial conference appointed a joint committee of eight (six ministers and two laymen—Knapp and a banker) that met in November in Jackson. The Reverend Seth Reed, who had been active in the Vineyard meeting during the crucial decade of its institutionalization in the 1860s, was secretary. Out of the November meeting came a corporation, the Michigan Camp Ground Association of the Methodist Episcopal Church, which was to erect buildings and improve its land, as well as hold camp meetings and "moral and religious services" and gatherings for "scientific and intellectual culture." A board of trustees was appointed: seven ministers plus Knapp and the banker. The committee also chose officers and six standing committees: ways and means, claims and accounts, titles and ornamentation, health and order, arrangement and worship, and transportation. In January 1876, the trustees chose Knapp's Petoskey site over four others which they had visited and over several others which they had not. One location had sent a representative to argue its case. The trustees met on the Petoskey grounds in May and instructed the Committee on Titles and Ornamentation to clear and plat the land.

The Committee on Titles and Ornamentation—the Reverend William H. Brockway, the Reverend Silas Heyler, and Knapp—set onto the terraces east of Petoskey the first and only camp meeting-resort founded with a romantic

plan, one in which consciously curving and countercurving streets worked with the topography for an artistically rendered, picturesque abstraction of nature as an antithesis to the usual urban grid. Knapp's biographers credit his taste and artistic skill for the quality of the new community, an acceptable attribution because Knapp had the deepest experience of the site, and as well, a varied professional background that provided access to new ideas. He was a man with wide-ranging interests, the kind of person likely to embrace advanced notions. Apprenticed at age ten in a Vermont woolen mill, he came to Michigan in 1844 at age twenty-eight to start a woolen factory in the state prison at Jackson.[8] Shortly thereafter, Knapp went into surveying and mining in the Upper Peninsula. As an agent of the Minnesota Mining Company, he reported on the geology and topography of the region and found important copper deposits. Contemporaries admired his discoveries and studies of prehistoric mining artifacts. In 1851 Knapp sold his mining interests and returned to Jackson to go into a nursery business, real estate, and various civic enterprises including being trustee of the Jackson cemetery, "a park for the living as well as a resting place for the dead." "There are few places more beautiful, anywhere. . . . Its charming undulations and quiet dells; its winding carriage ways, and shadowy paths; its beauty of sward and flower and tree; the care given to its low, still tents whose curtains never outward swing. . . . The cypress and willow, the parterre and terrace, the hill and dale,—all [are] arranged by the hand of nature, and that of the child of art, with a peculiar harmony."[9] These are the aesthetics of a romantic sensibility at work in nature and a vision of what would be forged at Bay View. Knapp was also chair of the building committee for the Jackson Methodist Church (1865–70), a large brick Gothic Revival building that brought a picturesque monumentality to the town. Between church, cemetery, and the camp meeting to come, it is tempting to view Knapp as a man who knew how to resolve through aesthetic action in a romantic vein the dilemma Hays and Tocqueville described about the material versus the spiritual.

Two original inked drawings of the plan of Bay View are in the association archives; the second is signed by the surveyor, John Keep, of Petoskey, and by the Reverend W. H. Shier for the trustees (fig. 5.1).[10] The plan represents more than half of the 326-acre purchase, the rest of the land to the south remaining in wooded reserve. The design shows an amateur hand, if compared with Olmsted's Riverside of seven years earlier, although its style is not unlike that of the early professional landscape architect Robert Morris Copeland as seen at Oak Bluffs, Massachusetts, a resort next to and in imitation of the Martha's Vineyard camp meeting.[11] Connections to the Vineyard must be assumed in design as well as institutional terms. As early as 1869, the Reverend William Perrine of Albion College, near Jackson, was collecting information about the famous island campground to take back to Michigan.[12] Copies of Copeland's Oak Bluffs plan, located next to the revival, were given to anyone who asked. The web of associations in romantic planning is richer than those of cemeteries alone; it reaches into the con-

5.1 Plan of Bay View, 1876, attributed to S. O. Knapp. (Bay View Archives: John Keep, Surveyor)

fusing tangle of paths at the Vineyard campground (those the accidental result of an additive geometry) to Oak Bluffs, the schooled exercise by an experienced cemetery designer. Ideas may or may not have come from the new commuter suburbs, too. Bay View can be explained without them as a combination of the two parts of the Vineyard model—camp meeting as well as planned speculative resort—telescoped into one production with luxury in space and housing as an improvement on the original.

The plan of Bay View, unlike that of Oak Bluffs, works better in three dimensions than two. The site is rugged, and the curving roads, seeming arbitrary on paper, are adapted to the topography (fig. 5.2); the grid to the northeast registers a flatter zone. The main entry from the northwest, the road from Petoskey with the railroad depot nearby, curves upward with a clear view on the right of a row of substantial Victorian cottages on fifty-foot lots along a terrace, a row that announces the Bay View theme. The houses sit in even setbacks, without fences and imbedded in greenery. The generous lot size alone—fifty by a hundred feet—along with the size of the cottages shows the luxurious cast of the founders' vision. Lot size is not only twice that of property in Lakeside, Ohio, which has double the number of cottages on the same amount of land, but it is also larger than lots in Oak Bluffs, which are thirty to thirty-five feet wide and fifty feet deep.[13]

Once past the first row of cottages, the visitor enters a flat zone with a powerful sense of interior: Fairview Park is about 750 feet long and defined by two crescent streets of cottages. The southern arc of houses, Fairview Ave-

5.2 Street in Bay View. (G. Randall Goss)

5.3 Row of cottages on Encampment Avenue. (G. Randall Goss)

nue, is backed by a ridge; the next terrace is crowned by sinuous Glendale Avenue and its bordering cottages. The northern Glendale row overlooks the row on Fairview Avenue below. In other words, the back lot lines in the block defined by Fairview and Glendale indicate such dramatic level change that the lots on each side are independent of each other, the higher southern line of cottages have a view over all to the bay, the lower northern line have a view into the park. This is the planning strategy: a communal sense created by the close line of houses marching along the street but sharp grade changes, often of twenty feet between each line, for privacy and views (fig. 5.3). Each terrace rises a step above the bay to become a platform for two rows of cottages separated by a street. Cottages look onto streets (fig. 5.4); cottages back onto streets but face out toward the bay; and cottages face into parks. These sitings, plus the grid in a low-lying area, perhaps left from an earlier attempt at platting, make Bay View interesting and varied.[14] Transitions from one street to another are curved, and planted islands at some intersections cut down on paving and give ceremony to daily activity. Sidewalks are placed in easy variance to the street, with the green space between sidewalk and street changing width or, occasionally, diverg-

5.4 Cottage facing Woodland Avenue and Little Traverse Bay. (G. Randall Goss)

ing completely from the street to slice through a small park. But sidewalks are later (1920s and 1930s) improvements of the original plan.

Hidden behind the trees of Fairview Park is Tabernacle Park, about twice the size of the first, which slopes up or south to a higher semicircular edge, a natural amphitheater. In its grove of beeches, it was the spiritual center of the Petoskey camp meeting, the original sanctified preaching space. The first preachers' stand of 1876–77 remains (fig. 5.5), an elegant office for ministers, with the platform in front and "bell cast" or "catslide" eaves supported by graceful countercurving brackets. Sheathing is vertical board and batten. The Downing imperative of this rustic mode set among the beeches shows a stylistic awareness similar to that of the plan of the grounds—a conscious artistic edge that both abstracts and enhances nature for feeling and psychic release.

The first Petoskey camp meeting, in August 1876, was an uncomfortable affair by post-Civil War standards but very much in keeping with the primitive simplicity and emotional power of the prewar revivals. Even as Bay View was being planned as the most generous of the new revival-resorts, Methodism was spreading frontier-style in the surrounding region via circuit riders,

5.5 B. F. Darling, builder, preachers' stand, 1876–77. (G. Randall Goss)

small class meetings, and a struggling young church nearby. The simultaneity of primitive frontier conditions and High Victorian vision is ironic. Seth Reed and his colleagues found ground-platting hard because of the dense undergrowth. Burning helped but left the ground sooty as well as stubbly from cutting. Carpenters set plank seating on a variety of improvised supports and built a section of the preaching stand. Two simple buildings were put up for lodging and meals. Most of the five or six hundred participants slept in tents or under wagons on shavings and hemlock boughs.

The meeting itself was in the "old style," forceful, earnest, and emotional. Dr. E. H. Pilcher, president of the association, led the dedication of the grounds, while a structure of prayers, sermons, and hymn-singing filled the succeeding week, dawn to dusk. The goal was conversion or, for those already in the faith, Christian perfection or holiness, a state of sinlessness much pursued in the mid-nineteenth century. The effect of the meeting was especially memorable at night.

> I shall never forget . . . the evening service at the first camp meeting. The scene was worthy of an artist. Torches lighted up the earnest faces of the crowd around the speakers' stand; beyond stood a circle of Indians like bronze statues against a background of gleaming white tents. The sighing of the wind through the giant trees of the

The Midwest in American Architecture

impenetrable forest about us, the sound of the waves on the shore, the fervent responses, the weeping of penitents, made a thrilling accompaniment to the solemn words of the preacher.[15]

The mix of deep emotional and religious experience with the raw sounds of nature and the eerie effects from flickering firelight was the core of most pre-war camp meeting memories. But this primitive simplicity had to change, for the meeting had only five years to propel frontier conditions into full Victorian flower in order to meet the warranty deed's $10,000 improvement challenge.

The trustees made a concerted effort for 1877, printing ten thousand circulars praising Petoskey's fresh air and pure spring waters, a two-story hotel was planned, and an interdenominational Sunday school congress was set for the week before the revival—another draw as well as an important religious goal. The trustees also chose the name "Bay View" for the Petoskey grounds, a name suggested by Reed, who knew about water-side attractions from his Martha's Vineyard experience.[16] In August 1876, so few people had leased lots that they could meet and sit on one log. That September, eight founders agreed in writing to build cottages, costing at least $100, by the following July. A row of five were completed on prime lots with a clear water view along the terrace above Woodland Avenue. Twenty cottages were in place by the end of the 1877 season. The next year's circular continued the push: a plan of the grounds, special railroad rates, fishing, hunting, nearby points of interest, and praise for the ambience of the "summer city" with its fresh air to keep away mosquitoes and hay fever. A five-year lease cost $2–5, depending on location, and cottages could be built cheaply and easily because of local lumber and carpenters. Knapp and Ralph Connable, a new member of the Committee on Titles and Ornamentation, would advise on cottage building.[17] By 1878, the "summer city" had thirty-five cottages, and the *Petoskey City Record* was reporting on its development.[18] An ice house and a dock were underway. Connable improved one of the blocks, clearing the balsam groves, digging out stumps, bringing in dirt, and grading and seeding the surface. His new lawns would be a "credit to old villages," better than the existing sand although the children might not think so. Connable also surrounded the block with a rustic fence of interlocking, twisted cedar boughs. Another improved block, which by autumn had one resident from Jackson and three from Detroit, had a sidewalk as well as a fence. Block identity was often expressed by these unifying rustic fences, perhaps all due to Connable's eye and hand. He found and presented to the association the much-loved "rustic pulpit"—a mass of interlocking birch and hemlock roots with four trunks rising up from the picturesque tangle to support a lectern, a lamp-holder, and two plant stands. Nature was codified in a "gnarled-limb" style just at the time the truly primitive grounds were giving way to a civilized rendition of rural domesticity.

From the start, with the preachers' stand and with the first cottages, Bay View's good fortune was assured by an architectural style that provided

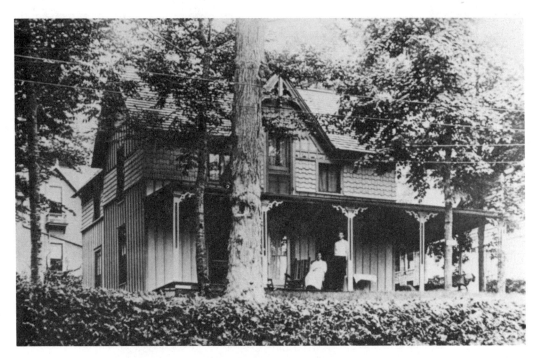

5.6 B. F. Darling, builder, Reverend W. H. Shier cottage, 1876–77. (G. Randall Goss)

just the right tone of civilized rural domesticity. Benjamin F. Darling, the carpenter-builder who built the first cottage and a hundred more after that, deserves the credit.[19] Born in 1836 in a Jackson log cabin as one of eleven children of a mill and dam builder who had come from New York only two years before, Darling was a rarity among Bay View founders because of his midwestern birth. Most founders, like Knapp, migrated from New England or New York. Darling's commitment was professional, not personal; he lived in Petoskey, and later on Mackinac Island, where he also built, and was a Free Will Baptist not a Methodist. His winter home in Jackson was much admired. Darling's first cottages show that he possessed a sensitive eye and a delicacy of touch, and had done some thinking about rural house types. The Reverend William H. Shier cottage (fig. 5.6), still in the Shier family, is a board-and-batten, flank-gable, rectangular-plan house with an emblematic front gable. Delicate posts support the roof of the wraparound porch. Next door was the Reverend Seth Reed's house, which had a picturesque L-plan. Today, a glazed sun porch trades historic character for undoubted amenity. The Reverend William H. Brockway's cottage (fig. 5.7), at the end of the row, but actually facing onto Fairview Park, is in superb historical condition. It is a hipped-roof building that is almost square in plan, with board-and-batten siding and a wraparound porch. Brockway, a member of the Committee on Titles and Ornamentation, was a Vermont and New York blacksmith who spent twenty-five years as a Methodist circuit rider in the Michigan wilds before engaging in mineral speculation, real estate, and railroad building,

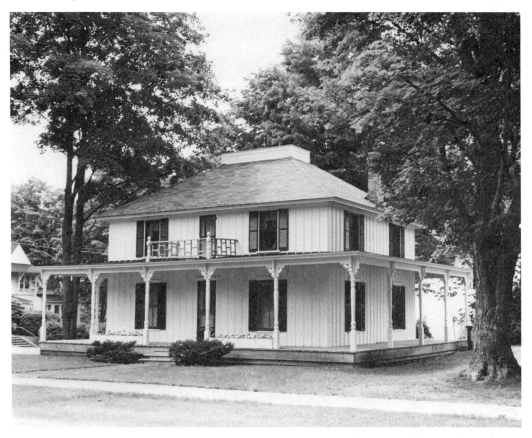

5.7 B. F. Darling, builder, Reverend W. H. Brockway cottage, ca.1879. (G. Randall Goss)

and becoming treasurer of Albion College.[20] These three houses, each with different plans and roofs but similar in their board-and-batten cladding and in lightness of touch, suggest that Darling was rendering a catalog of rural house types in a sensitively reduced scale.

We do not now know which of the other four hundred or so existing Victorian cottages in Bay View are the rest of Darling's hundred. Surely other hands were at work producing clever "house" variations peculiar to Bay View such as the variation on the typical campground cottage. Invented on Martha's Vineyard, propagated by stereopticon photographs, and imitated at camp-meeting grounds from Wesleyan Grove, Maine, to Ocean Grove, New Jersey, Lakeside, Ohio, and Pacific Grove, California, the Martha's Vineyard campground cottage is a one-and-a-half story end-gable structure with central double door, a lancet window on each side, and a projecting balcony above served by a second double door in the gable (fig. 5.8).[21] Vineyard cottages had pointed- or round-arched tops for doors and windows, Gothic or Romanesque imagery derived from New England Methodist churches.

While Lakeside's cottages retain these churchly motifs, Bay View's do

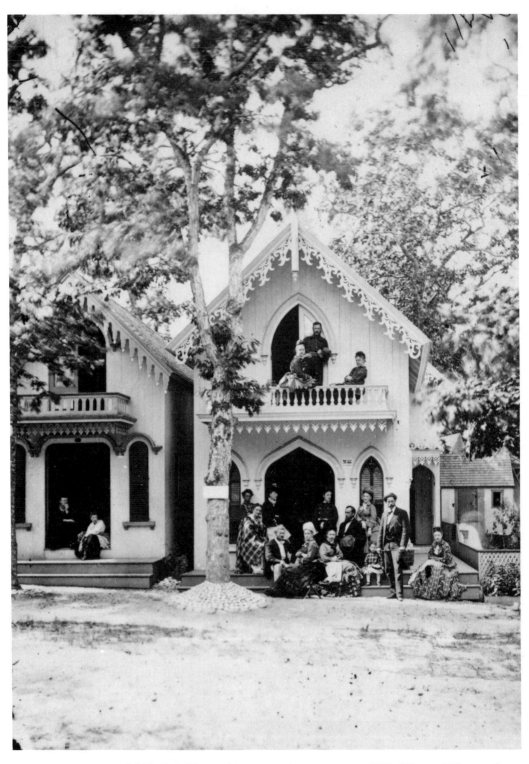

5.8 Martha's Vineyard camp meeting cottages, ca.1870. (Vineyard Vignettes)

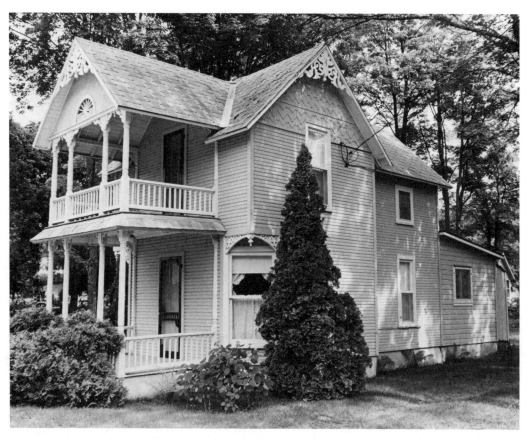

5.9 "Alridon," ca.1889. (G. Randall Goss)

not, using instead straight lintels and integrating the end-gable form with some motifs that are Bay View's own such as a two-story roofed porch, found elsewhere but used in Bay View with a consistency that suggests a colony theme. Another feature is a canting or chamfering of the front corners of the cottage block, with the resulting diagonal wall largely filled with plate-glass windows. "Alridon" (fig. 5.9) is a good example even through the main block is flank-gable, rather than end-gable, the intersection with the porch giving the building a crisp geometric presence. The theme has simpler variants, for example, one with the roof of the plain-end gable building continuing over the two-story porch, but these, too, have the Bay View canting of the ground-floor corners. Another Vineyard cottage variant is the T-plan cottage with the stem projecting as the facade. The board-and-batten version at 204 Fairview has a scalloped vergeboard of similar motif to Vineyard designs. The Queen Anne cottage at 409 Fairview (fig. 5.10) is an enriched campground cottage with an added Oak Bluffs theme—a two-story octagonal tower dramatically suspended over the void of the veranda.

Bay View's Victorian cottage will repay a close study of typologies,

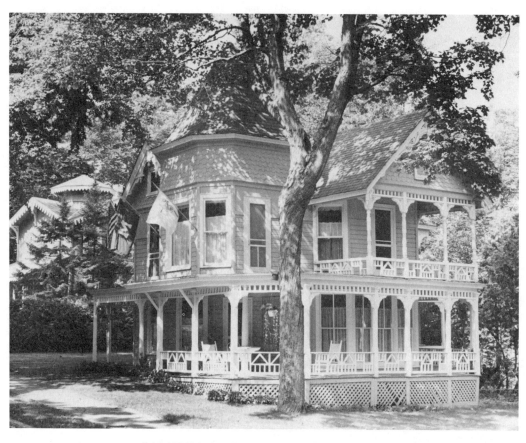

5.10 409 Fairview Avenue, "Pink Cottage" behind. (G. Randall Goss)

of individual builder's styles, and of unique building forms. The formula of "Alridon," with the axis of a flank-gable crossing that of the projecting two-story porch, plus the canted window corners, was used extensively but almost always in shiplap siding, as opposed to Darling's early board and battens. Many of this group—if indeed they owe to one builder—have wide, horizontally massed main blocks integrated with projecting two-story porches and, almost always, canted ground-story corners. "Parsons" (fig. 5.11), high on the hill off Knapp Avenue—the cheaper, lease-hold "preachers' row" in back—has porches wrapping the cottage and complex folding roofs joining porch and main block. Virtuoso shiplap boarding, in which a variety of board profiles were laid in a variety of angles, is played off against spindles, brackets, fretwork, and shingles and in a display of carpenter creativity, a Michigan equivalent of Cape May gingerbread or even Newport interior paneling. Thus, simple flank-gable cottages could, and did, become memorable. One has horizontally laid boards below sill level, diagonals in reverse directions between ground-floor windows, vertical boards above the windows, horizontal boards on the second story, and juxtaposed diagonals, or herringbone, in the gable. "Moon Cottage" (figs. 5.12, 5.13)

The Midwest in American Architecture

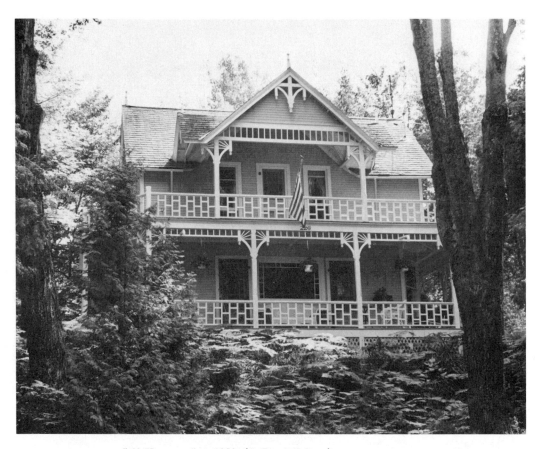

5.11 "Parsons," ca.1889. (G. Randall Goss)

on founders' row above Woodland Avenue sports flush board siding, simple shiplap, and the full array of vertical, horizontal, and diagonal possibilities in three different boarding profiles; the profiles are combinations of concave and convex curves worked against flat stretches and against concave and convex V's. Moon Cottage's other woodworking devices—sunbursts are only one—defy description.

Many remarkable individual cottages are in Bay View. One, for example, is an octagon; another has a frontal screen in Moorish arched latticework. Several have layers of fretwork and spindled screens. A well-placed Victorian star has flush board siding, decorative vergeboard in four gables, window surrounds like applique from a pattern book, and an octagonal turret with decorative boarding. There are also a dozen or so early twentieth-century houses of considerable craft, nicely proportioned shingle and clapboard bungalows with gambrel, gable, and bell cast roofs. Porches cut into the building volume are articulated with Tuscan columns, and other Colonial Revival details abound. These cottages show the hand of Lansing and Harbor Springs architect Earl Mead and are distinguished designs, even though unlike the earlier Victorian vision around them.

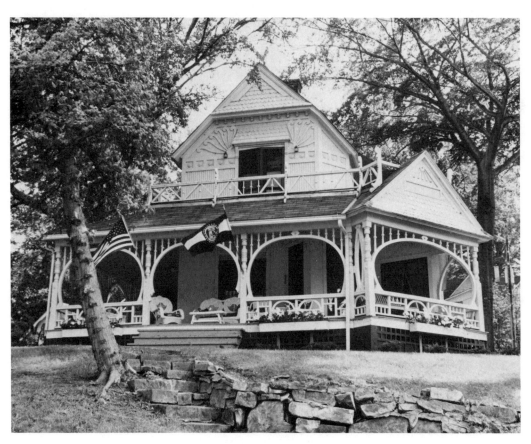

5.12 "Moon Cottage," ca.1877. (G. Randall Goss)

The Michigan Camp Ground Association's November 1875 articles of incorporation show one significant difference from the Martha's Vineyard model: the association was to hold religious meetings and also meetings devoted to "scientific and intellectual culture." While this phrase could reflect the transformation then underway at Fair Point camp meeting at Lake Chautauqua, New York, it is more likely to mark the Chicago-centered movement, from which chautauqua itself sprang, to liberalize religious teachings to incorporate modern learning, a reform of the old "fire and brimstone" revivalism with its perfectionist or holiness goals. Lewis Miller (1829–99), manufacturer, philanthropist and friend of Vincent's, was thinking this out at the Ohio State Camp Meeting for Holiness in 1872. John Heyl Vincent worked with progressive educators at the University of Chicago who wanted to broaden and raise the intellectual level of Protestantism, or, in Rexford Guy Tugwell's phrase, to "fertilize the cultural ground."[22] Sunday school teacher education was the forum in which the new biblical scholarship, as well as history, literature, biology, astronomy, and geology were to be shown as revealing God's immanence.

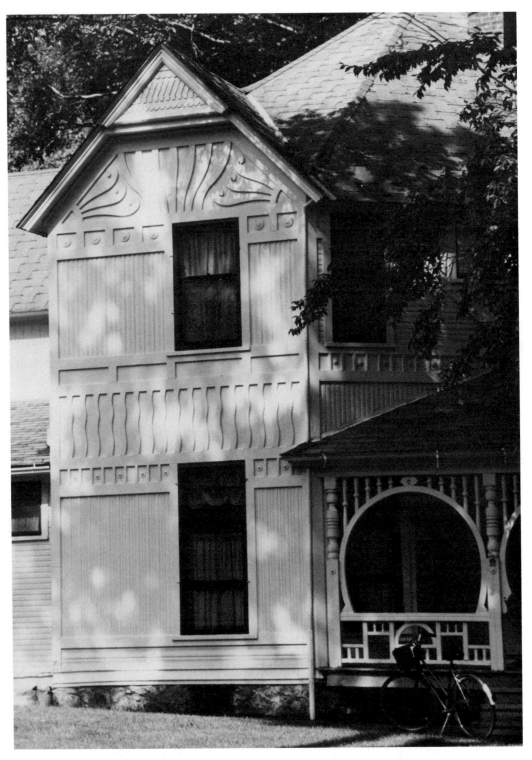

5.13 "Moon Cottage," side view. (G. Randall Goss)

In 1874, Fair Point held its first two-week Sunday school teachers' assembly. By 1875, the assembly was on its way, with Frances Willard, a youth at Des Plaines and by 1875 one of the great orators of her time, on the platform. In 1877, the state legislature changed the name "Fair Point" to "Chautauqua," obliterating embarrassing camp-meeting roots and endowing the site with its own memorable name. Vincent's special contribution was the Chautauqua Literary and Scientific Circle (CLSC), a college-level correspondence school, founded in 1878, which offered reading lists, a magazine, examinations, discussion groups or reading circles, and graduations—higher education for adults who did not have the opportunity to study when they were young.[23] Vincent believed that life-long intellectual work was necessary for full personal and spiritual development. In order to spin the CLSC system into productive enthusiasm, he weighted his college-in-the-home, the field, and the shop with a battery of institutional symbols. So that CLSC readers would have the advantages of institutional identification, "the college spirit," Vincent urged them to travel to Chautauqua in the summer for round-table discussions, socializing, and elaborate graduation ceremonies with class rituals built around colors, songs, and marches. The circles bordered on the esoteric; as they became an "advanced Chautauquan," CLSC members had their own hall in the grove hidden on a wooded hill—an emblem of the higher intellectual plane on which they lived. "They keep a calendar, and they mark the feasts, and they know what to do when they are there. They seem at home. There are hosts of them, all knowing each other, and apparently bound together by some secret association which has a mystic power."[24]

Vincent fantasized expansions of his lakeside institution: grand museums, stately halls, parks that would show world history from the Tower of Babel to the Statue of Liberty, a two-hundred-foot tower beaming a powerful light in all directions, light shows on land and water, models of the world's great cities, models of cheap cottages and farmhouses, a temple for an inner chautauqua guild so secret that none should know its name, and a Hall of Geography with a rotating globe much like in the lobby of Raymond Hood's Daily News Building (1930). World's fair, theme park, university, and spiritual retreat, Vincent's chautauqua-to-be is fascinating because he visualized it and because he was free with architectural metaphors: "College life is the vestibule to the temple" of life.[25] Or, in a classic Victorian megastructure, the chautauqua ideal was seen to stretch over the land as "a magnificent temple, broad as the continent, lofty as the heavens, into which homes, churches, schools, and shops may build themselves as part of a splendid university."[26]

In 1885, John M. Hall, a lawyer from Flint with a passion for prose and a mission of literacy and culture, by the trustees' invitation came to build a "summer university" for teachers and an assembly at Bay View. Hall, an Albion College graduate, knew that most rural people had neither the opportunity nor the cash for higher education. From 1886 until his death in 1914, Hall superintended liberal arts and education courses plus other pro-

grams and a full range of platform speakers for the assembly, which lived on after him by another seven years as one of the country's many imitation or "independent" chautauquas. In 1885, Vincent listed thirty-eight imitation chautauquas, from Ocean Grove, New Jersey (founded as a camp meeting, as were many), to Yosemite Valley, California, all using the name without Vincent's permission or, apparently, disapproval. David T. Glick has estimated that 292 independent chautauquas were formed, if only for a short time, before 1912.[27] By 1885, Vincent's reading circles had stretched across the oceans, and the independents perhaps only helped to confirm his hope that chautauqua would make "the whole world kin."

Hall designed the Bay View assembly as a summer center for midwestern CLSC readers who might not afford the trip to New York, offering round-table discussions and graduation ceremonies. In 1885, two thousand CLSC readers were in Michigan alone—a population seen to support the new endeavor much as the number of Methodists argued for a regional camp meeting ten years before. Vincent approved Hall's scheme, coming to dedicate the new Chautauqua Cottage as his readers' midwestern home away from home. Bay View continued as the CLSC Midwest center even after 1893, when Hall, as a critique of the original, produced a competing correspondence course, the Bay View Reading Circles. Hall wanted a more integrated curriculum than Vincent's and wrote and published textbooks in order to get it. The Bay View Reading Circles, which had twenty-five thousand members in 1914, may also have been cheaper than the CLSC. Keith J. Fennimore has described Bay View's graduation ceremonies, with their class reunions—each year under its own white picket gate—class trees, May poles wound with class colors, and engraved diplomas, as a great pageant for rural mid-Americans, "like a lost scene from Thornton Wilder's *Our Town*."[28]

The summer assembly and CLSC connection assured Bay View's success. Camp meetings continued until 1908, well past 1890 as specified by the warranty deed. Other institutions joined in: a summer headquarters for the Women's Christian Temperance Union, a Sunday school and Bible study department, the Epworth League for Young Methodists, a small liberal arts summer program, and a music conservatory that continues as a vital presence. Each acquired buildings in the 1890s, grand Queen Anne domestic structures set in a crescent on the high southern curve of Tabernacle Park, now renamed "The Campus," overlooking the old revival grove. With such dense institutional commitment, cottages flowed onto the lots. Cottage numbers increased from 122 in 1885 to 420 in 1900, a near peak; there were also several hotels.[29] The community's geographical range also increased. By 1888, association members came from all parts of the country: New York City, Washington, D.C., Atlanta, Kansas City, Colorado Springs, Dallas, Seattle, and Los Angeles. The traveling platform stars on the chautauqua circuit appeared, among them Frances Willard, William Jennings Bryan, Jacob Riis, Jane Addams, Booker T. Washington, Ernestine Schumann-Heink, Carl Sandburg, and Lillian Hellman. The music school brought performers inde-

pendent of various chautauqua booking systems. All this activity brought crowds to the cottages, hotels, and the surrounding region. Therefore, the question becomes, How much of the wide American success of romantic subdivision planning in the twentieth century resulted from Bay View's visitors? Perhaps they took home ideas about land design, along with the reformist ideals invoked from the platform, to create a thread of popular understanding parallel to the development of professional landscape architecture in schools and design offices.

Hall's programs demanded larger structures than the two minor ones the camp meeting had slipped into the beech grove: the preachers' stand and the Methodist book shop. The five new Queen Anne buildings became Bay View's institutional center, the buildings set in a line on the uphill or southern edge of the natural amphitheater of Tabernacle Park. The first, on the northeast corner, was Chautauqua Cottage (now the Bay View Women's Council), which Vincent dedicated as the midwestern focus for his CLSC students. Here the college-in-a-home was reified in a comforting, sheltering house with steep-pitched roofs, a variety of intersecting gables, wide verandas, and an asymmetrically placed tower pinioning the masses between heaven and earth. Decorative patterns in shingling and porch railings spice the basic shiplap cladding. The architect was W. X. Oliver of Flint, Michigan.[30] Continuing uphill from the Chautauqua Cottage are five other large structures. Four date from the decade after 1889 and are, like the first, well-preserved Queen Anne piles, most of them asymmetrically proportioned, with steep-pitched roofs, towers, and wraparound porches. The buildings are defined by crisp, variegated shiplap panels, with the boarding laid horizontally, vertically, and diagonally and catching the light in syncopated patterns set off in turn by patterned shingles, brackets, turned posts, sunburst gables, vergeboards, and delicately transparent fretwork railings. The star of the row is Evelyn Hall, built in 1890 for the Women's Christian Temperance Union. A scaffold of two-story porches reaches out into the verdure, one arm ending in a two-story gazebo counterbalanced by a three-story octagonal tower. Epworth Hall (1891) (fig. 5.14), the club for young Methodists, is slightly smaller but has a four-story tower plus several multisided bays rising only to dissolve at skyline into conically roofed open porches. This complex design, also by Oliver, is resolved at ground level with a broadly roofed wraparound porch with a fixed entrance, on center, denoted by a gable. Hitchcock Hall, built in 1889 for Sunday school teacher training, is another towered house with a stimulating interplay of shifting shiplap textures. Here, too, the wide veranda, a half-story up, is set forth as a spatial emblem of welcome and shelter. Loud Hall, erected in 1897 as a liberal arts summer school, has a stricter, more institutional flavor, but mansards and pents join the porch in scaling down the masses, while projecting corner pavilions assure both formal complexity and breezy interiors.

The Hall Auditorium (1914), chronologically the last of these institutional objects although set in the middle of the crescent, is a classical

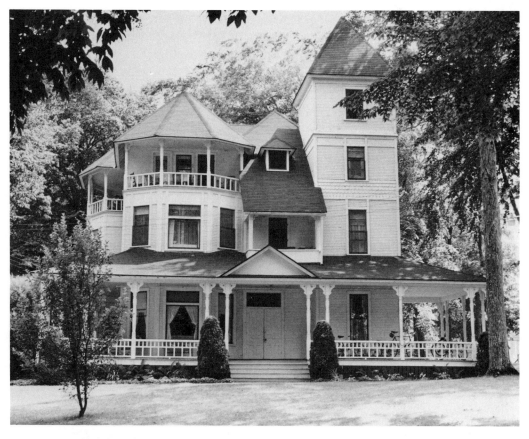

5.14 W. X. Oliver, Epworth Hall, 1891. (G. Randall Goss)

exercise in stuccoed masonry. Hall donated the building from the money he made from the Bay View Reading Circle textbooks and magazines. Hall Auditorium replaced a shed built in 1886–87, fondly known as the sheep barn, which served earlier assembly functions. The 1914 building's facade has a slightly projecting portico with four Ionic columns *in antis* under a full entablature and a pleasing rhythm of windows and piers to each side. The front part houses the Bay View Association's offices and archives. In back is a 1,700-seat auditorium for religious services, concerts, and regional events such as school graduations. Wider than deep, the auditorium has four steel arched trusses yielding a clear span of 102 feet. It contains a vast, light, and airy space, a surprise behind such a correct academic facade. The auditorium and the Queen Anne structures were well used through the middle of the twentieth century. From 1938 to 1969 they housed the Bay View Summer College of Liberal Arts, an Albion College program that enacted John Hall's dream of a summer university long after the chautauqua was finished. A music conservatory uses the structure now.

Bay View does have a handful of modern public buildings, some, such as the maintenance building behind the auditorium, of no particular dis-

tinction. The low 1952 auditorium in Fairview Park seems hardly noticeable amid the surrounding greenery. Unlike the New York chautauqua with its condominiums, modern construction at Bay View is minimal and unobtrusive. One distinguished later building does deserve mention, the 1931 orange brick library by Earl Mead, with its steep roofs and chimney stepsectioned into the wall. It is stylistically out of key with the Victoriana, but not in its level of craft and detail, which shows close attention to the lessons of Cranbrook. Completing the community core are a small post office, shuffleboards, playground equipment, swinging benches, and an attractive modern tower to protect the Bay View bells, always pealed at sunset, from traditional childrens' tomfoolery.

America's single-family suburbs, one of our most distinctive contributions to world building culture, are beginning to have their due in the historical and critical literature with the recent work of Kenneth T. Jackson, John Archer, Robert Fishman, Walter L. Creese, John Stilgoe, and others, especially those perceptive regional historians who write National Register nominations. The suburban ideal—the village in the park or, even, the city in the woods—depends on overriding nature as a matrix for dissolving care and binding isolated families, each in its own house, into a community. Pioneer nineteenth-century versions such as Llewellyn Park, New Jersey, Glendale, Ohio, and Park Forest and Riverside, Illinois, rehearsed the genre, while less clearly defined exercises, without the identity of memorable plans, grew along railroad lines west of Boston and Philadelphia and north of New York. These stated the formal ideal: the individual house cushioned in a web of greenery but still responding, even if indirectly, to other houses and to the streets. The four named examples had romantic plans acting as community monuments, giving form to the collective aura of the woodsy retreat and the feeling of psychic ease.

While Bay View may be of a different order as a second-home resort rather than commuter suburb, it may be as important as the others in the eventual history of the form. By 1900, Bay View, chock with elegant cottages and a success with residents and visitors from across the country, made the formal argument more completely, and therefore more forcefully than other communities. Riverside and Llewellyn Park were probably better known to design professionals but were, respectively, a developmental laggard and a private enclave, not widely experienced by as many people as the Michigan chautauqua-resort. Bay View, then, is not only one of the most attractive of the country's inventive Victorian communities, but it may also be one of the most significant.

NOTES

1. Alexis de Tocqueville *Democracy in America*, vol. 2 (New York: Harper and Row, 1966), p. 506; Elinor Rice Hays *Morning Star: A Biography of Lucy Stone* (New York: Harcourt, Brace, 1961), p. 119.

2. An earlier version of this chapter was written in May 1986 as a National Historic Landmark nomination. Jane Doerr, director of the Bay View archives, instigated the nomination process, brought me from Alabama to Bay View, and offered wise counsel. Max Doerr, Mary Jane Doerr, Ben Vanden Belt, Jr., Helen Guittard, and Rodney Slocum were especially informative and welcoming. The nomination also depended on the Michigan Department of History. Kathryn Eckert arranged and shared, Brian Conway did the hard parts, and Robert O. Christensen gave unstintingly of his Michigan research skills. Cathy Ferrier typed this version. Bay View was listed in the National Register of Historic Places in 1972 and became a National Historic Landmark in November 1988.

3. Bay View is formally "The Bay View Association of the United Methodist Church," an association of householders in Bear Creek Township, Michigan. It is a tax-exempt corporation under the state statute governing camp meetings. Despite its name, the association has no institutional relation to the United Methodist Church. Holders of the fifteen-year leases are the association members who pay an assessment for community costs and, as well, a personal property tax to the township on the cottages, which they own. Governance is by a self-appointing, nine-member board of trustees, a majority of whom must be members of the United Methodist Church.

4. An exception to the generally happy Bay View preservation story is two-lane Woodland Avenue, which crosses the community east and west and is owned by the association. It is being widened to accommodate the heavy traffic on U.S. 31, a four- and five-lane highway that connects at each end. The widening and its effect on the community have caused a split in the community as well as lawsuits. See Kathleen McCormick, "Roadway Wrangle: Resort Town Splits over Highway Rehab," *Preservation News* 28 (February 1988):14–15, and "Bay View Battles on, but Road Widened," *Preservation News* (July 1989):6. In October 1988, in *Historic Preservation Guild of Bay View v. Brunley et al.*, a U.S. District Court ruled that the widening of Woodland Avenue by the Michigan Department of Transportation was not subject to federal review procedures under Sect. 106 of the Historic Preservation Act because federal funds, although used on an adjacent segment of the road, were not being used within Bay View. The lawsuit, in which the National Trust for Historic Preservation was an active participant, had a positive effect. The Michigan Department of Transportation did the widening with unexpected sympathy for the ambience.

5. For Des Plaines, see Daniel R. Sailor, "125 Years of Methodist History: The Des Plaines Camp Ground," *Des Plaines Journal* (historical supplement), April 1984; also John O. Foster, "The First Des Plaines Camp Meeting, Des Plaines, Illinois, August, 1860" (1918), *Journal of the Illinois State Historical Society* 25 (January 1932): n.p.

6. The two most significant accounts of Bay View are Clark S. Wheeler, *Bay View* (Bay View: Bay View Association, 1950) and Keith J. Fennimore, *The Heritage of Bay View* (Grand Rapids: Wm. B. Eerdmans Publishing, 1975). The latter explores fully the life of the community during the early twentieth century. Wheeler published numerous documents from the Bay View archives. The present account of the foundation is built on his material and on other sources. Significant observations and information can also be found in Robert M. Carter, "Forum on the Bay, Factors in the Survival of Bay View Association," *Methodist History* 6 (January 1968):50–58; Mary Jane Doerr, "Bay View: A Michigan Chautauqua," *The Michigan Connection* (East Lansing: Michigan Council for the Humanities, 1984), pp. 8–9; Hugh Kennedy,

ed., *Fifty Years of Bay View* (Bay View: Bay View Camp Ground Association, 1925); and Margaret Burnham Macmillan, *The Methodist Church in Michigan: The Nine-teenth Century* (Grand Rapids: Michigan Area Methodist Historical Society, 1967), pp. 306–11.

7. J. H. McCarty to D. Darwin Hughes, August 1, 1875, *Proceedings of Annual Meetings of Bay View Camp Ground Association*, Bay View Archives.

8. *History of Jackson County, Michigan* (Chicago: Interstate Publishing 1881), pp. 660–61; 1886, pp. 240, 267, 495; 1890, pp. 201–3. I am grateful to Ruthellen M. Sharp of the Ella Sharp Museum in Jackson for material about S. O. Knapp.

9. *History of Jackson County, Michigan*, 1881, pp. 549–50; 1886, p. 550.

10. The plan generally taken as the first has a north arrow and a scale. The second has no north arrow and is inscribed well below the image with verifica-tion statements and the two signatures. A lengthened version of the scale has been redrawn (fig. 5.1, the second plan).

11. For a history of the Martha's Vineyard camp meeting and its ancillary resort, Oak Bluffs, see Ellen Weiss, *City in the Woods: The Life and Design of an American Camp Meeting on Martha's Vineyard* (New York: Oxford University Press, 1987).

12. Perrine would have known the Reverend William Brockway of the Commit-tee on Titles and Ornamentation from their Albion connection, suggesting a direct route from the Oak Bluffs plan to the Bay View plan and possible competition with Knapp as the latter's author. Perrine taught natural science, astronomy, and literature at Albion. By 1875 he was lecturing as a "Christian artist" for John Heyl Vincent at Chautauqua, New York, with stereopticon presentations of his travels in Palestine, demonstrating that history, geography, and science support the biblical evidence. See *Simpson's Encyclopedia of Methodism* (1880), and John H. Vincent, *The Chau-tauqua Movement* (1885, repr. Freeport: Books for Libraries Press, 1971), pp. 260, 270.

13. Ted J. Ligabel, "Lakeside" (unpublished National Register of Historic Places nomination, 1982).

14. A drawing of a street grid named "Bayfields" and dated 1873, with C. Smith as the surveyor and streets named State, Congress, Wall, Main, Clinton, and Fountain, is in the Bay View Archives.

15. Macmillan, *The Methodist Church in Michigan*, p. 311.

16. Seth Reed, *The Story of My Life* (Cincinnati: Jennings and Graham, 1914), p. 83.

17. "Bay View Camp Ground" (brochure in Bay View Archives), 1878.

18. *Petoskey City Record*, August 8, 1878, p. 1; November 14, 1878, p. 2.

19. *Portrait and Biographical Album of Jackson County, Michigan* (Chicago: Chapman Brothers Publishers, 1890), pp. 824–26.

20. *Representative Men of Michigan* (Cincinnati: Western Biographical and His-torical Association, 1878), p. 13; *History of Calhoun County, Michigan*, vol. 1 (Chi-cago: Lewis Publishing, 1913), pp. 125–26, 421–23.

21. Weiss, *City in the Woods*, chap. 3.

22. Rexford Guy Tugwell *The Light of Other Days* (Garden City: Doubleday, 1962), p. 119; Theodore Morrison *Chautauqua* (Chicago: University of Chicago Press, 1974). For a fascinating analysis of the continuity between nineteenth-century religious ideals and revivalist techniques and those of Chautauqua, see Alan Trachtenberg, "'We Study the Word and the Works of God': Chautauqua and the Sacralization of

Culture in America," *Henry Ford Museum and Greenfield Village Herald* 13, no. 2 (1984):3–11.

23. Vincent *The Chautauqua Movement*.

24. Ibid., p. 73.

25. Ibid., p. 3.

26. Ibid., p. 6.

27. David T. Glick, "The Independent Chautauquas Then and Now," *Henry Ford Museum and Greenfield Village Herald* 13, no. 2 (1984):33–39.

28. Fennimore, *The Heritage of Bay View*, p. 121.

29. The figure of 122 cottages in 1885 is from the directory published in the *Bay View Herald* for 1885, a promotional brochure in the Bay View Archives. That of 402 in 1900 is the number of residents who paid personal property taxes on cottages to the town in the first year that taxes were assessed, a figure furnished by Max Doerr.

30. The W. X. Oliver attribution and that of Earl Mead for the library are from the 1983–86 Bay View Association Historic District Survey.

6

SULLIVANESQUE ARCHITECTURE AND TERRA COTTA

RONALD E. SCHMITT

Louis H. Sullivan (1856–1924) and his followers, William Gray Purcell, George Grant Elmslie, and Frank Lloyd Wright, wanted to create an American architecture expressive of democracy and the industrial age. They understood the potential of the machine to produce economical building components and ornament. The "Sullivanesque," a movement and style inspired by Sullivan's work and ornament, exhibited this use of technology. Derived from Sullivan's floral and fluid ornamental designs composed over geometric grids, standardized components of terra cotta enabled the assemblage of unique and economical building facades. Manufactured Sullivanesque terra cotta gave focus and distinction to inexpensive, often commonplace, utilitarian buildings in Chicago and throughout the Midwest.

Much has been written about Sullivan's work and ornament, and, to a lesser extent, that of Purcell and Elmslie. Beyond these architects, however, little attention has been given to the Sullivanesque style. Although a minor movement during a period of design eclecticism (ca.1907–27), the Sullivanesque deserves greater attention. The style embodies the spirit and design philosophy of Louis Sullivan. His dream of a democratic architecture is captured in a number of otherwise anonymous buildings, a number being rapidly reduced through alteration and demolition. Adler and Sullivan dissolved their prestigious and productive architectural partnership in 1895. Sullivan's last large commission was the 1903 expansion of his 1899 Chicago department store, the Schlesinger and Mayer (now Carson Pirie Scott). Thereafter, Sullivan's architectural practice turned to smaller and fewer commissions, although the originality of his designs would continue.

Despite his diminishing practice, Sullivan's work was still published

and admired. The architectural journals *Western Architect* and *Architectural Record* consistently featured his completed buildings, and his work was published abroad. An example was included in Howard Robertson's *The Principles of Architectural Composition*, published in London in 1924. Robertson compared a Sullivan bank, the People's Savings Bank of 1911 in Cedar Rapids, Iowa, with a typical classical-styled, eclectic design: "This 'building' breaks away from tradition, and is a straightforward solution of the particular conditions affecting the design. It is by no means completely satisfactory, but it is vital and interesting."[1] European modernists, however, limited their definition of "function" and rejected ornamentation. To Sullivan, function entailed more than just utilitarianism. Function included the use of ornament. Ornament was intended to delight and to ennoble architecture with the American spirit. Function was organic. It was unity made complete by the integration of aesthetics and utility. It included the symbolic with the structural.

Despite coverage of Sullivan's work in certain publications here and abroad, the architectural press in America overwhelmingly featured the eclectic designs so prevalent in the first three decades of this century. Large architectural firms, corporate clients, and universities (the formal centers of architectural education) favored the Beaux-Arts classicism and other eclectic styles. The decline of the Chicago School was followed by the withering of the Prairie School movement. After World War I, the occasional works of Wright or Elmslie were the mere vestiges of these once-progressive movements. Diluted versions of the Prairie School style were built in the speculative guise of Chicago bungalows. Evolved from the Prairie School and Bungalow movements, Chicago bungalows were built throughout the Midwest, although concentrated in Chicago and suburbs like Berwyn and Cicero, Illinois. In contrast and although adapted by speculative builders and architects, the Sullivanesque seems to have been an enlightened art form with a philosophical base that enabled it to survive the demise of the Chicago and Prairie movements.

The reasons for the endurance of the Sullivanesque are numerous and complex. It seems to have been propagated for promotional and economical reasons as well as for its aesthetic and philosophical appeal. The adaptation of the Sullivanesque style can be attributed to six factors. 1) The coverage of Sullivan and his work in certain architectural journals prompted adaptation of his personal approach and style. 2) Louis Sullivan, the consummate artist and architectural hero, motivated lesser architects to try to emulate or imitate his style. 3) Small-scale buildings were generally compatible with the Sullivanesque. This included the small strip commercial structures of the period. Such buildings shared party walls and had only one or two major facades as part of a total urban frontage. Sullivan's design approach was facade-oriented and therefore appropriate for such a context. 4) In addition, Sullivan's approach to facade composition accommodated flexibility for utilitarian purposes. 5) Stock Sullivanesque terra cotta was, at the time,

economical in cost. Speculative strip commercial buildings usually had low construction budgets. Therefore, stock Sullivanesque ornament could meet budget demands while giving identity and beauty to the building. 6) Several Chicago terra-cotta companies promoted the Sullivanesque. Their reasons varied, but self-promotional commercialism must have figured prominently.

Louis Sullivan championed the idea of appropriate forms and spaces in architecture. This seems to have been the intent of most Sullivanesque architects, although their results varied in degree of success. However, similarities in compositional principles and the ornament used for building facades most noticeably identified the Sullivanesque. Sullivan often used terra-cotta bandings to lighten building facades by segmenting wall surfaces. He employed terra-cotta medallions to soften the brickwork and act as a focus or element of balance to complete the facade composition. On simple, small buildings such as the Purdue State Bank of 1914 in West Lafayette, Indiana, Sullivan restricted terra cotta use to simple, repetitive units for string courses and accents. This simple technique served as an archetype for many Sullivanesque designers.

The Farmers and Merchants' Union Bank of 1919 in Columbus, Wisconsin, projected a strong image of symmetry. However, the front facade was not symmetrical at the ground level because the entry was to one side, toward the street corner, with a large window opposite. This manipulation of the facade composition allowed for ground-level openings as required. The upper-wall surfaces of the facade, however, were symmetrical. This symmetry was emphasized by an ornamental cluster, complete with a terra-cotta eagle that jutted above the parapet. The symmetrical upper-wall surfaces of Sullivan's facades created a strong sense of balance and repose that gave a significance and presence beyond the actual physical size of the building. This strategy of facade composition reappeared with consistency in Sullivanesque buildings. Symmetry, emphasized by a central medallion engaging the sky, organized the facade of Sullivan's last built design. The William Krause Music Store (1922) on Lincoln Avenue in Chicago was done in association with a former employee, William C. Presto. Born in 1892 in St. Louis, Presto opened his own office in 1920 in Chicago[2] and offered the design of the Krause street facade to Sullivan. The result was an exuberant, richly ornamented, green terra-cotta facade. Terra cotta, an ancient material, was first employed in Chicago skyscrapers because of its fireproofing qualities, light weight, and durability. However, its decorative qualities were soon realized. In addition, terra cotta, as a clay product baked and fired from an easily molded plastic state, was an inexpensive material for ornament. Sullivan realized the new potential of the ancient building product.

The ornament that Sullivan developed for his building facades was highly original and personal. His use of floral, fluid motifs idealized nature and, perhaps, symbolized the need for harmony with nature. A practical benefit of Sullivan's terra-cotta ornament with its swirling lines was its ability to dominate and mask the construction joints of the pieces that composed

the ornamental design. In addition, the twisting and whirling movement was more suitable for hand-sculpting the clay models from which the terra-cotta molds were made. Rigid and controlled right-angled geometries were more difficult for the modeler to maintain, given the plastic nature of clay.

Some of Sullivan's earlier designs, such as the Guaranty (1894–96) and the Schlesinger and Mayer, had building facades completely clad in terra cotta. Facades entirely of terra cotta were more expensive than walls of brick with terra-cotta trim, as additional shop drawings, increased modeling labor, additional molds, and considerably more construction coordination were required. For economy, Sullivan undoubtedly turned to the predominant use of brick for his later commissions and restricted terra-cotta use to important, concentrated areas of building facades. After the Schlesinger and Mayer addition of 1903, only the tiny Home Building Association (1914) in Newark, Ohio, and the William Krause Music Store employed full terra-cotta facades. Similarly, these same factors determined terra-cotta use in buildings of the Sullivanesque designed by others.

Before 1906, the Northwestern Terra Cotta Company produced most of the terra cotta for Sullivan's buildings, including the Stock Exchange (1893–94), Schiller Theater (1891–92), and the Schlesinger and Mayer.[3] The Northwestern Terra Cotta Company's works and main office occupied twenty-four acres at 2525 North Clybourn Avenue and Wrightwood Avenue in mid-northwest Chicago, while a sales office was maintained downtown in the Railway Exchange Building on Michigan Avenue at Jackson Boulevard.[4] The Railway Exchange Building, (1903–4), was clad in the company's terra cotta and was designed by D. H. Burnham and Company, Architects. The terra-cotta pieces for the Adler and Sullivan buildings in St. Louis were produced by the Winkle Terra Cotta Company of that city.[5]

After 1906, Louis Sullivan's terra cotta was produced almost entirely by The American Terra Cotta and Ceramic Company.[6] The exceptions seem to include the Henry Babson Residence (1907) in Riverside, Illinois, which employed terra-cotta ornament from the Northwestern Company[7] and the Henry C. Adams Building (1913) in Algona, Iowa, where a local brick company seems to have produced the terra cotta.[8] The reason for the change in companies for the production of Sullivan's terra-cotta designs was that Kristian Schneider, the modeler of Sullivan's ornament, switched employment in 1906 from Northwestern Terra Cotta Company to The American Terra Cotta and Ceramic Company. Schneider (1865–1935) was born in Bergen, Norway, and came to Chicago in 1885. While carving clay models for plaster molds on the Auditorium Building, he met Sullivan and thereafter crafted the clay models of Sullivan's ornamental designs. Schneider stayed at the American Company until 1930, five years before his death, when he left for a position with the Midland Terra Cotta Company.[9]

The American Terra Cotta and Ceramic Company was founded in 1887 by William D. Gates (1852–1935).[10] Born in Ashland, Ohio, he came with his parents to Crystal Lake, Illinois, where he lived for most of his life. Educated

6.1 An advertisement for The American Terra Cotta and Ceramic Company. (*The Brickbuilder*, December 1914, p. ix)

as an attorney, Gates practiced law for only two years before he turned to the fabrication of clay into pottery. This, in turn, led to the production of architectural terra cotta. Gates was interested in architecture, and his artistic endeavors included sketching and watercolor.[11] The plant of The American Terra Cotta and Ceramic Company was located in Terra Cotta, Illinois, a suburb of Crystal Lake in McHenry County and forty-two miles northwest of the Chicago Loop. Its offices were located in the People's Gas Building, 122 South Michigan Avenue, in downtown Chicago.

Sullivan's ornament is most often associated with terra cotta, although he produced ornamental designs for cast iron, plaster, stone, wood, and glass. Because The American Terra Cotta and Ceramic Company produced virtually all of Sullivan's terra-cotta work, it was natural that the company would feature his designs in company advertisements and promotions. An advertisement for the company, published in the December 1914 issue of *The Brickbuilder*, featured a photograph of an ornamental panel from Sullivan's Home Building Association in Newark, Ohio, and ran with a text heralding "Plastic Ornament, which is the decorative keynote of modern tendencies in architectural design, can be expressed most effectively in architectural terra cotta. The great ingenuity of the designer in working out graceful scrolls and intricate foliage can be imparted to the modeled clay and then glazed

to insure durable and lasting qualities. The facilities of The American Terra Cotta and Ceramic Company for executing work of this character are unexcelled because of their wide experience in working with the leading exponents and advocates of this style of architecture from the time of its inception" (fig. 6.1).[12]

Beginning in July 1920, the American Company produced a small monthly magazine, *Common Clay*, that not only promoted the company and product, but also publicized Sullivan and the Sullivanesque. Just one example is the "Design for a Small Bank Front" that appeared in the March 1921 issue.[13] Evidently, the design was by a company draftsman who was not identified. Although somewhat primitive, the design is still an intriguing one for an ordinary storefront building.

Gates and Sullivan became friends through their business associations. As Sullivan's economic woes increased, Gates was among the many friends who either lent or gave him financial assistance. Sullivan's last office was in a back room, rent free, of an American Company building located at 1701 South Prairie.[14] However, it seems that Sullivan did not receive any royalties or financial compensation for the use of his terra-cotta designs that were duplicated for use on buildings designed by other architects. The molds of Sullivan's, as well as Purcell and Elmslie's, terra-cotta designs were retained by the American Company and occasionally reproduced. For example, the Indianapolis Terra Cotta Company, which was acquired in 1916 by the American Company and became its subsidiary,[15] seems to have reproduced some of Sullivan's ornament from his People's Savings and Loan (1917–18) of Sidney, Ohio, for a little-known bank in southern Indiana.

The Farmers' Bank and Trust in Poseyville, Indiana (fig. 6.2), appeared much like a Louis Sullivan design. The side elevation of the Poseyville bank, of which the front elevation is a simple transformation, was virtually a mirror image of Sullivan's Sidney bank. The Poseyville bank was built in 1924 and designed by Clifford Shopbell and Company, Architects.[16] The Evansville, Indiana, firm was founded in 1897 as Harris and Shopbell and became simply Clifford Shopbell and Company in 1909 upon the death of Will J. Harris.[17] According to Craig Zabel, the Shopbell designer for the Poseyville bank was Edward Thole. A native of Evansville, Thole was educated at MIT and was an admirer of Sullivan.[18] In 1924, Thole became a principal in the firm as Clifford Shopbell and Company reorganized and changed its name to Shopbell, Fowler, and Thole.[19]

Purcell (1880–1965) and Elmslie (1869–1952) were former employees of Sullivan. Elmslie was responsible for much of the design of Sullivan's ornament. In 1909, he left Sullivan's firm and became a partner in the architecture firm of Purcell and Feick. After Feick left for Ohio in 1911,[20] Purcell and Elmslie practiced in partnership, with offices in Minneapolis and Chicago. Purcell and Elmslie contributed significantly to the Sullivanesque movement and were admired and sometimes imitated. Their work, like Sullivan's, was published often. Three articles in the *Western Architect* were especially im-

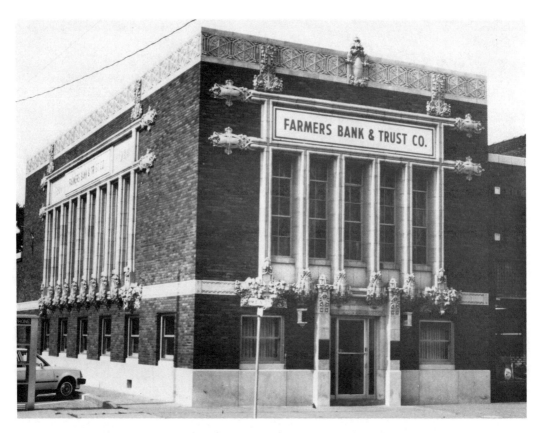

6.2 The Farmers' Bank and Trust (1924) in Poseyville, Indiana, featured terra-cotta ornament from The Indianapolis Terra Cotta Company, a subsidiary of The American Terra Cotta and Ceramic Company.

portant and influential. For the January 1913 and January and July 1915 issues, Purcell and Elmslie wrote the text and composed the layouts that dealt with their work and philosophy. Their partnership was effectively dissolved in 1920 when Purcell left for the West Coast. Elmslie continued to practice in Chicago.[21]

In addition to the motivation generated to design in the Sullivanesque, some architects were satisfied to literally duplicate the ornamental components from Purcell and Elmslie projects. For example, the terra-cotta entrance motif for the Merchants National Bank of Winona, Minnesota, designed by Purcell and Elmslie in 1911, was reproduced by the American Terra Cotta and Ceramic Company. These entry assemblies were used by Claude and Starck, Architects of Madison, Wisconsin, for two of their school designs. Two Lincoln Schools, one in Madison (1915) and the other in Monroe, Wisconsin (fig. 6.3, 1915–16, demolished in 1975), used the Purcell and Elmslie-designed terra cotta from the American Company. However, the terra cotta had a cheaper white glaze than the vivid colors used by Purcell and Elmslie. Louis Ward Claude, born in 1868 in Baraboo, Wisconsin,

6.3 The Lincoln School (1915–16) in Monroe, Wisconsin.

worked in the office of Adler and Sullivan for about two years and was with several other firms in Chicago before moving to Madison. Formed in 1896, the partnership of Claude and Edward F. Starck produced a number of Sullivanesque buildings in Wisconsin, Minnesota, and Illinois. The partnership was dissolved in 1929.[22]

Perhaps the largest, and considered by some critics and historians as the most significant, Sullivanesque design was the Woodbury County Court House (1916–18) in Sioux City, Iowa. The architects for the courthouse were Purcell and Elmslie, with William L. Steele as associate architect. The architectural terra-cotta ornament for the courthouse was designed by Elmslie, modeled by Schneider, and manufactured by The American Terra Cotta and Ceramic Company. The Chicago sculptor Alfonso Iannelli, born in 1888 in Andretta, Italy, was chiefly responsible for the exterior sculpture. John W. Norton of Chicago produced the murals.[23]

Steele (1875–1949) was a Sioux City architect who secured the Woodbury County courthouse commission and brought in Purcell and Elmslie to collaborate. He was born in Springfield, Illinois, and graduated in architecture from the University of Illinois in 1896.[24] He worked from 1896–1900 in Sullivan's office[25] under Elmslie's direction. He went to Sioux City in 1904 and formed his own firm in 1907 after dissolving a two-year partnership with

6.4 The S. S. Kresge Building (1917) of Sioux City, Iowa.

W. W. Beach as Beach and Steele, Architects.[26] Steele designed a number of Prairie School and Sullivanesque structures in Sioux City, for example, the S. S. Kresge store and office building of 1917 (fig. 6.4). The facade cladding and ornament were entirely of white glazed terra cotta supplied by The American Terra Cotta and Ceramic Company.[27] The bays of the three-story building were spanned by Chicago windows and terra cotta-clad spandrels. The columns read as pilasters or piers of terra cotta, with a strong vertical articulation. Each pier had a stylized capital of Sullivanesque ornament. This ornament seems somewhat rigid because the swirling movement was tight and the foliate was broad, as if also influenced by Arts and Crafts decoration. The Arts and Crafts influence often appeared in the ornament of such Chicago School architects as Pond and Pond and the firm of Nimmons and Fellows.

Although The American Terra Cotta and Ceramic Company produced virtually all of the terra cotta for the buildings of Sullivan and Purcell and Elmslie, it largely produced historically inspired ornament. The Sullivanesque terra-cotta ornament most often used in Chicago and throughout the Midwest was from a different and competing company. The Midland Terra Cotta Company was founded December 10, 1910 by Alfred Brunkhorst, son of one of the founders of Northwestern Terra Cotta Company, and architect

William G. Krieg.[28] Born in Chicago, Krieg (1874–1944) worked for his father, a contractor, until 1896, when he formed an architectural partnership with F. E. Gatterdam. However, the partnership of Gatterdam and Krieg lasted only two years before both men formed separate architectural firms. Gatterdam's practice concentrated on brewery buildings, and Krieg went on to become the city architect of Chicago in 1908. He resigned that post on September 1, 1910 to concentrate on the formation of the new terra-cotta company.[29] Krieg was elected president of the Midland Company on January 3, 1911, with F. S. Ryan as vice president. Both men served in these capacities until 1918, when Ryan died and Krieg retired to resume a private architectural practice. Krieg was succeeded as president by Hans Mendius. Born in 1879 in Germany, Mendius had been a draftsman, construction superintendent, and specification writer for various architects in Chicago from 1896 until 1911, when he joined the Midland Company as an estimator and salesman.[30] With Mendius as president, the position of vice president was filled by August W. Miller, who was born 1861 in Chicago. Walter S. Primley, born in 1887 in Elkhart, Indiana, was a stabilizing force. Through these administrative changes, he served as the secretary and treasurer of the Midland Company.[31]

The Midland Terra Cotta Company's plant was located on the northwest corner of West 16th Street and South 54th Avenue in Cicero, Illinois. Initially, offices were in the Chamber of Commerce Building (built in 1888–89 by Baumann and Huehl, Architects) at LaSalle and Washington streets in the Chicago Loop. In 1915, offices were moved to the Lumber Exchange Building in the Loop at LaSalle and Madison streets.[32] The Lumber Exchange Building was designed by Holabird and Roche, Architects and built in 1914–15. Clad with Midland's terra cotta,[33] the building was an advertisement and demonstration of the company product. Midland Terra Cotta was the latecomer and the smallest of the three major companies producing terra cotta in the Chicago area. Because of this, Midland probably promoted the Sullivanesque as a way to break into the Chicago market; or, perhaps, Krieg and Mendius just admired Sullivan and his ornament. Midland featured their own terra-cotta designs, which they termed Sullivanesque and promoted in company catalogs.

Sullivan's original ornamental designs were replicated by Midland Terra Cotta. For example, the terra-cotta piece over the interior main entry of the Owatonna Bank (1907–8) was the prototype and inspiration for several Midland imitations. These were Midland catalog stock pieces, numbers 7701 and 7702, which were often used as decorative lintels over entryways or as focus pieces on upper wall surfaces or parapets. These terra-cotta pieces were smaller in size than Sullivan's originals and were simplified for ease of construction placement. The assembled piece had right-angled perimeter configurations with dimensions modulated for brick coursing. The floral entwinements of the reliefs were simplified from Sullivan's design, although in many ways the Midland pieces had a visual strength that captured the essence of Sullivan's original, much like a sketch sometimes produces a

clearer image than the original. On the other hand, a few of the Midland stock components, and especially the smaller trim pieces, had a simplification of the Sullivan-like designs that were much like caricatures.

The Midland Terra Cotta Company developed many stock designs formed by various modular component pieces. One of the most popular was a terra-cotta medallion design that formed a circle, two feet six inches in diameter, by placing two half-circle pieces (number 4508) together. A common expansion of this design was the addition of a circumferential ring to expand the completed medallion to three-foot diameter. "Tabs" could also be added to form an ornate, symmetrical cruciform shape upon which the medallion design appeared to be superimposed. Another frequent variation using the half-circle pieces was the use of only one to form a semicircular design. This motif, in conjunction with additional pieces, often appeared adjacent to the parapet coping on many Sullivanesque buildings. The lunette and variations thereof were featured on plate 45 in the Midland Company catalogs and had the following descriptions: "The ornamental features on this plate and on plate 46 can be used in many ways to make your building ornate—they have been specially designed by our artists with this idea in view."[34] Differing and derivative designs, sometimes subtle but of infinite variety, could be created by interchanging, adding, or subtracting standardized stock terra-cotta pieces (figs. 6.5, 6.6).

Midland did not keep a large inventory of terra cotta on hand, but produced units from standard molds used over and over again. The process eliminated modeling and mold-making and thus saved time and money. All of the company's stock units were glazed with white enamel.[35] This contrasted with Sullivan's use of colorful but more costly glazes on his later work, or the natural colors of slips used on his earlier projects. Slips were liquid clays applied to the surface of the unit before firing and were often used to simulate stone.[36]

Midland's architects and draftsmen designed and drew examples of Sullivanesque building facades using the company's stock Sullivanesque terra-cotta components. These example plates were included in the company catalogs. The plates were numbered but undated, and added or deleted for the various catalogs issued without changing the identifying plate numbers. Plates numbered 1 to 44 were prepared before 1915, and many were included in company catalogs issued after that date. Additional or substitute plates were subsequently included in the undated catalogs, which were available at no charge to architects and contractors. The plates for Sullivanesque building facades or portions thereof were often adaptation guides or patterns for journeymen architects to produce their own Sullivanesque designs.

The names of the architectural designers for Midland's Sullivanesque terra cotta and building facade examples are unknown. Likewise, the modelers of the terra-cotta ornament remain anonymous. The company usually did not divulge the names of its workers, a practice that contrasted to The American Terra Cotta and Ceramic Company, which was more open about

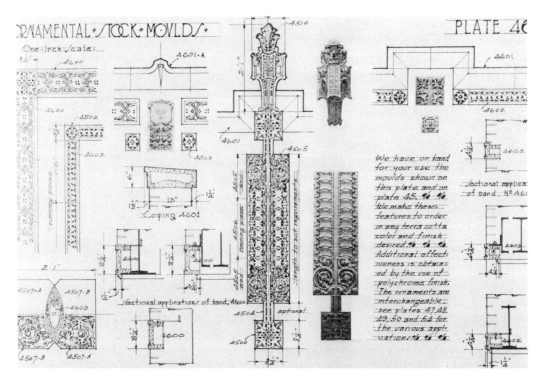

6.5 Some of the stock terra-cotta ornament available to develop Sullivanesque designs was illustrated in a catalog. The designs were simplified replicas of Louis Sullivan's ornament. (Midland Terra Cotta Company catalog, plate 46, ca.1922)

its employees. American's employees were often featured in its journal. The names of some of the draftsmen at Midland are known, however. Although only their initials usually appeared on the company's shop drawings, occasionally a full name also appeared. Among the draftsmen of the Midland Company from 1914 to 1921 were F. Grossi, George Johnson, C. Koedel, Miner, George Nejdl, T. Paulsen, Rigali, Risch, Robert Silvestri, and J. D. Zimmerlin. It seems none were licensed architects during this period.[37]

The advertising practices of Midland Terra Cotta contrasted with its Chicago competitors. Midland rarely was listed in Sweet's catalogs (1914 was one occasion) and must have believed it was not worth the cost of inclusion in *Sweet's Catalogue of Building Construction*. American Terra Cotta was almost always included, and Northwestern always had a major listing. In contrast, Midland consistently advertised in the trade journals *National Builder* and the Chicago-based *American Carpenter and Builder* (later *American Builder*). American occasionally, and Northwestern rarely if ever, advertised in these magazines, which were directed to speculative builders and their architects.

Midland Terra Cotta Company not only produced Sullivanesque terra cotta, but also, on occasion, provided the designs of Sullivanesque build-

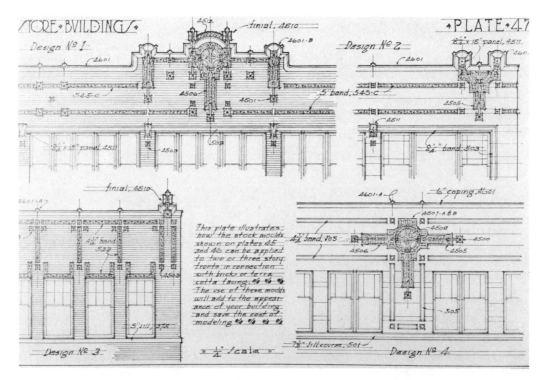

6.6 The Midland Company catalogs had illustrated examples of Sullivanesque building facades that used the company's stock terra cotta composed in various arrangements. (Midland Terra Cotta Company catalog, plate 47, ca.1922)

ings. Midland served as the architect for some builders; its records indicate that it acted as the architect or architectural designer for more than forty-five buildings.[38] It appears many of these employed traditionally styled terra cotta; however, a number used Sullivanesque designs.[39] Examples of the latter include four commercial structures grouped on North Paulina Street in Chicago near the Evanston boundary, as well as a store and post office building, built in 1921 and now destroyed, in Wilmette, Illinois.

Occasionally Midland was the designer for the architect, as in the case of the Pahl Building (1915–16, fig. 6.7) in Clinton, Iowa.[40] The architect for the building was the firm of Ladehoff and Sohn of Clinton. John Ladehoff practiced architecture independently from 1907 to 1915 and then for two more years in partnership with Frank Sohn before he left Clinton for a position with the Rock Island Sash and Door Company. Ladehoff's brother, Gus, was the contractor for the Pahl Building.[41] Midland Terra Cotta designed the facade of the building, which clad entirely in white glazed terra cotta, appeared much like a plate from the company catalog.

Sullivan's Van Allen and Sons Dry Goods Store (1913–15) in Clinton must have inspired local clients and builders because a number of Sullivanesque buildings were constructed there, for example, the Iowa State Bank (1913–

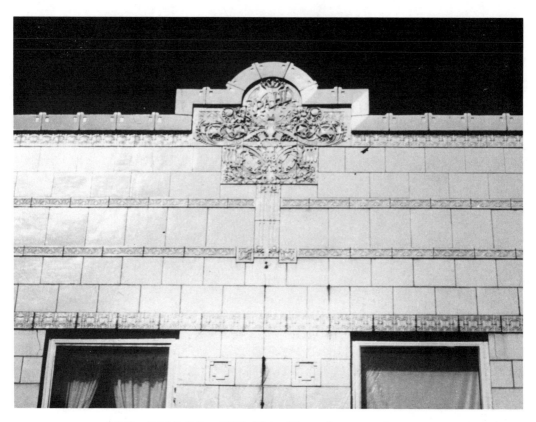

6.7 The Pahl Building (1915–16) in Clinton, Iowa, was the commission of Ladehoff and Sohn, Architects. The terra-cotta focus piece was customized with the building name, but the design was a stock unit based on ornament from Louis Sullivan's Owatonna Bank.

14, fig. 6.8).[42] Designed by architect Jervis (Harry) R. Harbeck, the building's terra cotta was executed by Midland Terra Cotta Company.[43] Harbeck was an obscure figure. Until 1903, he was with the architect Henry W. Tomlinson in Steinway Hall. At that date, Steinway Hall housed many Chicago and Prairie School architects. Tomlinson's office was across the corridor from the city office of Frank Lloyd Wright.[44] Harbeck left Chicago for Detroit in 1903. He had relatives in Lyons, Iowa, now part of Clinton, and that connection must have served to secure the 1913 bank commission.[45]

The bays of the Iowa State Bank were defined by piers capped with terra cotta. Angled terra-cotta trim sloped gently upward from each pier cap to suggest a pediment superimposed over the brick parapet of each bay. The ridge point of the terra-cotta trim was appointed with an ornate terra-cotta medallion. Each of the bays was subdivided by two smaller piers to form three window openings per story. The result was intriguing. Two unsympathetic additions disturb the design, however. A rear addition was constructed

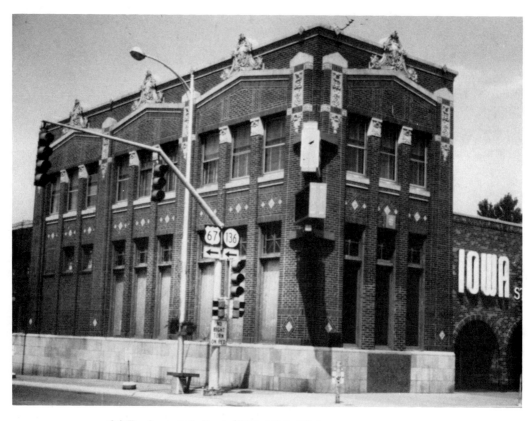

6.8 The Iowa State Bank (1913–14) in Clinton.

in 1931, and an expansion in 1961 resulted in a remodeling and repositioning of the entrance away from the original front.

In Chicago, hundreds of Sullivanesque buildings were constructed. The number built seems to have peaked in 1922.[46] Building construction in Chicago was booming that year, and the promotion and advertising of the Sullivanesque by local terra-cotta companies made an impact. Many different architects designed one or more Sullivanesque buildings. Most were eclectic designers who experimented with the Sullivanesque. But, after brief excursions into the style, and without philosophical commitment, these architects shifted to other styles.

Among the architects who produced Sullivanesque designs, only a few were devoted to that expression. Among these was William G. Carnegie. Carnegie never received many commissions, however, the majority were designed in the Sullivanesque, and some were very handsome. One was illustrated in *Architectural Terra Cotta: The Store* by the National Terra Cotta Society, which produced a number of books promoting terra cotta.[47] Built in 1915 for W. C. Jurgenson, the building's facade was framed by terra-cotta pilasters with eagles perched atop. The material came from Midland Terra Cotta.[48] Un-

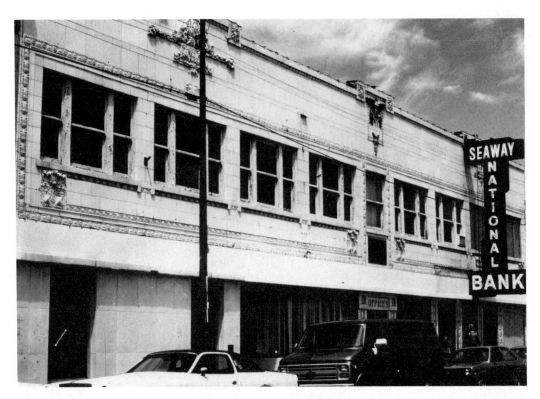

6.9 The front facade of the Roseland Safety Deposit Bank (1914) was of white glazed terra cotta. The building, on South Michigan Avenue in Chicago, was designed by William G. Carnigie, Architect.

fortunately, the facade has since been marred by alterations for a storefront church. Carnegie became a registered architect in 1911 and opened his own office soon thereafter. He initially maintained two offices: one in downtown Chicago, and the other in Roseland, a separate town later absorbed into Chicago's South Side. Carnegie's Roseland office was in a building next to the site for the Roseland Safety Deposit Bank.[49] The Roseland Safety Deposit Bank was built in 1914 (fig. 6.9) and underwent some remodeling in 1925. Both the original design and the remodeling were by Carnegie.[50] Two stories high, the front facade was Sullivan-inspired, glazed terra cotta. Among the terra-cotta features was an eagle and shield with colorful glazes. This too was a Midland stock piece, number 2904B, and measured four feet eight inches high with a dimension of five feet four inches for the span of the eagle's wings. All but one of Carnegie's buildings employed terra cotta from Midland; the one exception was supplied by American (fig. 6.10).[51]

The Chicago architect who seems to have been responsible for the largest number of Sullivanesque buildings in the city was Abraham L. Himel-blau. During the sixteen years he maintained a practice, he had more than one hundred buildings constructed. Of this number, more than a third have been demolished; most of those remaining employ Sullivanesque terra

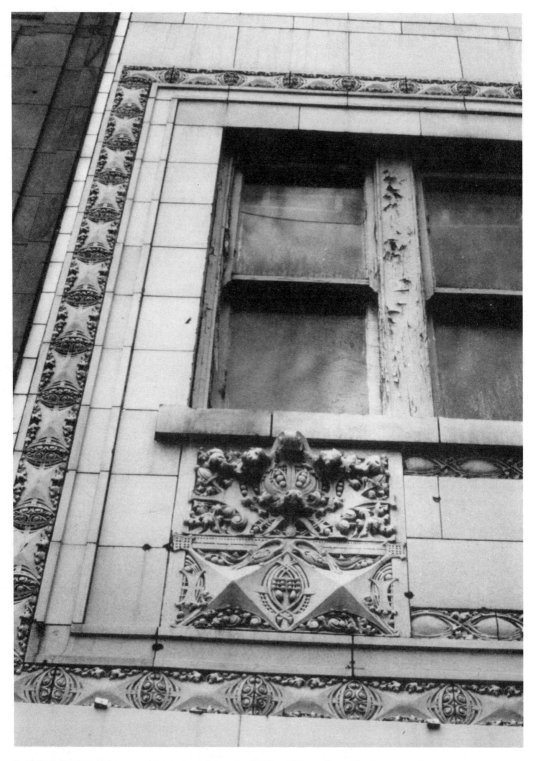

6.10 Detail of Sullivanesque ornament from the Midland Terra Cotta Company on the
Roseland Safety Deposit Bank.

6.11 Detail view of ornamental cluster based on Midland catalog facade example, detail number 1, plate 47. The central piece was the disc, number 4508. The white glazed terra-cotta facade in Wilmette, Illinois, has been demolished.

cotta.[52] Himelblau was born in 1890 in Waverly, Iowa, and came to Chicago with his parents at age ten. He completed the studies of the Chicago School of Architecture, which included classes at the Art Institute of Chicago and the Armour Institute. In partnership for only one year, 1914, as the firm Himelblau and Eisenberg, Himelblau thereafter practiced architecture in sole proprietorship until 1931, when the depression forced him to retire. He died in 1944.[53] Himelblau's first built commission was in 1915 for H. Emmermann and appeared in the September 1916 issue of *The Western Architect*. The apartment building, U-shape in plan, had quoins of terra cotta that gave it a Tudor expression, however, the ornament was Sullivanesque. It was the only Himelblau building that employed terra cotta from The American Terra Cotta and Ceramic Company. His other buildings used stock terra cotta from the Midland Terra Cotta Company.[54]

The buildings designed by Himelblau always employed terra cotta, but his designs varied in their application of ornament. Some of his designs seem to be excessive in their use of ornamental medallions, whereas others minimized the ornamental motifs and restricted Sullivanesque terra cotta to subtle accents and stringcourses. His smaller buildings tended to have

6.12 The architect Abraham L. Himelblau designed the building on West Roosevelt Road in Chicago and adapted a basic ornamental cluster as suggested in a Midland catalog. Much like detail number 1, plate 47, stock Sullivanesque terra cotta was composed with yellow brick.

ragged parapet profiles and excessive ornamentation that often seemed applied rather than integral as in Sullivan's designs. Conversely, Himelblau's larger buildings tended to be clean and simple, with uninterrupted horizontal parapets. However, most of his work fell between the two extremes. In general, Himelblau's designs were successful—especially given the scope of his commissions. The speculative building types that came out of his office were associated with the city's neighborhood commercial strips and adjoining apartment districts. His commissions included one-story commercial buildings, service garages, walk-up apartments, and mixed-use buildings with apartments or offices above the ground floor (figs. 6.11, 6.12).

What prompted Himelblau to use the Sullivanesque style is unknown. As a child, he lived with his parents on Chicago's South Side and attended a temple there believed to have been Adler and Sullivan's Kehilath Anshe Ma'ariv Synagogue (1890–91), and the ornament and rich interiors may have made a lasting impression.[55] Himelblau would have known of Sullivan through the Chicago School of Architecture because Sullivan had contact with that school; he was listed as a critic in architectural design in the school's 1914–15 yearbook. Himelblau, like some other Chicago architects

of ethnic background and educated in the city, may have been particularly attracted to Sullivan's call for an American architecture. Himelblau's attraction to the Sullivanesque may have been simply because of the nature of his practice, with its low-budgeted speculative commissions. The utilitarian flexibility of the Sullivanesque facade composition and the economical but handsome stock terra cotta produced by Midland Terra Cotta Company certainly contributed to Himelblau's success.

Louis Sullivan died in 1924. His death and the accompanying coverage he received from the press spurred additional interest in his life and work. More architects attempted the Sullivanesque in 1924 as an experiment or as tribute. However, with his passing, interest in Sullivan's work and ornament soon diminished, and the Sullivanesque decades were over. In some ways, the Sullivanesque may have been an "architecture of democracy." The machine production of terra cotta in the hand-molded Sullivanesque vein contributed significantly to a building art that all could enjoy.

NOTES

Research for this chapter was funded in part by a grant from the Graham Foundation for Advanced Studies in the Fine Arts.

1. Howard Robertson, *The Principles of Architectural Composition* (London: Architectural Press, 1924). On the building compared to Sullivan's, Robertson wrote: "A typical American Bank Building, The First National Bank, Hoboken by Kenneth Murchison. This type is dignified and well handled, but contributes little to the progress of architectural design" (p. 141).

2. A. N. Marquis, *Who's Who in Chicago: 1931* (Chicago: A. N. Marquis, 1931), p. 621.

3. *The Northwestern Terra Cotta Company* (Chicago, 1912).

4. Sharon S. Darling, *Chicago Ceramic and Glass* (Chicago: Chicago Historical Society, 1979), pp. 168, 185.

5. John A. Bryan, *Missouri's Contribution to American Architecture* (St. Louis: St. Louis Architectural Club, 1928), p. 353.

6. Statler Gilfillen, ed., *The American Terra Cotta Index* (Palos Park, Ill.: Prairie School Press, 1974). A detailed review of orders verifies terra cotta from the American Company for Sullivan's buildings.

7. Darling, *Chicago Ceramics and Glass*, frontispiece.

8. Lauren S. Weingarden, *Louis H. Sullivan: The Banks* (Cambridge: MIT Press, 1987), p. 79.

9. Martin W. Reinhardt, "Norwegian-born Sculptor, Kristian Schneider; His Essential Contribution to the Development of Louis Sullivan's Ornamental Style," paper presented at the Norwegian American Life of Chicago symposium, October 23, 1982, the Norway Center, Chicago.

10. *Illinois Society of Architects Monthly Bulletin* 19 (April–May 1935):4.

11. A. N. Marquis, *Who's Who in Chicago: 1926* (Chicago: A. N. Marquis, 1926), p. 329.

12. *The Brickbuilder* 23 (December 1914): ix.

13. "Design for a Small Bank Front," *Common Clay* 2 (March 1921):17.

14. Willard Connely, *Louis Sullivan: The Shaping of an American Architecture* (New York: Horizon Press, 1960), p. 285.

15. Gilfillen, *The American Terra Cotta Index*, p. 291.

16. Ibid., p. 296.

17. *The Western Architect* 12 (November 1909):11.

18. Craig Robert Zabel, "The Prairie School Banks of Frank Lloyd Wright, Louis H. Sullivan, and Purcell and Elmslie," Ph.D. diss., University of Illinois at Urbana-Champaign, 1984, p. 495.

19. *The Western Architect* 33 (April 1924):47.

20. David Gebhard, "William Gray Purcell and George Grant Elmslie and the Early Progressive Movement in American Architecture from 1900 to 1920," Ph.D. diss., University of Minnesota, 1957, p. 105.

21. Craig Zabel, "George Grant Elmslie and the Glory and Burden of the Sullivan Legacy," p. 1 of this volume.

22. D. Orr Gordon, Jr., "Louis W. Claude: Madison Architect of the Prairie School," *The Prairie School Review* 14 (Final Issue, 1977):6–7.

23. *Woodbury County Court House* (Sioux City: Board of Supervisors, Woodbury County, 1966), p. 35; much of this book consists of reprints from *The Western Architect*, February 1921.

24. Franklin W. Scott, ed., *The Semi-Centennial Alumni Record of the University of Illinois* (Chicago: Lakeside Press, 1918), p. 96; Mark L. Peisch, *The Chicago School of Architecture: Early Followers of Sullivan and Wright* (New York: Random House, 1964), p. 80, erroneously places Steele's graduation date as 1902.

25. Connely, *Louis Sullivan*, pp. 207, 286.

26. Scott, *The Semi-Centennial Alumni Record of the University of Illinois*, p. 96.

27. Gilfillen, *The American Terra Cotta Index*, p. 42.

28. Darling, *Chicago Ceramics and Glass*, p. 187.

29. A. N. Marquis, *The Book of Chicagoans: 1911* (Chicago: A. N. Marquis, 1911), p. 399.

30. Marquis, *Who's Who in Chicago: 1926*, p. 598.

31. Ibid., pp. 606, 707.

32. *American Carpenter and Builder* 19 (May 1915):103.

33. Gilfillen, *The American Terra Cotta Index*, p. 340.

34. *Midland Terra Cotta Company: Plates* (Chicago: n.d.), p. 45, undated catalog gift to University of Illinois Library on December 11, 1929.

35. Midland Terra Cotta Company advertisement, *American Carpenter and Builder* 20 (December 1915):117.

36. Nancy D. Berryman and Susan Tindall, *Terra Cotta* (Chicago: Landmarks Preservation Council of Illinois, 1985), p. 5.

37. The list of draftsmen, compiled from identifications on shop drawings, was compared to the "List of Architects Licensed to Practice in the State of Illinois," *Ninth Biennial Report of the Board of Examiners of Architects* (Chicago: Board of Examiners, January 1915), pp. 31–54, and "List of Licensed Architects," *Handbook for Architects and Builders* (Chicago: Illinois Society of Architects, 1921), pp. 37–57.

38. Gilfillen, *The American Terra Cotta Index*; a listing was compiled from notes on order records.

39. Determined by my field surveys.

40. Gilfillen, *The American Terra Cotta Index*, p. 347.

41. Ronald E. Schmitt, *The Architecture of Clinton, Iowa* (Clinton: Department of Community Development, City of Clinton, 1980), pp. 26–27, 45.

42. Schmitt, *Architecture of Clinton*, p. 66.

43. "Shop Drawings," *Midland Terra Cotta Company* (Chicago, 1913), courtesy of Northwest Architectural Archives, University of Minnesota Libraries, Minneapolis.

44. Determined by listings in *The Chicago Architectural Annual* (Chicago Architectural Club, 1902). Jervis R. Harbeck is listed as a member at 1107 Steinway Hall, the same office listing for Webster Tomlinson. *The Chicago Architectural Annual, 1903* lists Jervis R. Harbeck as a nonresident member at 123 Theodore St., Detroit, Michigan. Frank Lloyd Wright was not a member of the club, however, in *Frank Lloyd Wright to 1910: The First Golden Age* (New York: Van Nostrand Reinhold Publishing, 1958), Grant Carpenter Manson lists Wright's Chicago office as 1106 Steinway Hall for the years 1901–7 (p. 215).

45. Phil H. Feddersen (Clinton, Iowa, 1980), personal interview; Feddersen is an architect in Clinton and a distant relative of Harbeck's.

46. This seems verified by my extensive field surveys to identify an inventory of Sullivanesque buildings and cross-referenced to researched dates. More than twice as many Sullivanesque buildings seem to have been constructed in 1922 than in any other.

47. National Terra Cotta Society, *Architectural Terra Cotta: The Store*, vol. 3 (New York: National Terra Cotta Society, n.d.), p. 25.

48. Gilfillen, *The American Terra Cotta Index*, p. 351.

49. Illinois Board of Examiners of Architects, *Bienniel Reports: 1899–1915* (Chicago: Board of Examiners, 1899–1915), 1911, p. 31; 1913, p. 33; 1915, p. 34.

50. Gilfillen, *The American Terra Cotta Index*, pp. 340, 424.

51. Ibid., pp. 25, 335, 340, 344, 351, 352, 359, 417, and 424; a listing prepared of Carnegie buildings using terra cotta, and checking orders for the terra cotta verifies this.

52. Verified by my extensive field surveys to identify an inventory of Sullivanesque buildings.

53. Correspondence with A. L. Himelblau's son, Alan, November 1987.

54. Gilfillen, *The American Terra Cotta Index*; a listing prepared of Himelblau buildings using terra cotta, and checking orders for the terra cotta, verifies this.

55. Correspondence with Alan Himelblau.

7

BREWERY ARCHITECTURE IN AMERICA FROM THE CIVIL WAR TO PROHIBITION

SUSAN K. APPEL

 American industrial architecture of the nineteenth century was rich and varied, the physical and visual expression of a significant process—industrialization—that reshaped American life throughout the century, but especially after the Civil War. Industrial architecture of the entire period was more than just the history of mills and mill towns. It included many kinds of buildings and complexes which, although they shared some common features, also developed distinctive forms that reflected the particular needs and purposes of the industries they served. The variety of such specialized forms has yet to be understood completely, but it deserves study: first, to clarify how changing technology influenced the forms taken by industrial architecture, and second, to explain how industrial buildings, like other kinds of buildings, express culture—not just the drive to industrialize, but also the social, ethnic, philosophical, and economic conditions prevalent at the time of building. More specifically, such study should investigate the roles played in this architectural development by established traditions, new conditions, and the desires of both clients and professional designers.

Like many other industries in the later nineteenth century, brewing in the United States experienced phenomenal growth. The boom began with major changes in the kind of brewing practiced and the preference for German lager beer over traditional English common beer or ale. Introduced to America by German immigrant brewers in the 1840s,[1] *lagerbier* was light and effervescent and tasted different because it was fermented with a different kind of yeast and aged ("lagered") for an extended period after brewing. Lager was the preferred brew in Germany, and it became tremendously popu-

lar in America as well, stimulated first by a ready market in the vast numbers of German immigrants then flooding into the country.

While some of these Germans settled in the East, even more of them settled in the Midwest. Cincinnati, St. Louis, Milwaukee, Chicago, and dozens of other places large and small became centers of transplanted German culture, an enduring landmark of which was the brewery. Long before Milwaukee became known for its beer, Cincinnati and St. Louis were the leading brewing cities in the Midwest,[2] but all three contributed to the architectural development of the American brewery. Chicago also acquired significance as an important brewing center and headquarters for many of the most prominent brewery architects, who began to professionalize brewery design in the 1860s and 1870s.

Even before the emergence of brewery specialists within the architecture profession, the move to lager brewing itself gradually altered the design of breweries. In addition to a building in which brewing took place, the early lager brewery also required some kind of cool, generally underground storage chamber in which to lager the beer. Increasing demand for lager inspired more breweries to open, but also pushed the well-established ones to expand their facilities. As the industry grew, its success encouraged the invention of more efficient and economical equipment, which helped to regulate the process more scientifically and further increase production.

At the same time, new equipment forced the physical reorganization of brewery spaces. Increased production also intensified the problem of providing sufficient space and controlled conditions for both brewing and lagering vast quantities of beer. Solving these problems began to be more than brewers and traditional builders could handle. As a result, in the years following the Civil War, professionally trained architects and engineers began to address the issues of creating brewery buildings capable of containing new kinds of equipment efficiently, withstanding the weight of increasing amounts of materials, and taking advantage of new scientific, architectural, and engineering ideas. Brewery design as an architectural specialty grew and prospered along with the brewing industry until both were checked by Prohibition after World War I.

Before Prohibition, at least one prominent brewery architect set down his thoughts on the historical development of brewery architecture in the United States. Frederick Widmann of St. Louis, writing in 1912 in the important trade journal *The Western Brewer*,[3] laid out a sequence of three distinct periods in the brewery's history. During the first of these, dating from pioneer days to about 1860, breweries were generally small and very simple in their layout and manner of production. In Widmann's second period, from 1860–80, prosperity in the industry encouraged more carefully designed and substantially built breweries, requiring the services of the earliest architects and engineers recognized as specialists in this field. During Widmann's third period, from 1880 to the date of his article, brewery design was entirely dominated by architects and engineers, whose expertise helped brewers to

deal effectively with greatly increased demand, competition, and complexity in equipment and facilities.

Closer study of the changing nature of brewery design verifies Widmann's outline for the most part, although his final period could be extended a few years to the beginning of Prohibition or broken into a second and third generation of architects. Also apparent but not emphasized by Widmann is the fact that throughout the pre-Prohibition era, the most active of these architects were based in the Midwest. Of all the architects who came to work in the field, however, it was the first generation, the pioneers of professional brewery design, who established the essential features and direction of change that made possible the transformation of the vernacular brewery into a highly specialized and handsome form of industrial architecture.

In the period before the brewery architect emerged, breweries were vernacular buildings shaped in part by the needs of the brewing process and by traditional building forms and methods. Few breweries before the middle of the nineteenth century were very large, even in the East, or had equipment much beyond the most basic vessels and tools needed to run the operation by hand or by horsepower. A brew house was generally no more than two stories high, perhaps with a louvered cupola for ventilation, and its interior equipment was arranged to facilitate a relatively horizontal, semigravitational flow of the developing brew. The process entailed pumping water to a reservoir on the highest level, letting it run down into a copper for boiling, then down again into the mash tub, where it was mixed with malt to become mash. The mash was then pumped up into the brew kettle for boiling into wort, then run through large, shallow cooling pans arranged in a horizontal sequence before being transferred to large vats for fermentation and storage in cool, underground caverns. If the brewery became prosperous, it would likely adopt steam power, which began to complicate matters architecturally.[4] Unfortunately, few early breweries were illustrated or described in detail. It appears there was little architectural difference between breweries run by English or German brewers until lager began to catch on in the later 1840s and 1850s.

In St. Louis, lager brewing began when Adam Lemp established his first small brewery, probably in 1841–42.[5] Lemp had come to the United States from Germany, and his introduction of lager to St. Louis was credited with revolutionizing the local brewing business.[6] Architecturally, however, Lemp's brewery was traditional and vernacular in the American mode. His initial brew house and the cellar house added behind it (fig. 7.1) were tiny, two-story stone structures on a sixty-four-foot-wide lot on Second Street. These facilities were soon too small to satisfy demand, and in 1845 Lemp began altering a natural cave just south of the city limits for use as a lagering cellar for the beer produced back on Second Street.[7] A newspaper of the time found the project sufficiently interesting to describe in detail: "The cave is about one hundred yards long, and is divided into three compartments: the average width is about 20 feet, and the arch is turned with great regularity.

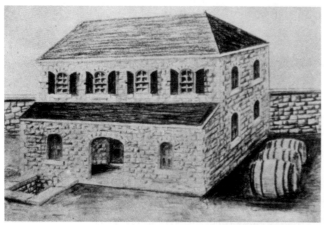

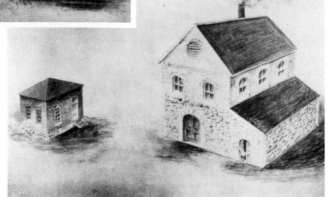

7.1 Adam Lemp's original brew house and storage cellar building, St. Louis, 1840s. (*One Hundred Years of Brewing* [Chicago: H.S. Rich, 1903], pp. 211–12)

Mr. L. has now stored in it about 3,000 barrels, and more may, when his arrangements are completed, be stored in it. The cave, and the style in which it is fitted up, and the taste displayed in laying off the grounds, will richly repay a visit."[8]

Enlarged facilities and continued high demand made Lemp one of the larger brewers in St. Louis by 1850.[9] Further expansion above the cellars[10] eventually made his the largest brewery in St. Louis, until Anheuser-Busch surpassed it in the early 1880s. Two years after Lemp's death in 1862, his son, William J. Lemp, moved the brewery's operations entirely to the site above the cellars, where he developed the business extensively. By 1875, the younger Lemp had invested more than $200,000 in buildings and machinery,[11] and the Lemp Brewery had become a compact cluster of three-story buildings (fig. 7.2) capable of producing more than forty-two thousand barrels of beer. The period when architects and engineers would reshape the brewery's architecture substantially was about to begin.

In Cincinnati, one of the earliest brewers of German background was George Herancourt, who came from Bavaria and established the City Brewery in 1836.[12] Herancourt represents the German brewer in a transitional period: he began brewing when top-fermented English beer was the norm, but turned to bottom-fermented German lager brewing in 1851, building the first underground lager cellars in Cincinnati in 1852. Almost nothing is pre-

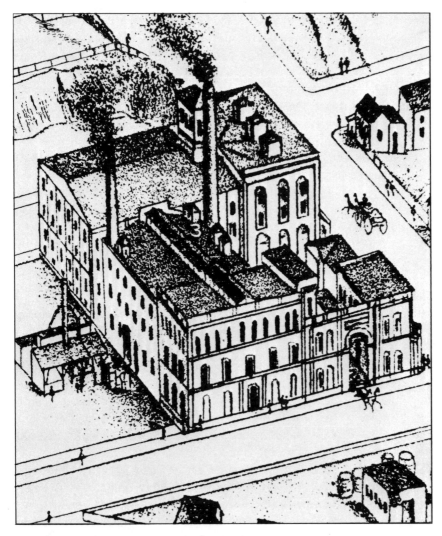

7.2 William J. Lemp Brewing Company, St. Louis, 1875. (Richard Compton and Camille Dry, *Pictorial St. Louis* [St. Louis: Compton, 1875], plate 9)

served of his original brewery, in part because of his prosperity. To keep up with demand, Herancourt's plant was enlarged considerably beginning in the 1880s under the direction of the architect George Rapp;[13] its remaining buildings thus no longer represent the vernacular phase of the history of brewery architecture.

Brewery architecture did not move directly from the primitive structures of the 1840s and 1850s to the professionally designed plants of the 1880s. Little remaining visual evidence documents clearly what happened to St. Louis breweries in the 1860s, but in Cincinnati in that decade, at least three major brewing firms built important structures that remained the core of their plants up to Prohibition. These three, the Hauck, Windisch–Muhlhauser, and

Moerlein breweries, begun in 1863, 1866, and 1868, respectively, resembled one another and demonstrated the enlarged form and more elaborate style associated with major breweries by the 1860s. None of the three was recorded as having been designed by a known architect. All were composed horizontally, with streetfronts of several distinct but connected units spread out along their respective properties. Each of them also shared what was basically an early Romanesque Revival style in brick, incorporating round-arched and circular windows aligned in regular patterns and set in pilastered walls capped with corbelled blind arcades and hints of battlements. While all had numerous windows, they also had a visual balance between openings and smooth, solid wall surfaces. Such features tied these American breweries to the German *Rundbogenstil,* an eclectic style combining Romanesque and Renaissance design elements, of which their owners may well have been aware.

Representative of these 1860s breweries was Windisch–Muhlhauser's Lion Brewery (fig. 7.3), built in 1866 by Conrad Windisch and Gottlieb and Henry Muhlhauser, all of German background.[14] Windisch had just sold his interest in the successful Moerlein Brewery to his partner and was establishing the brewery that would be Moerlein's strongest local competitor through the end of the century. In style, the Lion Brewery possessed all of the basic Romanesque Revival and 1860s brewery characteristics noted previously. It was composed of three major units, the center one slightly smaller than the outer two, all of them connected by narrow units with wagon entries in an *A-B-C-B-A* rhythm. This structure was about 227 feet wide by 156 feet deep and rose above extensive underground cellars dug in 1866, directly alongside the Miami and Erie Canal, which it used for transportation.[15]

The success achieved by breweries like Lemp, Windisch–Muhlhauser, Moerlein, and Hauck reflected the remarkable burgeoning of lager beer's popularity with the American public at large, not just the German-born.[16] To take advantage of this situation, brewers had to find ways to produce greater quantities of beer, lager it efficiently in larger temperature-controlled places, and distribute it to markets that began to extend far beyond earlier geographical boundaries. Continual expansion and innovation complicated the construction of brewery buildings. To work out the complexities, brewers turned more frequently to the professional architects and engineers who had begun to specialize in brewery design.

Widmann dates the pioneer generation of brewery architects to the period between 1860 and 1880. His dating seems intended to draw attention to this as an inaugural period when fundamental principles of brewery design were first worked out, but some of those whom Widmann characterizes as pioneers were active far beyond 1880. Widmann does not point out that most of these pioneer brewery architects, like many brewers, were German-born, and that some are known to have trained in German polytechnic schools. American brewery architecture in this important period thus

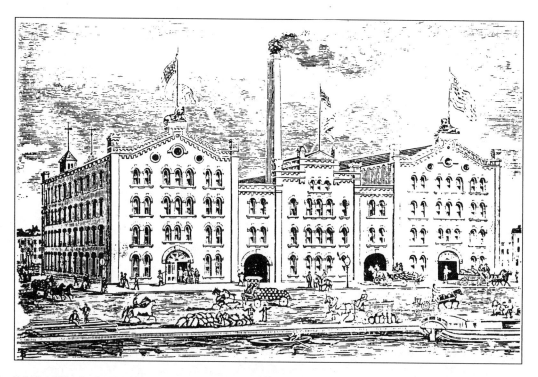

7.3 The Windisch–Muhlhauser Brewing Company's Lion Brewery, Cincinnati, 1866. (Andrew Morrison, *The Industries of Cincinnati* [Cincinnati: Metropolitan Publishing, 1886], p. 157)

acquired a double dose of German influence, while it also responded to the particular conditions of building and brewing in the United States.

Despite Widmann's claim, there is little evidence of architect-designed brewery projects before the late 1860s. One of the earliest known architect-designed brew houses was Edmund Jungenfeld's building for E. Anheuser and Company in St. Louis (1869). The company's owner, Eberhard Anheuser, was not originally a brewer, but by 1860, as a result of another firm's bankruptcy, he came into possession of the small Bavarian Brewery, built in 1852.[17] In 1865, when Anheuser took his son-in-law, Adolphus Busch, into the firm, the brewery was successful, but still considerably smaller than those discussed previously in either St. Louis or Cincinnati. It was, however, about to enter a period of exceptional growth as a direct result of Busch's involvement in the firm.[18] Adolphus Busch was universally acclaimed as the genius behind the phenomenal success of what became in 1879 the Anheuser-Busch Brewing Association.[19] It was under his direction that the brewery began rapidly to increase its production, and it was Busch who brought Jungenfeld's considerable talents to the task of expanding the brewery's physical plant.

Like Busch, Jungenfeld came from Mainz, Germany, and was well edu-

cated in his homeland before emigrating to the U.S.[20] Shortly after arriving in St. Louis in 1864, Jungenfeld entered into partnership with one of the most respected of the city's architects, Thomas Waryng Walsh, with whom he is known to have worked on numerous prominent public buildings.[21] However, when Busch employed Jungenfeld to build a new brew house in 1869, he set in motion a major shift in the career of Edmund Jungenfeld, who from then on began to specialize in this new branch of architectural design.[22] By the time of his early death in 1884, Jungenfeld had become a leading figure in the field.[23]

The relationship between Jungenfeld and Busch proved highly beneficial for the Anheuser-Busch Brewery as well. From 1869 almost to Prohibition, the brewery's physical layout and general appearance were guided first by Jungenfeld himself, then according to his plans or in the spirit of them by his handpicked successors.[24] By the early 1890s, Anheuser-Busch was often called the largest brewery in the world, and "while one of the most colossal establishments on the globe, with its massive buildings covering some forty-five full city blocks, there is [sic] being added constantly new buildings, new departments and facilities to meet the increase in consumption of its famous beers."[25] Most of those new buildings were designed by E. Jungenfeld and Company.

A glance at the brewery as it looked in 1869 (fig. 7.4) hardly prepares one for the mammoth complex Anheuser-Busch became later in the century. Instead, the 1869 brew house was a modest three-story structure, more or less rectangular, perhaps sixty-two by thirty feet in plan and about twenty-six feet high.[26] It was likely built of brick and featured triple round-headed windows regularly spaced in four of the five bays of the facade. The focus of the facade was a gabled central bay, which stepped out slightly from the rest of the wall and had double rather than triple windows. The bays flanking the center had large wagon entrances at ground level, giving the facade an *A-B-C-B-A* rhythm. Jungenfeld's rhythmic order, along with his window forms, balance between wall surfaces and openings and overall horizontality were reminiscent of, but simpler and less ornate than, the Cincinnati breweries of this same decade. Compared with the adjacent original brew house (on the left in fig. 7.4), Jungenfeld's design was clearly more orderly and more sophisticated, yet it hardly altered the traditional vernacular approach to brewery design.

Within ten years, though, significant changes were afoot in the design of breweries, and Jungenfeld's activities at Anheuser-Busch again illustrated those changes. The brewery's business had grown tremendously, especially after 1873, when Anheuser-Busch first introduced pasteurizing of bottled beer. This process allowed for long-term viability and distant shipment of bottled beer, the large-scale marketing of which propelled the brewery to enormous nationwide success.[27] By 1878, its production had surpassed sixty-eight thousand barrels,[28] far outstripping the original twenty-five-thousand barrel capacity of the 1869 brew house,[29] even though continuous addi-

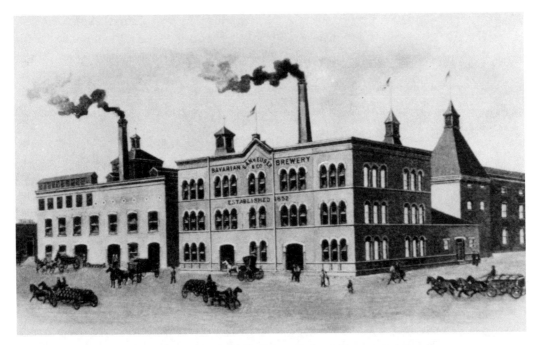

7.4 Edmund Jungenfeld, brew house for E. Anheuser and Company (right), with original brew house, St. Louis, 1869. (*One Hundred Years of Brewing*, p. 348)

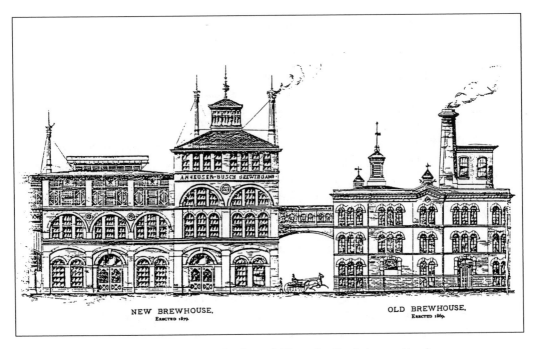

7.5 Edmund Jungenfeld, brew house and other additions for the Anheuser-Busch Brewing Association, St. Louis, 1879. (*The Western Brewer*, December 1879, supplement)

tions had been made to it. A larger facility was required—a second new brew house designed by Jungenfeld along with other additions (fig. 7.5), described and illustrated in an article in *The Western Brewer* in late 1879.[30]

The 1879 brew house was larger than that of 1869, perhaps 97 feet by 55 to 60 feet in plan overall, but was divided into two functionally and visually distinct sections. On the right, crowned with a cupola on a hipped roof, was the section where brewing actually took place, the process confined to a space only about 40 by 37.5 feet in plan, but about 50 feet high.[31] Inside (fig. 7.6), the water tanks, malt hopper, mash tub, brew kettle, and other equipment were organized vertically, rather than horizontally. This vertical interior arrangement was clearly expressed in the upright, cubic exterior design of this part of the structure. Jungenfeld's use of interior iron columns and beams, clearly visible in the section drawing, helped make possible the more vertical arrangement within. The iron supports took up relatively little floor space, allowing plenty of room for the enlarged hoppers, tanks, and kettles, yet had the strength to support the weight of several levels of large, liquid-filled vessels. Iron framing also helped protect the brewery from fire.

The walls of the new brew house were more open than in Jungenfeld's earlier design, providing abundant light and ventilation within. The exterior still showed groups of round-headed windows placed in a carefully ordered way, but now they were more ornately framed within a system of pilasters, larger arches and stringcourses. Although this brew house was in some ways more decorative than the earlier one, efficiency was also a primary concern, as indicated by *The Western Brewer*'s comment that the Anheuser-Busch layout "clearly illustrates the labor-saving principle of its construction on the smallest possible superficial area. From the cold water tank and hoppers to the grand, everything runs without the assistance of pumps."[32]

Such an interior arrangement constituted a full gravity-flow system of brewing—not an entirely new system, but one being reshaped at this period into a more emphatically vertical arrangement that was efficient and logical and came to be standard in lager breweries throughout the rest of the century. In this system, the raw materials of brewing (water, malt, hops, and any adjuncts used) entered the top of the brew house and were combined and cooked in various steps as appropriate, each step flowing by gravity from one level downward to the next.

At the bottom of the brew house, the brew was pumped with steam power to open surface coolers, where its temperature was reduced so that yeast could be added. In Jungenfeld's design, the coolers were on the upper level of the left section of the brew house, again supported by interior iron framing, in an area ventilated by louvered windows and cupola. From these surface coolers, the brew descended to the floor below, flowing over the ice-water-filled metal tubes of a Baudelot cooler to further reduce its temperature. It then was pumped again, first to the fermenting house, then to storage chambers to begin lagering.

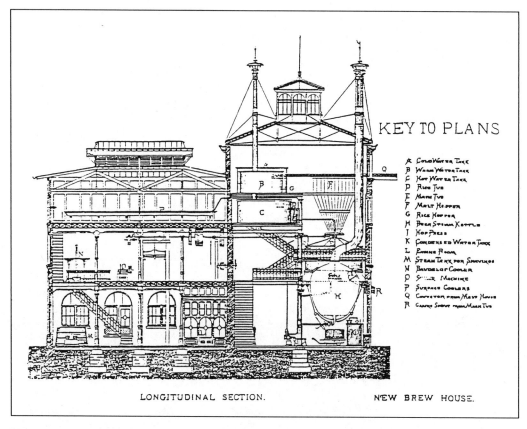

KEY TO PLANS

A Cold Water Tank
B Warm Water Tank
C Hot Water Tank
D Rice Tub
E Mash Tub
F Malt Hopper
G Rice Hopper
H Beer Steam Kettle
I Hop Press
K Condensed Water Tank
L Engine Room
M Steam Tank for Shavings
N Baudelot Cooler
O Sugar Machine
P Surface Coolers
Q Conveyor from Malt House
R Grain Spout from Mash Tub

LONGITUDINAL SECTION. NEW BREW HOUSE.

7.6 Edmund Jungenfeld, 1879 brew house, longitudinal section. (*The Western Brewer*, December 1879, supplement)

Jungenfeld's handling of these fermenting and storage structures was experimental and brings up other important changes occurring in the design of 1870s breweries. As production skyrocketed, brewers like Anheuser-Busch needed larger and larger spaces in which to ferment and lager beer at properly cool temperatures. Underground cellars were not entirely abandoned,[33] but their fluctuating temperatures in summer had traditionally confined brewing to the winter months.[34] Increasing demand required that more efficient avenues be explored for keeping fermenting and lagering cellars cool so that year-round brewing could become a reality. In the 1870s, these concerns spawned a wide variety of schemes to build the perfect above-ground icehouse. Most such structures contained three stories of "cellars" below a huge ice chamber. Jungenfeld's 1879 fermenting and storage additions to Anheuser-Busch, however, were based on a patented system devised by William D.W.C. Sandford, which spread out the components somewhat horizontally, both to avoid extremely heavy construction and to provide free-flowing cool air where needed.[35] The new fermenting house was here placed between two ice chambers, both with few if any wall openings to help

keep the cold inside; the smaller of the ice chambers also cooled a storage chamber below itself.

Although unusual in its horizontality, Jungenfeld's scheme was nevertheless an example of the decade's moving away from strictly underground lagering facilities. Above-ground and using natural ice to create a temperature-controlled environment, the icehouses were a transitional form. They stood between the early reliance of lager brewers on caves and underground cellars and the development of large-scale, above-ground, mechanically cooled stock houses made possible by artificial refrigeration in the 1880s and beyond. The quickness of this development is demonstrated by the fact that as early as 1881–82, again under Jungenfeld's direction, Anheuser-Busch boldly converted its entire plant to mechanical refrigeration, undertaking the largest refrigeration job attempted anywhere to that date.[36]

Jungenfeld's concern with refrigeration was in no way unique among early brewery architects. It was a basic issue to be dealt with, and some of the first generation of designers themselves invented or became distributing agents for the latest innovative ideas in refrigeration. Jungenfeld provides an introduction to one of these. From November 1878 to April 1880, he was a long-distance partner of Theodor Krausch, another German-born and German-trained brewers' architect and engineer. Krausch moved his office from New York City to Chicago in 1877,[37] a good indication of the growing significance of the Midwest as a base of operations. He was especially interested in refrigeration technology and in 1877 patented a system that combined natural ice with an early ice machine; the system was installed successfully in Buffalo and Chicago breweries.[38] In the 1870s and early 1880s, Krausch specialized in providing refrigerating houses for breweries from New York to Nebraska, Wisconsin to Texas.[39] In addition, he also designed new brew houses, notably the one built in 1885 in St. Louis as part of the great expansion of William J. Lemp's brewery.[40]

Krausch was one of a growing number of brewery specialists who congregated in Chicago from the 1870s on, making that city, with St. Louis, New York, and Philadelphia, one of the major centers of brewery design. By 1915, Chicago had produced almost twice as many of the brewery projects known to have been designed by architects as any other city in the country.[41] Many of these architects, in Chicago and elsewhere, shared the German heritage of their clients and brought to their work solid training that served them well in addressing emerging issues in brewery design.

One of the architects was Frederick Baumann, the first German-born architect to practice in Chicago, who arrived there in 1850 and is generally better known today for his work in buildings other than breweries.[42] No brewery projects actually built by Baumann are known, but by the 1870s, he was actively involved in this field. He also proved influential in its future development, especially through his writings. Baumann's up-to-date understanding of the problems of contemporary breweries appeared in an article

in *The Western Brewer* in November 1876.[43] His simple plan and section drawings (fig. 7.7) described a model brewery quite different from the norm of earlier decades, but quite like what was about to appear in Jungenfeld's 1879 Anheuser-Busch brew house. Even a quarter of a century later, *One Hundred Years of Brewing* declared the ideas expressed in Baumann's article "practical as well as prophetic."[44]

Baumann's model brewery plan was divided into two portions of roughly equal size, the lower part of the plan showing the brewery proper (to the left in the section), the upper part an above-ground fermenting and lagering house (to the right in the section). Shown in the section as the central element of the brewery proper, Baumann's brew house was to be four stories high above a tall basement, but limited in plan size. It was clearly intended for a vertically arranged gravity system of brewing and was centrally and efficiently located in the middle of malt and grain bins, boiler house, office, and other functionally related spaces. There was no sense here of the old horizontal organization of the early brewery. Instead, the brewery was organized in sections shaped and sized according to their different needs, and the brew house was becoming a distinctively vertical element among them.

The considerable bulk of Baumann's fermenting and lagering house in both plan and section reflected the need for plenty of space for these functions at this period. Baumann's interior arrangement was typical of the 1870s' above-ground icehouse. It was cooled by a large ice mass stored in a chamber atop a three-level sequence of spaces, with the fermenting room directly below the ice and two separate lagering floors below. Such a design required heavy construction to support the weight of the ice mass in the upper chamber[45] and the vats of liquid below, one reason that the icehouse would soon give way to a new variation of its theme. Despite his design here, Baumann also understood more advanced technological developments just emerging in the later 1870s that had major implications for the brewery and its architecture. He was remembered for correctly predicting in 1876, the same year these drawings appeared, that the brewery of the not-too-distant future would be cooled by cold air, not ice.[46] In this respect, Baumann anticipated the age of artificial refrigeration, about to dawn in the 1880s.

Visual evidence for the breweries of the 1870s is thin, but the appearance of quite similar ideas in the early work of Baumann and Krausch in Chicago and Jungenfeld in St. Louis throws some light on the architectural and procedural changes that began to alter the appearance of the American brewery in the period. Better preserved are visual records of breweries of the early 1880s, which show more clearly the changing appearance of the American brewery in the hands of other members of the pioneer generation of brewery architects. One of the most prolific of these was Fred W. Wolf, a German-born designer who established an office in Chicago in 1867. He became one of the most widely recognized and longest-lived of pioneer brewery architects and engineers, active and influential in the field from the 1870s until his death in 1912.[47] Wolf's early training in mechanical engineer-

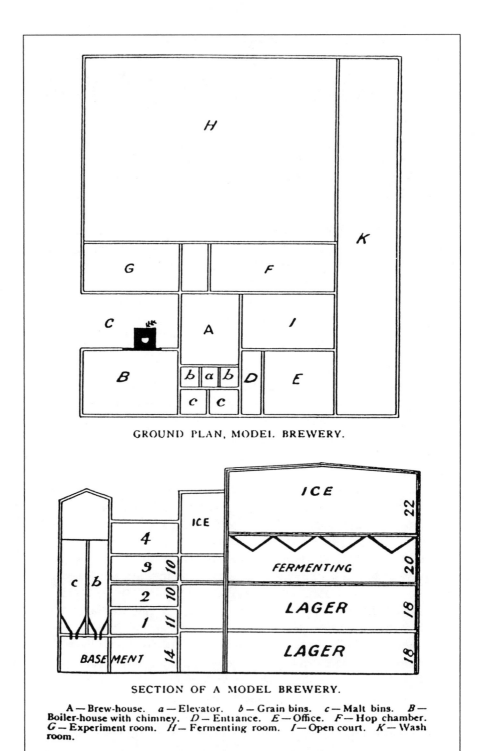

GROUND PLAN, MODEL BREWERY.

SECTION OF A MODEL BREWERY.

A — Brew-house. a — Elevator. b — Grain bins. c — Malt bins. B —
Boiler-house with chimney. D — Entrance. E — Office. F — Hop chamber.
G — Experiment room. H — Fermenting room. I — Open court. K — Wash
room.

7.7 Frederick Baumann, plan and section of a model brewery, 1876. (*One Hundred Years of Brewing*, p. 137)

ing led him to develop a number of new mechanical devices for brewers and maltsters. From 1882, he became a major figure in the field of artificial refrigeration, acquiring the U.S. patent rights to manufacture and distribute the famous German Linde ice machine.[48] In addition, from 1879 on, Wolf advertised his readiness to design and build breweries, icehouses, and related structures. Dozens of designs were attributed to Fred Wolf over the course of his career. Determining how many of them dating before 1894 can actually be identified as Wolf's alone is complicated by the presence in his office from 1874–94 of Louis Lehle, another fine designer of breweries.

Wolf's practice must have developed into a two-sided operation, one part engaged in more mechanical matters, the other in architectural projects. Lehle's position in the firm probably grew gradually, but became substantial. By 1889, if not before, he was managing the architectural side of things,[49] and he advanced further, becoming a partner in the renamed firm of Wolf and Lehle from 1889–94. The partners split in 1894,[50] with each man continuing in his own practice. Their relative architectural input during their time together may be mirrored in their activities after the breakup of the partnership: after 1894, Lehle was involved in almost 150 brewery projects, whereas Wolf is known to have worked on only thirty-five. Certainly, many of the projects from the Wolf office before 1889 must have been collaborations, if not actual designs by Lehle.

Among the earliest illustrated architectural designs attributed to Fred Wolf was a new brew house and projected malt house of 1880 for Fortune Brothers of Chicago.[51] Published only in a section drawing, the brew house demonstrated that Wolf was completely in touch with contemporary thinking on the proper arrangement of such a structure. All of the brewing equipment was organized vertically in a tall, narrow iron-framed space of several levels to facilitate a gravity-flow system of brewing. The connections among Wolf, Jungenfeld, and Baumann are apparent. Little can be said of Wolf's exterior design for this brewery, aside from *The Western Brewer*'s comment that the new buildings "tower high into the air, and are a great improvement for West Van Buren street";[52] they were also said to be solid and imposing, possessing a facade that complemented the new icehouse facade added to the brewery in 1879.[53] Wolf was thus designing something large, substantial, and efficient for a brewery still using an icehouse to lager and store its beer. Shortly thereafter he was promoting a revolutionary new technology—artificial refrigeration—and designing buildings to incorporate it.

Many changes, including some tied to mechanical refrigeration, were visible in Fred Wolf's (and Louis Lehle's?) 1884 design for the Foss-Schneider Brewing Company of Cincinnati (fig. 7.8). This brewery, a descendant of one begun in 1849, had almost outgrown its facilities when it was severely damaged in a February 1884 flood; together, these factors inspired the company to rebuild its plant entirely.[54] Wolf's plans provided a building of architectural grandeur considerably beyond what breweries had possessed in past de-

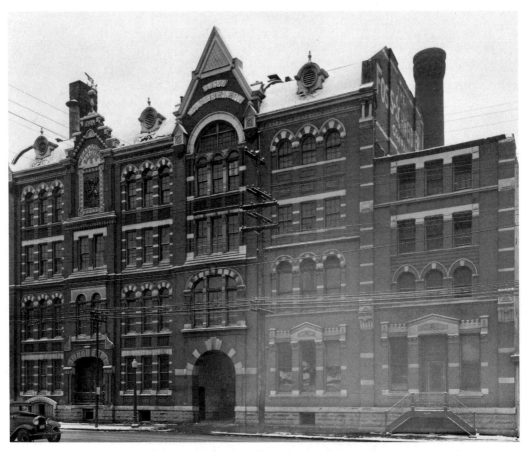

7.8 Fred W. Wolf (and Louis Lehle?), Foss-Schneider Brewing Company's Queen City Brewery, Cincinnati, 1884; 1938 photograph. (Cincinnati Historical Society)

cades. The Foss-Schneider Queen City Brewery was both highly decorative and very functional. Its street facade was varied but cohesive, arranged in six irregular bays, five of them four stories high and crowned with a tall bowed mansard roof that made room for a fifth floor.[55] Each bay or group of bays served a different function: the three on the left (south) were the brew house proper (further identified by inscription), the fourth was the mill house and wagon entrance to the interior yard, and the fifth was the office, which continued into the shorter sixth bay, the back of which was the boiler house.[56] The entire exterior was a rich mixture of brick, stone, and terra cotta, lively and polychromatic, with a High Victorian flavor of mixed heritage. Windows included both Gothic and Romanesque forms, some with Venetian banding or machicolations, gables were stepped and steep-sided, shaped of Flemish or German character, and the roof form and its circular louvered dormers had overtones of the Baroque and Second Empire styles.

Although the overall form was a horizontal block akin to what was seen in earlier breweries, this one showed neither their balance between wall sur-

faces and openings nor their simplicity of design. The wall was no longer a smooth foil for orderly and largely repetitive openings. It was far more plastic, colorful, and open, and if each bay was carefully ordered by aligning its windows and doors in both directions, variety was clearly more important to the designer(s) than regularity. Visually, the brewery had become a striking architectural element of the city at the same time that it provided efficient spaces in which to pursue a growing business: "the Foss-Schneider Brewing Co. was installed in one of the finest and most completely equipped brewery structures in the country, and Cincinnati was adorned with one more grand and magnificent building."[57]

Inside the brew house proper, according to a 1904 Sanborn Insurance Company map,[58] the brewing equipment was carefully organized, brew kettles behind the windows of the left bay, mash tubs behind those of the right, no doubt to facilitate the gravity-flow brewing that had already become typical. Floors in the brew house were cement and ceilings brick-arched, so that interior framing, although not specified as to material, may well have been iron.

Somewhat different from earlier breweries were the four- and five-story cold storage buildings adjacent to and behind the brew house. These were no longer icehouses, but large above-ground stock houses, perhaps forty feet wide and with a combined depth of about 160 feet, supported internally on wooden posts and cooled with mechanically generated cold produced by machines housed in smaller adjacent buildings. Foss-Schneider had begun using artificial refrigeration in 1882, when it installed two twenty-five-ton ice machines; Fred Wolf reorganized the refrigeration system, installing two additional thirty-ton Linde ice machines in 1884.[59] Appearing in other breweries of this period as well, the above-ground stock house became a new architectural element of the brewery by the mid-1880s, a more sophisticated kind of structure in which to ferment and lager beer, and one whose size could increase easily because it no longer needed to depend on massive quantities of heavy ice as the cooling agent.

Lehle, known to have been working with Wolf at the time of the Foss-Schneider design, eventually broke with Wolf in 1894 and went on to pursue his own successful career in brewery architecture. Although most of his work on his own is later in date than that of other pioneering figures, Lehle may rightly be seen as part of their generation. Like Wolf's, Lehle's career extended into the mid-1910s. Of his nearly 150 additional brewery projects, those for which exterior designs are known generally continued basic design features developed in brewery architecture through the 1880s. For example, Lehle's 1895 brewing plant for the Dubuque Brewing and Malting Company, Dubuque, Iowa (fig. 7.9) struck a kind of balance between the functional layout of its various components and the decorativeness of its Romanesque style. It also possessed a certain crispness of line and general organization that came to be common in Lehle's work. It had a picturesque roofline, broken by towers and short battlements, yet an orderly wall pattern of openings

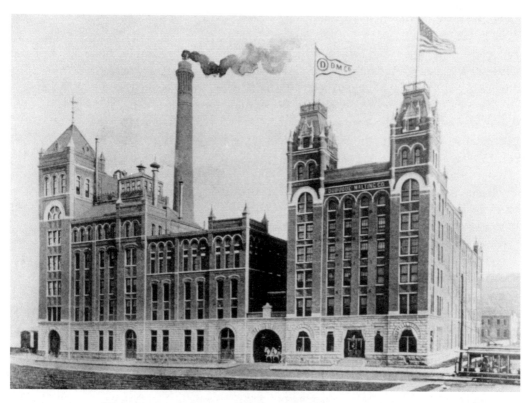

7.9 Louis Lehle, Dubuque Brewing and Malting Company, Dubuque, 1894–95. (*One Hundred Years of Brewing*, p. 517)

carefully aligned and arcaded across the top; the rock-faced coursed stone of the first story gave the whole a solid, but not overwhelmingly massive, base. All of Lehle's Dubuque buildings had concrete and stone foundations, brick walls and stone trim, and they were fireproofed with interior construction of iron and steel, brick and hollow tile arches, and cement and asphalt floors.[60]

If his exteriors did not change markedly in style, Lehle's structural methods showed his interest in the latest technological advances and his rapid assimilation of new ideas. This is particularly visible in his early use of reinforced concrete as a building material, a technique just coming into its own in the first two decades of this century and reported in accounts of Lehle's work by 1908.[61] In 1911, Lehle built "the first brewery stock house to be constructed wholly of reinforced concrete,"[62] for the Theo. Hamm Brewing Company, St. Paul, using the "mushroom" column system patented by C. A. P. Turner of Minneapolis. The following year, in the same issue of *The Western Brewer* in which Frederick Widmann's history of brewery architecture appeared, Lehle's article "Notes on Brewery Design" concluded with a strong statement encouraging the consideration of reinforced concrete for brewery projects. As he rightly concluded, "This material is destined to

occupy a most prominent place in the building and engineering operations of the future."[63]

Despite the prominence of brewery architects from Chicago and St. Louis, other cities such as New York also produced early brewery architects of importance. In addition to Jungenfeld and Wolf, Widmann's 1912 article named as important pioneers in brewery architecture both Charles Stoll and Anthony Pfund of New York City. Neither of the latter pair, however, is as well known as the former, and neither appears to have had nearly as long a career as Wolf or Lehle.

No illustrations and only a few references have as yet surfaced to bear witness to Stoll's contributions to brewery architecture. He must have been a prominent figure because he was entrusted with the design of the influential "Centennial Brewery," an exemplary modern working brewery set up in Brewers Hall during the Centennial Exhibition in Philadelphia in 1876. This occasion proved to be a great impetus to the future development of the brewing industry—its coming of age, according to Stanley Baron. Unfortunately, all that is known of Stoll's model brewery is that it could produce 150 barrels of beer in each brewing, used an icehouse for beer storage, and was the most popular part of the brewers' exhibit.[64]

Stoll advertised in *The Western Brewer* as a designer, builder, and equipper of breweries and related structures from 1877–85 and, like Theodor Krausch, had his own patented icehouse to offer as well. Three projects by Stoll for breweries in Brooklyn, New York City, and Pittsfield, Massachusetts, were reported in the trade press, none of them illustrated. One of these, the 1877 Otto Huber Brewery in Brooklyn, was noted as being of masonry and iron,[65] suggesting that his approach was at least as up-to-date as anything coming out of Chicago or St. Louis. Still, with so little specific information, Stoll remains an intriguing but shadowy figure, unknown beyond 1885.

Somewhat more information exists about Anthony Pfund's brewery projects, but he too remains in the background. Of the dozen projects by Pfund reported in the pages of *The Western Brewer* between 1879–83 five were described as new breweries of brick and iron. The use of iron in brewery designs was clearly increasing in frequency in both the East and Midwest. Pfund's last known but only illustrated project was the new Garryowen Ale Brewery for the Fitzgerald Brothers of Troy, New York, finished in early 1883 (fig. 7.10)[66] The brewery had a capacity of nearly sixty thousand barrels and was six stories high and forty feet wide on the street, 110 feet wide with the adjacent malt house. It was built substantially, with foundations laid on rock, thick walls, girders and pillars of iron throughout, with the first two floors of brick arches between iron joists covered with cement and asphalt.

The Garryowen Brewery's exterior design was restrained in style when compared with Wolf's design a year later for Foss-Schneider. Both were designed with the facade broken into distinct functional units, each of those ordered into bays and stories with pilasters and stringcourses. However, the overall effect in the Troy brewery was flatter, with less ornamentation

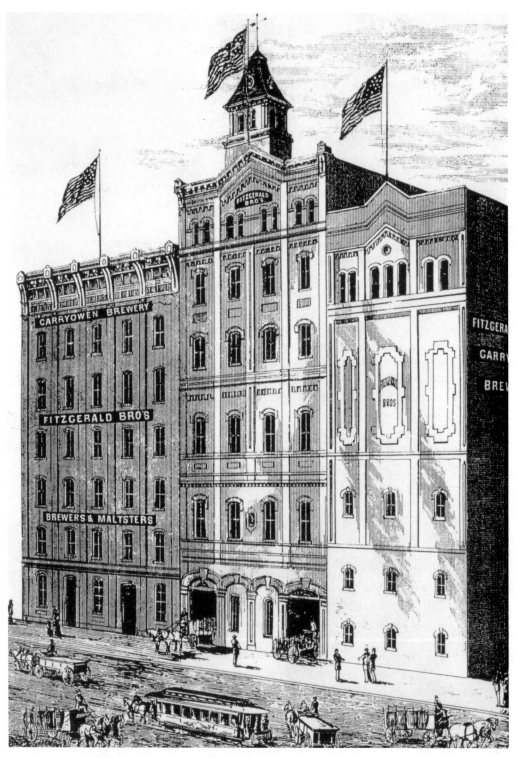

7.10 Anthony Pfund, Fitzgerald Brothers' Garryowen Brewery, 1883, Troy, New York. (*The Western Brewer*, February 1883, p. 261)

and a greater emphasis on the wall than found in the Cincinnati plant. It is not clear whether these differences can be attributed to the architect's own stylistic preferences or to the fact that this was an ale, rather than a lager brewery, run by non-Germanic owners.

A few other architects and firms were also active in brewery design in the first-generation period, for example, Lederle and Company (Joseph Lederle and Lewis Oberlein) in New York City, and Haas and Parsons Company (with J. D. Parsons) in Philadelphia; David Roberts worked in Canada at the same time. Even less is known of their brewery designs than those of Stoll and Pfund. While many breweries were constructed in the East during the time that the first-generation architects were active, more activity and more inspiration for further refining brewery architecture were generated by brewery architects in the Midwest. Some of them, like Wolf and Lehle, lived long lives that allowed them not only to continue working, but also to train and set examples for younger architects over several decades. Other pioneers, like Jungenfeld, died much earlier, but not before training younger designers who carried on and further developed architectural approaches begun by the pioneer generation.

From the solid foundation established by the earliest brewery architects arose the golden age of American brewery design in the 1880s and 1890s. A number of the younger architects who became prominent in this period began their careers in the firms of the pioneers. In St. Louis, Jungenfeld's office was the starting point for Frederick Widmann, Robert Walsh, and Caspar Boisselier, who continued Jungenfeld's business after his untimely death in 1884,[67] and whose masterpiece was undoubtedly the 1892–93 brew house for Anheuser-Busch, still in use. Jungenfeld also employed Wilhelm Griesser, who went on to open an office in Chicago in 1885, pursuing a noted and active career as a brewery designer into the 1910s.[68] Griesser was from 1888–90 the partner of August Maritzen, who got his start in Wolf's office. Maritzen, too, produced a great many brewery projects in the 1890s and attained a considerable reputation in the field.[69] Sometimes the Chicago connection extended beyond the Midwest; for example, Fred Wolf provided training, especially in artificial refrigeration, for the Philadelphian Otto C. Wolf,[70] who became the most prominent brewery architect in the East in the 1880s and 1890s. All of these men and others contributed to the ongoing refinement of the American brewery, yet remained loyal to the ideas, forms, and concepts initiated by the preceding generation.

Second-generation brewery designers also helped launch the careers of still younger architects. The third generation included Chicago-based Oscar Beyer, who had worked with Fred Wolf, then with Griesser and Maritzen, in whose firm he met his later partner, Fred Rautert.[71] More direct family connections also brought new designers into the field. Wilhelm Griesser, for example, saw to the education of his son, Richard Griesser, in American architectural practices and German architectural and brewing schools, then turned over his Chicago office to his son and moved his own operations to

New York City.[72] Such interrelationships among the three generations of pre-Prohibition brewery specialists gave the field a strong sense of continuity. In spite of competition among architects for brewery projects, most improved gradually on what had already been accomplished, rather than producing radically innovative schemes.

The continuity of development was soon to be broken, however. Architects of the youngest generation, taking the brewery into the early twentieth century, often found themselves designing smaller breweries because the largest companies' needs were generally met by architects with long-established ties to particular firms.[73] In addition, fewer new breweries were being established, in part because the ever-growing national-market firms tended to force smaller brewers out of business,[74] and in part because of the increasing success of prohibitionist forces.[75] With restrictive rationing of agricultural products during World War I, then full-scale national Prohibition, brewers and brewery architects alike found their livelihoods largely cut off by 1920.

From the Civil War until Prohibition, then, American brewery architecture was conditioned by its German heritage, the innovations demanded by the growth of the industry, and the expertise of well-trained architects and engineers. Springing from professional rather than vernacular attitudes initiated by the pioneer generation of brewery architects, both large and small brewing plants became generally more handsome and well-built structures through the later nineteenth and early twentieth centuries. They incorporated ever more sophisticated equipment for greater efficiency and production. To facilitate new brewing and structural ideas, their physical makeup changed, revealing a more scientific attitude among both brewers and architects. In exterior appearance, breweries took part in contemporary stylistic trends, but also expressed the usually German background of brewers, who took pride in making their buildings attractive additions to urban environments. The architects responsible for creating the late-nineteenth-century brewery as a distinctive industrial building type were not merely repeating revivalist styles or tapping into a lucrative source of commissions. They too were often of German heritage, well trained, open to technical innovation and seriously interested in continually improving a kind of building that symbolized the German impact on American culture, ethnically, socially, and technologically.

This phase of the history of brewery architecture was brought to an end by national Prohibition, and its especially German quality was lost in the anti-German furor of the World War I years. When Repeal allowed the resumption of brewing in 1933, many of the old breweries were brought back into operation, but they were frequently surpassed by new needs and new market conditions. Breweries built from that point on reflected other attitudes toward the design of industrial buildings, attitudes seldom sympathetic to the preservation of the old, despite its real beauty and rich history. The few pre-Prohibition breweries that remain nevertheless paint an expressive

picture of the architects, clients, and complex influences that shaped this colorful element of American industrial architecture in the late-nineteenth and early-twentieth centuries.

NOTES

1. Although it is unclear exactly who first introduced lager to the United States, when or where, *One Hundred Years of Brewing: A Complete History of the Progress Made in the Art, Science and Industry of Brewing in the World, Particularly in the Nineteenth Century* (Chicago: H. S. Rich, 1903), recounts the story by Charles C. Wolf, of the firm of Engel and Wolf, Philadelphia, that John Wagner of Philadelphia first made the brew in that city in 1840. Stanley W. Baron, *Brewed in America: A History of Beer and Ale in the United States* (Boston: Little, Brown, 1962), pp. 184–86, notes that lager was made in Philadelphia, New York, Cincinnati, St. Louis, Chicago, Milwaukee, and many other places in the 1840s and 1850s, once the cities' German populations were large enough to make it worthwhile.

2. Both Cincinnati and St. Louis had active breweries by about 1810, whereas Milwaukee's first dated to 1840. By the time lager arrived in the middle of the century, brewing was already a substantial industry in both Cincinnati and St. Louis. Even as late as 1877, Cincinnati was the third largest brewing center in the United States, behind only New York and Philadelphia, while St. Louis was fifth and Milwaukee only ninth. As the largest St. Louis and Milwaukee brewers developed more extensive markets, those cities pulled away from Cincinnati. Thus, in 1882, St. Louis was still the third largest brewing city in the nation and Milwaukee fourth, still behind New York and Philadelphia, but Cincinnati had slipped to sixth behind Brooklyn, *The Western Brewer* 7 (July 1882):1061.

3. Frederick Widmann, "The Development of the Buildings and Equipments of Breweries from Pioneer Times to the Present Day," *The Western Brewer* 38 (January 1912):29–32. Widmann was a principal in the firm of Widmann and Walsh, St. Louis, earlier known as Widmann, Walsh and Boisselier (1898–ca.1907), and earlier still as E. Jungenfeld and Co. (before 1884–98).

4. *One Hundred Years of Brewing* states that "steam power, step by step, crowded out manual labor, requiring frequent changes and additions in buildings, caused by the enlargement and the improvement in the operations, [and] more regard had to be paid to an increase of capacity than to fine architecture. . ." (p. 135).

5. James Lindhurst, "History of the Brewing Industry in St. Louis 1804–1860," M.A. thesis, Washington University, June 1939, pp. 34–35. Sources disagree over just when Lemp established his brewery, but Lindhurst cites city directory listings showing him as a grocer at Sixth and Morgan streets in 1840–41, while in 1842, Lemp and Company was a brewing concern on Second Street.

6. D. W. Grissom "Breweries," *Encyclopedia of the History of St. Louis*, ed. William Hyde and Howard L. Conard, vol. 1 (St. Louis: Southern History, 1899), p. 223. Lindhurst, "History of the Brewing Industry," declares that Lemp "opened a new era in the industry and for that reason may well be termed the 'Father of modern brewing in St. Louis' " (p. 37).

7. Ibid., pp. 35–36.

8. *Missouri Republican*, April 10, 1845.

9. Lindhurst, "History of the Brewing Industry," Appendix A. According to this

chart, the top producer in St. Louis for 1850 was the Winkelmeyer Brewery, whose annual production of 7,500 barrels of beer and ale was valued at $40,000; the smallest was the Gast Brewery, whose 150 barrels were worth $750. Adam Lemp, George Busch, and Charles G. Stifel all produced 4,000–5,000 barrels valued at about $24,000, tying for the fifth largest spot among the seventeen operating breweries.

10. Ibid., p. 73.

11. Richard Compton and Camille Dry, *Pictorial St. Louis: The Great Metropolis of the Mississippi Valley* (St. Louis: Compton, 1875), p. 191.

12. "The Late Geo. M. Herancourt, Cincinnati," *The Western Brewer* 5 (July 1880):698.

13. George Rapp, an architect raised and trained in Cincinnati, was especially active in Cincinnati brewery projects in the 1880s. According to Andrew Morrison, *The Industries of Cincinnati* (Cincinnati: Metropolitan Publishing, 1886), Rapp was a fellow of the American Institute of Architects, president of the Association of Ohio Architects and of the Cincinnati Chapter of Architects, and vice president of the Western Association of Architects (p. 214). He was reported to have designed the new brewery for the Herancourt Brewing Company in *The Western Brewer* 10 (February 1885):280.

14. Conrad Windisch was the son of a Bavarian brewer, came to Cincinnati about 1851, and worked in the Herancourt Brewery, among others, before becoming the partner of Christian Moerlein in 1854. In 1866, he sold his interest in the Moerlein Brewery, largest in Cincinnati, to form his own with the Muhlhauser brothers. *One Hundred Years of Brewing*, pp. 408–9; "Conrad Windisch, Esq., Cincinnati, O.," *The Western Brewer* 5 (December 1880):1273. Gottlieb Muhlhauser was also Bavarian-born, but emigrated to the United States as a child, according to *One Hundred Years of Brewing*, pp. 408–9. He and his American-born brother, Henry, operated a successful steam flour mill before associating with Conrad Windisch in the new brewery in 1866.

15. G. A. Muhlhauser, Receipt Book, 1866, collection of Rick Muhlhauser, Cincinnati, Ohio. This receipt book includes records of expenses for constructing the cellars, including materials such as lime and stone, actual digging, and masonry work.

16. In 1850, 431 U.S. breweries produced more than 750,000 barrels of beer, and per capita consumption was a little more than one gallon per year, *One Hundred Years of Brewing*, pp. 252–53; Baron, *Brewed in America*, p. 226. By 1870, those numbers had increased dramatically: a total of 1,972 breweries produced more than six million barrels of beer, and per capita consumption was 5.31 gallons, William L. Downard, *The Cincinnati Brewing Industry: A Social and Economic History* (Athens: Ohio University Press, 1973), pp. 29, 46. The upward trend continued, although the number of breweries declined, so that in 1890, the production of about 1,930 U.S. breweries surpassed 26 million barrels, and per capita consumption increased to 13.67 gallons, *The Western Brewer* 15 (June 1890):1307; Downard, *Cincinnati Brewing*, p. 46.

17. While some sources, such as *One Hundred Years of Brewing*, p. 348, claim 1857 as the year in which Anheuser acquired the Bavarian Brewery, Ronald J. Plavchan, *A History of Anheuser-Busch, 1852–1933* (New York: Arno Press, 1976), dates the acquisition to 1860 (pp. 14–19). Anheuser, formerly in the soap business, was a major creditor of the preceding firm, Hammer and Urban, which failed in 1860. According to Plavchan, Anheuser was optimistic that the little brewery could be a

success, despite its being twenty-ninth in size of the forty breweries then operating in St. Louis.

18. Anheuser's production in 1865 was fewer than four thousand barrels, but increased 100 percent in the next year, once Adolphus Busch was part of the firm. *The Western Brewer* 32 (January 1907):46.

19. One example of the laudatory appraisal of Busch's contributions is the following passage from Hyde and Conard, *Encyclopedia of the History of St. Louis*, "The time was opportune for inaugurating the manufacture of beer on a larger scale than had ever before been attempted in America. Adolphus Busch was master of the situation, and at once the enterprise with which he had become connected felt the vivifying effect of his mental force, his commercial acumen, and his splendid executive ability. He had the genius of a general coupled with the instincts of the merchant, and he marshaled the forces which tend to promote commercial growth not only with consummate ability, but with apparent ease" (vol. 1, p. 284). The change in the name of the firm was reported in *The Western Brewer* 4 (June 1879): 531.

20. Jungenfeld was born in 1841, reportedly studied at the best polytechnic schools at Darmstadt, Karlsruhe, and Paris, then traveled extensively, including to England, France, and Italy, before coming to the United States in 1864, *The Western Brewer* 9 (May 1884):829. Adolphus Busch was born about 1840 (accounts vary), was educated at a college in Brussels, then began his business education in a mercantile house in Cologne, emigrating to the United States in 1857, *The Western Brewer* 7 (October 1882):1575.

21. *The Western Brewer* 9 (May 1884):829.

22. Ibid., pp. 829–30. Because of the brewery's rapid growth and increasing need for new buildings, Jungenfeld "was obliged to devote more and more of his time to the training and studying of the smaller details, and the theories of brewing, so as to distinguish what was needful and useful in all the branches of this important business. . . ." In the literature of brewing, if not that of architecture, Jungenfeld is repeatedly referred to through the 1870s and early 1880s in the most glowing terms as a well known and highly qualified brewery architect.

23. In its obituary, "The Late Edmund Jungenfeld," *The Western Brewer* 10 (January 1885):86, proclaimed that "No man better understood the needs of brewers architecturally, or the building and laying out of brewery plant, and in this respect he has left many monuments of his skill and judgement that will carry his name to posterity. There are few men living capable of taking the place he occupied in our trade."

24. *The Western Brewer* 11 (November 1886):2390, commented on the planned design approach of the Anheuser-Busch expansion: "The original design of this vast group of buildings, made by the late Edmund Jungenfeld, is being carefully worked out, as they approach perfection and development—as building after building, elevator after elevator is added, by his successors, E. Jungenfeld & Co., who have charge of the entire work, and who have proved themselves worthy of the fame of their instructor, whose ideas and expert judgement he bequeathed into good hands." As early as 1875, Frederick Widmann, Robert W. Walsh, and Caspar D. Boisselier were listed in the St. Louis city directory as draftsmen for Walsh and Jungenfeld, then for E. Jungenfeld and Company. The three men continued the architectural practice under the latter name following Jungenfeld's early death in 1884. Finally, in 1898, they changed the firm name to Widmann, Walsh and Boisselier, *The Western Brewer*

23 (January 1898):7. Sometime between the end of 1904 and the beginning of 1907, Boisselier disappeared from the firm, which then became Widmann and Walsh. This is the same Frederick Widmann who wrote the article on the history of brewery architecture mentioned earlier.

25. *Pen and Sunlight Sketches of St. Louis* (Chicago: Phoenix Publishing, ca.1892), p. 82.

26. Dimensions for this brew house are rough estimates figured from the few dimensions included in drawings of the updated Anheuser-Busch facilities published in *The Western Brewer* 4 (December 1879): supplement.

27. "Memo from A-B, Inc.," newsletter for Anheuser-Busch Employees, no. 4 [1959], p. 5, Archives of the Missouri Historical Society, St. Louis, Brewing Industry Papers. This account noted Adolphus Busch's response to a major problem of early brewers, before pasteurization was known—how to keep beer from spoiling. Busch made a point of repeatedly visiting Europe and studying all advancements adopted by European brewers, thus learning early of Pasteur's great scientific work. He set his technical staff to work to perfect a method of pasteurizing bottled beer, which was accomplished in 1873, "after years of long and patient effort." Downard, *Cincinnati Brewing*, p. 46, explains that it was Busch's success with bottled beer and his effective system of distributing it by railroad that began to change the brewery into a national supplier, a goal pursued by the great Milwaukee brewers as well, if a bit later. The national scope of their marketing took these brewers into a different realm than the more regionally oriented brewers in Cincinnati, who (aside from Moerlein) never really tried to move in this direction.

28. *The Western Brewer* 3 (July 1878):434.

29. *The Western Brewer* 4 (December 1879):1091.

30. "Great Breweries of the World," *The Western Brewer* 4 (December 1879): 1091–92 and supplemental illustration.

31. Ibid., supplemental illustration. Approximate dimensions were again calculated from the few figures provided in Jungenfeld's drawings published herein.

32. Ibid., p. 1091.

33. Ibid. Along with the description of the new buildings at Anheuser-Busch, mention was made here of extensive, presumably preexisting storage vaults under the hill behind the new buildings, "all blasted out of solid rock, arched with bricks 21 ft. 6 in. wide, 13 ft. 6 in. high and cooled by direct application of ice. With the completion of the vaults in course of erection, there will be 1,886 lineal feet of vaults, giving the brewery a total storage capacity of over 50,000 barrels."

34. *One Hundred Years of Brewing*, p. 145.

35. "Great Breweries of the World," *The Western Brewer* 4 (December 1879): 1091, no other mention of Sandford or his system has been found.

36. *The Western Brewer* 7 (January 1882):56.

37. Krausch's advertisement in *The Western Brewer* 2 (June 1877):219, gave a New York City address. In describing a new brewery by Krausch in Chicago, the journal's place of publication, it referred to Krausch as "formerly of New York, but now a permanent resident engineer of this city," *The Western Brewer* 2 (September 1877): 344. Some years later, the same journal ran a biography of Krausch, wherein he was said to have been born in 1828 in Dresden and educated there at the *Kreutz Schule* and Polytechnic Academy. He emigrated to the United States during the Revolution of 1848, and after several years' work in railroad design, turned to the technical aspects

of the brewing business, for which he created any number of important technological devices and systems. His date of death is not known, but in 1885 Krausch was called "one of the oldest, if not the oldest, brewery and mechanical engineers in the country . . ." "Theodore Krausch, Esq., Engineer," *The Western Brewer* 10 (November 1885):2225.

38. Krausch's advertisement in *The Western Brewer* 3 (April 1878):235, claimed that his refrigeration system was working perfectly at A. Ziegele's brewery in Buffalo, and was being constructed for Michael Brand's new Lion Brewery in Chicago.

39. Based on references listed in Krausch's advertisement in *The Western Brewer* 3 (November 1878):764.

40. Lemp's 1885 brew house is not discussed herein because most images which include it show it so enclosed by other structures as to make it difficult to analyze effectively.

41. At this writing, I have uncovered roughly 1,680 architect-designed brewery projects dating between the 1860s and 1910s and created by 67 known architects or firms. They range in scope from providing some small component of a brewery to designing whole new plants. Of these 1,680 projects, the majority came out of four major cities: 858 projects can be attributed to architects from Chicago, 460 to those from Philadelphia, 141 to those from St. Louis, and 82 to those from New York. A second group of four cities provided less substantial numbers of brewery designs: 43 from Cincinnati firms, 36 from Pittsburgh, 24 from Brooklyn, and 12 from Boston. The remainder were scattered among architects in a variety of other cities.

42. See comments on Frederick Baumann as the first German architect to practice in Chicago in Roula M. Geraniotis, "An Early German Contribution to Chicago's Modernism," in *Chicago Architecture 1872–1922*, ed. John Zukowsky (Munich: Prestel-Verlag, 1987), pp. 92–94. Baumann was born in Prussia, studied architecture and building in various trade schools, and attended the university and the Royal Academy in Berlin.

43. Reprinted with illustrations in *One Hundred Years of Brewing*, pp. 136–37.

44. Ibid.

45. John P. Arnold and Frank Penman, *History of the Brewing Industry and Brewing Science in America* (Chicago: G. L. Peterson, 1933), p. 114, note that such an ice chamber could be twenty feet high and when full could represent a weight of perhaps 1,150 pounds per square foot.

46. Baron, *Brewed in America*, p. 236.

47. According to Fred Wolf's obituary in *The Western Brewer* 38 (March 1912): 129, he was born near Heidelberg in 1837, educated in local schools, trained first as a locksmith, then in a locomotive works and the sugar industry before studying mechanical engineering at a technical college in Karlsruhe. He emigrated to the United States in 1866, and settled in Chicago in 1867.

48. *The Western Brewer* 7 (September 1882):1395, reported Wolf was the new general agent in the United States for the Linde machine and planned to install a patent Linde *eis maschiene* in the new brew house he was then building for Wacker and Birk, Chicago.

49. Lehle's role was mentioned in a short article, "The Fred W. Wolf Company," *The Western Brewer* 14 (August 1889):1759, which gave considerable attention to current orders placed with the company for Linde ice machines, but also noted how busy it was with architectural design: "Not alone in the machine shops, but also

in the architects' department of Mr. Fred W. Wolf, so ably managed by his partner, Mr. Louis Lehle, do we find this same activity."

50. A notice that Louis Lehle, "late of the Wolf & Lehle Co.," had opened his own offices appeared in *The Western Brewer* 19 (March 1894):523. The notice also indicated that Lehle had twenty-two years of experience in brewery and malt house design.

51. A section drawing appeared in *The Western Brewer* 5 (March 1880): supplement, but was referred to only briefly on p. 250. It showed the already finished new brew house for Fortune Brothers and the malt house they planned to add soon.

52. *The Western Brewer* 4 (October 1879):873.

53. *The Western Brewer* 5 (March 1880):250.

54. The flood damage and the choice of Fred Wolf as architect for the new brewery were reported in *The Western Brewer* 9 (March 1884):473. *The City of Cincinnati and Its Resources* (Cincinnati: Cincinnati Times-Star, 1891), p. 92, notes that the flood devastated the city, including the Foss-Schneider malt house, which collapsed while holding sixty thousand bushels of malt; despite the damage, the company's business was still better than the preceding year's. George M. Roe, ed., *Cincinnati: The Queen City of the West* (Cincinnati: Cincinnati Times-Star, 1895), p. 170, says nothing of the flood damage, but noted that Foss-Schneider's business was so large in 1884 that the firm acquired more ground for a larger facility and engaged "a regular brewing architect."

55. The sixth bay at the right (north) was lower and flat-roofed, suggesting the remains of a once-taller bay. The illustration of the brewery generally used in the company's advertising after 1884 supports this notion because it showed a facade ten bays wide with a very tall, separately mansarded tower at this sixth bay. However, a 1904 insurance map (Sanborn Insurance Company, *Insurance Maps of Cincinnati* [New York: Sanborn Map Company, 1904], vol. 1, plate 49) indicates that the brick part of Foss-Schneider was then basically as seen in the 1938 photo, with the sixth bay just two stories high; to its north was only a one-story frame structure. This discrepancy suggests that a good portion of what the company showed in its advertising was never actually built. Artistic license was not unusual in such illustrations, which complicates trying to determine how breweries really looked in the past.

56. Aside from the brew house's inscription, the functional layout was clarified using the detailed plan of the brewery found in the 1904 Sanborn Map.

57. *The City of Cincinnati and Its Resources*, p. 92.

58. Sanborn Insurance Company, *Insurance Maps of Cincinnati*, vol 1, plate 49.

59. *One Hundred Years of Brewing*, 239, mentions the machines installed in 1882 without identifying their make. Those acquired from Fred Wolf in 1884 appear as numbers 230 and 231 in a list of Linde machines then in operation in "The Linde Ice Machine," *The Western Brewer* 10 (April 1885):688–89.

60. "Brewing in Dubuque, Iowa," *The Western Brewer* 20 (February 1895): 358–59.

61. Lehle's experiments with this material dated to the earliest phase of its development for large-scale building projects. As reported by Sigfried Giedion, *Space, Time and Architecture*, 5th ed. (Cambridge: Harvard University Press, 1967), pp. 325–27, reinforced concrete was first used in the United States by Ernest Ransome in the 1890s, but not used widely until the first decade of the twentieth century. C. W. Westfall's "Buildings Serving Commerce," in *Chicago Architecture 1872–1922*, ed.

Zukowsky, indicates that in Chicago, traditional mill construction "was challenged at the turn of the century when reinforced concrete began to be used in special applications, but this alternative to traditional construction did not become the dominant system until after World War I" (p. 81).

62. "Concrete Construction as Applied to a Brewery Stock House," *The Western Brewer* 36 (April 1911):176–77.

63. Louis Lehle, "Notes on Brewery Design," *The Western Brewer* 36 (January 1912):10–15.

64. Baron, *Brewed in America*, pp. 226–27.

65. The most detailed account of a Stoll project accompanied the announcement of the opening of Otto Huber's model brewery in Brooklyn in *The Western Brewer* 2 (November 1877):462. The new brewery was described as thirty-four by seventy feet in plan and five stories high, built of solid masonry and iron, with a malt tower and cupola on top bringing the height to 110 feet. It had a capacity of sixty thousand barrels per year. Stoll must have been well established in the trade as a brewery designer, given that he was here acclaimed as having "again won lasting praise for his thorough experience and judicious judgement in designing and executing brewery work."

66. "Brewing in Troy, N.Y.—Fitzgerald Bros.," *The Western Brewer* 8 (February 1883):261 and supplemental illustration, n.p.

67. An obituary for Edmund Jungenfeld in *The Western Brewer* 10 (January 1885):86, stated that Widmann, Walsh, and Boisselier had long been employed by Jungenfeld, were selected by him as his successors, and had been "fully and heartily endorsed by all brewers and maltsters with whom they were thrown in contact during their service with the deceased."

68. Griesser was born in Baden, Germany, where he worked as an architect for some time before emigrating to the United States. He worked in Jungenfeld's St. Louis office until the latter's death in 1884, then established his own office in Chicago; his first complete brewery plant was built for the Keystone Brewing Company of Pittsburgh, 1885–86, "Brewing in Pittsburgh," *The Western Brewer* 11 (July 1886): 1447. The pages of *The Western Brewer* reveal more than 125 other brewery projects created by Griesser all over the country and dating up to 1915.

69. August Maritzen's work after the demise of his partnership with Griesser was extensive, although limited in time. Nothing was heard of him after the end of 1898, but by then he had worked on almost eighty projects in every region of the country and internationally as well, *The Western Brewer*, 1890–98, passim.

70. Despite their having the same family name, no family connection between Fred Wolf and Otto Wolf has surfaced. Otto C. Wolf was the son of Charles Wolf, an important early lager brewer in Philadelphia. After being educated in mechanical engineering at the University of Pennsylvania, Otto Wolf spent three years with Fred Wolf's company in Chicago, familiarizing himself especially with the intricacies of mechanical refrigeration. He opened his own office in Philadelphia in 1883, and at his death in 1916, was said to have completed 572 projects, the vast majority of them for breweries. "Otto C. Wolf, Deceased," *The Western Brewer* 48 (January 1917):5.

71. Oscar Beyer and Fred Rautert first appeared as the Chicago firm of Beyer and Rautert in 1893, after both had worked with various other architects and firms specializing in brewery design. Beyer had been with Fred W. Wolf for a number of years, then was foreman for Griesser and Maritzen (whose firm was dissolved in late

1890), and continued with August Maritzen. Rautert had worked with Charles Kaestner and Company, then Griesser and Maritzen (where he presumably made contact with Beyer), and was briefly a partner in Lewandowski and Company before joining Beyer. *The Western Brewer* 18 (November 1893):2446.

72. Born in Baden, Germany, in 1868, Richard Griesser came to the United States at the age of seventeen, about the same time that his father opened his practice in Chicago; obituary for Richard Griesser, *Illinois Society of Architects Monthly Bulletin*, 23 (December 1938–January 1939):8. In 1892, after six years' experience in his father's office, Griesser returned to his native Germany to complete his studies in architecture and engineering in German technical schools and to take a course in the German brewing schools, which further prepared him for a career in brewery architecture; *The Western Brewer* 17 (November 1892):2489. After his return in 1895, Griesser probably spent another few years with his father, then opened his own office in Chicago in 1900; *The Western Brewer* 25 (January 1900):12, his first advertisement appeared on page 52. At that same time, Wilhelm Griesser moved his base of operations to New York City, where he had previously had a branch office, turning over his Chicago business to his son. The Wilhelm Griesser Engineering Company was first noted as being located in New York, rather than Chicago and New York, in late 1899, in a notice in *The Western Brewer* 24 (November 1899):446.

73. Edmund Jungenfeld, for example, has already been cited as the architect responsible for beginning the development of the Anheuser-Busch plant in St. Louis as early as 1869. As has also been indicated, his ideas were carried out and expanded after his death almost exclusively by his successors, E. Jungenfeld and Company (later Widmann, Walsh and Boisselier, then Widmann and Walsh), through 1912. In like vein, Fred Wolf served as primary architect for another major firm, the Joseph Schlitz Brewing Company, Milwaukee, from 1874 to the breakup of his partnership with Louis Lehle in 1894; "The Jos. Schlitz Brewery, Milwaukee," *The Western Brewer* 16 (May 1891):1106. Lehle is recorded in *The Western Brewer*, 1895–1911, passim, as carrying on all known additional projects for Schlitz before Prohibition.

74. Baron, *Brewed in America*, p. 260, comments on the stiff competition that raged among the national brewers and their ability to take business away from smaller local brewers, thanks to their superior facilities and capital for advertising. He also notes (p. 265) that one means of insuring a free field in an economy based on free competition is to buy a competitor's plant and operate it as a branch of one's own or to shut it down completely.

75. Ibid., chap. 32, "The Brewing Dynasties and Their Enemies," pp. 286–94, and chap. 33, "Victory of the Drys," pp. 295–310. Although national Prohibition did not officially go into effect until January 1920, from 1917 on, brewers and distillers were increasingly cut off from supplies by crop failures, labor shortages, and wartime concerns for food supplies. The growing power of the Anti-Saloon League of America and its commitment to the prohibition of alcoholic beverages meshed with these conditions to bring about passage of the 18th Amendment. The groundwork had already been laid by campaigns to impose prohibition on a state-by-state basis; as noted in Donald Bull, Manfred Friedrich, and Robert Gottschalk, *American Breweries* (Trumbull, Conn.: Bullworks, 1984), p. 9, nine states were dry in 1912, fourteen in 1914, and twenty-three in 1916.

8.1 Walter Burley Griffin, ca.1910. (Library of Congress)

8

WALTER BURLEY GRIFFIN, LANDSCAPE ARCHITECT

CHRISTOPHER D VERNON

 Walter Burley Griffin (1876–1937, fig. 8.1) is usually remembered as a Prairie School architect, an able protégé of Frank Lloyd Wright (1867–1959), and the urban designer of Australia's federal capital, Canberra. However, Griffin's ability as a landscape architect and his American landscape designs generally have been overlooked. Not only was Griffin a talented landscape architect, but his designs also exemplified the Prairie School expression in landscape architecture. Circumstances suggest that Griffin may have been influenced by the Danish-born landscape architect Jens Jensen (1860–1951).

In the late nineteenth and early twentieth centuries, Louis Henri Sullivan (1856–1924) and Wright were among the leaders of a new expression in architecture that resulted ultimately in the well-known work of the Chicago and Prairie schools. Concurrently, Jensen and other midwestern landscape architects crusaded against landscape design styles of European origin. This lesser-known movement within landscape architecture coalesced in what Wilhelm Miller (1869–1938) first referred to as the "prairie spirit in landscape gardening," or the "prairie school."[1] These landscape architects chose to work within the context of the open, horizontal, midwestern landscape and to allow it—and its indigenous vegetation—to inform their designs. Griffin's landscape designs also would come to exemplify Miller's "prairie spirit" in landscape architecture.

Throughout his youth, Griffin lived in the verdant, tree-sheltered environment of suburban Chicago. Born in Maywood, Illinois, on November 24, 1876, Griffin attended the public schools of Oak Park and subsequently moved with his family to the Chicago suburb of Elmhurst in 1893. After the

construction of the new family home, Griffin "persuaded his parents to plant local trees in the garden and, because of the comparatively dense growth, the neighbors named the place 'The Jungle.' "[2] This was perhaps the first expression of Griffin's nascent interest in landscape design.

The immediate, railroad-accessible environment of Chicago itself was probably a contributing factor in the genesis of Griffin's interest in larger-scale landscape designs. In 1893, Griffin made numerous visits to the World's Columbian Exposition. Frederick Law Olmsted's (1822–1903) Wooded Isle and naturalistic lagoons, in addition to his earlier design for the suburb of Riverside (1869), presented the young Griffin with a sharply contrasting alternative to the ubiquitous grid of urban and suburban Chicago. Impressed by the potential of such designed environments, Griffin later recalled that the Columbian Exposition was "our great example of a scheme or system . . . the thing that appealed to everybody, the thing that made that exhibition last for twenty years in the minds of all people, was that it provided a place for everything and had everything in its place."[3]

In 1895, Griffin began his study of architecture at the University of Illinois and also continued to develop his interest in landscape design. In his final year of study, he enrolled in what were then the only two courses offered in landscape design, forestry and landscape gardening. The courses were described in the 1898–99 *Catalogue of the University of Illinois:* "Forestry —This course embraces a study of forest trees and their natural uses, their distribution, and their artificial production. The relations of forest and climate are studies, and the general topics of forestry legislation and economy are discussed. Landscape Gardening—Ornamental and landscape gardening with special reference to the beautifying of home surroundings. The subject is treated as a fine art."[4] Offered through the College of Agriculture's Department of Horticulture, the courses were representative of what would become in 1907 a professional course in landscape gardening. Unlike architecture, landscape architecture was a relatively new profession; not until the year of Griffin's graduation in 1899 was the American Society of Landscape Architects founded.[5]

Following graduation, Griffin embarked upon a career in architecture. Hired as a draftsman in Chicago, he went to work in architect Dwight Perkins's (1867–1941) studio in Steinway Hall in late 1899. The architects H. Webster Tomlinson (1870–1942), Robert C. Spencer, Jr. (1865–1953), and Wright also maintained offices in Steinway Hall. Sullivan also was a visitor to the studios. It was in this environment that the inexperienced Griffin would become immersed in the philosophies and principles of the new Chicago School.[6] It is important to note that Griffin also established an independent practice in landscape architecture, preparing the landscape plan for Eastern Illinois State Normal School, Charleston, Illinois, in 1900.

Wright, in need of a drafting assistant, brought Griffin to his Oak Park studio in 1901.[7] By then, Wright had realized the first mature expressions of his prairie house in designs for the Harley Bradley and Warren Hickox

8.2 The long-vanished gardens of the William E. Martin residence, Oak Park, Illinois. (Wright, *Ausgeführte bauten und entwürfe* [Berlin: Wasmuth, 1911], p. 69)

residences in Kankakee (1900) and the Ward Willits residence in Highland Park (1901). In response to the prairie landscape of the Midwest, Wright advocated that "We of the Middle West are living on the prairie. The prairie has a beauty of its own and we should recognize and accentuate this natural beauty, its quiet level. Hence, gently sloping roofs, low proportions, quiet sky lines, suppressed heavy-set chimneys and shelter in overhangs, low terraces and out-reaching walls sequestering private gardens."[8]

Griffin's responsibility in the Oak Park studio, in addition to office supervision and general drafting, was the design of "sequestered private gardens."[9] Given Griffin's education in landscape design and his knowledge of horticulture, it is improbable that anyone else in Wright's employ at the time would have been given the responsibility for executing the highly detailed landscape designs associated with Wright's work of the period. Marion Mahony (1871–1962), also in Wright's employ and who married Griffin in 1911, later remarked that after Griffin's arrival in the Oak Park studio she "saw the revolution in methods and results that took place when landscape architecture was made a part of architecture. . . ."[10] Upon receipt of a new commission,

8.3 View of Darwin D. Martin gardens, Buffalo, New York, ca.1905. The newly planted "flori-cycle" is visible in the lawn area. The pergola of the Martin residence is seen to the left and the George Barton residence (1903) to the right. (University Archives, State University of New York at Buffalo)

it is most likely that Wright would have originated the design for the structure and site organization, and Griffin subsequently would have prepared any detailed landscape and planting designs.

Griffin's landscape work for Wright is perhaps best exemplified in his residential landscape designs for two brothers, William E. Martin in Oak Park, Illinois, and Darwin D. Martin in Buffalo, New York. In 1902, Wright designed a three-story prairie house for William E. Martin on a generous lot in Oak Park. In addition to supervising its construction, Griffin was responsible for the planting and detailed design of the extensive walled gardens that surrounded the house.[11] Griffin's design for the gardens included lily pools, trellises, and a massive, vine-covered pergola (fig. 8.2). The overall horizontal effect of the garden elements reduced the verticality of the house visually and related it to its flat site. The original lot has been subdivided and the gardens razed to make way for another residence. Consequently, Wright's site plan has been destroyed.

Darwin Martin subsequently commissioned Wright for the design of his own home, to be located in Buffalo. Again, in addition to sending Griffin to New York to supervise the construction, Wright employed him as landscape architect.[12] As in the William Martin gardens, the landscape design of the Darwin Martin grounds also featured a large pergola that united the house with a conservatory, in this case probably a manifestation of Mrs. Martin's avid interest in horticulture. Of particular note was Griffin's semi-circular

8.4 View of mature plantings along the pergola of the Darwin Martin residence. The sculpture in the foreground, "Spring," is by Richard Bock. (University Archives, State University of New York at Buffalo)

planting—a "flori-cycle" composed of vegetation selected to create a sequential bloom from March to November—which contained and framed the view of the surrounding residences (figs. 8.3, 8.4).[13]

While employed by Wright, Griffin also executed several independent commissions. Barry Byrne (1883–1967), a fellow Wright apprentice, recalled that Griffin's relationship to Wright was unusual in that Wright allowed Griffin to continue a separate private practice.[14] These initial independent commissions helped to establish Griffin's own professional identity.

In February of 1905, Wright embarked on a voyage to Japan. Upon his return, he encountered financial difficulties and was unable to compensate Griffin for outstanding salary. After accepting a collection of Japanese prints as payment, Griffin resigned—or may have been fired—from the Oak Park studio in 1905. Later that year, he once again returned to Steinway Hall, this time to commence a fully independent practice. By then, he displayed a marked preference for landscape design, his office letterhead and signature bore the inscription "architect and landscape architect." In addition, in 1907, Griffin exhibited his work in the annual Chicago Architectural Club exhibition under the title of "landscape architect."[15]

Of particular significance to Griffin's career as a landscape architect was the arrival of Jensen. Jensen, then in the middle of an often-strained relationship with the West Chicago Parks District, had established a private

practice in Steinway Hall shortly before Griffin's return. The men had probably been acquainted as early as 1904, since both were members of the City Club of Chicago and the Chicago Architectural Club and were mutually known to Perkins, Spencer, Sullivan, and Wright.[16] By 1908, Griffin and Jensen were leading "Saturday Afternoon Walking Trips" through remnants of the primeval Chicago landscape which would later be incorporated into the Cook County Forest Preserves system—no doubt further enhancing Griffin's knowledge of the region and its indigenous vegetation.[17]

By this time, the outspoken Jensen had formulated and begun to advocate a landscape design aesthetic rooted in the expression of the regional characteristics of the midwestern landscape. Unlike eastern landscape architects who had executed projects in the Midwest, such as Olmsted, Jensen's aesthetic took the open, horizontal prairie landscape as both its inspiration and model. He manifested his regional inspiration in the use of indigenous vegetation in naturalistic landscape designs, symbolic recreations of the prairie landscape. In their mutual pursuit of landscape architecture, Griffin and Jensen shared this inspirational bond, and it is likely that the experienced Jensen found a willing student in the younger Griffin. However, the manner in which the two designers articulated the "prairie spirit" in their landscape designs demonstrated differences as well as overall similarities.

Reflecting his personal reverence for nature itself, Griffin viewed his primary role as a landscape architect and architect as enhancing the natural characteristics of a given site: "The basis of our study, I think, is Nature itself. If we can go into Nature that has been undefiled by man we can get a beauty equal to that of any primitive architecture, or we have the architecture of plants and of the animals where Nature's laws are allowed to work themselves out. These laws are inviolate in the emphasis of structural necessity, and taking advantages of natural conditions, and in expressing those conditions with maximum possibility."[18]

This aspect of Griffin's philosophy was exemplified in his 1906 campus plan for the Northern Illinois State Normal School in DeKalb. Taking advantage of existing site conditions, Griffin organized the campus around a series of existing lakes—allowing the topography of the site to dictate the location of walks and drives. The plantings and proposed buildings were located so that views to and from the surrounding landscape were maximized and existing vegetation preserved. The primary feature of Griffin's design was a series of formal terrace gardens (fig. 8.5) that surrounded the school's principal building. The terrace gardens functioned not only as an architectonic setting for the building—a transition between the natural landscape and the built environment of the campus—but also as additional support for the foundation of the structure itself: "Upon Mr. Griffin's first visit to the site he found that the foundation of the building was not, in his opinion, of sufficient strength. He therefore conceived the idea of offering some support by building a series of terraces, which also afforded the opportunity for formal planting. . . . Both the upper and lower plateaus [terraces] are uti-

8.5 View of Griffin's formal and naturalistic plantings on the campus of the Northern Illinois State Normal School (now Northern Illinois University), DeKalb, ca.1910.

lized for formal and natural styles of gardening combined, but no abrupt or startling transition from one to the other style is discernible."[19] Furthermore, the formal, geometric plan of the terrace gardens was in part the result of Griffin's attempt to harmonize the gardens with the "octagonal battlements of the building, and hides the incongruity made manifest by the convergence of two driveways approaching the buildings at right angles."[20]

Griffin's plantings enclosed and defined the perimeters of his landscape designs for larger residential properties and planned communities, creating an inwardly focused enclave. He elaborated that his perimeter plantings "serve for screening out, closing in and subdividing each property in the ways that will enhance to the most its apparent area and disguise any un-natural lack of continuity with its surrounding areas. . . ."[21] This aspect of Griffin's use of indigenous vegetation is demonstrated in his plan for the Trier Center neighborhood development in Winnetka, Illinois, which was partially executed in 1912–13.

In general, at the perimeters of properties, Griffin's plantings tended to be highly naturalistic in form and character. However, Griffin created architectonic environments as the settings for the structures themselves—

to mediate between exterior natural space and interior man-made space. In fact, many of the formalistic landscape devices used by and associated with Wright—window boxes, planters, trellises, sunken gardens, and formal pools—also were mirrored in Griffin's work. In the immediate vicinity of a residence, Griffin used vegetation as a type of architectural ornamentation: ornamental and exotic plants, versus indigenous ones, tended to dominate these architectonic settings. Griffin's preference for an abstract formalistic transition between interior and exterior space contrasted sharply with Jensen's more literal articulation of the "prairie spirit." Jensen had developed a distaste for formal design and the use of exotic vegetation and eventually preferred naturalistic design exclusively.

Much as the selection and development of a vocabulary of materials was crucial to Griffin's architecture, so it was to his landscape plantings. Toward that end, Griffin developed several design criteria for the selection of individual plant species. Miller reports that Griffin frequently chose such indigenous tree species as the hawthorn (*Crataegus*) for its horizontal branching patterns that abstractly "repeated the line of the prairie."[22] Griffin's use of such vegetation achieved an effect, however subtle, similar to the horizontal planes of his architecture. He also wanted to provide seasonal variety in his planting designs, another criterion for his selection of vegetation. The semi-circular planting he designed for the Darwin D. Martin residence (fig. 8.3) was a masterful example of this aspect of his planting design. In addition, in the formal terrace gardens at the Northern Illinois State Normal School, Griffin used shrubs that bloomed in June and would provide a backdrop for the school's outdoor commencement ceremonies. Griffin equally was concerned with achieving "winter attractiveness" in his landscape designs, frequently including evergreens or species with colored twigs or fruit. Jensen, too, sought to create these effects in his landscape designs, although he ultimately rejected Griffin's formal lines and exotic plants.

The first three years of Griffin's independent practice (1906–9) were dominated by commissions for individual residences, and in several instances landscape designs were prepared as an extension of his architectural services. However, with the new decade came an expansion in the scope and scale of his practice. Although they had dissolved their association several years earlier, Griffin again came into contact with Wright's office. Because of Wright's decision to abandon Oak Park and pursue the publication of his works in Europe, he sold his practice to Hermann Valetin von Holst (1874–1955),[23] who retained Wright's former apprentice Marion Mahony. The two architects subsequently "inherited" Wright's clientele and several unfinished commissions. Immediately before his departure, Wright had initiated three residential commissions in Decatur, Illinois, for Adolph and Robert Mueller and E. P. Irving. These commissions consequently were completed by Mahony in 1910–11. At Mahony's suggestion, Griffin was retained as the landscape architect for the projects shortly before their mar-

8.6 Griffin's landscape plan (ca.1911) for the Robert Mueller and E. P. Irving residences, Millikin Place, Decatur, Illinois. The entrance to Millikin Place is punctuated by a brick-tiered gate and the street is defined by a low, clipped hedge. Note the overall informal character of the plantings. (Burnham Library-University of Illinois Microfilming Project)

riage on June 29, 1911 (figs. 8.6, 8.7). In his landscape design for the Mueller and Irving residences, Griffin treated the three properties—situated along a newly constructed street extension, Millikin Place—as a harmonious whole. Griffin and Mahony designed a brick-tiered gate for the entry to Millikin Place, and Griffin terminated the extension with a landscaped cul-de-sac as a means of limiting and segregating vehicular through traffic. The street itself, originally paved with bricks, was enhanced with distinctive brick and wrought-iron light standards, tree plantings, and was defined by a low, clipped hedge. Griffin treated the individual properties in a similar manner: low hedges and specimen tree plantings defined each lot spatially, while still maintaining a sense of visual continuity from one residence to another.[24] He also accented the driveway entrances with shrubs and enclosed the three properties with naturalistic perimeter plantings. The enclosing spatial effect of the perimeter plantings, the unified street lighting and entry gate, and the segregation of the vehicular circulation all contributed to the overall design of a self-contained, harmonious enclave. The Millikin Place project was the first in a series of Griffin's larger-scale landscape designs, and it foreshadowed design elements which he would develop more fully in later projects like the Trier Center neighborhood development.

In January of 1912, with Mahony's invaluable assistance, Griffin prepared an entry for an international competition for the design of Australia's federal

8.7 Griffin's landscape plan (ca.1912) for the Adolph Mueller residence, Millikin Place, Decatur, Illinois. Griffin terminated the street extension with a landscaped cul-de-sac. In addition to his naturalistic perimeter plantings, Griffin included a formal, sunken garden and reflecting pool in his landscape design. (Burnham Library-University of Illinois Microfilming Project)

capital, Canberra. In May, it was announced that Griffin had won the competition. Despite the major career changes this heralded, work still remained in the Chicago office. From the time of the Canberra competition onward, progressively larger-scale American commissions dominated Griffin's practice. The largest of these American commissions again came as an indirect result of contacts initiated by Wright.[25] In July of 1912, Griffin received a commission for the design of an entire subdivision, later known as Rock Crest–Rock Glen, to be developed in Mason City, Iowa. Given an eighteen-acre site consisting primarily of a series of limestone bluffs bisected by Willow Creek, Rock Crest was to occupy one bluff and Rock Glen the other. Griffin was to locate and design twenty residences, streets, and pathways, and to prepare a landscape design for the site as a whole. Drawing upon his talents as both an architect and landscape architect, Griffin sited the individual residences with his characteristic sensitivity for both the topography and "possibilities" of the site:

> by the regulation of the houses to the perimeter, the area of gentle slope to the river will be preserved indefinitely for open view very much as nature designed it and for those purposes of retreat and recreation to which nature has so well adapted it . . . the endless fascinating possibilities for domestic architecture with the unrepeated

variations of view, soil, ruggedness, luxuriance, prominence and seclusion, need only the due attitude of appreciation to work themselves out in structures as unique as their sites, cut into rock or perched on the crest or nestled in the cove as the case may be.[26]

Griffin also used the existing woodland vegetation as both a visual screen for the community itself—buffering it from surrounding development—and as a community park. Despite the large scale of the project, Griffin designed the landscape of each individual residence and prepared planting plans for house sites.

In July of 1913 Griffin was invited to Australia to consult on his plan for Canberra with the Australian government. During his visit, he was appointed to the position of "Federal Capital Director of Design and Construction," a move that necessitated his move to Australia.[27] Despite an attempt to maintain an office in Chicago and make trips back to the Midwest, Griffin's decision to accept this position, in effect, ended his American career. Aside from supervising the site work and battling for the implementation of his Canberra plan, Griffin also established a private practice and later received several commissions in India. It was there he died of peritonitis in February 1937. Once removed from the American scene, Griffin's professional standing dissipated, and with his death, he was, until recently, all but forgotten.

The scale and scope of Griffin's American work had exceeded that of other Prairie School landscape architects: Jensen, for example, seldom achieved such integration of natural and built environments. Although he did prepare several larger-scale park and boulevard systems and city plans, few were executed. It was Griffin who perhaps most completely articulated the Prairie School of landscape design. His obscurity, due in part to the attention given Wright, is both regrettable and undeserved. Despite being overshadowed by Wright and the outspoken Jensen, Griffin's own talent enabled him to function simultaneously as an architect and as a landscape architect. The dual roles complemented and enhanced one another and, coupled with his holistic vision, enabled him to create integrated environments. Griffin achieved this integration at many scales: not only did his architectonic residential landscape dissolve into more open naturalistic surroundings, but Griffin also harmoniously inserted these designed environments into the expansive landscape of the Midwest itself. Set in a landscape of bucolic abstraction, his inwardly focused communities were a symbolic middle ground between the urban pattern and the surrounding prairie.

NOTES

I gratefully acknowledge the assistance of several individuals who provided invaluable assistance during my research on this project: Shonnie Finnegan, university archivist at the State University of New York at Buffalo, and Nancy Knechtel helped

locate materials documenting Griffin's role in the Darwin D. Martin project; Griffin scholar Donald Leslie Johnson of The Flinders University of South Australia provided photocopies of some of the Australian sources; and Florence Kraemer of the Prairie Club provided a photograph of one of Griffin's "Saturday Afternoon Walks." My wife Tanya and John Hoffmann also helped me. Finally, I am indebted to Walter L. Creese for unlimited inspiration and encouragement.

1. Wilhelm Miller, *The Prairie Spirit in Landscape Gardening: What the People of Illinois Have Done and Can Do Toward Designing and Planting Public and Private Grounds for Efficiency and Beauty* (Urbana: University of Illinois Agricultural Experiment Station Circular no. 184, 1915), p. 5. Miller was an assistant professor of landscape horticulture and head of the Division of Landscape Extension at the University of Illinois from 1912–16. Before his work at Illinois, Miller had been an influential horticultural editor and writer for *Country Life in America* (1901–12) and *The Garden Magazine* (1905–12). In addition to Griffin and Jensen, Miller included the work of Ossian Cole Simonds (1855–1931) in his definition of the Prairie School of landscape architecture. Late Victorian gardenesque and the Italianate gardens of Charles Platt (1861–1933) are representative of the European-inspired landscape design aesthetics disfavored by the Prairie School landscape architects.

2. James Birrell, *Walter Burley Griffin* (Saint Lucia, Australia: University of Queensland Press, 1964), p. 11.

3. Walter Burley Griffin, "A Eulogy of System," *The City Club Bulletin* 7 (1914): 66.

4. *Catalogue of the University of Illinois* (Urbana: University of Illinois, 1899), p. 210. The University of Illinois offered its first classes in landscape gardening in 1868. Griffin's instructor in landscape gardening, Joseph Cullen Blair (1870–1961), was familiar with the naturalistic landscape designs of Olmsted. Blair also was a friend of Jensen's.

5. The American Society of Landscape Architects was founded on January 4, 1899, in New York City. Of eleven founding members, only one, Ossian Simonds, was a native of the Midwest. The first professional curriculum in landscape architecture was offered by Harvard University in 1901.

6. See H. Allen Brooks, "Steinway Hall, Architects and Dreams," *Journal of the Society of Architectural Historians* 22 (1963):171–75.

7. Walter Burley Griffin, *The Semi-Centennial Alumni Record of the University of Illinois*, ed. Franklin W. Scott (Chicago: R. R. Donnelly and Sons, 1918), p. 120.

8. Frank Lloyd Wright, "In the Cause of Architecture," *The Architectural Record* 23 (1908):157.

9. Griffin, *Semi-Centennial Alumni Record*, p. 120. Griffin described his position with Wright as being that of both an architect and landscape architect.

10. Marion Mahony Griffin, "Democratic Architecture, Its Development, Its Principles and Its Ideals," *Building* (Australia) 14 (1914):101.

11. Miller corresponded with Griffin in January of 1914. It was at this time that Griffin informed Miller that he was responsible for the landscape design of Wright's William E. Martin residence in Oak Park. In a manuscript draft of Miller's *Prairie Spirit*, he stated that Griffin's "chief American work in landscape architecture has been done . . . in Oak Park for W. E. Martin . . . these designs were done while in the employ of other men. . . ." Apparently, Griffin objected to the phrase "while in

the employ of other men," as Miller marked the passage "rejected." No reference to the W. E. Martin residence appeared in the final publication, only its location, Oak Park, was mentioned. Miller subsequently traveled to Chicago and toured Griffin's projects with Byrne, then in partnership with Griffin, in February of 1915.

12. The landscape planting plans for the Darwin D. Martin residence, contained in the archives of the State University of New York at Buffalo, bear Griffin's signature and title *landscape architect*. See also the correspondence between Wright and Darwin D. Martin in *Frank Lloyd Wright: Letters to Clients*, ed. Bruce Brooks Pfeiffer (Fresno: The Press at California State University, Fresno, 1987), pp. 11–14.

13. The "flori-cycle" was foreshadowed in the 1902 landscape plan for Wright's Ward W. Willits residence in Highland Park, Illinois. Griffin was in Wright's employ at this time and actively engaged in the Willits project. See *Frank Lloyd Wright Monograph 1887–1901*, ed. Yukio Futagawa (Tokyo: A. D. A. Edita, 1986), p. 190.

14. Francis Barry Byrne to Wilhelm Miller, July 3, 1915.

15. Chicago Architectural Club, *Catalogue of the Twentieth Annual Exhibition of the Chicago Architectural Club* (Chicago: Barnes-Crosby, 1907), n.p.

16. Jensen chaired the City Club's City Planning Committee, 1910–13, and Griffin succeeded him for 1913–14. Jensen joined the membership of the Chicago Architectural Club in 1904; Griffin had been a member since 1900. Griffin and Jensen concurrently exhibited their work in the club's 1905 and 1907 exhibitions. Jensen executed several landscape designs for Wright. In addition, Jensen also collaborated with William Drummond, George Washington Maher (1864–1926), Spencer, Sullivan, and other Prairie School architects.

17. See Earl W. Albright, "Saturday Afternoon Walks," *Outdoors with the Prairie Club*, comp. Emma Doeserich, Mary Sherburne, and Anna B. Wey (Chicago: Paquin Publishers, 1941), pp. 24–62.

18. Walter Burley Griffin, "Architecture and Democracy," *Building* (Australia) 13 (1913), p. 64.

19. Frank Keffer Balthis, "An Illinois School Campus," *The American Botanist* 21 (1915):2–3. Balthis was the campus gardener and also was a friend of Jensen's.

20. Balthis, "An Illinois School Campus," p. 3.

21. Walter Burley Griffin, "Emory Hills: Domestic Community Development in Small Farms, for Outer Suburban Zone, Chicago, Illinois," *The Western Architect* 20 (1913):73.

22. Miller, *Prairie Spirit*, p. 5.

23. H. V. von Holst also was a member of the City Club of Chicago and the Chicago Architectural Club. In 1913–14, he was a member of the City Club's City Planning Committee, then under the direction of Griffin.

24. The Adolph Mueller residence received a particularly lavish landscape treatment. Griffin's design for the residence featured a formal reflecting pool (since destroyed) and a sunken garden.

25. J. E. E. Markley and Joshua Melson, two of the four commissioners of the Rock Crest–Rock Glen development, had both previously been clients of Wright's.

26. Walter Burley Griffin, "Rock Crest and Rock Glen, Domestic Community Development, Mason City, Iowa," *The Western Architect* 20 (1913):76.

27. Mark L. Peisch, *The Chicago School of Architecture: Early Followers of Sullivan and Wright* (New York: Random House, 1964), p. 118.

9.1 Solon Spencer Beman (1853–1914), who preferred the initials "S. S." Painting by Oliver Denton Grover for the Illinois Chapter of the American Institute of Architects, 1911. (The Chicago Historical Society)

9

S. S. BEMAN AND THE BUILDING OF PULLMAN

JOHN S. GARNER

 In 1915, on the occasion of the unveiling of a portrait of the archi-
tect S. S. Beman (1853–1914), Louis Sullivan delivered a eulogy on
behalf of the Illinois Chapter of the American Institute of Architects.
Beman's portrait would be hung alongside those of Burnham, Jenney, Root,
and Wight in the Gallery of Noted Architects in the Art Institute of Chicago
(fig. 9.1). Sullivan, who must have sensed his own career drawing to a close,
was uncharacteristically charitable. Of Beman, he said: "I think of him as a
friend first, and architect second, because throughout the past our relations
have been so much in accord and so full of affections. . . . He was always
in advance of his time. . . . To me his leading characteristic was his great
enthusiasm conjoined with an extraordinary perseverance."[1]

In the year that Dankmar Adler hired Louis Sullivan and the two em-
barked on the first of a series of commissions that would launch their part-
nership and bring them renown, a young man arrived from New York and
stole the largest commission of the century. How those architects of Chicago
must have smarted at the idea of an outsider receiving a $6 million plum, to
build from stratch a model town.

Solon Spencer Beman was only twenty-six when he first met George M.
Pullman in 1879. Although a young man, he had already established an
architecture practice in New York City. His knowledge of architecture de-
rived from seven years' apprenticeship with the firm of Upjohn and Upjohn.
Richard Upjohn was the founder of the American Institute of Architects and
a distinguished elder statesmen of the profession. Pullman took an immedi-
ate liking to Beman and was impressed by the young man's ambition. The
men enjoyed a special relationship, and Beman served from time to time as
consultant to Pullman's Palace Car Company. Pullman first commissioned

Beman to design an addition to his house in Chicago. But before the year was out, he invested Beman with responsibility for designing the buildings of a model town and coordinating on-site construction. Beman later received commissions to design the Pullman office building on Michigan Avenue, and with Pullman's endorsement was hired to design such large projects as Chicago's Grand Central Station, the two Studebaker buildings, also in Chicago, the Pabst office building in Milwaukee, and the Pioneer Press Building in St. Paul. Nor was the town of Pullman his only industrial commission, for he designed Proctor and Gamble's "Ivorydale" near Cincinnati. Despite these later commissions, Beman's reputation lay in what he achieved in Pullman. Even rival architects like Sullivan were forced to admit that "He was well chosen and he performed well. I doubt if any architect in the country at that time could produce work superior to that of Mr. Beman, when you consider the nature of the work [Pullman]."[2]

Notwithstanding the cordial relations between Beman and Pullman, their model town became engulfed in controversy. From the outset, it elicited the opinions of journalists, economists, labor leaders, and social reformers. More recently, historians have attempted to put its lessons in perspective. Although its architecture and planning have been described in some detail, the significance of at least one pioneering feature of the town has been overlooked. But before examining again what Beman and those who assisted him achieved, it may be appropriate first to gauge the impact the town had upon completion.

Two events covered by the Chicago press attracted national attention during the depression of 1893–94, both of which had lasting repercussions. One was the "great fair," the World's Columbian Exposition, which drew streams of visitors from home and abroad. So popular was the event that its sponsors held it open a second year. A spectacular achievement, it marked Chicago's debut as a city of national prominence capable of hosting an important cultural event. The Exposition celebrated America's technical prowess. Its exhibits of brightly painted machinery placed on pedestals and draped in colorful bunting dazzled onlookers fascinated by the industrial arts. From all walks of life, and from places large and small, the well-to-do and the ne'er-do-well gathered to view its exhibits and side-show attractions. The other event, which closed down the Exposition and forever tarnished the image of the nearby model town of Pullman, was the Pullman Strike.[3] Its notoriety seized headlines from coast to coast, and although the strike ultimately failed, it forced a recognition of the limits of private capital in a free-enterprise society. No architect's plan, no matter how well designed, could offset the flawed social experiment that Pullman came to represent.

In Sullivan's Transportation Building at the Exposition, there was a plaster of paris model of Pullman together with pamphlets that extolled the town's many virtues. On display were examples of the railroad cars—the interiors of which had been designed by Beman and built in Pullman, while

outside other Pullman cars departed at regular intervals from the Exposition's terminal to give excursions to the model town, conveying as many as two thousand sightseers a day in the summer of 1893.[4] In the following year, these cars were used again, this time to transport federal troops quartered temporarily on the Exposition fairgrounds before encamping at the model town to quell the rioting caused by the Pullman Strike. The target of the strike was the intransigent George M. Pullman, who had refused to meet with labor leaders to mitigate the hardships caused by the depression.[5] Resentment of the man carried over to the town, which symbolized his power and control.

Born in 1831, Pullman was the son of a Connecticut farmer and mechanic who eventually settled in upstate New York. As a young man, he was confronted with the support of his family after his father's death. He took up a contract made by the elder Pullman to relocate a number of dwellings along the Erie Canal to higher ground. Success in that venture brought him to Chicago in 1859 where contracts were being let to raise buildings along the marshy east end of Lake Street. Not only did he prove resourceful in acquiring commissions, but he also executed with remarkable skill the daunting task of elevating multistory buildings to their new street levels.[6] What is more, in a competitive climate, he exhibited a single-minded determination to succeed. By grasping the details of large-scale labor and technical organization, he remained a step ahead of the competition.

During the Civil War, Pullman tried his hand at several enterprises, but after a sleepless train ride between Chicago and New York he settled on the idea of manufacturing a comfortable sleeping car, and in 1865 built a prototype of his famous "Pioneer." In 1867 he founded the Pullman Palace Car Company, and by 1869 had his cars rolling on ten different railroads. Within a decade, he had outmaneuvered both Carnegie and Vanderbilt to get his sleeper adopted by the principal east-west railroads, including the transcontinental run. In 1875 Pullman produced a luxury coach with swivel seats. Craftsmanship was something he insisted upon, for he had once worked as a cabinetmaker. Although the Pullman Palace car is a classic example of specialization, its marketing ran counter to prevailing trends. But Pullman believed the public would gladly pay the price for quality and comfort, and although he did diversify by building several types of cars, he never sacrificed quality to procure quantity. To maintain quality he either leased his cars or sold shares in them to railroads, furnishing his own conductors and porters, and ensured good service by hiring "spotters" who would quite literally go undercover to check the cleanliness of the cars and efficiency of their staffs.[7]

Although Pullman had acquired small railroad yards in Chicago and Detroit, he needed a large parcel to consolidate his works and to provide a community for his workers. In January 1880, amid considerable speculation over where he would locate his new plant, he acquired 3,500 acres twelve miles south of Chicago. Bordering Lake Calumet on the east and the tracks

of the Illinois Central Railroad on the west, the land was acquired for $200 an acre, or $700,000 in sum. Lake Calumet was a small body of water with a channel that emptied into Lake Michigan.[8]

The site obtained good transportation both by rail and by barge because the company depended on large supplies of iron for car chassis, lumber for car bodies, and coal to fuel a foundry and steam engine. Pullman had purchased the great Corliss steam engine that had been displayed at the Centennial Exhibition of 1876 to run his plant. The "great leviathan" had cylinders forty inches in diameter and pistons with a stroke of ten feet, cranking out 2,400 horsepower to operate lathes, saws, drills, presses, and pumps.[9] Conveyed through a system of axles and gears, belts and pulleys, this single source of power operated everything in the car works. It represented the last gasp of steam before electricity and was the penultimate expression of steam-power technology. In addition to good access to transportation and a power supply, the development required housing for workers because commuting time and expense from Chicago was too great, and the nearby settlements of Hyde Park, Kensington, and Rosedale lacked sufficient housing. Although it was not unusual for companies to supply their workers with housing on nearby tracts, often administered by a subsidiary land company, as did McCormick in Chicago, it was unusual—in fact extraordinary —to incorporate housing as an integral element in a comprehensively designed industrial plan. To the extent that his cars exemplified specialization, Pullman's model town came to represent the apotheosis of the factory system.

Planned housing estates for workers date to antiquity, but independent and economically self-sustaining towns, furnished with factories, houses, and stores, and designed in one entity to be managed by a single business enterprise, awaited two developments which coalesced during the nineteenth century. "Specialization" and the "factory system" were logical developments stemming from the Industrial Revolution. The late-eighteenth-century mill village with its one-product economy began to give physical expression to specialization. By 1814, however, specialization had taken a more formal structure, at least as seen in Waltham, Massachusetts, and later in Lowell and scores of towns in New England where the factory system brought the various phases of processing under one roof. Workers left the relative independence of their cottage workshops and took up the routine of the factory with its new form of management. Market competition affected factory design and labor organization, and with the search for resource sites to permit large-scale development, industrialists were challenged to lay out new towns according to a plan best suited to facilitate production and accommodate a work force. The company town—built, owned, and managed by a single enterprise—served as a kind of paradigm for industrialism in urban design. From textile towns to machinery towns to towns of the extractive industries, the single-enterprise or company-owned town was more pervasive in the urban settlement of America than generally as-

cribed. Known all too well, however, is that most company towns, especially those of the extractive industries associated with mining and oil production, gained notoriety as wretched places in which to live and produced a blight upon the landscape.[10]

Nevertheless, a few towns were thoughtfully planned and handsomely built. What separated these model towns from others was an environmental interest taken by their developers, an interest that during the nineteenth century took the form of philanthropy and paternalism. And a distinction between the two should be made. At a time when no safety net of government-funded social programs existed to protect industrial workers, there was little in the way of security for workers beyond what they could save to ensure against job loss, injury, or poor housing. For many, industrial employment was precarious and oppressive. For the immigrant, uprooted from his or her native country and separated from family, the ordeal could be devastating and the search for security—let alone social amenity—seemingly futile. Nor were most forms of philanthropy of much avail. Settlement houses, although philanthropic in purpose, appeared too late in the century and were too few in number to help any but the desperate. Another form of philanthropy was exhibited by wealthy businessmen such as Alfred T. White and his Model Tenement Association of Brooklyn. But despite his fine example, there was little incentive for others to follow suit, investing capital in building quality "low-rent" tenements with an equally "low return" on investment.[11]

Although these forms of philanthropy were of little consequence—save for Andrew Carnegie's libraries—there was an alternative to blank-check philanthropy, and that was paternalism. Paternalism also demonstrated social concern for the working class, but from a business point of view. It provided an incentive to those who extended it. Unlike philanthropy, it was philosophically cost-effective in that one might do unto others in proportion to what one wanted them to do in return. Thus paternalism was a form of social engineering with the goal of improving the condition of both donor and recipient. Its fatherly implications were no doubt detested by some but surely welcomed by others. Robert Owen at New Lanark, Scotland (1799–1816), had provided the classic example of paternalism as a textile mill employer who sought to improve the quality of life among his workers in return for their fealty and greater job efficiency.[12] He reasoned that a healthy and contented worker was less of a liability. Paternalism was also a factor in labor procurement and retention. And, in theory at least, it could militate against the threat of organized labor and strikes. George Pullman viewed paternalism in just that way, as a pragmatic means of securing order and improvement for an industrial society.

Ground was broken in April of 1880, and work on Pullman progressed at a feverish pace. Construction began on the car shops, foundry, and engine house. Within a year, the factories were put in operation and—with much fanfare—the first of Pullman's public buildings opened its doors to the approbation of all in attendance. Four years later and embracing a high

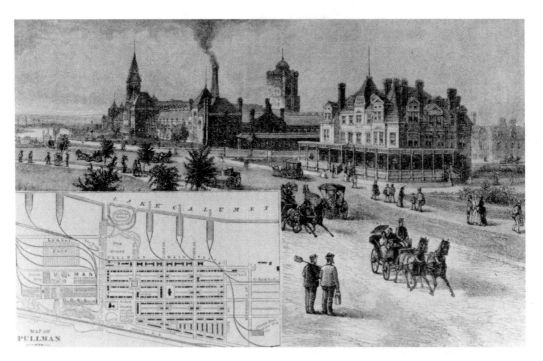

9.2 Pullman, Illinois, with Office Building (left), Florence Hotel (right foreground), and Water Tower; the plan inset is oriented with north to the left. (*Harpers' Monthly Magazine*, 1885)

standard of construction in houses, stores, and factories, furnished with water, gas, sewers, paved streets, and walks, the model town could boast a population of 8,400 (fig. 9.2).[13]

The men selected to assist Beman in designing the model town were Nathan F. Barrett and Benezette Williams. Barrett was a landscape architect with an office in New York City. He had been hired in 1879 to landscape the grounds of Pullman's summer retreat at Longbranch, New Jersey. Little is known about Barrett. Overshadowed by others of his profession such as Olmsted, Copeland, and Cleveland, he seems to have had a successful practice and was capable of rendering a picturesque landscape. Some years later, probably because of his involvement with Pullman, he was hired to lay out New Birmingham, Texas, for A. B. Blevins's New Birmingham Iron and Land Company, a subsidiary of the St. Louis, Arkansas, and Texas Railroad. It was Barrett who recommended Beman to Pullman when the latter needed an architect to design an addition to his Chicago residence on Prairie Avenue. Beman's other assistant, Williams, was a civil engineer who assisted in the design, layout, and operation of the sewage system. His expertise placed Pullman in the vanguard of experiments in sanitary reform.[14]

By the mid-nineteenth century, most large cities had undertaken measures to rid themselves of wastewater. The advent of municipal waterworks accelerated the need to carry away the effluent from businesses and house-

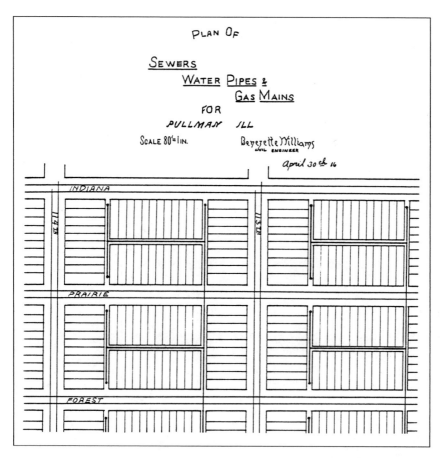

9.3 Detail of a Plan of Sewers, Water Pipes, and Gas Mains for Pullman, Illinois by Benezette Williams, 1886. (Redrawn from a plan in the collection of The Art Institute of Chicago)

holds. Small towns, on the other hand, lagged behind. Such places rarely addressed the problem of sewerage before the beginning of the present century. Privy vaults and cess tanks maintained through private ownership were the order of the day. The costs of providing a municipal system were simply beyond the means of most towns, and only the fear of contaminated wells forced them to take action.[15]

The type of sewage system employed at Pullman was the "separate" or two-pipe system. At an estimated cost of $1 million, and before a single building was erected, the subterranean system underlaid everything else (fig. 9.3). It may well have dictated the town plan. Surface drainage from streets, building lots, and playgrounds was conducted through more than thirty-three thousand feet of tile pipe measuring between six and eighteen inches in diameter. Because of Pullman's relative flatness, having been graded to an average height of seven feet above lake level, drainage was extremely important. Drainpipes carried the water in a west to east lateral

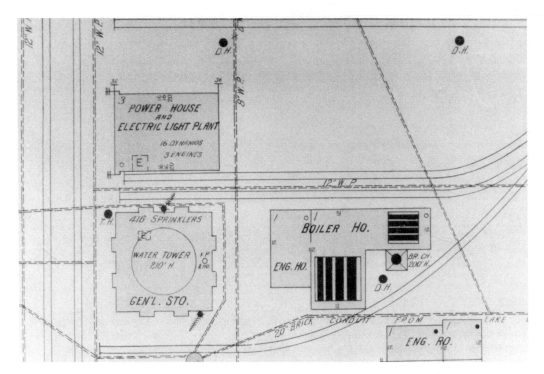

9.4 Plan detail of Water Tower, Power House (a later building), and Boiler House (not shown but adjacent was the Engine House). The dashed lines indicate water pipes; the solid lines indicate railroad sidings. (*Chicago*, vol. E [Sanborn-Perris Map Co., 1897], p. 67.

system to Lake Calumet. At a greater depth was the sanitary sewer, placed at least ten feet below grade and falling from south to north beneath the longitudinal streets to a depth of sixteen feet. The raw sewage was collected at one point in a reservoir beneath the Water Tower, Pullman's most prominent feature (fig. 9.4). From this point at the north end of the industrial site, the wastewater was pumped through a twenty-inch-diameter iron main to a 140-acre farm south of town. Through a system of drainage tiles, the waste (mixed with lake water) was leached into fields as fertilizer. The fields were cultivated to provide produce for Pullman and elsewhere. The Water Tower represented an engineering feat. Its foundations were sunk forty feet below grade to accommodate the sewage receptacle; fresh water purchased from neighboring Hyde Park was pumped to a tank above supported by four Phoenix rolled-iron columns reinforced by masonry piers. Its large size and elevation ensured adequate water pressure and reserve storage in event of fire.[16]

Beman, although architect in charge, collaborated with his associates in designing the town. The task was too large for one man to grasp every detail. Because the land was flat and marshy, it required considerable fill. There were no land contours to incorporate into a design, such as the gentle

swells created by the turns of the Des Plaines River in nearby Riverside, laid out in 1869 by Olmsted and Vaux. Moreover, the site was bounded on the east and west by prominent features, Lake Calumet and the raised embankment of the Illinois Central Railroad track, defining a long rectangle. With the extension of Cottage Grove Avenue, a main north-south road to Chicago, and the existing grid plan of Chicago, a ready orthogonal solution to flatland subdivision lay close at hand. But what may have convinced Beman to employ a grid for Pullman was the matter of land use, which zoned factories and utility plants to the northern part of the site—tying into Chicago's main access to transportation—and zoned housing and community buildings to the south. Logically, pedestrian routes were oriented to give the most direct path between home and factory—hence straight north-south streets, with houses facing those streets on elongated blocks, 660 feet in length. The laying of underground pipes for water, gas, and sewage in a similar orthogonal arrangement reinforced the pattern. Public buildings were placed in between the factories and houses; the Arcade Building—the shopping and entertainment center—was located near the tracks in prominent view and access. The Market Building offered a convenient stop between home and work (fig. 9.5).

When compared to the strictly residential development at Riverside, Pullman may appear dull and unimaginative because of its grid; its plan, however, was simply the best solution given the requirements and the terrain. The partitioning of a town into industrial and residential zones was not introduced at Pullman. There are well-known prototypes such as Saltaire, England (1853–63) by Lockwood and Mawson and Noisiel-sur-Marne, France (1871–89) by Jules Saulnier. In earlier, unplanned factory towns, there was no separation between the factories and houses which fanned out around them. But it would be presumptuous to assume that Beman borrowed from those examples. The existing site conditions and the contraints posed by the conditions dictated Pullman's design. In no other factory town was there a system of underground utilities and services comparable to Pullman's.[17]

In turning to housing, George Pullman recognized "that the working people are the most important element which enters into the successful operation of any manufacturing enterprise." In testimony before the U.S. Strike Commission, Pullman stated:

> We decided to build, in close proximity to the shops, homes for
> workingmen of such character and surrounding as would prove so
> attractive as to cause the best class of mechanics to seek that place
> for employment in preference to others. We also desired to establish
> the place on such a basis as would exclude all baneful influences,
> believing that such a policy would result in the greatest measure of
> success . . . from a commercial point of view. . . . The relations
> of those employed in the shops are, as to the shops, the relations
> of employees to employer, and as to those of them and others living

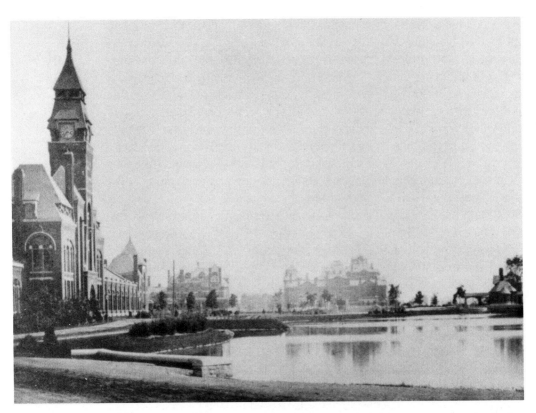

9.5 View of Office Building with landscaped basin as cooling reservoir for the Corliss Engine. To the south in the background is the Florence Hotel (left), the Arcade Building, and the Depot (right). (*Architectural Reviewer*, 1897)

 in the homes, the relations are simply and only the relations of
 tenant to landlord.[18]

By providing housing, he could affect the quality of workers' living environments, assuring a standard of shelter and sanitation. Moreover, maintenance could be provided on a regular basis and monitored by the company. If the health and welfare of workers could be secured, unnecessary absenteeism could be avoided—and, in theory, workers kept happy and contented. As a witness to the cramped tenement conditions caused by the Chicago Fire of 1871 and the attendant problems of slum neighborhoods, Pullman had contributed to charities and was a founder of the Chicago Y.M.C.A., which stressed religion, temperance, and family unity. His new town was intended to promote these values, and well-designed housing was a means to achieving that end. Most of Beman's houses were semidetached row houses or double-family two-story units with parlor, kitchen, and dining room below and three bedrooms and water closet above. Only 10 percent had bathtubs as fixtures, although all units had plumbing. A number of apartment buildings also were constructed for single men. In all, 1,800 units were built. An

9.6 Double-family row houses in Pullman. The company was forced to divest its housing after 1908, and the remaining units are tenant-owned, which accounts for the variations among units.

apartment in a double-family house cost the company $1,700 to build and rented for $17 a month, returning 12 percent per annum to the company. Overall, rents were higher in Pullman than in Chicago but not for comparable housing, as a labor investigation would show.[19]

Irving K. Pond, Beman's chief draftsman, borrowed from William Le Baron Jenney's office, recalled the quality of construction years later. Bricks were manufactured on-site from the lake-bed clay and trusses, window sash, and stud partitions were fabricated in the shops. Said Pond, "in spite of the short time in which all this materialized there was not a square foot of shoddy construction, not a wall of plasterboard or stucco, hardly a wooden shingle; but walls were of brick and roofs of slate, all laid by mechanics who took pride in their work. I know this because I worked on the scaffolds with the men, helped them lay out the patterns of brick ornament, some of which were designed on the spot, and with them worked out the bond."[20] Although the differences in fenestration and ornament among the units were subtle, an attempt was made to offer some variety, much in the way as did Norman Shaw's Bedford Park houses of 1876, published in *The Builder* (figs. 9.6, 9.7).

The only nonresidential buildings in Pullman, apart from the factories, were the Arcade, Market, Florence Hotel, school, depot, stables, and Green-

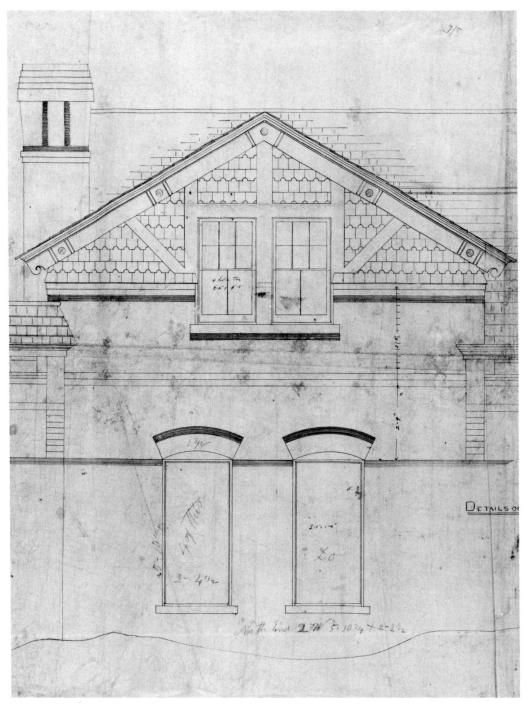

9.7 Solon Spencer Beman, Pullman Palace Car Company: Dwellings; Block Six Flats and Cottages, Pullman, Ill., ca.1880, black ink on linen, 70 × 109 cm, Gift of the Pullman Company, Inc., 1989.467.5. (c. 1990 The Art Institute of Chicago, All Rights Reserved)

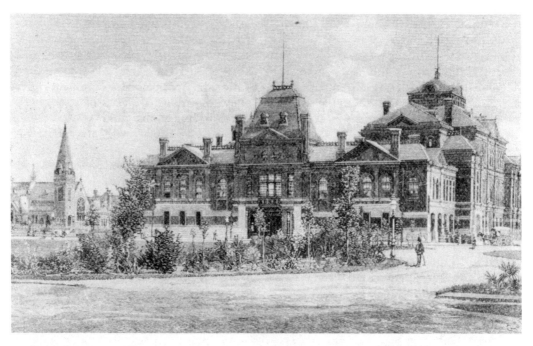

9.8 Arcade Building with the Greenstone Church at left in the background. (*Harper's Monthly Magazine*, 1885)

stone Church. The Arcade, demolished in 1926, was once the pride of Pullman. It was a forerunner of the enclosed shopping center, providing goods, services, and entertainment. In addition to leasing space to Chicago merchants for drygoods, furniture, tobacco, a newsstand, drugs, and jewelry, it contained a bank, an eight-thousand-volume library, and a theater to seat one thousand for performances such as *Little Lord Fauntleroy*, *The Fairies' Well*, and *A Barrel of Money*. Great attention was paid to the details of the building, from the quality of woodwork to the painted scenery of the stage set. It was in the Arcade that the offices of "city architect" were maintained (fig. 9.8).[21]

Fire destroyed the original Market Building, and it was replaced in 1893 by a two-story structure with stalls for grocery vendors below and an assembly room with clerestory above. It was truncated as a result of another fire in 1931, long after it ceased to perform its original function. From an architectural standpoint, its most distinguishing features were the four exedrae of apartments that framed its plan. A Brunelleschian arcade supports the ground-story facades of each, a feature that Beman would have recalled from his visit to Florence in 1892 (figs. 9.9, 9.10).[22]

The Greenstone Church, which takes its name from the color of the serpentinite rock quarried in Pennsylvania and used in its construction, was intended to be interdenominational. Various congregations could rent the

9.9 Circle Apartments at the intersection of 112th Street and Stephenson Avenue. The Market House (right), together with the apartment arcades, was reconstructed in 1892 after a fire. (*Architectural Reviewer*, 1897)

sanctuary and schedule services. For Pullman, himself a Unitarian, churches no doubt represented a poor investment in terms of occupancy versus space and cost, and he deemed one to be sufficient. The Methodists eventually took it over.[23]

The Florence Hotel, named for George Pullman's eldest daughter, was built to serve company guests and was one of the first buildings occupied in 1881. It contained a suite for Pullman's use, as well as fifty other rooms with kitchens, dining rooms, and bar below. The bar was the only place in town where liquor was sold. The hotel's Queen Anne trim was painted green, Pullman's favorite color.[24] It was while sitting on the hotel veranda that Pullman did something he was supposed never to do—reversed a decision that he had made earlier in the day. According to John McLean, a Pullman resident and the company physician, Pullman, whose peppery disposition was well known, had been persuaded to ride in an experimental automobile invented by one of his workers. It was a hot day and the vehicle's gasoline powered engine gave out, forc'ng Pullman to return to the hotel on foot from the north end of the industrial site. "As he walked he became warmer, and as his temperature arose, his temper went with it. Every man who crossed his path felt his displeasure, and by the time he reached the hotel he had bodily

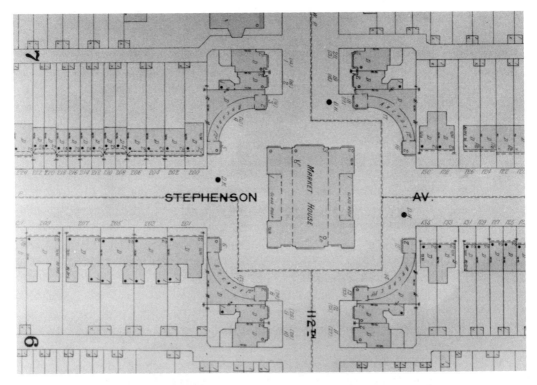

9.10 Plan detail of the Circle Apartments and Market House. (*Chicago*, vol. E. [Sanborne-Perris Map Co., 1897], p. 70.

fired a number of employees, including some at the hotel."[25] But after a cold drink, he regained his composure and ordered those fired to be rehired.

If Pullman provided the amenities of well-constructed homes with modern utilities in an attractive setting, with shopping conveniences and regular entertainment, then what went wrong? The record speaks for itself. The notorious Pullman Strike resulted in layoffs and reduced wages as a result of piecework labor and the company's refusal to discuss grievances with workers, let alone to arbitrate. But these problems alone would not have destroyed the model town, for within a year workers were back on the job as the company resumed full production. There was more to it. Before the strike, workers and their families had experienced a model environment based on the precepts of one man who was benevolent in a business sense in that his workers could share in the company's wealth as manifested by the model town. But for Pullman, benevolence, like everything else, was a business proposition, and when the business fell on hard times, benevolence ended. Paternalism was a one-way street. Despite unemployment and cutbacks, rents were not reduced. What was an indignity to workers before the strike—the company's practice of subtracting rent before issuing paychecks—became an outrage. The pent-up emotions of families before the strike, who refused to criticize certain aspects of the town for fear a "spotter"

would report them, afterward unleashed a barrage of complaints that were amplified by the press and Pullman's political enemies. For example, when their employer suggested they vote Republican, the workers overwhelmingly voted Democratic in the Pullman precinct. The model town was pictured as a feudal barony—a model not to be copied—and its owner a tyrant. Pullman, a few years earlier portrayed as a benevolent and kindly patriarch, had become a beleaguered and sinister figure whom Jane Addams likened to a modern King Lear.[26]

Even before the strike, the experiment at Pullman had been called into question by the political economist Richard T. Ely, who challenged the idea of building model towns for fear that economic interests—and not social concern—would motivate the captains of industry, especially when the chips were down, which in Pullman proved to be the case.[27] Ely was not the first to make a critical assessment of Pullman. Carroll D. Wright, soon to become the first U.S. commissioner of labor, visited the model town in 1884 and applauded the initiative of an industrialist taking matters in hand, in laying out a comprehensively designed town when there were few alternatives to providing a decent living environment for the working class. In discussing Pullman, he called attention to the earlier tradition of industrial villages in New England, like Peacedale, Rhode Island, South Manchester, Connecticut, and St. Johnsbury, Vermont. Years later, after numerous industrial investigations and a career spent investigating social injustices, Wright observed that to the extent Pullman was a failure, it was a failure in industrial management and not industrial planning.[28]

The strike alone did not destroy Pullman's model physical environment. What destroyed the efficacy of Beman's comprehensive plan was its exclusiveness—its ownership by the company—and the paternalism behind its management. The antitrust suit which forced the company to divest its real estate after 1908 removed its social stigma. But it also removed the protection the town had received in the form of long-term site maintenance. Although S. S. Beman never wavered in his loyalty to George M. Pullman, he must have regretted bitterly the events that overtook his first and foremost commission. His chief draftsman later wrote of Pullman: "The heart is gone out and what is left is the machine . . . of the scores of men who were under me in Beman's office during the building of the town . . . [those still alive] would not know and some would hardly care to know the place should they return."[29] Annexed by Chicago, Pullman declined into the desuetude of a decaying South Side neighborhood. Its Arcade and Market buildings, without the company's support, succumbed to outside economic forces. The parklike setting that once distinguished Pullman withered away.

Because of its checkered past, Pullman has been stigmatized. As a company town, it became a negative symbol of the "age of enterprise." Overshadowed by the Pullman Strike, the town's rational layout, modern utilities, and specialized architecture have yet to be evaluated fully. Leaving aside the social experiment that has been justly criticized, Beman's plan and architec-

ture were remarkable for the early 1880s. In comprehensiveness of design and municipal services, Pullman was once unique.

NOTES

This chapter was first delivered as a paper at a symposium titled "Late Nineteenth-Century American Architecture: The Triumph of Capitalism" at the University of Delaware in 1981. When embarking on a study of Beman and Pullman, one must acknowledge a debt to Thomas J. Schlereth and Stanley Buder. Schlereth is at work on a biography of Beman, which will place the architect within his proper framework of the Chicago School. Schlereth's "Solon Spencer Beman: The Social History of a Midwest Architect," *The Chicago Architectural Journal* 5 (1985):9–31 provides the most complete listing of Beman's works. For Pullman, Buder's *Pullman: An Experiment in Industrial Order and Community Planning, 1880–1930* (New York: Oxford University Press, 1967) provides the most thorough and balanced record to date. His dissertation contains an extensive bibliography of sources.

1. "Address by Mr. Louis H. Sullivan," before the Illinois Chapter of the AIA, June 8, 1915, typewritten text in the manuscripts collection of the Chicago Historical Society, pp. 1–2.

2. Charles E. Jenkins, "Solon Spencer Beman," *Architectural Reviewer* 1 (March 1897):47–101; Buder, *Pullman*, pp. 50, 73–74; Carl W. Condit, "Solon S. Beman," *Macmillan Encyclopedia of Architects*, vol. 1 (New York: Free Press, 1982), pp. 175–76; "Address by Sullivan."

3. Willam A. Coles and Henry Hope Reed, eds., *Architecture in America: A Battle of Styles* (New York: Appleton-Century-Crofts, 1961), pp. 137–211; Almont Lindsay, *The Pullman Strike* (Chicago: University of Chicago Press, 1942), pp. 207, 233.

4. "The Progress of the World," *The Review of Reviews* 10 (August 1894):132–37; Buder, *Pullman*, p. 147.

5. Lindsay, *The Pullman Strike*, p. 233; "The Progress of the World," p. 134.

6. Buder, *Pullman*, pp. 4–7; Richard H. Titherington, "George M. Pullman," *Munsey's Magazine* 11 (June 1894):254; and "George M. Pullman," *National Cyclopedia of American Biography*, vol. 11 (New York: James T. White, 1901), pp. 279–80.

7. Richard T. Ely, "Pullman: A Social Study," in *The Land of Contrasts: 1880–1901*, ed. Neil Harris (New York: George Braziller, 1970), pp. 129–30; "Pullman," *National Cyclopedia*, p. 279.

8. Ibid., pp. 127–28.

9. Mrs. Duane Doty, *The Town of Pullman* (Pullman, Ill.: T. P. Struhsacker, 1893), pp. 41–43.

10. John S. Garner, *The Model Company Town: Urban Design through Private Enterprise in 19th-century New England* (Amherst: University of Massachusetts Press, 1984), pp. 54–63.

11. Raymond A. Mohl and Neil Betten, "Paternalism and Pluralism: Immigrants and Social Welfare in Gary, Indiana, 1906–1940," *American Studies* 15 (Spring 1974): 5–6, 14; see also James Ford et al., *Slums and Housing*, vol 1 (Cambridge: Harvard University Press, 1936).

12. Leonardo Benevolo, *The Origins of Modern Town Planning* (Cambridge: MIT Press, 1975), pp. 42–49; Carroll D. Wright, *Some Ethical Phases of the Labor Question* (Boston: American Unitarian Association, 1902), pp. 75–76.

13. Buder, *Pullman*, pp. 51–59; Carroll D. Wright et al., *Report of Commissioners of the State Bureaus of Labor Statistics on the Industrial, Social and Economic Conditions of Pullman, Illinois* (Washington: Government Printing Office, 1884), pp. 3, 9.

14. "The Arcadian City of Pullman," *Agricultural Review* 3 (January 1883):72; John W. Reps, *Cities of the American West: A History of Frontier Urban Planning* (Princeton: Princeton University Press, 1979), p. 605; Buder, *Pullman*, pp. 50–51; Schlereth, "Solon Spencer Beman, p. 10; Ann Durkin Keating, Eugene P. Moehring, and Joel A. Tarr, *Infrastructure and Urban growth in the Nineteenth Century* (Chicago: Public Works Historical Society, 1985), pp. 20–21; and Martin Melosi, "The Impact of Sanitary Reform Upon American Urban Planning, 1840–1890," *Journal of Social History* 13 (Fall 1979):89–91.

15. Ellis L. Armstrong, ed., *History of Public Works in the United States, 1776–1976* (Chicago: American Public Works Association, 1976), p. 402.

16. Wright et al., *Report of the Commissioners . . . Pullman, Illinois*, pp. 3–6; Schlereth, "Solon Spencer Beman," pp. 12–13; Doty, *The Town of Pullman*, pp. 201–5.

17. Schlereth suggests that Pullman may have derived from the plan of Saltaire, England, one of the planned industrial towns of the nineteenth century, first cited in the *Report of the Commissioners . . . Pullman, Illinois*, p. 2, and stemming from a visit to Pullman in the summer of 1884. Saltaire is also mentioned by Robert M. Lillibridge in "Pullman: Town Development in the Era of Eclecticism," *Journal of the Society of Architectural Historians* 12 (October 1953):17. Both towns had orthogonal plans with industrial buildings to one side, housing to the other. But the towns do not compare in architecture, nor does Saltaire possess the subterranean system of water delivery and sewerage that influenced the layout of Pullman. For a description of Saltaire and other early English industrial towns, see Walter L. Creese, *The Search for Environment: The Garden City, Before and After* (New Haven: Yale University Press, 1966).

18. *The Strike at Pullman, Statements of President Geo. M. Pullman . . . before the U.S. Strike Commission* (Washington: U.S. Government Printing Office, 1894), pp. 1–2.

19. Buder, *Pullman*, pp. 32–35, Ely, "Pullman: A Social Study," p. 126; see also Carroll D. Wright, *Report on the Factory System of the United States* (Washington: U.S. Government Printing Office, 1884).

20. Irving K. Pond, "Pullman: America's First Planned Industrial Town," *Illinois Society of Architects Monthly Bulletin* 1 (June–July 1934):6.

21. Lillibridge, "Pullman: Town Development in the Era of Eclecticism," pp. 17–22; Doty, *The Town of Pullman*, pp. 11–19.

22. Lillibridge, "Pullman: Town Development in the Era of Eclecticism," p. 20; "Solon S. Beman," *National Cyclopedia of American Biography*, vol. 14 (New York: James T. White, 1910), pp. 304–5.

23. "The Arcadian City of Pullman," pp. 83–84; Ely, "Pullman: A Social Study," p. 130.

24. *Pullman Journal: A Publication of the Historic Pullman Foundation* (Summer–Fall 1983):1–5; see also Theresa Ducato, "Pulling for Pullman," *Inland Architect* 26 (March/April 1982):7–20.

25. John McLean, *One Hundred Years in Illinois* (Chicago: Privately printed, 1919), p. 227.

26. Ely, "Pullman: A Social Study," pp. 130–31; *The Strike at Pullman*, pp. 20–

24, 27; Lindsay, *The Pullman Strike*, pp. 230–31; and E. L. C. Morse, "Pullman and Its Inhabitants," *The Nation* 59 (July 1894):61–62.

27. Ely, "Pullman: A Social Study," pp. 121–32.

28. Carroll D. Wright, [Massachusetts] *Bureau of Labor Statistics, Sixteenth Annual Report* (Boston: Wright and Potter, 1885), pp. 1–28; Graham Romeyn Taylor, *Satellite Cities, a Study of Industrial Suburbs* (New York: D. Appleton, 1915), pp. 28, 32–35. See also Carroll D. Wright, *The Relation of Political Economy to the Labor Question* (Boston: A. Williams, 1882), pp. 52–53, and *The Industrial Evoloution of the United States* (New York: Charles Scribner's and Son, 1902), pp. 313–20.

29. Pond, "Pullman: America's First Planned Industrial Town," p. 8.

AFTERWORD

What had been an important expression in architecture and design in the period between 1880 and 1920 rapidly dissipated thereafter. The maturing of the Midwest as a region seems to have exhausted something of its self-expression. Architecture in cities like Chicago, Milwaukee, and St. Louis assumed a more conservative and conventional appearance. Architects grew complacent as large offices with national reputations sought conformity in proportion to their success. The waning influence of Louis Sullivan and the Sullivanesque, the diffusion of the Prairie Style, Prohibition, the quaint nativism of chautauquas, and the negative image of industrial towns would have an irrevocable and irredeemable effect on certain types of building. What once was novel and trend-setting had become dated and provincial.

The Chicago Tribune Tower Competition of 1922 was symptomatic of change. First prize went to an established New York architect whose design reflected the prevailing historicism of the period. Its handsome form was emblematic of the prestige office towers that had been erected in New York during the preceding decade. More challenging designs came from foreign entries. Emphasis was placed on style, not structure; and there was nothing revolutionary about the winning design in either regard. In the meantime, buildings like the 1886 Rookery, which had pioneered in office building design, underwent renovations to update their interior spaces. William Drummond, the University of Illinois graduate who had worked for Wright and then practiced independently in the Prairie Style, succumbed to the slick imagery of Art Deco in his 1930s' renovation of the Rookery. The building has since become a curious survivor of the Chicago School, an object for restoration and rehabilitation. By the 1930s, however, the lessons of tall building

design had been learned, and the history of early iron framing had become a subject of interest for scholars like Turpin Bannister (1904–82).

Although raised in the Midwest, Bannister received his training in architecture from Columbia University and completed his graduate study in architectural history at Harvard. He taught at Rensselaer and later at Auburn University before arriving at the University of Illinois in 1948 to chair the architecture program. He was a founder of the Society of Architectural Historians, its instigator and publicist who shepherded the society through its early years. He launched the *Journal of the Society of Architectural Historians*, and as its editor he encouraged the publication of architectural history as a subject distinct from the broader field of art history. Those early issues of the *JSAH* have a peculiarly technical bent, attributed in part to the influence of Bannister. Although a student of medieval architecture, he became fascinated by American building and its technical development.

Bannister's singular achievement was *The Architect at Mid-Century: Evolution and Achievement* (1954), which he organized and wrote for the American Institute of Architects. It is an erudite and inclusive compilation by a meticulous scholar. Among other things, Bannister traces the education and practice of American architects from earliest times to the middle of the twentieth century. Of lesser magnitude are his essays on early iron-framed buildings and James Bogardus in *The Architectural Review* and *JSAH*. No one, today, can undertake a study of the skyscraper and early metal framing without consulting his essays. In 1957, Bannister left the University of Illinois to become dean of the College of Architecture and Fine Arts at the University of Florida. During his tenure at Illinois, however, he realized Rexford Newcomb's wish—to extend instruction in the history of architecture to include the nineteenth and twentieth centuries. His carefully prepared course outlines and the slide library that he enhanced have assisted his successors to the present day.

Bannister's departure brought two new, yet accomplished, scholars to the School of Architecture—first Ernest A. Connally, and shortly after, Walter L. Creese. Connally had studied architecture at the University of Texas before following the now-familiar path to Harvard to complete his education in architectural history. He taught courses in Renaissance and Baroque and had a special interest in French colonial architecture. Before arriving at Illinois, he taught at Washington University in St. Louis and was introduced to the nearby site of Ste. Genevieve. French settlements in the Mississippi Valley were an early, although significant, regional influence on American architecture. At Ste. Genevieve, Connally directed the restoration of the Bolduc House for the Society of Colonial Dames. During his tenure at Illinois, he supervised a number of projects for the National Park Service, including studies of Cape Cod, Massachusetts. By 1968, he had become indispensable to the National Park Service and was appointed the first director of the Office of Archaeology and Historic Preservation in Washington, D.C.

Like Connally, Walter Creese had put his knowledge of history to prac-

tice. In Louisville, in addition to his academic appointment at the university, he became involved in city planning and preservation issues. He sought support for the restoration of Shakertown, the nineteenth-century Shaker settlement in Pleasant Hill, Kentucky. Because of travel obligations and other commitments, Creese's arrival at the University of Illinois was delayed a year. The postponement enabled a recent graduate of Northwestern University, H. Allen Brooks, to serve on a visiting appointment. Brooks' 1957 dissertation, "The Prairie School: The American Spirit in Midwest Residential Architecture, 1893–1916," and his later book provided a starting point for a renewed commitment among graduate students who wished to study the architecture of Frank Lloyd Wright and his contemporaries within a regional frame-work. The foregoing essays in this book, influenced in turn by Walter Creese, examine once again these familiar figures of an impressive age.

Despite some spectacular and award-winning buildings completed in the Midwest in recent decades, it was the period 1880–1920 that first captured the essence of a new architecture in America's heartland. Through the study of architectural history, represented by the research and writing of the scholars mentioned in the opening and concluding pages of this book, we have a far greater appreciation of this regional accomplishment.

For his encouragement of this project, I wish to thank R. Alan Forrester, a graduate of the School of Architecture of the University of Illinois and its present director. Robert Gilvesy and Barry Swedeen, two resourceful graduate students, assisted with the research of records in the University Archives. Professors Maynard J. Brichford and John M. Hoffmann of the University Library provided additional information. Included in the captions of the illustrations are the individuals and organizations that provided them. Jane Cook of the School of Architecture's administrative staff is to be thanked for typing and correcting the final manuscript. Finally, the contributors and I are indebted to Mary Giles, Karen Hewitt, and Richard Wentworth of the University of Illinois Press for sharing advice and providing editorial assistance.

CONTRIBUTORS

Susan K. Appel is assistant professor of art history at Illinois State University. She received her B.F.A. from Bowling Green State University and her M.A. in art history from the University of Iowa. She is completing her doctoral dissertation on pre-Prohibition brewery architecture at the University of Illinois at Urbana-Champaign and has published related articles in several journals and collections of essays.

John S. Garner is professor of architecture at the University of Illinois at Urbana-Champaign. He received his B.Arch. degree from Oklahoma State University, M.Arch. from the University of Illinois, and Ph.D. from Boston University. A former NEH Fellow and Fulbright Scholar, he is author of *The Model Company Town: Urban Design through Private Enterprise in 19th-century New England* (1984).

Roula Mouroudellis Geraniotis is an architectural historian in Potomac, Maryland. She received her Diploma in Architecture from the National Technical University in Athens, Greece, and M.Arch. and Ph.D. from the University of Illinois at Urbana-Champaign. A former Newberry Library Fellow, she has published several articles on the influence of German architectural theory and practice in American architecture, including "An Early German Contribution to Chicago's Modernism" in *Chicago Architecture: 1872–1922, Birth of a Metropolis* (1987).

Narciso G. Menocal is professor of architectural history at the University of Wisconsin-Madison. He received his B.Arch. and M.Arch. from the University of Florida, and his Ph.D. from the University of Illinois at Urbana-Champaign. He is the author of *Architecture as Nature: The Transcendentalist Idea of Louis Sullivan* (1981), *Keck and Keck, Architects* (1981), and of numerous articles on American architecture, especially on Frank Lloyd Wright and Louis Sullivan. He has held a fellowship from the Buell Center for the Study of American Architecture, Columbia University and is presently a Guggenheim Fellow.

Ronald E. Schmitt is associate professor of architecture at the University of Illinois at Urbana-Champaign, where he teaches graduate design. Previously, he was an archi-

tect, designer, and preservationist in Chicago. He received his B.Arch. and M.Arch. degrees from the University of Illinois. His research on the Sullivanesque is supported by a grant from the Graham Foundation for Advanced Studies in the Fine Arts.

Deborah Slaton is an architect/historian with Wiss, Janney, Elstner Associates, Inc. in Chicago. She received her B.A. from Northwestern University, and her M.A. in English and M.Arch. from the University of Illinois. She is the author of numerous historic structure reports and articles on restoration and preservation technology.

Christopher Vernon is a doctoral candidate in historical geography at the University of Illinois at Urbana-Champaign. Following undergraduate study in architecture and landscape architecture, he received a master's degree in landscape architecture from the University of Illinois. A former Edward L. Ryerson Fellow, he has an abiding interest in the Midwest and the architecture and landscape design of the Prairie School.

Ellen Weiss is assistant professor of architecture at Tulane University. She received her B.A. from Oberlin College, and M.A. and Ph.D. from the University of Illinois at Urbana-Champaign. Currently a director of the Society of Architectural Historians, she is the author of *City in the Woods: The Life and Design of an American Camp Meeting on Martha's Vineyard* (1987).

Craig Zabel is assistant professor of art history at The Pennsylvania State University. He received his B.A. from the University of Wisconsin-River Falls, and A.M. and Ph.D. from the University of Illinois at Urbana-Champaign. He co-edited *American Public Architecture: European Roots and Native Expressions* (1989), and has taught at the University of Illinois, University of Virginia, and Dickinson College.

INDEX

Index